THE
Object of Labor

Art, Cloth, and

Cultural Production

Edited by Joan Livingstone & John Ploof

Designed by Ann Tyler

School of the Art Institute of Chicago Press
Chicago, Illinois

The MIT Press
Cambridge, Massachusetts
London, England

This publication and accompanying international symposium was made possible by the William Bronson and Grayce Slovet Mitchell Lectureship in Fiber and Material Studies at the School of the Art Institute of Chicago.

MIT Press books may be purchased at special quantity discounts for business or sales promotional use. For information, please email special_sales@mitpress.mit.edu or write to Special Sales Department, The MIT Press, 55 Hayward Street, Cambridge, MA 02142.

Essays are set in Adobe Garamond and Officina. This book was printed by Palace Press International, Hong Kong.

Library of Congress Cataloging-in-Publication Data

The object of labor : art, cloth, and cultural production / edited by Joan Livingstone and John Ploof.
 p. cm.
 Includes bibliographical references and index.
 ISBN: 978-0-262-12290-0 (hardcover : alk. paper)
 1. Handicraft industries. 2. Material culture. I. Livingstone, Joan, 1948- II. Ploof, John.
HD9999.H362O25 2007
338.6'425—dc22

 2006027386

10 9 8 7 6 5 4 3 2 1

Editors: Joan Livingstone and John Ploof
Managing Editor: Susan Snodgrass
Assistant Editor: Judith Leemann
Designer: Ann Tyler
Prepress/manufacturing coordination: Kathi Beste

Endpapers: a project by Christine Tarkowski

The Object of Labor
www.saic.edu/objectoflabor

Contents

vi **Joan Livingstone, John Ploof**
Introduction

1 **Maureen P. Sherlock**
Piecework: Home, Factory, Studio, Exhibit

31 **Alan Howard**
Labor, History, and Sweatshops in the New Global Economy

51 **J. Morgan Puett, Iain Kerr**
That Word Which Means Smuggling Across Borders, Incorporated: The Multipled Suit

59 **Karen Reimer**
Work Now

67 **Helen Haejin Cho**
Machine Dreams

81 **subRosa**
Can You See Us Now? ¿Ya Nos Pueden Ver?

89 **Margo Mensing**
Lace Curtains for Troy

105 **Anne Wilson**
Damask

113 **Carol Becker**
Amazwi Abesifazane: Voices of Women

131 **Andries Botha**
Amazwi Abesifazane: Reclaiming the Emotional and Public Self

143 **Lara Lepionka**
Visible Links

151 **Darrel Morris**
I mean this

159 **Viji Srinivasan, Dr. Skye Morrison, Laila Tyabji, and Dorothy Caldwell**
Stitching Women's Lives: Sujuni and Khatwa from Bihar, India

181 **Barbara Layne, Sue Rowley**
Inventory of Labor

189 **Park Chambers**
Signifiers

197 **Lou Cabeen**
Home Work

219 **Lisa Clark**
What are you making?

227 **Brian Jungen**
from Prototypes for New Understanding

229 **Susie Brandt**
Sew Your Own Stump Flag

235 **Pepón Osorio**
from Trials and Turbulence

239 **Nancy Gildart**
Torn and Mended: Textile Actions at Ground Zero and Beyond

255 **Sadie Plant**
Ada Lovelace and the Loom of Life

265 **Lia Cook**
Hands on Spots

273 **Alison Ferris**
Biting and Chewing in Contemporary Art

281 **Nick Cave**
from SOUNDSUITS

283 **Janis Jefferies**
Laboured Cloth: Translations of Hybridity in Contemporary Art

295 **Yinka Shonibare, MBE**
Big Boy, Leisure Lady, Gay Victorians

297 **Kimsooja**
from Cities on the Move

299 **Mary Jane Jacob**
Material with a Memory

315 **bell hooks**
An Aesthetic of Blackness: strange and oppositional
Aesthetic Inheritances: history worked by hand

333 **Ann Hamilton**
from indigo blue

337 **Neil MacInnis, in collaboration with Judith Leemann**
Deco-jamming is Eco-glam!

357 **Ingrid Bachmann**
Hand Labour and Digital Capitalism at the Chicago Board of Trade

369 **Merrill Mason**
Iron Into Lace

377 **Kevin Murray**
Artist as Insect

 Christine Tarkowski
Endpapers

393 *Contributors*

398 *Acknowledgments*

399 *Credits*

400 *Index*

Introduction

Joan Livingstone and John Ploof

The essays and art in *The Object of Labor: Art, Cloth, and Cultural Production* explore the personal, political, social, and economic meaning of work through the lens of art and textile production. The ubiquity of cloth in everyday life, the historically resonant relationship of textile and cloth to labor, and the tumultuous drive of globalization make the issues raised by this collection of special interest today. Essays by twenty cultural critics and historians of art and labor, and eighteen artists' projects consider cloth and other forms of visual and material culture within the context of a broad range of artistic practices, labor histories, and social meanings. Throughout, contributors examine the quotidian aspects of cloth, expanding their inquiry to include the impact of shifting world economies and social dynamics embodied in works of art and labor.

The Object of Labor is constructed as an intertextual document rather than a linear collection of prose. Although bound in sequence, these essays and projects can be read in any order. They can be encountered "promiscuously" as suggested by cultural studies scholar Richard Johnson who writes that texts "pour in on us from all directions in diverse, coexisting media, and differently paced flows."[1] Thus, *The Object of Labor* invites conversation that operates through and between its folds, links, and contingencies, illuminating how all of our lives are becoming increasingly intertwined culturally, economically, and politically.

Opening cross-border links in international trade and finance, globalization can be seen as an international phenomenon of economic, technological, political, and cultural exchanges promoted by modern communication, transportation, and legal infrastructure. Social critic and essayist Barbara Ehrenreich argues, "The problem is not so much that the world is so tightly linked now – by trade, investments, and high-speed telecommunications – but that the links converge in such a small number of hands . . . In effect, these multinational enterprises have become a kind of covert world-government – motivated solely by profit and unaccountable to any citizenry."[2]

Sociologist Boaventura de Sousa Santos echoes this concern when she writes that globalization requires a critical focus on sets of social relations that involve conflicts and, hence, both winners and losers, stating "More often than not, the discourse on globalization is the story of winners as told by the winners."[3] The contributors in this anthology perforate and disrupt this one-sided perspective with critical and compelling visions that take a variety of forms.

These issues also have particular relevance due to the historical relationship of textile to labor history and to the current phase of global capitalism. Political scientist

1. Richard Johnson, "What is Cultural Studies Anyway?" *Social Text,* no. 16 (Winter, 1986-87), pp. 38-80.

2. Barbara Ehrenreich, "Foreword," *Field Guide to the Global Economy,* eds. Sarah Anderson and John Cavanagh with Thea Lee, and the Institute for Policy Studies (New York: The New Press, 2005), p. viii.

3. Boaventura de Sousa Santos, "Toward a Multicultural Conception of Human Rights," *Zeitschrift für Rechtssoziologie,* 1997, 18(1), pp. 1-15.

Jane Schneider and anthropologist Annette B. Weiner suggest that cloth is made politically and socially salient through human actions, stating that:

Capitalist production and its associated cultural values reordered the symbolic potential of cloth in two interrelated ways. First, altering the process of manufacture, capitalism eliminated the opportunity for [laborers] to infuse their product with spiritual value . . . Second, by encouraging the growth of fashion . . . capitalist entrepreneurs vastly inflated dress and adornment as a domain for expression through cloth. Despite these shifts of emphasis and the worldwide expansion of capitalist manufacturing and fashion, ancient cloths and traditions of making them continue to reemerge with political — indeed often subversive — intent, above all in societies emerging from colonial domination.[4]

4. Annette B. Weiner and Jane Schneider, eds., *Cloth and Human Experience* (Washington and London: Smithsonian Institution Press, 1989), p. 4.

Originating with the history of survival, cloth manufacture, and its accompanying division of labor, expands to impact all spheres of culture and power. Additionally, the physical and intimate qualities of fabric allow it to embody memory and sensation and become a quintessential metaphor for the human condition. Crossing between arenas of function, craft, art, and ritual, the meaning of cloth from its most banal to its most splendid form affects our daily lives and welfare in terms of gender, race, ethnicity, sexuality, class, invention and technology, commerce and work.

In *Piecework: Home, Factory, Studio, Exhibit*, philosopher Maureen P. Sherlock writes against perceiving the concerns of artists and laborers as separate. Sherlock tracks the intricate mechanisms coupling our cultural and economic lives, examines the perpetual craving for newness in art and fashion, and maps the continual movement of galleries and factories into new geographies. In tracing "the disconnected sites of piecework," she elucidates the ways in which the internal operations of capitalism shape the experience of subjects in locations ranging from elite graduate art schools to offshore factories producing underwear for Wal-Mart. With its underlying argument for widespread access to "work that is safe, protected, meaningful, and justly compensated," Sherlock's essay serves as a call for artists to drop the belief that theirs is a struggle significantly different from that of disenfranchised workers anywhere.

Labor historian Alan Howard's *Labor, History, and Sweatshops in the New Global Economy* traces the intertwined coevolution of the apparel industry and organized labor, from the first collective actions of immigrants working in New York's garment district in the early 1900s to today's global economy with its transnational corporations, "commodity chains," and increasingly isolated, unprotected, and invisible offshore workers. He outlines the uneven process by which labor movements, human rights activists, and an engaged citizenry have struggled to put an end to sweatshops. Drawing on this history, Howard sets forth "strategic options for confronting the global sweatshop of the twenty-first century."

Seducing the reader into abandoning the certainty of categories and fixed readings, J. Morgan Puett and Iain Kerr disturb the pace of capitalism with a delightfully slippery project extending from their installation at the Massachusetts Museum of Contemporary Art, *That Word Which Means Smuggling Across Borders, Incorporated:*

The Multipled Suit. Charted here are the varied origins of their "multipled suit." Depicted as a set of plans are thirty-eight "quasi-components" from which the multipled suit can be assembled, along with directions for ordering this custom-made suit for oneself. Folding found patterns and source materials into rigorously subjective processing methods, Puett and Kerr refashion "the possible futures of business practices . . . masculinity, and alternative forms of engagement."

In *Work Now,* Karen Reimer addresses her approach to labor and her use of materials and processes that allow us to see how our own worldview is imposed upon what we encounter. In this interview, she speaks of the way illegible or partially obscured information spurs a projective response from viewers, and of her interest in the play between subjective and objective modes of reading. The works presented here are embroidered renderings of found texts, frequently pages in their entirety, or selected passages that include only certain words that give rise to unexpected meanings.

Helen Haejin Cho's *Machine Dreams* explores Korean mythology, the shifting nature of immigrant women's labor in the U.S. garment industry, and the navigation of creative identity. In a folded narration, we first encounter the shifting world of two Korean-immigrant garment workers through the eyes of their young daughter, then double back to view that world through research done by that same daughter, now an artist and filmmaker, on the economic and political forces that shaped her family's life.

A common strategy among many of the contributors in this anthology is to expose systems of global economy. This is a goal shared by the artist collective subRosa. Their installation *Can You See Us Now? ¿Ya Nos Pueden Ver?* at the Massachusetts Museum of Contemporary Art, asks visitors to cut the tags out of their clothing and pin them onto a world map, marking the geographic distribution of apparel production and thus mapping "the often invisible intersections of women's material and affective labor." The participatory structure of subRosa's installation ensured that visitors could see themselves both as complicit in globalized labor conditions and as capable of investigating and participating in resistance struggles.

Artist and writer Margo Mensing created the installation *Lace Curtains for Troy: Collar City at the Millennium* for the Arts Center in Troy, New York. It developed from research on the region's garment-producing history, particularly the invention and production in the nineteenth century of the detachable collar (thus Troy's nickname, Collar City). In her essay, Mensing articulates the development and decline of garment manufacturing in the Hudson Valley region through the story of the Rielly family textile business that manufactured hundreds of collars for Mensing's installation. In an era in which artists increasingly contract out elements of their work to be manufactured by others, Mensing underscores the importance of naming those whose labor enables her own.

Anne Wilson's project *Damask* subverts the conventions of domestic refinement and decorum through the stitching of fine human hair onto the surfaces of luxurious table linens. Drawn from her larger project *A Chronicle of Days,* consisting of 100 hair-stitched damask fragments each completed within one day, six pieces are presented

here as if laid out in a sample book, or an archive of possibilities, from which one might choose and place an order.

In *Amazwi Abesifazane: Voices of Women*, cultural critic Carol Becker reflects on the *Amazwi Abesifazane* project that gathers testimony from indigenous and tribal women of South Africa, who were largely excluded from the processes of the post-apartheid Truth and Reconciliation Commission. These testimonies, now numbering in the thousands, take the form of memory cloths – small, embroidered narratives – and are made to embody the participant's experience of "a day I will never forget." Becker examines the ways in which working on the project has led to heightened feminist and social consciousness among participating women and how these cloths contribute crucial details to the collective rebuilding of memory still underway in South Africa.

In a related essay, sculptor Andries Botha, founder of the *Amazwi Abesifazane* project, makes evident the extent to which the project was developed as a work of conceptual art occupying "social as opposed to symbolic space." Metaphors of territory and terrain bring legibility to complex cultural patterns, laying bare the deep structural ties between inequalities and indignities across all scale and manner of social system, from apartheid state to global art market. Botha challenges artists and critical thinkers to turn the labor of re-imagination onto the very cultural forms that support creativity, using the example of *Amazwi Abesifazane* to indicate promising pathways by which artists might work as members of collective efforts to reshape social and economic landscapes.

Wondering where one's ordinary household items come from is for many a fleeting curiosity, but for Lara Lepionka it became the ambitious research project *Visible Links,* spanning several continents and an array of work. Starting with the retail store clerk who sold her an ordinary place setting, Lepionka tracked down over 600 people whose labor went into producing this place setting. Sending out single-use cameras, she gathered photographs of each worker in her/his workplace that were then exhibited as an installation and printed as a poster. In sending the poster back out to each represented workplace, Lepionka makes visible the links of human labor within a network of globalized trade.

Through small, pieced, densely embroidered works and collaged drawings, Darrell Morris depicts men of the American office and their puritan work ethic. In *I mean this,* we see these men through the close eye of Morris himself, a perpetual outsider for whom the dynamic of power is viewed through the lens of class and masculinity. The text accompanying the works, written by Morris in a voice as warmly humorous as it is painfully honest, recounts his job history from stock boy to artist.

Stitching Women's Lives: Sujuni and Khatwa from Bihar, India, consists of four essays by Viji Srinivasan, Dr. Skye Morrison, Laila Tyabji, and Dorothy Caldwell that together report on efforts to revive dormant textile traditions in the Indian states of Bihar and Jharkand. Through the stitching of personal narratives, cloth production is recast as a vehicle of cultural resistance and economic empowerment, providing income and meaningful work for women in this impoverished region. The *Stitching*

Women's Lives project merges the aims of a commercial venture with those of accountability for both social and economic return on the participants' investment. As such, it is driven by the hybrid goals of social entrepreneurship. Within the context of globalization, hybrid organizational models such as this and the *Amazwi Abesifazane* project in South Africa develop between and through private and public sector initiatives. They perforate the divide between rich and poor with innovative solutions to interrelated problems of sustainable economic and cultural development.

In Barbara Layne and Sue Rowley's *Inventory of Labor,* we encounter a perspectival field of textile tools, once used in homes and factories, now obsolete and consigned to a second life as artifacts. Stored as bits of digital data within the computer banks of museums, this catalogue of tools foreshadows a technology of the virtual.

In his artist's project *Signifiers,* Park Chambers examines subcultural dress codes fashioned by gay men from work clothes, such as Levi's 501 jeans and colored bandanas, to signify sexual preferences and identify those preferences to other gay men. In the era of the gay liberation movement of the late 1960s to mid-1980s, this act of repurposing work clothes served to queer everyday fashion, emphasizing the hypermasculinization of the working man's clothing as a self-identified prop of sexual identity.

In *Home Work,* artist and scholar Lou Cabeen analyzes the competing ideologies that shaped the environment in which late-nineteenth-century and early-twentieth-century American women practiced embroidery. Into this historical narrative, Cabeen splices personal reflections of her great-grandmother and "the sanctuary her stitching offered us both." She examines the intertwined histories of working-class, middle-class, and leisured women, their use of craft as a means of decoration and self-expression in American society, and the sensuous pleasure that needlework allowed.

Guided by the question "What does it mean – personally – to make things in a postindustrial time?" North Carolina artist Lisa Clark developed her project *What are you making?* The resulting photographs depict a diverse spectrum of makers holding before them projects ranging from rag dolls to large crocheted afghans. Accompanying excerpts from interviews attest to the sense of self-reliance and accomplishment that comes from knowing how to do for oneself.

Appropriating the Nike Air Jordan trainer, a highly charged status symbol from popular culture, Brian Jungen, a Canadian artist from British Columbia with Swiss and Dane-zaa First Nations roots, literally deconstructs this ultimate symbol of global capitalism. He then reassembles it into simulations that reiterate the formal qualities of Northwest Coast Aboriginal artifacts.

Susie Brandt's project *Sew Your Own Stump Flag* is a sardonic do-it-yourself guide to sewing a decorative flag as well as a comment on the environmental and economic tensions in the Adirondack region of upstate New York. Rather than the usual seasonally appropriate or geographic state banners that hang outside rural and suburban homes throughout the United States, Brandt's flag is for a tree stump. This stump flag serves as an iconic regional banner, a reminder of the tensions existing between "tourism and logging, visitors and residents, preservationists and resource management advocates."

A portfolio of Pepón Osorio's work presents three interrelated installations developed during a residency at the Philadelphia Department of Human Services. Focusing on the foster care system, Osorio worked closely with social workers, administrators, and clients to conduct an institutional critique in which he sensitively reveals a government system from the inside – both at work and dysfunctional – through the material culture of intake offices, courtrooms, and warehoused personal possessions.

As a working artist trained in textile arts, Nancy Gildart was struck by the ubiquity of textiles – real and metaphorical – in the spontaneous memorials, patriotic displays, and commemorative gestures that appeared in response to the September 11, 2001, attacks on the World Trade Center in New York City. In *Torn and Mended: Textile Actions at Ground Zero and Beyond,* Gildart proposes the concept of "textile actions" as both an intuitive impulse and an artistic strategy that figure in the creation of social space, the encouragement (or stifling) of community dialogue, and the ongoing work of collective response.

In *Ada Lovelace and the Loom of Life,* Sadie Plant investigates the influence of textile technologies on the development of early computing machines, paying particular attention to women's roles in these intertwined histories. Plant reexamines the early-nineteenth-century invention of the Jacquard loom (a system of punched cards by which the weaving of patterns could be partially automated) and its relationship to the collaboration of Ada Lovelace and Charles Babbage, who in the 1840s worked together to construct and program the Analytical Engine, one of the first calculating machines. Plant's reexamination of these intersecting histories, and the movement of her writing across disciplinary conventions, invites a provocative discussion between psychoanalysis, art, textiles, and computing.

Employing the ability of jacquard technology to create realistic images in thread, artist Lia Cook's *Hands on Spots* opens with an original woven jacquard ribbon of Joseph-Marie Jacquard, depicting the inventor at work. Enlarged fragments reveal threads making up the woven portrait, focusing on the inventor's hands. Subsequent pages reveal another set of hands – those of Cook herself. Encountering her hands twice (once in the image as they manipulate a thick spotted fabric and again in the weaving itself) evokes the parallel way in which Jacquard's labor is looped and extended.

Biting and chewing, elemental forms of human labor, have been engaged by artists over the past thirty years to both shape material and produce meaning. In her essay, Alison Ferris identifies a number of contemporary artists, including Vito Acconci, Hannah Wilke, Ann Hamilton, and Janine Antoni, for whom the act of mastication takes on a generative, performative function, drawing attention to "the material body within the conceptual process of making art." Ferris draws on psychoanalytic theory to examine the issues of incorporation and destruction, desire and aggression, ambivalence and frustration.

Nick Cave creates provocative sculptures that sample from histories of art, fashion, and ceremonial costume. Remixing conventional aesthetic hierarchies, Cave's work is imbued with issues of race, gender and sexuality, class and culture. Named *SOUNDSUITS* for their ability to generate a cacophony of image and noise, these

performed works are constructed from an agglomeration of found materials and detritus of visual culture.

The "metaphorical use of textiles to illuminate social and political relations" is being explored in art practice and among cultural theorists such as Sarat Maharaj, Gayatri Chakravorty Spivak, and Kobena Mercer. In *Laboured Cloth: Translations of Hybridity in Contemporary Art,* artist and scholar Janis Jefferies develops the conceptual and critical underpinnings of her own visual work and that of three other contemporary artists – Mindy Yan Miller, Zarina Bhimji, and Yinka Shonibare, MBE. Through the manipulation of found and made cloth and clothes, each of these artists explores the intersecting lines of cultural identity and transformation, alienation and displacement, hybridity and translation.

Yinka Shonibare's work embodies the complexity of cultural hybridity and postcolonialism. The Nigerian-British artist employs elaborately constructed Victorian costumes made of batik, a textile recognized as typically African yet more accurately traced to its origins in Dutch colonialism.

In *Cities on the Move,* an eleven-day performance, Kimsooja traveled throughout various Korean cities riding in, and sometimes on, a small truck piled high with *bottari* – brightly colored cloth bundles used by Korean refugees and merchants to transport possessions and objects. These actions signify human movement, migration, contemporary nomadicism, and the experience of displaced peoples.

In *Material with a Memory,* independent curator Mary Jane Jacob elucidates the ever-evolving meaning and value of cloth, its capacity to carry inherited references, and its ability to disrupt cultural certainties. She discusses three second-generation postmodern artists and the site-specific, textile-based works they created for the 2002 Spoleto Festival USA in Charleston, South Carolina. Yinka Shonibare's *Spacewalk* engages the evolution of trade cloth used by the artist to address "the complex cultural interchange of textile production," particularly as it shapes expectations of black identity. J. Morgan Puett's *Cottage Industry* recreates the universe of a textile factory within a domestic setting as workers reconfigure and reconstruct multiclass, multipart garments which piece together lost social histories. Kimsooja's *Planted Names* presents a series of memorial carpets for Drayton Hall Plantation, woven with the names of Africans and African-Americans who labored there.

In the paired essays *An Aesthetic of Blackness: strange and oppositional* and *Aesthetic Inheritances: history worked by hand,* cultural critic bell hooks calls for revitalized discussions of the historical and contemporary intersections of aesthetics and race, and for movement toward a radical aesthetic that "uncovers and restores links between art and revolutionary politics, particularly black liberation struggle." hooks recalls the legacy of her quilt-making grandmother, using her story to write against the erasure from history of such unknown women's artistic labor and to challenge the notion that the ability to think critically, to engage in abstract or theoretical speculation, is a function only of class and educational privilege.

Ann Hamilton's *indigo blue* resonates with a regional labor history of cotton and indigo production embedded within the economy of plantations and slave labor in

Charleston, South Carolina. Line by line, a text version of recorded history is methodically erased, creating room for a parallel version of history to be recorded. This story of human labor is encountered at ground level through the strata of 14,000 pounds of folded, used blue uniforms embroidered with names of workers recently laid off, and juxtaposed, from above, by an overseer's room filled with the excess of rotting bags of soybeans.

In *Deco-jamming is Eco-Glam!,* artist Neil MacInnis fools with words, inventing a special nomenclature through which to examine the way queer characters in three films use textiles "as material support for the transformation of their individual circumstances." The invention of terms such as *sexy-work* (a form of queer labor in which the impulse to embellish and adorn operates between private desires and the obligations of work) allows MacInnis to reposition decorative practices as subversive disruptors of entrenched social paradigms. He reframes filmic moments that would otherwise be understood under the rubric of identity crisis, arguing that *sexy-work* and the kind of deception it entails must be recognized as "essential cultural labour."

In *Hand Labour and Digital Capitalism at the Chicago Board of Trade,* Ingrid Bachmann posits the Chicago Board of Trade as a site where commonly accepted binary divisions between manual and intellectual labor, economic and cultural systems, and material and digital communication break down to reveal the complex nature of their interrelationship. Bachmann investigates the performative, theatrical nature of the trading floor with its open outcry system and garishly patterned jackets worn to signal trading firm affiliation. Important for Bachmann is the opportunity this site provides to consider "the erasure of human labour, and by extension hand labour, in the rhetoric and discourses around digital and information technologies."

Based on her experience as an artist-in-residence at the Kohler Company foundry in Wisconsin, Merrill Mason's project *Iron Into Lace* examines the uncanny translation of a lace collar – an elegant, feminized, status accessory – into a base, masculinized, and immutable cast-iron commodity. Photographed with a sumptuous lens, her work embodies the erotic qualities of a menacing narrative through ambiguous references to the body, a dressing room, and a woman's vanity.

In the concluding essay *Artist as Insect,* Kevin Murray locates the potential for new forms of artistic creativity in entomorphosis, the process of becoming insect. Here artists increasingly internalize the operations of arthropods, moving from using insects to make art, to making work by acting or thinking like insects, before finally returning to a renewed consciousness of their own humanity. Murray identifies contemporary artists working "as insects" in a matrix of concepts and terminology (such as "hive mind") that have emerged in recent years to describe the collective, nonhierarchical, and distributed knowledge systems structuring contemporary technological societies.

Christine Tarkowski's images of piled sandbags enclose this volume in the form of endpapers. Usually constructed of a coarse jute fiber, sandbags attempt to shore up against impending flood waters, but more often than not fail, as the weight of seepage presses against this temporary barrier.

Inverting this dialectic, we can imagine the sandbag as the weight of multinational corporate forces separating rich and poor, and the flood waters as the persistent cultural provocations that insist on a more just form of globalization. The challenge presented by contributors to this volume is to recognize the ways in which our daily lives are intertwined with a global market that impacts and pervades cultures everywhere. As cultural theorist David Trend has stated: "Ultimately this is where the processes of cultural production, education, and democracy intersect: where citizens recognize their own involvement in formations of power. This is not a realization that comes easily, because so many elements conspire to frustrate the process. The corporate consolidation of the mass media and the alienation people feel from government promote a belief in the intractability of the status quo."[5] Herein, this anthology seeks to pose questions about changes in culture and society brought on by globalization and explores how to proceed in individual and collective ways that value the humanity and labor of all people.

5. David Trend, "Cultural Struggle and Educational Activism," in *Art, Activism and Oppositionality: Essays from Afterimage,* ed. Grant H. Kester (Durham and London: Duke University Press, 1998), p. 180.

PIECEWORK

Maureen P. Sherlock

HOME,

FACTORY,

STUDIO,

EXHIBIT

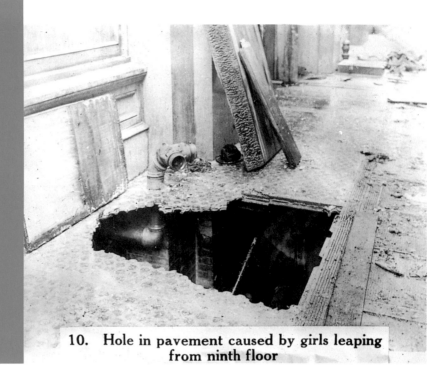

10. Hole in pavement caused by girls leaping
from ninth floor

*Hand-colored glass slide
of photograph taken after
the 1911 Triangle Shirtwaist
fire in New York City. Hole
in pavement caused by girls
leaping from ninth floor.*

*For Mary Anne Walkley who died an early death in a London sweatshop, for
the still unidentified people among the 146 dead in the Triangle Shirtwaist fire
(numbers 46, 50, 61, 95, 103, 115, and 127), and for my father, Matthew J.
Sherlock Jr., a lawyer who spent a lifetime defending blue-collar workers in the
workmen's compensation courts of New York City.*

Day laborer, guest worker, illegal immigrant—a myriad of terms that serve
to deny the humanity of millions of workers the world over who make
frocks and frou-frous for low wages in oppressive working conditions.
Lighting up the firmament of the Church of Designer Names, the spectacle
of these icons averts the mind's eye from child labor in Indonesia and
sweatshops hidden in every immigrant neighborhood in the United States.
The international visibility of the producers of real goods is eclipsed by the
sartorial glow of the commodity. The world of fashion has played itself out at
the intersection of art and commerce since the French Revolution, disguising
or denying a fragile and worked-to-the-bone body as its substrate. *La Mode*
colonized the department store, industrial furniture making, and interior

decor, as well as every form of display and exhibition from the Crystal Palace to Diana Vreeland at the Metropolitan Museum of Art and beyond. While art itself has a long history as a rarified and separated substance, often presenting itself as superior to the mere surface affect of "style," the truth is that it contains contradictions that parallel those of the economy and the institutional forms of life it shapes. At this historical juncture, the complex system of the rag trade is the model not only for art, but all forms of production, distribution, advertising, and consumption. The plight of every textile and garment worker, past and present, is the future of everyone under the rule of a global late capital.

The fates of art and fashion are tied to the forms of the dominant social system, sometimes leading, sometimes lagging, but always intertwined with its ideological apparatus. They are built on ". . . the bedrock of nineteenth-century commercial relations, urbanisation and technological developments . . . modern fashion continues to bear a relationship to them, for all the specific differences of its recent developments."[1] At first, fashion appears to resolve certain conflicts within the economy by creating new "needs" for the consumer that result in increased production and profit, but it also displaces many of the older producers and their goods. In flexible accumulation someone always pays, and anyone can be left with a warehouse full of Cabbage Patch Kids or Currins, Beanie Babies or Basquiats. Fashion has become the name of the game from celebrity sheets to designer stoves, hot art to hip hop, as every aspect of the economy has moved from values like durability or function to that of the "new." As quickly as a novelty succeeds, it is reproduced to a state of exhaustion and finally displaced into the junkyard of dead cultural cachet. The "shock of the new" is a marketing device that was first tested in the arena of art and fashion and is now applied to most commodities which, like Euro-styles from IKEA, quickly reveal themselves as the *schlock* of the new. One's shelf life in art may seem to be a little longer, each international museum *needs* its Julian Schnabel or its Jeff Koons after all, but even here the spell of the commodity transforms artists' works not into masterpieces but dated and mannered moments in the spectacle of art marketing.

We cannot really talk of art *history* after modernism; a progressive teleology has given way to a mere succession of anecdotal styles and individuals existing in splendid isolation. Criticism is now without shared theoretical principles and easily degenerates into mere gossip or pure promotional pap. Art schools callously marshal corporate marketing techniques that leave all questions of education or edification behind; what counts is what is countable at the tuition cash register, and publicity becomes the name of the game.

1. Caroline Evens, *Fashion at the Edge: Spectacle, Modernity and Deathliness* (New Haven: Yale University Press, 2003), p. 6.

2. Erin Mackie, *Market a la mode: Fashion, Commodity, and Gender in The Tatler and The Spectator* (Baltimore: Johns Hopkins University Press, 1997), p. xiii.

In the public sphere, art "is deeply invested in the commercial marketplace and its standards of fashion, but veils that investment so that it can claim a status outside the market and its trivial, ephemeral values."[2] In associating itself with transcendental status, art tries to conceal its naked relation to money, thus posing as a pure or autonomous abstraction free of social, historical, or class representation. As art empties itself of all but formal contents, it finds a place in a series of global contexts ready to decorate for the financial cartels that dot the urban landscapes of museums and biennials. Art and fashion sell real estate and style to a cosmopolitan art audience that wants to see the same face in the mirror of culture—its own. It therefore renders invisible the work and lives of local artists and audiences, since *meaning* is here only established by the transnational art trade show hosted by cities seeking recognition from world weary collectors and nomadic curators in the global art system of late capital.[3]

3. For an excellent analysis of these operations, I recommend both Julian Stallabrass, *Art Incorporated: the Story of Contemporary Art* (London: Oxford University Press, 2004) and Chin-tao Wu, *Privatising Culture: Corporate Art Intervention Since the 1980s* (London: Verso, 2001).

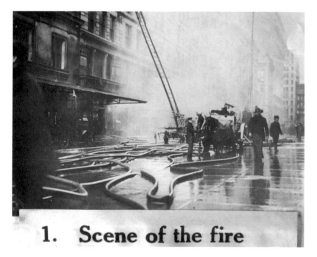

1. Scene of the fire

Hand-colored glass slide with image from Triangle Shirtwaist fire. Scene of the fire.

The description of work as neo-conceptual art, for instance, is often merely a mask for neutralized and depoliticized work, inoffensive to everyone, everywhere, while the irreverence of the other side of the art coin, Pop Art, though tied to commercial culture, fails to appraise or judge its own sources or operations. At every level, the art world insists on the avoidance of conflict that is the *modus operandi* of the suburban management teams that govern its moves. In contemporary art we are currently being entertained by court jesters vying for corporate and government funding that by definition supports only safe and sanitized art. Given the dominance of museums, it was only a matter of time before artists began making work *for* the museum, most recently installation art and large-scale Cibachromes or digitized photography.

3

Public projects, for the most part, continue to be mere pacification programs bringing the values of the white middle class to those who may not be interested in sharing them. Private collectors break down into multiple groups, but the dominant ones participate in an international art world for social cachet, investment, and business contacts.

At every level of capital's operation, however, there are unconquered terrains within which people will always try to establish their own narratives, even as they are co-opted by the force of larger schemes. In his seminal work on Marx's *Grundrisse, Marx Beyond Marx,* Antonio Negri forestalls any monolithic or determinate interpretation of the economy by insisting on two autonomous subjects in its history.[4] Capital and its citizen-workers tell very different tales at the same time and place, with the former trying to harness the latter's antagonistic struggles for self-determination to its own labor processes for profit. Every site, therefore, is composed of two contrary logics: first, a political economy seeking hegemonic control of everything, and secondly, individuals or groups asserting new parameters of life and subjectivity for themselves. In the hallowed halls of art, there is the siren song of the dominant culture and an emerging atonal scale that reveals the voice of its central crisis. To cope with this perceived threat, capital either co-opts the different drummer for its own repertoire or cuts off his hands. Fortunately, these musicians are also nimble dancers who move on quickly to join yet another fugitive pick-up band jooking the joint.

In 1854, writing on subversive street literature in Paris, Charles Nisard exclaimed: "No one agrees voluntarily to be buried alive, and even the splendor of the tomb does nothing to make the sojourn more wholesome."[5] It may be the nature of capital to create imaginary solutions to the real contradictions of social life, but the pleasure domes of Disneyland prove to be poor substitutes for real social life. Arts and Crafts street signs cannot disguise a city's lack of affordable housing, nor do situation comedies provide a road map to intimacy. Each artist must choose his or her own place in the struggle—is one an apologist and decorator, or a poet practicing Rimbaud's disordering of the senses? More importantly, is art even capable of being anything more than a commodity in a game of high-end money laundering or aesthetic colonialism? Peter Wollen rather despairingly comments on the global luxury market: "The art world is now inextricably linked with advertising and publicity through sponsorship of museum shows and through its association with 'lifestyle' marketing in the media, which leads to a convergence of art with design, fashion and even cuisine."[6] He fails to grasp that resistance to this invasive market still takes place, but it operates at border sites capital does not yet fully occupy, or those it feels to be already secured and so has left unattended.

4. Antonio Negri, *Marx Beyond Marx: Lessons on the Grundrisse* (Brooklyn: Autonomedia, 1991).

5. Charles Nisard as cited by Michel de Certeau in his *Heterologies: Discourses on the Other,* trans. Brian Massumi (Minneapolis: University of Minnesota Press, 1986), p. 119.

6. Julian Stallabrass, *High Art Lite* (New York: Verso, 1999), p. 185.

7. Leora Auslander, "The Gender of Consumer Practices," in *The Sex of Things: Gender and Consumption in Historical Perspective,* ed. Victoria de Grazia with Ellen Furlough (Berkeley: University of California Press, 1996), pp. 80-81.

8. Daniel Bell, *The Cultural Contradictions of Capital* (Evanston, IL: Northwestern University Press, 1978), p. 72.

9. James A. Schmiechen, *Sweated Industries and Sweated Labor: The London Clothing Trades 1860-1914* (Chicago: University of Illinois Press, 1984), p. 3.

The ephemeral commodity tries to structure all of everyday life and our position in it. "Subjectivities, identities, and solidarities are created by commodities . . . class, gender, nation, and even self were constructed through the acquisition and use of goods."[7] We now need to own them to even understand who we are, since even our self-definitions come through the prism of products made to shape us in their image. Like the latest trend in small, black, eyeglass frames, we myopically identify "the look" over the actual function of the object, seeing ourselves through the rose-colored lens of the other's beady-eyed representation of style. We, as subjects, are split by what Daniel Bell calls the cultural contradiction of capital: "On the one hand, the business corporation wants an individual to work hard, pursue a career, accept delayed gratification—to be, in the crude sense, an organization man. And yet, in its products and advertisements, the corporation promotes pleasure, instant joy, relaxing and letting go."[8] The subject feels pulled in two different directions, one of social responsibility, and the other, individual hedonism.

The main institutions this essay will deal with are the home, the factory, the studio, and the exhibition as sites of conflict where capital seeks to solidify its power and profit over the existential needs of people to make themselves out of their own labor, intelligence, and creativity. As a global and seemingly unfettered capitalism privatizes every domain from land use to the Internet, what Pierre Bourdieu calls "cultural capital" comes to provide Hans Haacke's "social grease" for everything from urban real estate development to endless biennials in a worldwide network of financial centers. In doing so, it consigns to the liminal the infinite variety of real producers, factory workers and artists alike, neither of whom live or work in SoHo any more. The galleries have moved up river, or on to Brooklyn, Long Island City, Harlem, or, god forbid, even to New Jersey. Like other displaced workers, artists increasingly rely on piecework for their survival: odd jobs without health insurance, fabricating for other artists, remodeling, and food services. Piecework is often marginalized in discussions of the industrial growth of factories, but it is the other side of capital and is often called by another name—sweating:

> *Working either in a "slop" shop or taking "homework" meant long and tedious hours of labor, abominably low wages, and degrading and unhealthy surroundings . . . found in trades like tailoring, furniture-making, and chain-making . . . Above all, sweating meant the movement of work to unregulated premises, often the worker's home, but just as often any backroom, basement, or garret shop . . . It was here that one could disregard all restriction on hours, pace and conditions of work and quality of goods; it was here that the system acquired its reputation for squalid misery.[9]*

Poverty is a culture silently nurtured by those privileged by race and class to their own advantage, their cunning sins of omission render invisible their callous disregard for others.

Artists remain isolated from these workers because they espouse, for the most part, the values of the class to which they aspire—the collectors who buy contemporary art and the cadre of curators and dealers who broker the deals in an almost entirely unregulated financial market. Artists' lives are planted squarely in two very different classes, that of the artisans and manual workers in whose neighborhoods they often live in, and that of the collectors and patrons whose wealth they aspire to by means of the sales of their yet unrecognized cultural capital. What most artists fail to realize is that the same forces that ruptured the fragile peace between business and labor in industrial America have also radically changed their own futures. Outside of New York City, the epicenter of late capital, art economies are subject to near convulsive reactions to economic or institutional change. The vibrancy of the Chicago art world, for instance, fell apart in the collapse of the late 1980s stock market. Even the growth of the stock bubble of the nineties was unable, for example, to restore the nonprofits, as the elimination of the alternative gallery scene was guaranteed by the lack of government support for all but the most established traditional institutions. The privatizing of all cultural operations has left art as a pawn of the corporate interests that support it and of the judgment of a conservative political arena. Young artists, with less financial investment in the society, used to feel freer to critique the social

Spinning room – winding bobbins with woolen yarn for weaving, Philadelphia, PA.

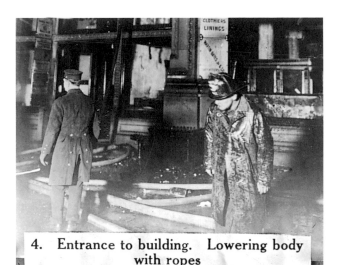

4. Entrance to building. Lowering body with ropes

Hand-colored glass slide with image from Triangle Shirtwaist fire. Entrance to building. Lowering body with ropes.

10. Stallabrass, *High Art Lite*, p. 271.

order, and these wildcards, therefore, had to be disciplined by limiting the state support on which they depended. Private galleries have assumed a nomadic existence based on real estate development trends and the erosion of a base of local buyers and corporate collecting. Moving when rents get too high, gallery owners gentrify new areas and then are displaced to another urban zone in need of upscale transformation.

Art criticism has also been retrenched, and rigorous thinking about the place of work in the battle of ideas has been replaced with the fluffy aestheticism that now dominates the scene. According to Julian Stallabrass, the failure of both a political and creative avant-garde on an international level left us with no coherent alternative narrative of a world beyond capitalism:

> *Without it, there is no stable or concrete position from which to criticise, no shared trajectory or vision of the future, and no link to wider social or political issues, since even the limited ideals of postmodern orthodoxy have fallen to consumer atomism. Without such a view, flurries of incidents remain just that. Art criticism becomes like fashion writing, obsessed with the minutiae of the season's trends, and addicted to their facile exposition.*[10]

We have lost any sense that there is a development in art; all we now have is the merely anecdotal evidence that though art is still practiced, it is not a *practice* with its own visual and discursive history. As art becomes a commodity it is subject to the laws of fashion, and each fall and spring a flock of newly professionalized MFA artists enter the arena of chance to reproduce the reigning orthodoxies of their high-priced schools. An academic aversion to conflict and controversy creates a pseudo-collegiality that rewards only "professional looking" art lacking the edginess and force prized by another generation. Upon graduation, most artists find themselves forced to take their aesthetic piecework on the road with little chance of advancement beyond the fragile alliances they made in school.

Traditional piecework lacks even the hope of a naive young artist; workers have no intellectual control over their production, which is carefully watched and graded. It is a brutal life of necessity with few worker protections, where

owners and property, not human beings, are always favored by the law. On March 25, 1911, in New York City's Triangle Shirtwaist fire, 146 people died either directly from the fire or by leaping to their deaths from the ninth floor to escape the blaze and its choking smoke.[11] The factory was cashing in on the popular success of Charles Dana Gibson's fashionable illustrations of his Gibson girl, who wore cinched waist blouses with high collars based on menswear, favored by the new working girls in the city. The fire began in the mounds of cotton material that loomed like mountains in the dark workrooms where people sewed for six days a week often without a known wage. Seeking safety on the window ledges while waiting for the fire trucks to arrive, they soon discovered the ladders were not long enough to reach them. Having seen tenement fires in New York, pogroms in Russia and Eastern Europe, or the destruction wrought by a reactivated Vesuvius in Italy, the immigrant poor believed that if you jumped your family could at least identify your body. Several young girls leapt while embracing each other, and at least one couple kissed for the last time, stepped off the ledge, and crashed through the concrete and glass sidewalks leaving their outlines on the hole in the ground. The elevator was broken, the cheap fire escapes melted in the heat, and the doors were locked to keep the young immigrant tailors and seamstresses from stealing. The owners were never punished. They received $500 for each person from their insurer, and three years later they settled with the families of the dead for $75 a piece, capitalizing even on their deaths. Shirtwaist blouses were all the rage, but within a few years they were out of style.

By the time unions like the Amalgamated Clothing and Textile Workers Union and the International Ladies' Garment Workers' Union gained safer labor conditions, decent wages, and benefits, most manufacturers had moved to the South where there were no unions. Decades later, the garment industry shifted again to countries that permitted even greater exploitation of human labor and less safety control. Just as these workers didn't care about the plight of workers in New York and New England, workers on the Pacific rim don't care about the "outsourcing" of American jobs from the South. Capital always wins when there is no solidarity among workers, as it pits one geographic zone against another and remains largely indifferent to the lives of the people in the communities that surround its factories.

The collapse of labor unions that began with Ronald Reagan's firing of air traffic controllers has left many workers in nineteenth-century conditions from Los Angeles to Mexico to Southeast Asia. Right-wing regimes worldwide have traditionally failed to strictly enforce protective labor laws, and have an increased tolerance for an excessive pollution of lead, mercury, and other carcinogens. On May 19, 1993, in Nakhon Pathon Province, Thailand, in

11. Two of the best historical works on the fire are Leon Stein, *The Triangle Fire* (Ithaca: Cornell University Press, 2001) and David von Drehle, *Triangle: The Fire that Changed America* (New York: Atlantic Monthly Press, 2003). I also recommend a site maintained by Cornell University on the fire with many photographs taken at the time: www.ilr.cornell.edu/trianglefire/.

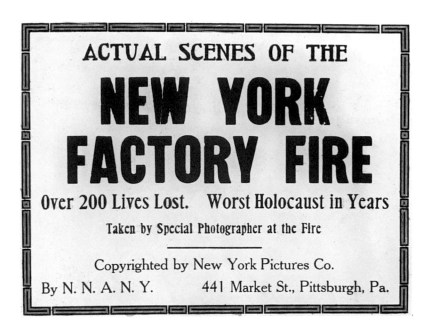

ACTUAL SCENES OF THE

NEW YORK FACTORY FIRE

Over 200 Lives Lost. Worst Holocaust in Years

Taken by Special Photographer at the Fire

Copyrighted by New York Pictures Co.

By N. N. A. N. Y. 441 Market St., Pittsburgh, Pa.

Hand-colored glass slide from Triangle Shirtwaist fire.

a factory complex that had several earlier fires, almost 200 workers lost their lives. In three unsafe buildings made of low-grade steel that melted in the heat, many of the workers were either burned or crushed to death. People leapt from the third and fourth floors in hopes of escaping because, as usual, the doors were locked to keep them from stealing. The sites were filled with the tons of cotton and polyester used to make stuffed toys: 188 invisible deaths recede into history, while the perfect commodity fetish of cloned Beanie Babies is clearly heading to the cemetery of dead signs. The reign of fashion descends into the bowels of fashionability, the madness of collecting, and the total abstraction of human needs.

To clarify the position we find ourselves in historically, it is necessary to examine the internal operations of what now seems so unchallengeable: capitalism itself. It is plagued by an irresolvable conflict between supply and demand usually defined in terms of the inflexibility of production and the flexibility of demand. Its conundrum is that the temporary relief of one side's conflicts always results in the disruption, for good or for bad, of the other. If capital is weighed down by union contracts for fair wages and factories no longer suited to new technologies, then it is unable to compete with rapidly changing demands of consumption styles it produces through advertising. If cheaper labor costs in locales foreign to the homeland beckon, capital moves on like the predatory economic system it is, and abandons whole communities

9

THE SWEAT BEHIND THE SHIRT
THE LABOR HISTORY OF A GAP SWEATSHIRT by Jesse Gordon and Knickerbocker

Cartoon by Jesse Gordon and Knickerbocker from the September 3/10, 2001, issue of The Nation.

that grew up around its earlier formations. Mill towns become rust belts after the move to the sun belt that gradually gives way to the Asian Pacific rim. As South Korean workers unionize, capital travels to exploit Southeast Asia, and the state capitalism of China responds in kind. Each relocation produces not only cheap labor but cheaper goods that are made available to the economically marginalized shoppers at a neighborhood Wal-Mart, in whose *danse macabre* the poor exploit the poor. In producing new pools of consumers, however, older ones are required to pay for the transition, and the pattern of uneven development is sustained. In China, for instance, an early stage of industrial capital dominates with its polluting coal furnaces and lack of worker protections in mines and mills. Euroamerican countries, on the other hand, are facing a very different set of problems marked by transitioning to a new economy based on service jobs, cheap immigrant labor, the proliferation of subcontracting, and outsourcing.

Hand-colored glass slide with image from Triangle Shirtwaist fire. Fire nets broken by girls leaping (opposite).

Late capital (as opposed to industrial capital) seeks the Holy Grail of political economy—completely flexible accumulation in production and consumption. Its latest tool for achieving this goal is the global regulation of inventory control through point-of-sales communication with suppliers through the Internet.[12] Jobbers and subcontractors, once mainly the staple of the garment industry, have become a far more universal phenomenon. Marx once critiqued the rag trade in nineteenth-century Paris as not truly industrial and, therefore, unorganizable. What he could not envision was that its posture would become a model for multiple industries at the close of the twentieth century. As financial risk in the system is placed on lower and lower levels in the production process, wealthy capitalists are more and more insulated from economic loss as they now nimbly move from site to site, indifferent to the people they leave behind. As fashion and labor historian Nancy L. Green asserts: "The economics and politics of flexibility—from the point of view of capital—can be summarized by three basic elements: the avoidance of fixed costs, a fixed labor force, and fixed rules. Flexibility permits the adjustment of supply to demand by cutting the risk of long-term investment, adjusting the labor force to production needs and limiting rigidities due to union and legal restrictions that regulate wages, benefits, social welfare payments, and working conditions."[13]

12. For the best overview of the current status of inventory control in late capital see F. H. Abernathy, J. T. Dunlop, J. H. Hammond, D. Weil, *A Stitch in Time* (New York: Oxford University Press, 1999).

13. Nancy L. Green, *Ready-to-Wear and Ready-to-Work* (Durham: Duke University Press, 1997), p. 138.

In the garment trades larger companies rapidly adapt to new styles by simply abandoning pieceworkers who made a certain collar, for example, leaving ever smaller units of production to "carry the bag" of an old-fashioned look. The poorest people in the supply chain were left with the costs of the failure to correctly assess a new market style on the part of management. Green continues: "From pleats to shoulder pads, the extreme variability inherent in the fashion business has . . . meant high levels of turnover, seasonal unemployment, and poor working conditions which seem to be a common corollary to the highly competitive

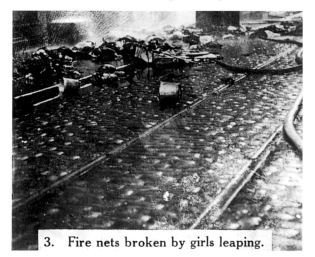

3. Fire nets broken by girls leaping.

14. Ibid., p. 6.

contracting-out system."[14] These changes of styles have more representation in history than the people who produced them and were left to fend for themselves. The tailors wait for the goddess *La Mode* to roll the roulette wheel for this year's recycled fashion. Fashion is an economy whose sole end is the maximization of profit for investors, not the sustaining of meaningful life for a world population.

All great political theories and social movements find their origins and energies not from the fantasy of a utopian future, but from the memories of forgotten ancestors. Mary Anne Walkley's strange obituary caught the attention of Karl Marx as he worked on the first volume of *Capital*, and she is the shadow who haunts my own understanding of his work:

In the last week of June 1863, all the London daily papers published a paragraph with the "sensational" heading, "Death from simple overwork." It dealt with the death of a milliner, Mary Anne Walkley, twenty years old, employed in a highly respectable dressmaking establishment, exploited by a lady with the pleasant name of Elise . . . It was the height of the season. It was necessary, in the twinkling of an eye, to conjure up magnificent dresses for the noble ladies invited to the ball in honour of the newly imported Princess of Wales. Mary Anne Walkley had worked uninterruptedly for 26 hours, with sixty other girls, thirty in each room. The rooms provided only one-third of the necessary quantity of air, measured in cubic feet. At night the girls slept in pairs in the stifling holes into which a bedroom was divided by wooden partitions . . . Mary Anne Walkley fell ill on Friday and died on the Sunday, without, to the astonishment of Madame Elise, having finished off the bit of finery she was working on.[15]

LA MODE.

15. Karl Marx, *Capital*, vol. 1 (New York: Penguin Books, 1976), pp. 364-65.

16. Ibid., p. 342.

17. de Certeau, *Heterologies*, p. 121.

Illustration La Mode *from a 1963 reprint of* Un Autre Monde *by J. J. Grandville. Originally printed in 1844; shown here as a hand-tinted facsimile reproduction (opposite).*

The callousness of Madame Elise is that of a privileged purveyor of high-end goods utterly indifferent to the life, or death, of the women under her servitude. Her workrooms were the beginning of a factory and piecework system that transformed the life of a productive worker into the fleeting shade of a fancy ball dress. The gown was not only worth more than the individual, it had, in fact, sucked the life of Mary Anne Walkley and transformed it into a glossy fetish of death in the royal kingdom of surplus value. It would be an error to think that these conditions belong to the past, to the earliest stages of capital. As Marx says, "Capital is dead labour, which, vampire-like, lives only by sucking living labour, and lives the more, the more labour it sucks."[16] If it is true that the life which exists in the worker's body is transferred through the production process to the commodity, thereby creating the illusion that capital has a body of its own and is capable of reproduction, then it is also true that the marketing of objects as diverse as designer art schools or high-heeled shoes takes its light from the transformation of the blood of others.

Among the most moving series of works revealing the intertwining of the plight of artists and laborers are the drawings of country weavers Vincent van Gogh made when he returned to his father's house in North Brabant in the winter of 1884. At a point in history when home artisans were being displaced by factories, the artist fully identified with these people who had been portrayed in Dutch genre paintings surrounded idyllically by the family life that van Gogh longed to create for himself. As urban smokestacks spewed forth their black death, many artists dreamt of a romanticized country village free of urban alienation. Forgetting the pogroms, the reactionary politics, and the poverty of rural existence, van Gogh, like many artists before and since, set out in search of a dream never grounded in a material analysis and indulged in what Michel de Certeau has termed *rusticophilia*.[17] In her excellent book, *Van Gogh's Progress: Utopia, Modernity, and Late-Nineteenth-Century Art*, Carol Zemel claims the artist valorized peasants and rural artisans as stolid workers and good Christians. In claiming that they were uncorrupted by the fast-living and loose-moraled proletariat, van Gogh reveals the mythic ethos of Jean-Jacques Rousseau who sees the cities filled with blue-stockinged women who are a threat to his own magical kingdom of restoration male theology. The romance of the rural is always tied to the belief in a golden age before either capital or the Enlightenment, both of which opened the possibility of social movement from one's assigned space in the economic, religious, political, and social order of the earlier status quo. The moral superiority of "community life" in the Upper Peninsula of Michigan or the "red

13

states" is just the latest phase in a counter-revolution against the very foundations of an urban democracy and its ever more inclusive tolerance and expansion of human rights.

Aesthetic reactionaries seek to counter capital with *pre-capitalist* values like the elitist production of William Morris's workshops, or the current fascination with hand-blown glass. The homelessness they feel in the city is never for the real plight of the urban poor, but a metaphoric or nostalgic returning home, part of a quest for an imaginary utopia where one feels whole. "Capitalism calls forth the independent individual to fulfill certain socio-economic functions; but when this individual . . . begins to explore the internal universe of its particular constellation of feeling, it enters into contradiction with a system based on quantitative calculation and standard-ization . . . Romanticism represents the revolt of the repressed, manipulated and deformed subjectivity, and of the 'magic' of imagination banished from the capitalist world."[18] Soon political economy will occupy even these moments, for leisure has become yet another target to exploit, and imagination is reduced to a product of advertising, desires not even our own.

18. Robert Sayre and Michael Lowy, "Figures of Romantic anti-Capitalism," *New German Critique,* 32 (Spring-Summer 1984), p. 58.

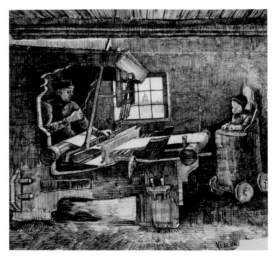

Vincent van Gogh, Weaver, with Baby in a High Chair, *1884, pencil, pen, and brown ink, heightened with white on paper; 12 3/8 x 15 3/4 in. Collection Van Gogh Museum (Vincent van Gogh Foundation), Amsterdam.*

This contradiction of utopia and capital appears in van Gogh's weavers: "For the loom and its structure, rather than the weaver and his skills, dominate the images; the worker is reduced to an accessory of the monumental machine . . . almost lost in a dark cramped interior . . . the psychologically oppressed artist projects his identity and alienation into images of caged artists."[19] Later artists transformed the weaver into dolls, puppets, and automatons as a response to the increasing amount of rote actions required in mass production and through them confronted "the possibility that people's identities and emo-

19. Carol Zemel, *Van Gogh's Progress: Utopia, Modernity, and Late-Nineteenth-Century Art* (Berkeley: University of California Press, 1997), pp. 58-60.

20. Julie Wosk, *Breaking Frame: Technology and the Visual Arts in the Nineteenth Century* (New Brunswick, NJ: Rutgers University Press, 1992), p. 81.

Hand-colored glass slide with image from Triangle Shirtwaist fire. Bodies at the morgue.

tional lives would take on the properties of machines."[20] As the exhausted body was drained of animation, it was replaced by the fashion mannequin or the heroin-chic model, each lacking the charm of a Charlie Chaplin who honored the workers he mimicked.

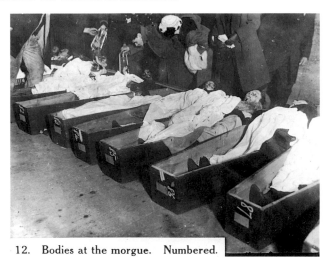

12. Bodies at the morgue. Numbered.

This type of economy operates by progressively separating intellectual from manual labor in an effort to manage and control production costs through fragmentation of the product into small-scale sites that facilitate rapid turnover. The fiber and clothing industries have always been at the vanguard of the changing nature of capital as it moved from home weavers and pieceworkers to high-end ateliers and later steam-driven factories using machinery deliberately designed for the small hands of children and women. "Sweated labor" is the term most often used to describe piecework, where the worker is paid not for their timed labor, but for the number of objects produced by the worker. This work can be done either at home or in small, "mom and pop" factories at the lowest end of the feeding chain. In many instances, time quotas are also imposed on these low-paid, often illegal, workers, and they also reproduce ancient prejudices of the value of men's over women's work. What is of particular importance to us is the ever sharper division between the "designer" and the maker who, along with their working conditions, is usually entirely unknown to the intellectual operations of the "managers" of the operation. Moving from country to country, abstract capital continues, in a new colonial form, to exploit labor and resources through institutions like the World Bank, draining Third World countries of what little they have of their own. This new imperial form is that of the commodity, and the metaphor of its ubiquity is Coca-Cola, sign of the world dominance

of the United States. As every place is transformed by the "American thing," indigenous and local forms of living have atrophied, leaving us only with a homogeneous system of values.

Alfred Sohn-Rethel's masterwork *Intellectual and Manual Labour: a Critique of Epistemology* is the leading analysis of how and why capital progressively separates intellectual and manual labor.[21] Though this form of alienation appears in all economic systems, each is specified by the unique division of labor of one or another economic formation. The primary or ideal condition of human labor is a unity of head and hand, he who thinks and plans the appropriation of nature to transform it through labor into a human good finds satisfaction. One may also find fulfillment when working with others on a common project under collective control, as opposed to capital where one is told what to do by others who do not participate in the labor process and who control the goods made and their distribution for profit. Dissociative fragmentation in modern capital, on the other hand, increasingly separated workers from not only control of their products, but also the satisfactions associated with planning and practicing skills that lead to a finished object, not just a partial one.

The man who brought the level of labor segmentation to a scientific level was the American engineer Frederick Winslow Taylor, who, for the first time, turned over both the segmentation and the *speed* of production from the workers to management, claiming that cost remains essentially the same whether one produces more or less. He took virtually all control, including safety and health, out of the producer's hand, thus rendering him/her *mindless*. No longer apprenticed to a craftsman from whom he/she learned his/her skill as an artisan, the worker was reduced to measured labor, while all intelligence and knowledge of the process remained with management. This effected a radical change in the type of subjectivity capital selected and shaped. By segmenting each moment of labor, its control would be totally in the hands of managers who could arbitrarily replace any "moment" in the line with an unskilled or semi-skilled worker for less money, or replace the function with machinery. In wresting an abstract control of capital from the productive hands of the worker, the manager seems in full control of the product that Marx understood would become the fetishized commodity of exchange value, while the producer of real use value fades into shadow. It is in this operation that any dream of collective action on the part of workers dissipates into the faceless abstract "worker" constructed by the disconnected sites of piecework.[22] Since they only produce one section of abstract labor, they lose a sense of being a producer, the subject of their own acts, or masters in some small part of their fate. Under this new management,

21. Alfred Sohn-Rethel, *Intellectual and Manual Labour: A Critique of Epistemology* (Atlantic Highlands, NJ: Humanities Press, 1978).

22. Ibid., p. 153.

time no longer has an ebb and flow, but is only the continuous monotony and even the coercive timing of the now. As Sohn-Rethel puts it: "Taylor does not learn his time measure from the workers; he imparts the knowledge of it as the laws for their work. The whole claim of 'science' for his functional task management . . . corresponds to the treatment of productive human work in accordance with the logic of appropriation . . . [and] the handing over of a coin in payment for a commodity separates the time of the act from all its contents."[23]

Though artists understand their own subjectivity and creativity as separate from industrial production, they fail to take note of the similarities. They too can produce work that is no longer marketable and subject to geographic distribution limitations. Having little or no control over the institutional legitimation necessary to promote the *distinction* of their work, they also lose control of their art once it is *paid* for and transformed into a mere commodity. Artists, like manual laborers, do not profit from future secondary sales of their work, nor do they control the conditions of their ownership or display. "Not only did the Taylorism of modernity accentuate the division between design and execution, mental and manual labor, but it created entire industries and classes built on 'mental labor' and the appropriation of the skills of the craft worker . . . the mental skills and the performing skills of the arts were also appropriated and reorganized in the first half of the twentieth century."[24] This arrangement stabilized for a while until the public subsidy of culture created by the New Deal was challenged by the privatization schemes of late capital under succeeding regimes.

Museums and art schools have now become pawns in the legitimation schemes of corporate cartels and urban tourism. By increasing corporate sponsorship the museum gradually only does shows that meet with the approval of its backers, and artists begin to make work in accordance with their new rules of display and acceptable content. The growth of museum stores and exhibition/hotel promotions have made art more like shopping than its modernist, spiritual pretensions as the new religion of liberal capital. Each year, the art world becomes more and more professionalized with degrees in arts administration, criticism, etc., proliferating into ever more specialized and specious technocrats. Jobs that traditionally went to artists and art historians are now manned by business bureaucrats with little to no knowledge of either the history or the actual practice of art. Artists will meet the same fate as the cabinet makers of High Point, North Carolina, or the collar makers of New York's Troy: there will be a few token successes like the changing scene of cult furniture and fashion "designers," and the rest will wonder why they just didn't go to law school—it costs about the same as an MFA.

23. Ibid., pp. 154-55.

24. Michael Denning, *The Cultural Front: The Laboring of American Culture in the Twentieth Century* (New York: Verso, 1998), p. 38.

The "political" art that began surfacing in the seventies and eighties was canalized back into the realm of the personal and its identity politics. It was disconnected from the organizing necessary for the effective transformation of an indifferent social structure and, therefore, provides a safe place to bring up an issue without producing political conflict. There is a great difference between addressing an audience with conflictual issues and merely confronting them with bad-boy art. "Beauty today," says Theodor Adorno, "can have no other measure except the depth to which a work resolves contradictions. A work must cut through the contradictions and overcome them, not by covering them up, but by pursuing them."[25] Against Adorno, impoverished critics like Donald Kuspit and Dave Hickey appeal to another kind of beauty, a decorative and depoliticized work to be enjoyed along with other entertainments. With an "end of art" rhetoric that parallels the "end of history" ideology of late capital, they appeal to the wealthy patrons who pay their lecture fees. As the bubble economy grew in the nineties, more market-friendly art[26] emerged as a full-fledged member of the entertainment industry, and museums began to look like Wagnerian opera sets awaiting the arrival of the Valkyries.

25. Theodor W. Adorno, "Functionalism Today," *Oppositions*, no. 17 (1979), p. 41.

26. For an excellent history and analysis see Julian Stallabrass, *Art Incorporated*.

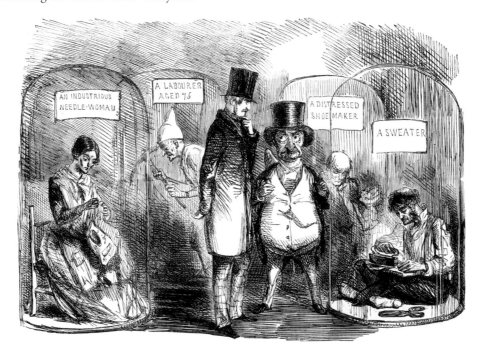

SPECIMENS FROM MR. PUNCH'S INDUSTRIAL EXHIBITION OF 1850.

(TO BE IMPROVED IN 1851).

27. Stallabrass, *High Art Lite*, p. 270.

Stallabrass points out: "The shift of seeing art as an integral part of an intellectual culture which also involved philosophy, music, literature and the sciences, to one that sees it as a lifestyle issue, a compliment to an interest in furnishings and floor coverings is a profound one." With the collapse of both a political and creative avant-garde, there remained no coherent alternative narrative of the future: "Without it, there is no stable or concrete position from which to criticise, no shared trajectory or vision of the future, and no link to wider social or political issues, since even the limited ideals of postmodern orthodoxy have fallen to consumer atomism. Without such a view, flurries of incidents remain just that. Art criticism becomes like fashion writing, obsessed with the minutiae of the season's trends, and addicted to their facile exposition."[27] We have lost any sense that there is a necessity or development to art, all we have at this time is the merely anecdotal; evidence that though art is still practiced, it is not a *practice* with its own visual and discursive history.

Marx had earlier realized that the mode of production shaped the constitution both of individual subjects and their relationships to each other. If one's labor is atomized, then so is one's species life as a human being, and it is here that we rejoin the critique of everyday life. Capital gradually comes to pervade all of life through segmentation, regimentation, and spectacle. Its institutional formats like museums, world trade fairs, shopping, and the home itself become forms of discipline and social control. Though there were industrial trade shows in England long before 1851, the Great Exhibition of the Works of Industry of All Nations in London became a key marker for nineteenth-century studies ranging from the prefabricated architecture of Paxton's Crystal Palace to the display of colonized peoples.

Cartoon by John Leech portraying Prince Albert overlooking laborers under glass from the April 13, 1850, issue of the periodical Punch (opposite).

What most writing on the Great Exhibition misses is the crisis that affected all of Europe in 1848 when working people rose up demanding franchise. In England, the Charterist Movement organized a demonstration of 25,000 workers at Kensington and struck fear into the ownership class. The Exhibition was the first use of a large-scale spectacle as a diversionary tactic against labor and class unrest. It served to create a sense of social identity based on the liberal internationalism of Prince Albert—a major force behind the show. The industrial machinery was presented as the universal guarantee of the *natural* superiority of Western nation-states. A new narrative of patriotism was introduced to bind the "dangerous classes" to the myth of being English (and white) above all other designations like economic class. One Charterist, at least, denounced the exhibit as "plunder wrung from the people of all lands, by their conquerors, the men of blood, privilege, and capital."[28] The periodical *Punch* agreed and portrayed

28. G. Julian Harney, *The Friend of the People*, no. 22, 10 May, 1851, p. 152, as cited by Jeffrey A. Auerbach, *The Great Exhibition of 1851: A Nation of Display* (New Haven: Yale University Press, 1999), p. 132.

the Prince overlooking laborers under glass while noting that the celebration of labor Albert touted was clearly intended as a screen over the real conditions of workers in England who understood that the whole show was an attempt to wean them of political action.[29]

29. Auerbach, *The Great Exhibition of 1851*, p. 134.

The economic principle that guided the organizers was that of "free trade," and the abandonment of protective labor tariffs as the Empire expanded its domain. The literature constantly extolled the peace that would follow a Pax Britannia of freely flowing raw materials, finished goods, and the exotic objects that would soon fill the homes of the wealthy. One can almost imagine an earlier version of Thomas L. Friedman exclaiming that countries that share Yardley's English Lavender would never go to war with each other. The Manchester School of Economics, the foundation of today's *laissez-faire* conservative trickle-down theories from Margaret Thatcher to George W. Bush, called for an unfettered capitalism with no government interference or regulation.[30] Bringing "civilization" to the savages took on new meaning as the fair claimed that capitalism would automatically bring freedom and peace to the nations of the world. At the same time, the Foreign Secretary, Lord Palmerston, was justifying Britain's invasion of Greece under the aegis that the nation had an interventionist duty to rectify injustice in other nations through what came to be called "gunboat diplomacy." If this seems familiar it is because capital is in crisis again, but this time it is solving its problem by abandoning the very industrial sites and workers it sought to establish during the last century.

30. Ibid., p. 163.

Museums too have undergone a series of changes consonant with the dominant social system. As an institution, the museum has played an important role in the establishment of the nation-state. Earlier Renaissance collections of treasured objects or plunder were modeled on the *kunstkammer* or cabinet of curiosities. Pictures were densely arranged in a block with no wall space around the paintings. They tended to formal rather than historical systems of arrangement and, therefore, stressed scrutiny of individual parts rather than the whole: "this way of seeing was indifferent to chronological sequence . . . It concentrated on the pictorial qualities—what we would now call *style*."[31] Later, taxonomic functions and provisions for more "scientific" lighting enabling close inspection brought the separation of one work from another by "empty space." All of this contributed to a presumed goal of transparency:

31. Andrew McClellan, *Inventing the Louvre: Art, Politics, and the Origins of the Modern Museum in Eighteenth-Century Paris* (Berkeley: University of California Press, 1999), p. 5.

> *Late-eighteenth-century museums initiated the now commonplace practice of isolating works of art, both from each other, through hanging and frames, and from the social roles and physical contexts that they originally enjoyed, in the service of direct or transparent viewing. The desire for transparency entailed erasure*

of the life of a picture, its purpose and critical fortunes, between leaving the artist's studio and entering the museum, at the same time that newly developed restoration techniques sought to insulate it from the ravages of time . . . museums aspired to simulate the conditions of the studio . . . Transparency in the museum encouraged (and still encourages) the illusory sensation of direct contact with the act of creation, the fiction of a canvas as fresh and as present as the day it was painted.[32]

32. Ibid., p. 6.

This abstraction of the artwork was accompanied by Romanticism's assertion of the absolute autonomy of the creative artist. Freedom from the patronage of both the Church and the State with their inherent conservatism, however, is a hollow victory if artists are only re-disciplined by a *laissez-faire* market with its own set of reactionary values.

History comes to the museum with the French Revolution's transformation of the Louvre palace into a public display of the Republic's wealth "repossessed" from the defeated royal court. The history told, however, is from a specific point of view aimed at securing a new mythological foundation for the French state that subsidized the display. Developing a new conceptual model appropriate to each successive sponsor—state, private, and corporate—the *history* of art detailed by the museum represents those who foot the bill. The Metropolitan Museum of Art during the Reagan Presidency revealed its class bias with shows "appointed" by fashionista Diana Vreeland, a consulting curator for its fashion department. Vreeland openly colluded with Bloomingdale's department store in New York to present a series of French couture and historical costume exhibitions. Her France was not that of the Declaration of the Rights of Man, the Revolution, or Republican virtue; she replaced *Liberty, equality, and fraternity* with *Let them eat cake at Bloomies.* "As in the Met shows, the French essence celebrated at Bloomingdale's was artisanal, aristocratic, and intimate . . . The gifts of delicacy, grace and the art of living were elementally French, transcending the vicissitudes of politics and history."[33] Vreeland's sensibility was shared by the Republican Party's dedication to the arrogant display of their own "lifestyles of the rich and famous," encouraging the frivolous amusements of Texas wealth in *Dallas* and the cult of foreign aristocratic styles in *La Belle Epoque* of Nancy Reagan. Vreeland was a bellwether of what was to come for many museums: first, she could raise much needed revenues for blockbuster shows from the private sector who could benefit from tie-in publicity, and, second, her retooling of the museum's stores both within the museum and in its secondary satellites. Surface style became more important than history and substance, for what is good for Yves St. Laurent is good for the Metropolitan and *Harper's Bazaar!*

33. Debora Silverman, *Selling Culture: Bloomingdale's, Diana Vreeland, and the Aristocracy of Taste in Reagan's America* (New York: Pantheon Books, 1986), p. 80.

The Queen of Fashion dictated a New Conservatism in women's clothes, thus announcing the demise of the Women's Movement and the return of the fashionable woman with one wave of her hand.

The latest stage of the museum's "capital development," if you will, is the transformation of the museum into a literal corporation. With the expansion of New York's Guggenheim Museum to Bilbao, Venice, and Berlin, we have the first franchising of an American brand name and what Chin-tao Wu has called "cultural profiteering" on a global scale. "If Guggenheim is the epitome of the nineties art institutions that envisage their futures in the twenty-first century as being multinational museums, it inevitably sees itself in terms similar to those of a multinational. Once business vocabulary and corporate sets of values enter an art institution, its theater of operations will soon be dominated by the ethos and practices of multinationals."[34] The director of the museum, Thomas Krens, proclaimed: "We do very well at corporate support . . . We have put this programme of global partners in place . . . with institutions like Deutsche Bank, Hugo Boss and Samsung— and a few others that we'll announce soon . . . [we are] pursuing the American cultural system to its inevitable conclusion."[35] In this system there will only be formal innovations easily occupied by advertising, and pleasant art that will facilitate weddings, fund raising, and singles nights at the museum. Marketing the museum allowed board members to improve the values of their downtown properties that were being emptied of businesses and transformed into condominiums filled with the bibelots of this year's new battery of bling-bling.

In the nineteenth century, especially in France, the interior of the middle-class home developed parallel to both the department store and the museum. The bourgeois domestic begins to be seen as a private museum that will soon need its own curators or "taste professionals" to arbitrate between the home's competing objects, both old and new. These shifts, particularly in England, France, and the United States, brought with them, says Leora Auslander: "The explosion of new institutions and discourses devoted to analyzing goods, as well as providing advice on appropriate consumption, bear witness to the new centrality of goods, . . . the texts included decorating magazines and books, etiquette books and advertisements."[36] Cadres of new workers appeared who advised neophyte or insecure middle-class women on the socially correct forms of dress and decor. Women arranged, men paid, and designers became the intellect if not the angel of the house. This separation of the manual and the intellectual also extended to the craftsmen who had designed their own products and discussed refined aesthetic issues, but now only followed the designs of others who often had no skills in the field. Making beautiful things had been part of working-class male identity, but

34. Chin-tao Wu, *Privatising Culture*, p. 282.

35. Ibid.

36. Ibid., p. 81.

22

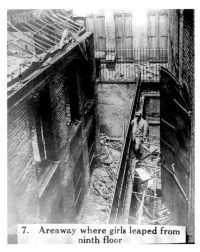

7. Areaway where girls leaped from ninth floor

37. Leora Auslander, *Taste and Power: Furnishing Modern France* (Berkeley: University of California Press, 1996), p. 226.

38. Didier Maleuvre, *Museum Memories: History, Technology, Art* (Stanford: Stanford University Press, 1999), p. 115.

39. Ibid., p. 116.

Hand-colored glass slide with image from Triangle Shirtwaist fire. Areaway where girls leaped from ninth floor.

from the 1860s on, labor was being redefined and, with it, an artisan's need for knowledge and a sense of the beautiful.[37] Middle-class women's only productive role was tasteful consumption, while the producers of decorative objects were left with no intellectual purpose, only rote, repetitive actions until the fashion mavens dictated a change in style.

If to dwell is to own, then the orchestration of decor is not only a primary sign of class, but the bourgeoisie's ability to construct a reassuring history unperturbed by the visible inequities of the motherland, or the increasing nationalist agitation in the colonies. As Didier Maleuvre notes: "Collecting is a way of taking possession of the world, a way of domesticating the exotic . . . [by] cultural plundering, stylistic borrowing, and historical pastiche . . . The household gods are historicism and conservation, a mixture of postcard exoticism and erudite panache."[38] The home is filled with historical nostalgia for an imagined past: "Conceived as a showcase of the past, the home embodies the great conservative force in society . . . Home is where things abide, where they stay the same; it is an idyllic retreat from the progress of science, social upheaval, and industrialism."[39] Even more importantly, capital reinforces the home as the center of a new form of middle-class private life in order to undermine the potential political force of *associative* public life. The home, like the department store, severed the connection not only to producers, but also to the lower classes who hawked goods on the streets or public markets. Like the current practice of isolating classes and races in public housing, "white flight" encourages an "out of sight, out of mind" lack of social responsibility or concern for the poor. "The truth is that privatization of existence stems from the submission of individual autonomy to the dictates of the economic totality. The more existence is subjugated to the vagaries

of market fluctuation, the more the 'home' increases in mythical value . . . capital creates a dream of self-governed privacy just as it destroys it in reality."[40]

40. Ibid., p. 122.

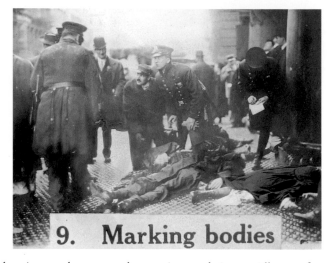

9. Marking bodies

Hand-colored glass slide with image from Triangle Shirtwaist fire. Marking bodies.

In the nineteenth century, the exterior was being rapidly transformed not into a local neighborhood but as an exotic world to be explored through colonialism, tourism, and photography. "The individual was increasingly pulled [both] 'abroad' and 'home,' by the force of an actual or imaginary relationship with a developing imperialist world system on the one hand and by the affective pull of personal existence, always both powerfully material and deeply imaginary, on the other. The home was producing human subjects for empire; the house was filling with its products."[41] Stereoscopic travel photography, for instance, allowed vast colonial empires to enter the family's drawing room, thus creating a subject for whom "the world is my oyster." The Victorian middle class was free to roam the earth finding images of itself everywhere, yet always needing more affectively and materially. As Peter Osborne has pointed out: "the Victorian home was a cultural device, a mechanism whose function was the maintenance of order . . . it was able to transform a disruptive desire to wander into an affirmation of settlement, into an entertainment, and to translate prospects of the strange and fearful into sources of reassurance."[42] Not only the content of the stereoview, but its *formal* presentation disciplined the connection between perception and desire.

41. Peter Osborne, *Travelling Light: Photography, Travel and Visual Culture* (Manchester: Manchester University Press, 2000), p. 54.

42. Ibid., p. 58.

In our own time, Martha Stewart restores the home as the site of imaginary production, or perhaps more correctly, as the site of production of the *domestic imaginary*. The *economic real* more and more requires two incomes to support family life, and her viewers, therefore, seek a vicarious participation in a more leisured construction of reproductive family values. Second-wave

feminism clearly showed the double struggle, the double helix so to speak, whereby women seek to establish an expanded sense of themselves beyond the definition of wife and mother. The fact is that its political force was *permitted* by capital to expand its productivity and marketing, while producing new "necessities" for the working woman. We move from ground beef to Hamburger Helper in less than a generation. Martha Stewart is important because she recognized that women had a real sense of loss over that fictive woman who did it all from scratch—Halloween costumes and elaborate pumpkin ghost decorations, as well as fresh baked cookies and handmade candies. This dream haunts women in the present who work, because families can no longer survive on one income. In a country where razor blades turn up in homey treats, Martha provides us with a holiday time in memorial, perfect communities and nostalgic familial events from Neverland. Turkey Hill is the fulfillment of a calculated desire for a miniaturized kingdom where, at last, everything is under the creative control of an organized imaginary wife and mother that I, the viewer, will never be. Stewart raises a woman's acts of domestic consumption to an art practice in a way first initiated in nineteenth-century France where the female consumer is an agent of social reproduction.

We must not lose sight of the fact that these modes of private life and desire are clearly not extended to most of the working classes of every developed country in nineteenth- and early-twentieth-century life. Packed into tenements, totally dependent on the vagaries of seasonal work, they

Drawing in warp, front view. Dallas cotton mills, Dallas, Texas.

13783—Spooling Yarn, Dallas Cotton Mills, Dallas, Texas, U. S. A.

are the human reminders of the predatory nature of capital we find in the haunting photographs of John Thompson's London, Lewis Hine's and Jacob Riis's New York, and Eugene Atget's Paris. Even then, there was a universality to the barbarism of capital, and writers from every industrial country exposed its operations. Armentières was France's queen city for the production of the highest quality linens for the luxury crowds of the *rive gauche*. During the city's strike of 1903, the socialist leader Jean Jaures spoke of the

Spooling yarn, Dallas cotton mills, Dallas, Texas.

> *poor households of weavers . . . poor apartments, narrow, minuscule, a few square meters, where miserable families with seven and eight children are piled up without air, without light, without furniture, without anything that gives human life some dignity, . . . we saw beds that had not a scrap of linen to cover the modesty of infants. The Queen of linen could not spare a bed sheet to cover these poor people . . . all lay down pele-mele in a miserable promiscuity where vice cannot help but germinate.*[43]

43. William M. Reddy, *The Rise of Market Culture: The Textile Trade and French Society, 1750-1900* (Cambridge: Cambridge University Press, 1987), p. 326.

As the department stores with their polished glass cases disguised the origin of the fancy work on sale, so too the homework of the sweated poor was invisible until conditions became so bad that middle-class women organized counterdisplays of their conditions. In June 1906, London's *Daily News* opened a "Sweated Industries Exposition" at Queen's Hall in the West End. It was so successful that it was extended for two extra weeks. "Forty-five trades, representing the familiar clothing trades as well as lesser known sweated industries like tennis-ball making, furniture-making, saddlery,

44. James A. Schmiechen, *Sweated Industries and Sweated Labor*, p. 165.

hosiery-making, and cigarette-making, were depicted; workers were present to perform their tasks. The faces and workrooms of society's least fortunate were brought to the front steps of the utopian Edwardian upper classes."[44] What in 1851 was merely a tabloid cartoon appears here in the flesh, the workers themselves fetishized and put on display in crèches like a department store at Christmas.

In France, conservative Catholic women's groups mounted traveling shows called "Expositions of Economic Horrors" to display the personal, if sensationalized, tragedies of homework. "These exhibits parodied the display of products and their fantasy sense of 'progress' at international expositions. Juxtaposing the marvels of industry with the miseries of sweating dramatized what reformers saw as the failures of technology and the social costs of unregulated industrialization. The lists of prices consumers paid for various articles of clothing, presented alongside hours workers spent making those same items and the appalling low rates they were paid."[45] We see similar attempts in late capital to diagram the international economic traffic in exploitation because the long struggle of industrial workers for social and economic justice in countries like the United States is giving way to the exploitation of cheap foreign labor, the form of late capital.

45. Judith G. Coffin, *The Politics of Women's Work: The Paris Garment Trades, 1750-1915* (Princeton: Princeton University Press, 1996), p. 217.

And what is our role as artists and intellectuals in the twenty-first century when we realize that so many of us have been turned into specialists, apologists, and mouthpieces for the dominant order? According to Socrates, we are supposed to be argumentative troublemakers, gadflies biting the great

In a great spinning room (104,000 spindles), Olympian mills, Columbus, SC.

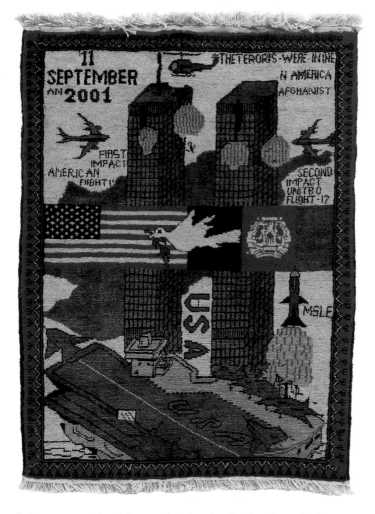

Afghan war rug, 2001, depicting the events of September 11, 2001. Cotton and wool, 33 x 24 1/2 in.

ass of the state, and its right and left hands: the family and religion. Marx, of course, understood the role of political economy in Plato's body politic, and it is these forces that have been central to our consideration. In his book *Acts of Resistance: Against the Tyranny of the Market,* Pierre Bourdieu calls on us to carry the Enlightenment's torch of knowledge back into the cave of the shadow puppets of religious and state terrorism: "I would like writers, artists, philosophers and scientists to be able to make their voice heard directly in all the areas of public life . . . I think that everyone would have a lot to gain if the logic of intellectual life, that of argument and refutation, were extended to public life."[46] He continues that if we are to defend real values beyond their trivialization in fanatical zeal, then surely

46. Pierre Bourdieu, *Acts of Resistance: Against the Tyranny of the Market* (New York: The New Press, 1998), p. 9.

they must include "the republican equality of rights, rights to education, to health, culture, research, art, and, above all, work."[47] I might also add, to work that is safe, protected, meaningful, and justly compensated: All labor is a form of art that is not yet recognized.

47. Ibid., p. 24.

EPILOGUE

On March 19, 1958, fire broke out in a garment factory in lower Manhattan just a few blocks south of the site of the Triangle fire. The 623 Broadway building, at the intersection of Houston, would become part of the center of the art world for a few short years in the 1980s until it too was overshadowed by high-end development. Leon Stein, a member of the ILGWU and the great historian of the Triangle fire, raced down from the Village to 623 to watch: "It was six stories high, had no sprinklers, its fire escape was useless . . . It was shaped like a giant wind tunnel . . . The fire had started on the third floor in a textile finishing firm . . . it burned for seven minutes before an alarm was turned in—from the street."[48] The well-run union shop on the fourth floor had no time to get out, as the smoke filled the floor in seconds. Then the floor collapsed to the one below and twenty-four people died. Standing in the street, Stein saw his friend Josephine Nicolosi, who lived nearby and had survived the original Triangle fire. As they both watched the fireman lower the bodies in canvas baskets, she cried to him: "What good have been all the years? The fire still burns."[49]

48. Leon Stein, *The Triangle Fire*, pp. 213-14.

A sophomore in high school at the time, I had not heard about the fire on my way home from school. When my father returned from his law office near Manhattan's city hall, he told me what happened with tears in his eyes and a cracking voice. He did not yet know if any of his clients were among the dead or injured, but explained to me that in the end the legal system would only protect property and those that owned it, just as it had for the Triangle. To prove his point, he claimed never to have won a single case for a victim of white and grey lung disease; even while the factory managers continued to use giant fans blowing into the factories suspending minute fibers of cotton that were then breathed in by the textile workers. He asked me that I never forget all those garment workers, butchers, secretaries, and kitchen help who had, in fact, paid for my home and education. My father could have made much more money had he been in another area of law, but as a young man he decided that the working class deserved the best lawyers, not the dregs. As the years went on I added to his list of workers

49. Ibid., p. 214.

all the anarchists, the red-headed *Pétroleuses*, the artists of the Paris Commune, like Gustave Courbet, who stood by the Parisian blue shirts in the aftermath of the Franco-Prussian war, Chicago's Wobblies, and today's Afghan refugees who continue to weave testaments to their lives in a current history of oppression and war. Tillie Olsen dedicated her book *Silences* to them all, and so do I, and so would my father:

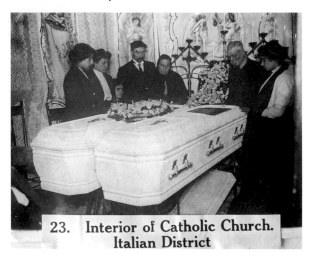

23. Interior of Catholic Church.
Italian District

Hand-colored glass slide with image from Triangle Shirtwaist fire. Interior of Catholic church, Italian district.

For our silenced people, century after century their beings consumed in the hard, everyday essential work of maintaining human life. Their art, which still they made—as their other contributions—anonymous; refused respect; recognition; lost.[50]

50. Tillie Olsen, *Silences* (New York: Delta, 1978), p. ix.

Alan Howard

Labor, History, and

Sweatshops in the New Global Economy

The apparel industry has long been plagued by a noxious creature known as the sweatshop. The word conjures up images of sweltering tenements and dark lofts, of women and children toiling into the night for wages that will barely keep them alive, of that infamous sign on the factory door: *If you don't come in on Sunday, don't come in on Monday.* It is the peculiar nature of this industry that such conditions can be found today more or less as they existed 100 years ago. The scene of the crime has shifted and spread, the skin color of its victims tends to be darker; but today we are confronted by this manmade plague that at the beginning of the last century most Americans considered an insult to human dignity.

Clothing, women's in particular, remains a most unpredictable commodity. Weather and season and the whims of fashion drive apparel merchants to minimize their risks of getting caught with goods they can't sell or without items that are flying off the shelves. The industry has historically dealt with this unpredictability by pushing risk down through the production chain: from retailer to manufacturer to contractor and subcontractor and ultimately into the worker's home. From the retailer's point of view, this broad base of small, readily available, and easily disposable producers is the ideal solution

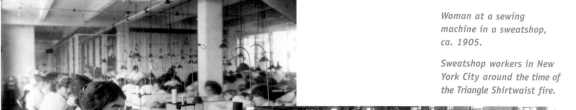

Woman at a sewing machine in a sweatshop, ca. 1905.

Sweatshop workers in New York City around the time of the Triangle Shirtwaist fire.

to the inherent volatility of the market. From the point of view of the workers at the bottom of this industrial pyramid, it is a system that subjects them to relentless pressure, and the worst imaginable forms of exploitation and self-exploitation. It creates the sweatshop, which in turn undermines legitimate enterprises and drives standards down even further. "Nice guys go out of business," remarks a union negotiator, reflecting the near impossibility of maintaining decent standards in one shop when the work can be easily moved to a sweatshop down the street or in another country.

This basic dynamic has not changed in over 100 years. But we know how the system works and how to fix it. At various points over the past century the power of the sweatshop to depress the wages and living conditions of workers throughout the industry has been reduced and even neutralized by the power of workers to defend themselves and of government to regulate the industry. It is a struggle profoundly influenced by the prevailing economic and political climate of the times and by the force of public opinion that both shapes and reflects those times.

"The sweatshop is a state of mind as well as a physical fact," writes Leon Stein in the introduction to his invaluable *Out of the Sweatshop*. "Its work

1. *Out of the Sweatshop: The Struggle for Industrial Democracy,* Leon Stein, ed. (New York: Quadrangle, 1977), p. xv.

day is of no fixed length; it links pace of work to endurance. It demeans the spirit by denying to workers any part in determining the conditions of or the pay of their work."[1]

Some scholars trace sweatshops back to the 1840s when it is recorded that a group of working women in New York, protesting their miserable wages, were told by an employer that "he could obtain girls from Connecticut who would work for even less." Between 1880 and 1900, more than three million European immigrants poured into American cities, Jews fleeing the pogroms of Russia, Italians and Slavs and other workers with their own visions of America and freedom. They were drawn into the apparel industry by the tens of thousands, desperate for work at almost any wage. The industry, expanding as the purchasing power of women created a mass market for their clothing, was able to accommodate them. Here is how the economist John R. Commons described the system in 1901:

> The term "sweating," or "sweating system," originally denoted a system of subcontract, wherein the work is let out to contractors to be done in small shops or homes . . . The system to be contrasted with the sweating system is the "factory system," wherein the manufacturer employs his own workman, under the management of his own foreman or superintendent, in his own building . . . In the factory system the workmen are congregated where they can be seen by the factory inspectors and where they can organize or develop a common understanding. In the sweating system they are isolated and unknown.

> The position of the contractor or sweater now in the business in American cities is peculiarly that of an organizer and employer of immigrants. The man best fitted to be a contractor is the man who is well acquainted with his neighbors, who is able to speak the language of several classes of immigrants, who can easily persuade his neighbors or their wives and children to work for him, and who in this way can obtain the cheapest help. Enormous changes were taking place in the industry—the use of electric power, the emergence of a mass market for ready-made clothing, economies of scale that concentrated large numbers of workers, even an insurgent labor movement—and yet the sweatshop remained intact and grew even more pernicious.[2]

2. Ibid., pp. 44–45.

"Workers toiling in dark, humid, stuffy basements on Division Street, children of eight years and women, many of them far from well, sweating their lives away in these hellholes" so shocked State License Superintendent Daniel O'Leary on an inspection of garment shops in New York City in 1900, according to a contemporaneous account, "that he has asked the union for help and advice."[3]

3. *The Daily Forward,* November 21, 1900.

It would be a few years before the infant International Ladies' Garment Workers' Union (ILGWU) would be able to provide much help, but it had plenty of advice. Outlaw homework. Bring the subcontracting shops under control. Protect the right of workers to strike, organize, and bargain collectively. Improve and enforce health and safety codes. There was more, but that would do for starters.

A decade later, a series of events would mark one of those periodic turning points in the industry—and in this case exert an influence over the course of industrial relations in America for the next fifty years. In 1909, a walkout of several hundred workers from the Triangle Shirtwaist Company in New York's Lower Manhattan garment district sparked a strike of 20,000 shirtwaist makers throughout the industry. They were mainly young Jewish and Italian immigrant women, their condition as the most viciously exploited workers in the industry long acknowledged but ineffectively addressed by both the male-dominated unions and government authorities. The strike became a cause, as community leaders—particularly socially conscious and socially prominent women—joined the picket lines, raised funds, and galvanized public opinion in support of the strike.

The following year it was the men's turn. In New York, 60,000 cloak makers, inspired by the success of the shirtwaist makers, paralyzed the industry with a general strike. At the same time in Chicago, workers at the Hart, Schaffner, and Marx firm sparked an explosive strike in that city's garment industry that would give birth to the Amalgamated Clothing Workers of America (ACWA), the men's clothing counterpart to the ILGWU.

The cloak makers strike in New York led to the signing of what was called the Protocol of Peace. According to Leon Stein, the Protocol "won universal acclaim. Scholars, journalists, and government experts cited it as a model worth emulating in a time of rising industrial unrest. Out of the turmoil and chaos of the sweatshop a new concept of industrial democracy had emerged."[4] Shaped by the legendary judge Louis D. Brandeis, who had been brought in to mediate the strike, the Protocol required employers to recognize the union and a union shop, set up a grievance procedure and a Joint Board of Sanitary Control to police health conditions in the shops.

Six months after the signing of the Protocol, 146 workers perished in a fire at the Triangle Shirtwaist factory. The tragedy shocked the nation and dispelled any lingering euphoria about how quickly or easily the Protocol would solve the problems it had so hopefully engaged. As Gus Tyler notes in his magisterial history of the ILGWU, *Look for the Union Label*, the Protocol signified the beginning of an uneven progress, fraught with setbacks, that continues to this day.[5]

4. *Out of the Sweatshop*, p. 120.

5. Gus Tyler, *Look for the Union Label: A History of the International Ladies' Garment Workers' Union* (New York: M.E. Sharpe, 1995), p. 73.

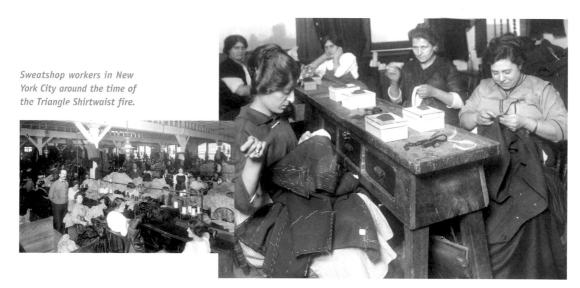

Sweatshop workers in New York City around the time of the Triangle Shirtwaist fire.

Over the next quarter century, the struggle against the sweatshop ebbed and flowed with the political and economic tides of the nation and the twists and turns of the industry. It bottomed out in the first years of the Great Depression and then leaped forward with the New Deal. Once again, it became clear that the most effective weapon against the sweatshop and the most reliable indicator of progress in the battle was the organized strength of the workers themselves. Between 1931 and 1933, membership in the ILGWU and ACWA jumped from less than 40,000 to over 300,000. From this dramatically broadened base, contractual demands had an industry-wide impact and fierce debate swirled around the subject of a government-sanctioned code and labeling plan for the industry. The eventual passage of social and labor legislation during this period reinforced the attack on sweatshops, helping to stabilize the industry by setting and enforcing national standards.

Labor Secretary Frances Perkins reflected the tenor of the times in 1933 when she appealed to consumers to think about the human cost of a $4.95 dress she had noticed on display in a store window. The dress was undoubtedly made in one of the hundreds of contractor sweatshops that had moved from New York City's garment district to surrounding states, she noted, where the employer believed the labor laws were less stringent and he could escape attention.

What is the way out for the conscientious consumer who does not want to buy garments, even at a bargain, made by exploited labor? Common sense will tell the purchaser that someone must pay the price of the well-cut silk dress offered at

$4.95. The manufacturer is not producing these frocks for pleasure or for charity. If the purchaser does not pay a price that allows for a subsistence wage and reasonable hours and working conditions, then the cost of the "bargain" must be sweated out of the workers.

The red silk bargain dress in the shop window is a danger signal. It is a warning of the return of the sweatshop, a challenge to us all to reinforce the gains we have made in our long and difficult progress toward a civilized industrial order.[6]

6. *Out of the Sweatshop*, p. 226.

The sweatshop was never completely eradicated, but over the next thirty years it was steadily pushed to the margins of the industry. A key factor was the union's success in establishing "joint liability" in the women's clothing sector of the industry, making the manufacturer (also known as the jobber) responsible for the wages and conditions of his contractors. This was established in contractual agreements with employers that also required union jobbers to use union contractors. Joint liability strikes at the heart of the sweatshop system by cutting through the fiction of the contractor as an independent entity. This the union learned the hard way. Following the Protocol, hundreds of manufacturers responded by closing their own "inside" shops and becoming jobbers—contracting out their work to many smaller shops. By the mid-1920s, 75 percent of production workers in the coat and suit industry were employed in contracting shops, a reversal of the ratio a decade earlier.

A commission appointed by New York governor Alfred E. Smith in 1926 documented the way the jobber controlled conditions in its contractor shops and created the pressures that undermined legal standards. The commission recommended the establishment of some form of joint liability, which was rejected by employers. Nevertheless, the union was able to obtain joint liability in contracts in the 1930s and eventually made it a national standard in contracts throughout the industry. Despite numerous legal challenges, the jobber responsibility provisions of garment industry contracts have been upheld in the courts and their protection incorporated into federal labor legislation.

By the mid-1960s, more than half of the 1.2 million workers in the apparel industry were organized and real wages had been rising for decades. The sweatshop had been relegated to a minor nuisance, its very marginality the symbol of an American success story. A new generation of immigrants, primarily from Asia and Latin America, were drawn into the industry and, like their European predecessors, found decent jobs that gave them self-respect and their children an opportunity to do even better. A similar experience was occurring in towns and communities beyond the big city production

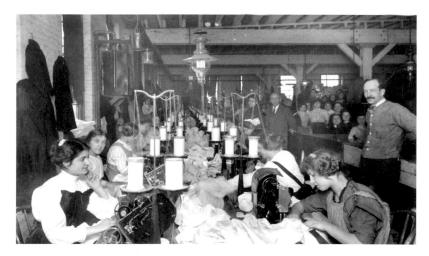

Sweatshop workers in New York City around the time of the Triangle Shirtwaist fire.

centers, as employers probed new regions of the country in their continuous search for lower wages.

But this was still a time shaped by the implied social contract of the New Deal and of robust economic growth. The notion that government did not have a responsibility to correct the dislocations and inequities of market-driven decisions was considered a quaint relic of a reckless *laissez-faire* ideology. While the political convulsions that seized the nation and much of the world during these years were not expressed in the economic terms that characterized previous periods of social crisis, they were nonetheless based on the assumption that democratic governments had an interest in protecting the vulnerable and were accountable to the will of the people. The impact on workers of these social and political upheavals was contradictory, but as the high hopes of the 1960s fractured into the disillusionment and lowered expectations of the 1970s, seismic shifts were underway in the structure of the apparel industry—the consequences of which would not become clear for many years to come.

The Industry Goes Global

In April 1995, a human rights group in Honduras discovered thirty-three Bangladesh workers in a free-trade zone factory, transported there by the contractor. They worked eighty hours a week for twenty cents an hour and could not leave their dormitories without permission from the company. They were sewing shirts that retailed for $12.94 at Wal-Mart.

Why should an employer bring workers from Bangladesh to Honduras to be paid twenty cents an hour when there is an abundant supply of Hondurans

ready to work for almost as little? The same question could be asked of the now infamous contractors in El Monte, California, where at about the same time it was discovered that seventy-two women had been imported from Thailand and held in virtual slavery for up to seven years, sewing clothes for some of America's top manufacturers and retailers—even though they were surrounded by thousands of workers toiling for wages not significantly higher. Why go to all this trouble to save a few cents more? The answer lay in the nature and logic of the sweatshop. Its function is to minimize the cost of labor by whatever means necessary, to appropriate every penny of value. Back on New York's Division Street in 1900 it may have meant charging the worker for the electric power consumed by her machine or for a broken needle. In El Monte and Honduras in 1995 employers rediscovered the advantages of indentured labor. The difference between cheap and cheaper labor, no matter how vile the means of obtaining it, is the organizing principle of the sweatshop.

In 1961, 4 percent of the clothes sold in the U.S. market were imports. Fifteen years later imports accounted for 31 percent. Today it's approaching 90 percent and still climbing—about $100 billion a year worth of clothing. The increase has come mainly from Third World countries producing everything from underwear to overcoats. These transactions are commonly referred to as "trade," suggesting the exchange of goods between nations, but that is something of a misnomer.

Some economists describe the industry as being organized along global "commodity chains" dominated by a handful of large retailers. When one retailer, for example, accounts for 25 percent of all the underwear sold in the United States, that corporation—Wal-Mart—virtually sets the price at which underwear must be produced by manufacturers and contractors and ultimately, of course, the workers. The movement of commodities up the chain from producers to market, with the retailer setting not only the price but also specifications of design and quality, is more like activity within a single transnational enterprise than the act of one country selling its goods to another.

These pricing pressures have driven the shift of production to lower wage sectors of the global economy, whether they are located in another country like China or in one of the thousands of sweatshops in the United States. Corporations have been allowed and even encouraged to do this by government policies, virtually unimpeded by the enforcement of minimal standards and laws. The transnational corporations of today are direct descendants of the New York firms that closed their own factories in the 1920s and became jobbers, contracting out work to the "foreign zones"

(as they were called then) of New Jersey, Pennsylvania, and other nearby states. In the 1950s and '60s, they extended production into the low-wage and right-to-work South, and then kept right on going across the seas. In effect, employers have succeeded in extending the sweatshop system on an international scale, and just as within this country early in the last century, it has driven down standards throughout the industry worldwide.

These market pressures were aided, abetted, and to a lesser degree created by Cold War political policies of the U.S. government. Alfred E. Eckes, chairman of the U.S. International Trade Commission during the Reagan administration, has documented how government tariff and trade policies were designed to favor particular countries, in accordance with their strategic value in containing communism, at the expense of domestic producers. Eckes argued that however you care to measure the success of these policies, they are no longer relevant to the post-Cold War economy, and they have done significant damage to domestic industries.[7]

7. *Foreign Affairs* (Fall 1992), pp. 135–54.

If you believe the apologists for these policies, all is well in the best of all possible worlds. The United States will eventually shed itself of a low-tech, low-skill industry, poor countries will develop an industrial base capable of launching their workers into middle-class prosperity, and the American consumer will have cheap clothes to buy.

The facts tell another story. There are still more than 400,000 apparel workers in the United States, earning less in real wages than they did in 1955, even though their productivity has more than doubled. In three out of four of those countries to which production shifted, real wages in the industry also declined. It is no coincidence that in the few Asian countries that have raised the living standards of working people, we also find the growth of unions or government income and trade policies that encouraged a more equitable distribution of wealth than unregulated markets would allow. And while there are plenty of relatively inexpensive goods in the stores, take a look at the labels: a lot of those $9.95 blouses are made in the U.S.A. The labels might reveal something else: identical items, one made overseas and one domestically, both selling for the same price. The labels tell us two things. For some goods, the cost of sweatshop labor in the United States has been driven so low that it is competitive to produce them here. In other instances, the difference in the labor costs offshore and the unionized U.S. worker, a ratio that averages about 1:15, reflects the vast fortunes that have been made by the middlemen, manufacturers, retailers, and their bankers who have succeeded in globalizing the sweatshop.

The system is out of control; its cruelties and absurdities crying out for reform. In many of the countries that produce shoes and clothing primarily

for export, half the people walk around barefoot and in rags. In Africa, entire national industries have been wiped out. In Asia, companies that had abandoned production in Japan, Korea, Hong Kong, and Taiwan for the lower wages of the Philippines, Thailand, Bangladesh, and China are now moving on to Vietnam, Cambodia, and Laos, and even to the Pacific Islands like Saipan and American Samoa, where—shades of El Monte and Honduras—Chinese workers have been transported to live and toil as virtual slaves. In India and Pakistan, 1.5 million children are hard at work sewing and stitching products sold in the U.S. market. In China, now the world's largest producer of clothes, textiles, shoes, and leather, some cities have more productive capacity in these industries than all of Europe combined. The European apparel industry is in free-fall, as firms shift production to Central and Eastern Europe where wages are as low as any in the world and where you will find at least one former bomb factory filled with sewing machines operated by nuclear scientists.

Perhaps the biggest "beneficiaries" of this new global production system have been Mexico and the Caribbean region, where half a million workers now account for more than a quarter of U.S. apparel imports. This has been the fastest growing area of apparel production in the world, fueled by tariff and other financial incentives from the U.S. government and by proximity to the U.S. market. The economy of countries like the Dominican Republic, now the fourth largest exporter of apparel to the United States, have been transformed but not necessarily improved. "We are not developing a country," observed Jorge Sierra, a human rights leader from the region. "We are destroying a generation."[8]

8. Charles Kernaghan, interview by author, January 18, 1996.

Where once peasants labored from dawn to dusk cutting sugar cane that enriched local oligarchs and built the Fifth Avenue mansions and Manhattan skyscrapers of the American sugar barons; now the children and grandchildren of those peasants sit at sewing machines from dawn to dusk, and sometimes well into the night, making bras and jeans and blouses that through the magic of the market are transmuted into multimillion dollar CEO compensation packages and handsome profits for the privileged few. The average wage in the Dominican assembly plants, known as *maquilas*, does not come close to the country's official poverty line, but apparently some of the wealth is bubbling up. Not far from one of the largest free-trade zones in the country, merger mogul Henry Kravis has built his new $24 million Greco-Roman estate—financed from his various leveraged buyouts that included at least one big retail chain—a monument so outrageously ostentatious, suggests a local newspaper, that the famous American financier ordered a stateside media blackout for fear of a public relations backlash.

In addition to the geographical spread of the industry, a change has occurred in its internal structure that has accelerated the return of the sweatshop: the role of the retailer. Many contractors now work directly for retailers, producing what is known in the trade as private labels. In this relationship, the retailer functions as a manufacturer, creating the design, providing the fabric and other raw materials, and setting the price. Even when a big retailer deals with a traditional manufacturer, the retailer by virtue of its dominant market position sets the parameters to such an extent as to often reduce the manufacturer to a virtual contractor. There is a wide and subtle spectrum to this relationship, but there is no question that the balance of power has shifted decisively to the dozen or so big retailers that have consolidated their control in this bankruptcy-wracked industry and account for 75 percent of all apparel sales in the United States.

Blaming Immigrant Workers

Over the past thirty years as the U.S. government was opening the domestic market to apparel produced in Third World countries, a more diverse and family-oriented immigration policy increased the number of immigrants coming from many of those same nations. Like earlier generations of new Americans, many found work in the apparel industry. But these new immigrants would be forced to swim against powerful currents. Not only had the U.S. garment industry begun to shrink because of the shift to offshore production, American politics had also entered one of its uglier periods.

It is common to blame "illegal aliens" for the prevalence of sweatshops. It's worth recalling that back in the days when there were no "illegal" immigrants because there were virtually no quantitative restrictions on immigration—with the egregious exception of the discriminatory anti-Chinese laws—the same alarm was raised about the masses of "foreign" and "inferior" European workers who poured into American cities by the millions. It was these same workers, of course, who did so much to organize the unions and propel the great reform movements that shaped America as an industrial democracy. And while you would never know it from the rancid demagoguery that frames the issue in the political arena, those good, hard-working, family-loving immigrants of yore relied on public services in proportionally far greater numbers than the vilified immigrants of today.

In the immediate aftermath of September 11, 2001, concerns about "illegal aliens" focused more on questions of national security than on sweatshops, but this hysteria about foreigners is deeply rooted in the American experience. *Scapegoat* is derived from the old Hebrew name of a demon and refers to a

goat on whose head are symbolically placed the sins of the people. When it was the Irish and the Italians, Romanism and Rum were going to ruin the country, and then came the always handy Jews. There has not been a day in the 230 years of the Republic that some citizen has not stood before a gathering of fellow Americans to declare that the end is near due to the presence on our shores of this or that group of foreigners. Most of the time these passions are held in check. But in moments like these, when economic and political insecurity touch large numbers of people, the primitive ritual is transmitted into public policy and we are supposed to be convinced that in this way the problem will be solved.

It is essential to focus on the people responsible for sweatshops. "Illegal aliens" constitute probably about 5 percent of the American labor force. They are in the United States because there is a market for their labor: thousands of employers who are rewarded for extracting value from workers who cannot defend themselves. These employers are even rewarded by the law designed to punish them, an insidious provision in the 1986 Immigration Reform and Control Act known as "employer sanctions" which requires the federal government to penalize anyone employing an illegal immigrant. Theoretically, it sounds reasonable. In practice, it succeeds only in denying a few day's pay to someone who will find another job down the street under the same wretched conditions, and actually makes it harder to enforce labor laws since employers have learned to use it as a threat against workers who dare to assert their rights. Employer sanctions should be repealed, replaced with sanctions on those much higher up the corporate commodity chain and with international development policies that do not force millions of people across borders that no democracy can ever completely close.

When it comes to identifying the cause of sweatshops, the anti-immigrant fervor is a gigantic and cruel distraction. Borders are naturally porous and there are limits to how much the flow of people across them can be restricted. What could be done, however, is to invest some political capital in labor standards that transcend increasingly irrelevant national boundaries. There are virtually none now: the only laws operating in the global labor market are those of supply and demand. One authoritative study projects that in such a market wages in a global industry will tend to equalize at a level slightly higher than those paid today in Nigeria—a little under $2 an hour.[9] That's the good news (unless you happen to be a $10 an hour unionized workers in the United States), because it suggests that millions of workers in poor countries now making a lot less than that are in for a big raise. The bad news: in the real world, the chronic suppression of workers' rights in

9. Isabelle Grunberg, *Rival States, Rival Firms: How do People Fit In? The Global Unemployment Challenge*, United Nations Development Programme, Office of Development Studies (Discussion Paper Series, 1996).

many of those countries means that wages will not rise even to what a "free" market should permit. The weakness of laws protecting workers' rights and the lack of international labor standards have generated the infamous "downward spiral" of workers forced to compete with each other on the basis of ever more miserable working conditions.

Perhaps this is what Ronald Reagan had in mind when, shortly after he broke the PATCO strike in 1981, he tried unsuccessfully to lift the fifty-year ban on homework in the women's apparel industry. He lost that particular battle, but he succeeded in setting into motion the antigovernment hysteria that, among other things, has left the Department of Labor (DOL) with 940 inspectors to monitor two million workplaces—approximately the same number of inspectors, by the way, that Nike claims it employs to assure that its worldwide production facilities are in compliance with the law. If DOL's 940 inspectors did nothing but monitor the 22,000 apparel plants in the United States, they would still have their hands full. With these limited resources going to enforcement of labor laws, nobody should be surprised that workplace standards throughout the economy have deteriorated.

Resistance to these policies has mitigated some of their most harmful effects, but it has never been able to stop them. Until the implementation of the North American Free Trade Agreement (NAFTA) in 1994 and the creation of the World Trade Organization (WTO) in 1995 signaled the apparent triumph of "free trade," the labor movement followed a strategy of alliance with its own domestic industries to limit imports. In the apparel industry, this entailed a series of elaborate quota systems that expired in 2005; now there are no quotas on any apparel, textiles, or most other goods traded in the world market. Some sectors of the industry have succeeded in temporarily carving out exemptions from the new regime, but this is the point we have actually been moving toward over the past thirty years, based on mountains of learned disputation about the blessings of open trading systems and the evils of protectionism. Official ideologies tend to reflect and promote the interests of dominant economic powers. When nationally based corporations ruled their own countries, trade barriers protecting national industries were official policy. In this era of transnational corporations, about 2,000 of which control half of the world's trade and three-quarters of its financial assets and have no national loyalties, it is their insatiable interest in consolidating access to the entire global market that animates the fashionable economic theories of the early twenty-first century.

The purpose of the transnational corporation is to maximize profits for its shareholders, which, it is argued, is the most efficient way for a society to organize its economic system. But what if this "efficiency" marginalizes

hundreds of millions of people from the system itself? What if it destroys the environment? What if it tends to equalize wages at less than $2 an hour? What if it reduces mass purchasing power and depresses the economy as a whole? What if it condones and even encourages the proliferation of sweatshops?

Unless we are prepared to accept the notion that corporate profits have now become the final authority of right and wrong, then there must be limits placed on the enormous powers of transnational corporations— limits that direct economic activity toward the values and vision of social justice and political equality. Let us now examine our strategic options for

Police brutality outside the Pantex factory in Bangladesh, 2004.

Bangladeshi sweatshop worker, 2001.

confronting the global sweatshop of the twenty-first century.

Strategic Options for Confronting the Global Sweatshop

We must begin by recognizing what in the apparel industry has changed and what has not over the past half-century. It is an industry still characterized by many small firms competing on slender margins. This is less the case in the men's wear and mass-produced commodity sectors of the industry than in the more fashion-sensitive women's sector, but in the United States alone there are more than 20,000 firms with an average of fifty employees, starting up and shutting down with the seasons and the vagaries of the market. Add to these numbers the new element of globalization, the contractors large and small scattered across the face of the earth, the families in rural villages, and the thousands of workers in free-trade zone factories, all feeding the

flow that terminates in our department stores and malls, and we begin to get a sense of the daunting scope of the challenge.

The first and indispensable order of business is to make the system visible and keep it in the public eye. This has begun to happen, with a peculiar American flavor. The shock of El Monte was followed by a campaign that focused on the Gap and one of its contractors in El Salvador, and then came the Kathie Lee Gifford scandal in 1996 when the muckraking National Labor Committee discovered that the TV talk-show celebrity had lent her name to clothing being produced in Honduran and New York City sweatshops. The coalescing of grass-roots labor and human rights activists brought a crusading spirit to the issue that made it impossible to ignore.

It was a turning point, but it would be foolish to underestimate the resistance to change. Within weeks, the ever resourceful *New York Times* dispatched reporters to a free-trade zone in Honduras and a Nike contractor in Indonesia, resulting in articles with headlines that read "Hondurans in 'Sweatshops' See Opportunity" and "For Indonesian Workers at Nike Plant: Just Do It." Passing lightly over references to strikes against abusive conditions and reflecting peculiarly selective interviews, the reports concluded that "sweatshops"—their very reality questioned by those deftly placed quotation marks—are better than no jobs at all. Perhaps encouraged by this support for their case by no less an authority than the *New York Times*, the big retailers and several large manufacturers refused to participate in President Clinton's high-level panel convened in August 1996 to study the problem. They were not keen on the idea of exposing their voluntary and self-policing codes of conduct to independent scrutiny, nor did they seem any more receptive to the notion of organized workers than they had ever been.

But most of the elements of a successful strategy can be found in those first few months of the politically sensitive election year of 1996: public exposure and pressure, government action, corporate responsibility, and—most critical of all—the empowerment of workers. These are the checks that must be placed on corporate power. A system of industry-wide standards must be rebuilt, almost from the ground up, as was done at the time of the Protocol and then again during the New Deal. The building materials have not changed all that much, but the dramatic changes in the scope and structure of the industry mean that we cannot simply reproduce old formulas.

There are special problems, for example, with the application of offshore codes of conduct and monitoring programs. In most of these countries, regulatory infrastructures are exceedingly weak; employers often wield dictatorial power; massive poverty and unemployment and no tradition of unionization leave workers nearly powerless. Under such circumstances,

the typical company monitoring program simply extends the control and concealment that breeds the sweatshop.

If companies really want to know what is happening in their contractors' shops offshore, they need credible independent monitors who have the confidence of the workers. This is the great virtue of the path-breaking programs established by the Gap in El Salvador or the Rugmark labeling campaign for hand-knotted carpets made in India and Nepal and, more recently, by the Workers Rights Consortium, created in 2000 on the wave of antisweatshop student activism to monitor the production of clothing for U.S. universities. But these and other effective monitoring programs are important only if they become prototypes for a comprehensive international system, administered by an organization with adequate authority and resources like the International Labor Organization (ILO). Perhaps the most promising of these initiatives has been the ILO monitoring program in Cambodia, which linked increased access to the U.S. market with credibly verifiable compliance with international labor rights.[10]

10. Sandra Polaski, *Cambodia Blazes a New Path to Economic Growth and Job Creation,* Carnegie Endowment for International Peace (Carnegie Paper, 2004).

Competitive pressures being what they are, however, we have seen that monitoring programs will not work without dramatically enhanced legal enforcement of industrial standards. Governments at the local, state, and national level must enact the necessary laws and provide the resources to enforce them. Legislation is needed that establishes "joint liability" for retailers and manufacturers. When Kathie Lee's blouses were discovered in sweatshops in New York and Honduras, neither Wal-Mart nor the manufacturer who had contracted with the shops had a legal responsibility for the working conditions. The "guilty" parties were the owners of the sweatshops. This defies the logic of the system and lets retailers and manufacturers off the hook. Besides fines and responsibility for unpaid back wages, retailers must be legally required to have monitoring programs, with specified and uniform standards, for their manufacturers and contractors. The Wal-Mart executive who agreed to pay $5 wholesale for the blouses did not have to be a mathematical genius to know that the garment would be made in a sweatshop. Such a decision is irresponsible —and should be illegal. The U.S. Department of Labor has developed highly detailed monitoring guidelines that have been offered to employers on a voluntary basis. If we are serious about eradicating the sweatshop, these standards should carry the force of law. The big corporations that drive the production process must take responsibility for labor standards the same way they are responsible for quality, price, and delivery schedules.

But effective enforcement standards domestically will not solve the problem, for as we have seen, employers have the option of sending the work

to shops offshore where workers are often even more vulnerable to abuse. Transnational corporations and the production systems they have developed have outraced the ability of laws to follow them across national borders. And if the legitimacy and authority of international law are still in their infancy, international labor standards and worker rights are embryonic.

The rules of the WTO restrict the ability of any single nation to deny entry of goods produced under conditions which the importing country may deem objectionable, from products made with child labor to tuna caught with nets that kill dolphins. The restrictions are legally amorphous, however, subject to fierce debate and geopolitical maneuvers. There are those who say that free trade means exactly that, no restraint on the sale and purchase of goods across national borders; violations of international law and standards should be duly punished but not with trade sanctions, which will only be used by protectionists to undermine the new system. The other side argues that these new WTO rules overturn a half-century of U.S. laws that say the conditions under which goods are produced do matter and matter greatly; that the only effective punishment for such violations are trade sanctions; and that rules can be established for assuring that sanctions are applied for violation of internationally recognized rights and not for protectionist measures.

These are the conflicting principles underlying the great policy debates on China and NAFTA and various other issues in which the banner of basic human and worker rights is carried into battle against what appear to be the far superior forces of the New World Order. But the situation is not hopeless. There is a consensus on the content of "internationally recognized worker rights"—prohibition on child and forced labor, discrimination in employment, the right to organize, bargain collectively, and to strike—but the terrain of how violators should be penalized is still very much contested. The weak labor and environmental "side agreements" in NAFTA implicitly recognize the principle of trade sanctions while rendering them practically inoperative. Several U.S. laws, such as the Generalized System of Preferences (GSP) and the Caribbean Basin Initiative, contain stronger provisions making access to the U.S. market contingent on the enforcement of internationally recognized worker rights. The European Union has its own version of GSP, and virtually every international organization with any authority pertaining to the issue finds itself entangled in the conflict. In a bold attempt to cut through this legislative morass, a bill was introduced in the U.S. Senate in 2006 that would prohibit the import, export, or sale of sweatshop goods in the United States.

This question of how laws and standards will be extended and applied to the contours of the new international economy will only be resolved over

the course of a long struggle, and then never with satisfying finality, just as the process has unfolded within nations. Some view the challenge as utopian, and perhaps it once was. Today it has a practical urgency, and not only because of what happened in the apparel industry. Testifying before a government commission on worker-management relations in 1994, Jay Mazur, president of UNITE, the apparel workers union created in 1995 by the merger of the ILGWU and the Amalgamated Clothing and Textile Workers Union (ACTWU), offered some advice:

> *Our long history with contracting out contains important lessons for other industries, many of which are following the example of apparel by assigning more and more functions to indirect or contingent workers . . . I believe the broad principle involved here could be applied across the board to many industries, services, and situations. That principle is that the businesses which control outsourcing, under whatever name you call them—"virtual employers," "core corporations," or simply manufacturers—must be held responsible for the wages, benefits, and working conditions of their "virtual" or contingent employees, who are known as contractors. Much of the poverty and economic disorder in the world today stems from the system we have tragically allowed to develop, in which practical economic power has been allowed to divorce itself from legal responsibility . . . The history of our century clearly shows the differing results when the controlling manufacturers are or are not held to account for conditions in their contractor shops, including compliance with wage and hour, child labor, and other laws, let alone union contracts.*[11]

11. Jay Mazur, testimony before the Commission on the Future of Worker-Management Relations, Washington, D.C., July 25, 1994.

This advice, perhaps not surprisingly, was ignored, leaving the matter once again in the hands of the workers themselves.

The role of the North American labor movement in this struggle is critical. The late twentieth-century myth surrounding the movement was that it had been rendered obsolete by its own success. We now see this was inaccurate on both counts: its success was momentary and it is still very much needed. The decline of the workers' movement, the result of its own complacency and a relentless ideological and political assault by employers, has tipped the balance in our economic system. The evidence of systemic crisis is everywhere; the data almost numbing on the hungry and the poor, the growth of inequality, the anarchy of production. Defenders of the status quo invoke the holy laws of supply and demand and moral precepts of hard work and abstinence. It is too much to take. No wonder the labor movement shows signs of rediscovering its vocation of comforting the afflicted and afflicting the comfortable.

In taking on the global sweatshop, unions have had to adjust their vision

to the new horizon of the industry. From the time that Inspector O'Leary concluded his tour of the sweatshops on Division Street in 1900 with an appeal to the union for its help and advice, the most efficient mechanism for curbing abuses in the industry was a union strong enough to monitor and enforce standards that had been set either by legislation or contractual agreement. This strength was built over decades of sacrifice and struggle, passing through stages that parallel those of other industries: isolated strikes, rudimentary national organizations, more strikes, and then pivotal movements in which massive uprisings coalesce with reformist political currents and social movements and change becomes structural, rooted in industrial practices and legislation.

But it is always an uneven process, two steps forward, one step backward, offensive and counteroffensive. The pattern in the apparel industry has been for firms to seek new areas of production beyond the union's reach. To maintain standards, the union was forced continually to follow the work. In the 1930s, there were still New York City locals with contracts that defined their jurisdiction as the area within the five-cent fare of the city's mass transit system; beyond that were the hinterlands. As the industry spread to other cities, states, and regions of the country, and then to Puerto Rico, the union kept adjusting its sights and followed. But when the industry began its huge movement offshore in the 1970s, the union did not and perhaps could not follow the work in the same way. Relations were maintained with unions in other countries through international structures of the labor movement. Some assistance was provided to needy affiliates. Meetings and congresses were duly convened. In theory and rhetoric, international solidarity was alive and well. In practice, it was overwhelmed by Cold War political considerations and employers' technological and strategic command of the playing field.

Workers and their unions in the apparel industry are now undergoing an historic adjustment of their strategic vision. It has become a matter of their very survival. The industry must be rationalized and humanized, and there is no greater force with the interest and capacity to do this than the workers themselves. The sewing machine operators in Honduras and New York City stitching together Kathie Lee blouses work in the same industry, are employed and similarly exploited by the same firms, and literally speak the same language. Like generations of workers preceding them, they can, must, and will organize—with the active solidarity of a revitalized labor movement that exercises the same freedom of communication and movement across national borders that corporations have long utilized to their exclusive advantage. Enlightened employers will accept this development, as they have in the past,

allowing them to compete in a more stable industry, on the basis of technological innovation, superior design, and more effective marketing. Those who resist the establishment of decent standards in the industry must pay a price: fines from stepped-up enforcement, disrupted production by demoralized or angry workers, and the rejection of their goods by consumers increasingly sensitive to the conditions under which goods are produced.

This spells big trouble for many apparel manufacturers and retailers, who in recent years have placed great importance on brand identity and the good image of their labels. Massive investments are made to enhance those images—and information reaching the public that damages them can have serious economic consequences for a firm's bottom line. This vulnerability gives workers and consumers a powerful new weapon in the struggle against sweatshops.

But it would be premature to announce the imminent death of the sweatshop. Too much remains to be done. One serious and immediate problem is the structure of the labor movement itself. The old apparel and textile unions in many of the industrially developed countries, including the United States, having found it impossible to reverse their rapid decline in membership, have shifted their attention and organizing efforts to other industries. While this can certainly be seen as a rational response to the demands of institutional survival, it also takes out of play a tremendous potential force for the organization of hundreds of thousands of unorganized apparel and textile workers in the United States and millions more around the world. To be sure, there are still some unions and spunky, little worker centers and even, theoretically, large, official international labor federations engaged in this historic task, but they would be the first to tell you that they have a long way to go.

The truth is that our optimistic scenario can only be imagined in a radically altered political climate. The historic gains of apparel (and other) workers have coincided with the ascendancy of national political movements, like those of the Progressive Era and the New Deal, that redressed the balance between human needs and property rights. Nothing less is needed today on a global level. The force required to move institutions as powerful and entrenched as the modern transnational corporation is beyond the capacity of one group of workers or a single strata of the population. Sparks may fly from a strike in one factory or, to invoke the spirit of the kind of movement we need today, a sit-in at one lunch counter, but unless and until they involve the action of masses, reverberate through the structure of the entire society, coalesce with allies, and eventually take political form, our momentary victories will be smothered in a system and culture that regard the sweatshop as inevitable and the suffering of its victims of very slight human consequence.

J. MORGAN PUETT – IAIN KERR
CORPORATE PARTNERS
INVOLVEMENTS WITH

JAMIE L. GRACE, ABBY LUTZ, BARBARA BOT-
TING, ROBIN RICHMOND, SPURSE, MARY
LARRIMORE, DANA SHERWOOD, THE
ADINISTRATIVE DEPARTMENTS OF MASS
MOCA, THE AMERICAN TEXTILE HISTORY
MUSEUM, JASON SIMON, THE KANELOS
FAMILY, THE LATE DAN FAZEKASE, FREED-
MAN DEROSA & RONDEAU, AND OTHERS.

THE MULTIPLED SUIT FOR THE DISCERNING
MAN, WOMAN, OR OTHER.

UNRIVALED PERFECT FITTING, EASE OF
HANDLING, QUICK ADJUSTMENT, GREAT
COMPLEXITY, AND GENERAL CONVENIENCE.
WE KINDLY SOLICIT YOU TO COME TO BE
TOUCHED AND FITTED.
AGENTS WANTED EVERYWHERE.

WWW.THATWORDWHICHMEANSSMUGGLINGACROSSBORDERSINCORPORATED.COM
A CALL IS RESPECTFULLY SOLICITED

THAT WORD WHICH MEANS SMUGGLING ACROSS BORDERS, INCORPORATED

THE MULTIPLED SUIT

FOR THE DISCERNING MAN, WOMAN, OR OTHER
UNRIVALED IN PERFECT FITTING, EASE OF HANDLING,
QUICK ADJUSTMENT, GREAT COMPLEXITY, AND GENERAL CONVENIENCE

THAT WORD WHICH MEANS SMUGGLING ACROSS BORDERS, INCORPORATED IS A FORM OF BUSINESS PRACTICE DIRECTED TOWARDS EMERGENT AND RESPONSIVE FORMS OF SARTORIAL COMPOSURE AND BODILY ENVIRONMENTS. THIS PRACTICE WILL CONTINUALLY SHIFT AND TRANSFORM AS IT MOVES ITS LOCATION FROM ONE SITE TO THE NEXT.

THE MULTIPLED SUIT—A GARMENT WHICH IS AT ONCE A MULTIPLE, MULTIPLIED, AND MULTIPIECED. THIS SUIT IS NOT A SET OF COMPLETE-INTO-THEMSELVES PIECES (THE JACKET, THE VEST, THE PANT), BUT A SUIT OF QUASI-PIECES THAT CAN CONSTANTLY DRIFT IN FORM AND COMPOSITION. MANY PIECES COME TOGETHER TO FORM A SKIRT WHICH BECOMES PANTS, PANTS BECOME A JACKET, AND JACKET DRIFTS OFF ELSEWHERE. THESE PIECES, IN WANDERING ACROSS OUR BODIES AND OUR DESIRES, WANDER ACROSS THE LARGER TERRAIN OF THE POSSIBLE FUTURES OF BUSINESS PRACTICES (CORPORATE AND INCORPORATE IDENTITY), MASCULINITY, AND ALTERNATIVE FORMS OF ENGAGEMENT.

THE SUIT'S PATTERNS ARE CONDENSATIONS OF A LARGE ARRAY OF FORCES. THE DESIGN PROCESS BEGINS BY FILTERING TOPOGRAPHICAL AND ARCHITECTURAL SPACES THROUGH EARLY AMERICAN FITTING SYSTEMS. THE DESIGN SYSTEM THEN PROCEEDS BY FUSING AND TRANSLATING HISTORIES OF THE MASCULINE, STYLE, AND REGION WITH FILM TRANSCRIPTS AND HISTORICAL CORRESPONDENCES, ALL OF WHICH ALLOW THE FINAL SUIT TO BE AN ELEGANT AND FINELY CRAFTED MODULAR GARMENT CONSTANTLY SHIFTING AND SLIPPING THROUGH IDENTITIES – FROM JACKET TO SKIRT TO PANT TO AS YET UNRECOGNIZED FORMS OF ATTIRE.

DURING 2004, THE MULTIPLED SUIT WAS PRODUCED IN A SMALL SQUATTERS SHACK IN THE RUBBLE OF THE THIRD FLOOR GALLERIES OF MASS MOCA IN NORTH ADAMS. WITHIN THIS TRANSHISTORICAL DWELLING A MASTER TAILOR TOOK ORDERS AND ARRANGED CAREFUL TOUCHINGS AND FITTINGS. THIS PROVISIONAL SHACK IS THE BEGINNING OF A LONG-TERM PROJECT TO EXPERIMENT WITH QUESTIONS OF COMPORTMENT TODAY.

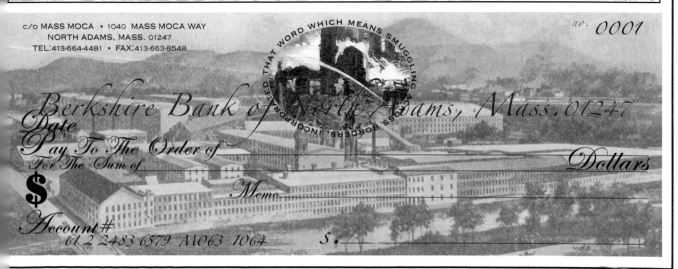

c/o MASS MOCA • 1040 MASS MOCA WAY
NORTH ADAMS, MASS. 01247
TEL: 413-664-4481 • FAX: 413-663-8548

no. 0001

Berkshire Bank of North Adams, Mass. 01247

Date

Pay To The Order of

For The Sum of

Dollars

$

Memo

Account #
612 2483 6579 M063 1064

S.

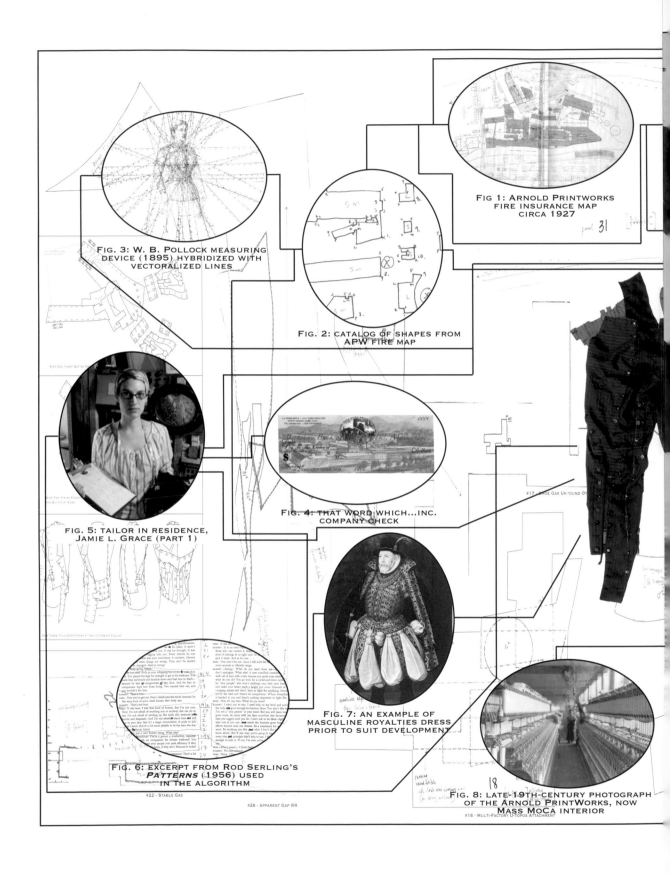

FIG 1: ARNOLD PRINTWORKS
FIRE INSURANCE MAP
CIRCA 1927

FIG. 3: W. B. POLLOCK MEASURING
DEVICE (1895) HYBRIDIZED WITH
VECTORALIZED LINES

FIG. 2: CATALOG OF SHAPES FROM
APW FIRE MAP

FIG. 4: THAT WORD WHICH...INC.
COMPANY CHECK

FIG. 5: TAILOR IN RESIDENCE,
JAMIE L. GRACE (PART 1)

FIG. 6: EXCERPT FROM ROD SERLING'S
PATTERNS (1956) USED
IN THE ALGORITHM

FIG. 7: AN EXAMPLE OF
MASCULINE ROYALTIES DRESS
PRIOR TO SUIT DEVELOPMENT

FIG. 8: LATE-19TH-CENTURY PHOTOGRAPH
OF THE ARNOLD PRINTWORKS, NOW
MASS MoCa INTERIOR

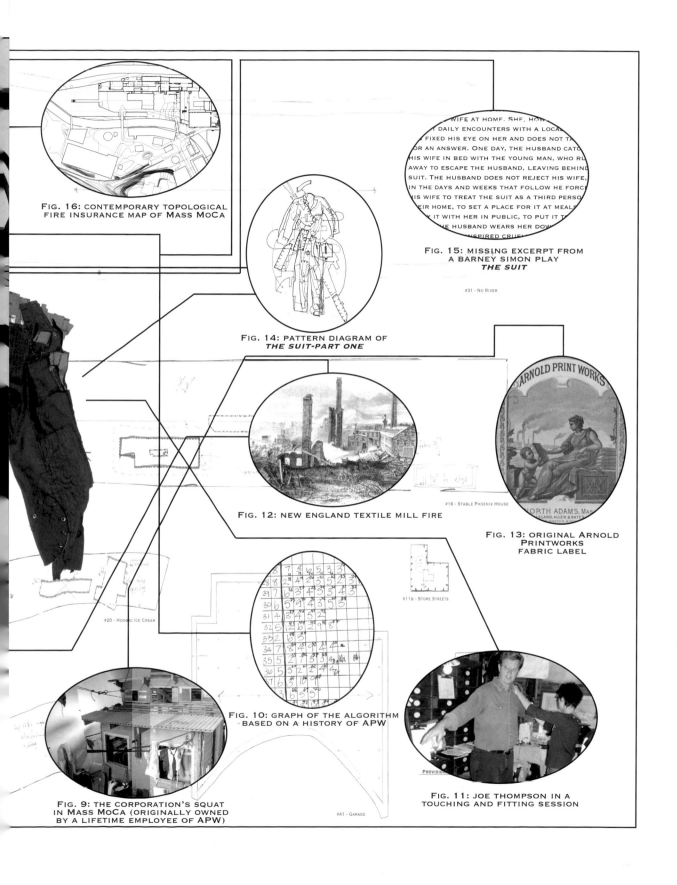

FIG. 16: CONTEMPORARY TOPOLOGICAL
FIRE INSURANCE MAP OF MASS MoCa

WIFE AT HOME. SHE, HOW
DAILY ENCOUNTERS WITH A LOCA
FIXED HIS EYE ON HER AND DOES NOT T
OR AN ANSWER. ONE DAY, THE HUSBAND CATC
HIS WIFE IN BED WITH THE YOUNG MAN, WHO RU
AWAY TO ESCAPE THE HUSBAND, LEAVING BEHIND
SUIT. THE HUSBAND DOES NOT REJECT HIS WIFE,
IN THE DAYS AND WEEKS THAT FOLLOW HE FORC
HIS WIFE TO TREAT THE SUIT AS A THIRD PERSO
EIR HOME, TO SET A PLACE FOR IT AT MEALS
Y IT WITH HER IN PUBLIC, TO PUT IT T
HE HUSBAND WEARS HER DOW
NSPIRED CRUEL

FIG. 15: MISSING EXCERPT FROM
A BARNEY SIMON PLAY
THE SUIT

#31 - NO RIVER

FIG. 14: PATTERN DIAGRAM OF
THE SUIT-PART ONE

#16 - STABLE PHOENIX HOUSE

FIG. 12: NEW ENGLAND TEXTILE MILL FIRE

ARNOLD PRINT WORKS

NORTH ADAMS, MAS
LAND, ALLEN & BATE

FIG. 13: ORIGINAL ARNOLD
PRINTWORKS
FABRIC LABEL

#20 - HOOSIC ICE CREAM

#11B - STORE STREETS

FIG. 10: GRAPH OF THE ALGORITHM
BASED ON A HISTORY OF APW

PROVISION

FIG. 9: THE CORPORATION'S SQUAT
IN MASS MoCa (ORIGINALLY OWNED
BY A LIFETIME EMPLOYEE OF APW)

#41 - GARAGE

FIG. 11: JOE THOMPSON IN A
TOUCHING AND FITTING SESSION

INSTRUCTIONS FOR THE PROCEDURAL ALGORITHM IN FORMING
THE PATTERNS FOR THE SUIT (PART ONE):

1) EXTRACT ALL POSSIBLE, USABLE SHAPES FROM THE HISTORICAL INSURANCE MAP (FROM ALL PERIODS). MAKE A POINT OF USING ALL POSSIBLE OUTLINES: BUILDINGS, ROADS, RAIL LINES, TOPOGRAPHY, ETC. (THIS GIVES US 41 BASIC PATTERN SHAPES).

2) NUMBER THESE SHAPES AND ALPHABETIZE ALL POINTS ON EACH SHAPE.

3) USE THE HISTORICAL SUMMARY OF ARNOLD PRINT-WORKS COMPANY TO DETERMINE THE MULTIPLES OF EACH PIECE AND THEIR SCALE:

 A) NUMBER THE LINES OF THIS TEXT TO CORRESPOND TO ALL 41 SHAPES (E.G. USE THE FIRST 41 LINES).

 B) THE FIRST WORD OF EACH LINE DETERMINES THE NUMBER OF PIECES EMERGING TOWARD A PATTERN PIECE.

 C) THE NEXT NUMBER OF WORDS (AS INFORMED BY THE FIRST WORD), DETERMINES SIZE MULTIPLICATION OF EACH PIECE BY COUNTING THE NUMBER OF LETTERS IN THESE WORDS).

 (THIS PRESENTS 197 PIECES (MULTIPLES) OF THE ORIGINAL 41 IN DIFFERING SIZES).

4) USING THE W. B. POLLOCK MEASURING DEVICE (PATENTED 1895), FLATTEN THIS DEVICE INTO A SYSTEM OF 34 VECTORALIZED LINES. NUMBER EACH LINE AND ALPHABETIZE POINTS 1 CM APART ON EACH.

5) USE THE FIRST PARAGRAPH OF THE TEXT (SECOND VERSION OF THE HISTORY OF ARNOLD PRINTWORKS) TO DETERMINE THE 20 COMPOSITE PIECES MADE (ADDING 6 TRUMP OR FAVORITE PIECES CHOSEN BY THE COLLABORATORS).

6) TAKE THE ROD SERLING TELEPLAY *PATTERNS*, AND SELECT 20 PASSAGES WHICH ARE PERTINENT EPISODES TO THE SUBJECT:

 A) SUPERIMPOSE THE ARNOLD PRINT-WORKS HISTORY/ALGORITHMS OVER THE 20 SERLING PASSAGES. AND DELETE THE CORRESPONDING WORDS FROM THE *PATTERNS* TEXT.

 B) COUNT THE NUMBER OF WORDS BETWEEN EACH DELETION. THIS DETERMINES THE CORRESPONDING PIECE NUMBER TO BE SELECTED.

 C) APPLYING THIS TO ALL 20 PATTERN PIECES ALLOWS A NEW FORMULA OF COMPOSITE PIECES TO EMERGE.

7) MAP THESE PIECES ONTO THE FLATTENED W. B. POLLOCK DRAFTING SYSTEM DIAGRAM.

8) TAKING THE JASON SIMON LETTER, THE PIECE NUMBER DETERMINES THE WORD SELECTED FROM THE SIMON LETTER WHICH DESCRIBES HIS UNCLE BARNEY SIMON'S PLAY *THE SUIT*.

 A) THE LAST PARAGRAPH ACTUALLY DESCRIBES A SCENE THAT WAS OMITTED FROM A VERSION WHICH PLAYED IN NEW YORK CITY IN THE LATE 20TH CENTURY.

 B) EACH PIECE NUMBER FINDS A WORD; THE FIRST LETTER OF THE WORD IS TRANSLATED INTO A NUMBER, WHICH DETERMINES WHICH VECTOR IN THE FLATTENED POLLOCK SYSTEM IS USED.

 C) THE LAST LETTER OF THE WORD DETERMINES WHICH LETTER OF THE VECTOR THE PIECE LANDS ON.

 D) THE SECOND LETTER OF THE WORD DETERMINES WHICH ALPHABETIZED POINTS OF THE PIECE CORRESPOND TO THE PREVIOUSLY SELECTED ALPHABETIZED POINT ON THE VECTOR (POLLOCK SYSTEM).

9) ONCE ALL PIECES HAVE BEEN POSITIONED, THEY ARE THEN ENLARGED INDIVIDUALLY AS PER PREVIOUS DETERMINATION. THIS PRESENTS THE FINAL OUTLINE OF A COMPOSITE PIECE, WHICH IS A USABLE PATTERN PIECE IN THE SUIT.

THIS IS THEN FURTHER MODIFIED BY OTHER PROCEDURES TO DETERMINE (1) MATERIALS, (2) METHODS OF STITCHING, AND (3) QUALITIES OF COMPOSITION.

"HIS RESOLUTION OF SETTING A FASHION FOR CLOTHES, WHICH HE WILL NEVER ALTER, IT WILL BE A VEST, I KNOW NOT WELL HOW; BUT IS TO TEACH THE NOBILITY THRIFT, AND WILL DO GOOD."
(REFERRING TO CHARLES II PRONOUNCEMENT REGARDING THE DEVELOPMENT OF A ROYAL MALE DRESS CODE, AS RECORDED IN S. PEPYS' DIARY, OCTOBER 7TH, 1666.)

THIS GESTURE AFFECTS THE NEXT HUNDRED YEARS OF SARTORIAL DECORUM. AT ITS CORE, IT PROCLAIMED A NEED TO RENOUNCE EXTRAVAGANCE (EFFEMINACY), AND DISTINGUISHED ROYALTY AS BOTH THE THRIFTIEST AND THE MOST RESPECTFULLY CONTAINED. SOBRIEOUS FASHION HISTORIANS CALL THIS *THE GREAT MASCULINE RENUNCIATION*. CONSPICUOUS CONSUMPTION BECOMES FEMINIZED AND INCONSPICUOUS CONSUMPTION BECOMES MASCULINE.

FOR THE NEXT 300 YEARS, THIS VEST, AND OTHER COMPONENTS OF THE SUIT, BECAME A GARMENT THAT WOULD HARDLY CHANGE IN ITS BASIC CONSTRUCTION OR MEANING. ALSO UNCHANGED WAS OUR UNDERSTANDING OF THESE VALUES OF MASCULINITY, AS THE HISTORIAN DAVID KUTCHKA NOTES: "THE ABSENCE OF DISPLAY DEPICTED AS VIRTUOUS—MODESTY AND PLAINNESS AS QUINTESSENTIALLY MASCULINE."

THAT WORD WHICH MEANS SMUGGLING ACROSS BORDERS, INCORPORATED HAS BEEN DEVOTED TO SLOWING DOWN CAPITALISM IN ORDER TO RECONSTRUCT THESE NOTIONS OF SARTORIAL DECORUM, AND IN DOING SO, TO PROCEED IN A WAY THAT WOULD CARESS AND REARRANGE THESE MODEST HISTORIES INTO SOMETHING JOYOUS AND REFRESHING. THE CORPORATION, AT THIS NEW PACE, DELICATELY BELABORS HISTORIES AND PLACES. THIS PROCEDURE AIMS TO CREATE A QUASI-*ACRITICAL* ENGAGEMENT (IN THIS WE MEAN TO SHIFT FROM THE REFLEX OF CRITIQUE TOWARD A NEW ENGAGEMENT WITH THAT OF INVENTION). TO BE WITH INSTITUTIONS, TO BORROW FROM OUR BIOLOGICAL WHOLE, TO FIND A WAY TO COEVOLVE THESE SYSTEMS—TO MUTUALLISTICALLY BE "FOR, OF, AND WITH THE WORLD."

THIS CORPORATION IMAGINES THAT A COEVOLUTIONARY STRATEGY COULD TAKE PLACE THROUGH A RE-FASHIONING OF MASCULINITY. THIS MASCULINIST GESTURE DARES TO COLLABORATE WITH A NEW SORT OF CONSUMPTION—RETOOLING THAT OF THE CONSPICUOUS VS. INCONSPICUOUS TO A "MULTIPLICITOUS CONSUMPTION." IN THIS WE HOPE TO "FOREVER REARRANGE" NOTIONS OF LABOR AND ALL THAT FALLS AWAY FROM THESE SURFACES.

THESE EXPERIMENTS ARE TAKING PLACE IN A PROVISIONAL MANNER. PART 2 OF THAT WORD WHICH MEANS SMUGGLING ACROSS BORDERS, INCORPORATED (MILDRED'S LANE, BEACH LAKE & THE CONTEMPORARY ARTS FORUM, SANTA BARBARA) PROPOSES THAT THESE BOUNDARIES THAT HAVE CONSUMED OUR VERY BEING SHOULD SLIP TOWARD AN OPENNESS, TO ALLOW THIS CORPORATION TO INTERSTITIALLY SQUAT AT THE INTERSECTION OF SOCIO-ECONOMY, ANTHROPOLOGY, TECHNOLOGY, CULTURE, AND SCIENCE. AND IN DOING SO, ALLOWING FOR THESE TRANSFORMATIONS INTO A FUTURE TO OCCUR.

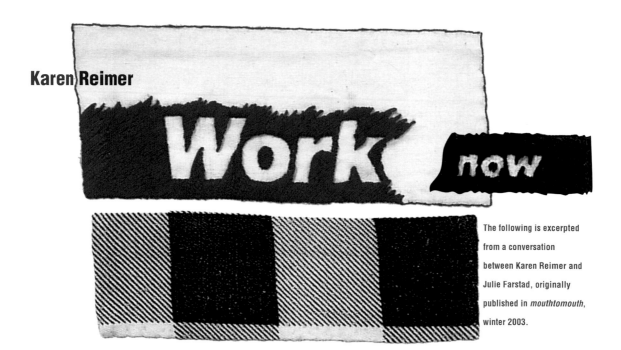

Karen Reimer

Work now

The following is excerpted from a conversation between Karen Reimer and Julie Farstad, originally published in *mouthtomouth*, winter 2003.

Julie Farstad: There's a sense of absurdity to sewing that I like—that determination to pursue this extreme, manual labor that others might find pointless.

Karen Reimer: I was raised to think that work is of value in and of itself, whether or not it has a product. This is another reason I'm interested in the whole concept of labor—I'm kind of a workaholic and I can't stop myself. So, within this work ethic, you work to make *yourself* valuable.

JF: I read that you're Mennonite, and I wanted to know if that has affected your work.

KR: I don't want to turn my family's religion into some sort of exotic Otherness, so I get sort of uncomfortable talking about this, but I do think that my upbringing taught me a somewhat intense work ethic. It was a moral requirement to work really hard, and you were valuable if you did. I think that came from the religion, although it may be much broader than just Mennonites—it's probably Protestants or Puritans, in general. It does affect your worldview; it informs your notions of morality. There's one little embroidery piece I did of a parking ticket stub that said "Violation Notice," and I always think of that as having intimations of morality—you've been given notice that you've violated, and you need to compensate by working really hard.

JF: Do you ascribe to the notion that "idle hands are the devil's workplace"?

KR: I wouldn't say that I *ascribe* to it. Rather, I'm trying to think about it—maybe get some distance on it somehow. That saying implies that if you don't keep busy, you will get into moral mischief. And somehow embroidery became this thing for women to do when they weren't doing anything else.

JF: So from a Mennonite perspective, are you being a good girl, or a bad girl?

KR: I don't know. I'm not that bad a girl, but what constitutes rebellion in that culture is so mild. This occurred to me when I was in graduate school at the University of Chicago. I was in this situation where maybe I was getting too educated, and I was already living in Chicago, so there was all this potential for wickedness in both those things. My parents were always very supportive of my being an artist though. They weren't image-burners at all. They don't know much about art, but they took the attitude that if I do it, it must be okay. I did find it was easier to talk about my work with them when I used something like embroidery or carpentry because we share those skills. It may have actually influenced my practice because I tend to make things with objects or techniques that don't belong strictly in the art world. Somehow, because it made it possible for my parents to enter it or understand it a little better, I came to think that maybe this was something that would work with other people, too.

JF: It's equal-opportunity art.

KR: I hope. One of the leftovers from high modernism is that people who aren't educated in art think they can't understand it, or they think that they're not supposed to. But I do hope, although I think it's maybe delusional, that using these kinds of techniques makes the work a little more accessible to nonart-world folk. I think I can also bring up class here because I realize that the reason my parents don't have the education to look at "high" art is class. My parents were poor—my father barely finished high school because he was working—and school was a luxury. So I think I have a lot of class hostility; in a way I feel allied to the class I was brought up in. If I can't actually be accessible, I want to at least be nonintimidating to what I see as my class, even though I know I've educated myself out of it.

JF: Your embroidery works seem to deal with the idea of information and what happens to information when it becomes transformed by your process. What is that transformation, as you see it?

KR: One of the points I want to make by using that process is that what you read is pretty much reliant on who you are and what's in your head already—what you already know. There's not some kind of pure information there. So if I make the language a little more iffy in terms of its legibility, you're forced to project your own sense into it. You're trying to read it and you don't know if you're *really* reading it. With the more illegible pages, they usually have some kind of word or phrase that you can actually make out—like a title—and that, I think, drives what you are likely to read in it. So it's about projecting meaning into something.

Awkwardness and Obscurity, *1999, embroidery, 7 7/8 x 5 1/4 in.*

Minimalism, *1998,*
embroidery, 7 1/8 x 4 7/8 in.
Collection of Linda Glass
and Jeff Mercer.

JF: Like when you're walking or driving down a street and glance at a sign, and half the time you think it says something it totally doesn't say.

KR: Yeah, that's definitely part of it. It's about subjectivity and objectivity. I would argue that there is no objectivity because nobody could achieve it. So I'm just trying to emphasize that and push it so you have to be aware of your subjectivity when you're reading something.

JF: Do you then exaggerate the role of the subjective to highlight the fact that you don't believe in objectivity?

KR: Yes, although I'm enacting my own experience, so what you really see is myself becoming unable to be objective. But I think there's no real subjectivity either. Both of them can be tools— ways of thinking about things—but they're always impure. You are incapable of being totally objective because you live in yourself, and you're incapable of being totally subjective because you share all your ways of making meaning culturally. You're a product of what you are taught, and of your language.

JF: Your work is changing now. You no longer copy every element of your sources. Now you pick and choose the words from the original that make it into your embroidery— there's this censorship or editing going on. How does that affect the work?

KR: The idea of taking something from the public realm and putting it in the personal realm has become a bigger issue. I'm pushing the language to shift its meaning to say what I see in it, instead of what it was intended to say. Newspapers put different kinds of language onto the same page—you have ads and news stories—and when I pick out words and force them to be read with each other across that language difference, something interesting happens. Somehow those different languages contaminate each other, and I think it reveals things. There's this one embroidery I did that has the sentence "We'll organize your whole house" repeated several times, which is from an ad, and it's juxtaposed with the word "Disappearance" from a news headline. For me, that juxtaposition spoke to the kind of creepy, coercive social agenda of the idea of "organization" or order—a lot has to disappear to achieve order.

Equal, *1999,*
embroidery, 2 1/2 x 1 3/8 in.
Collection of Linda Glass
and Jeff Mercer.

Helen Haejin Cho

Machine Dreams

The story I am about to tell you is "older than my body, my mother's, my grandmother's. For years we have been passing it on so that it may live, shift, and circulate, so that it may become larger than its proper measure, always larger than its own in-significance."[1]

Mother tells me, "long ago in Korea, when magical creatures were as common as cabbages, there lived *Hae-Nyos,* 'sea girls,' who dived deep into the waters to forage the sea floors." These girls could hold their breath for four to six minutes at a time.

I can hold my breath for one minute and twenty-three seconds.

I am four years old living in San Pedro, California. It is a warm summer day

and I am wearing a pale blue cotton dress sewn for me by Mother. Sitting on the grass in front of the Mariposa apartment complex, I smell the scent of lemon dishwashing liquid as I watch Father sponge down our little red Chevy hatchback. Something wet hits the back of my head, and as I turn around, the giggling boy and girl behind me pull their eyes taut. Father watches this, and then splashes the children with water. The children run off and later bring their father, a giant next to my own. I see Father falling into a bucket of soapy water and Mother running to call the police.

I draw in a deep breath and count . . . One. Two. Three.

It is three o'clock in the morning. Mother wakes me to feed me breakfast before she leaves for the garment factory. Warm rice and seaweed fill my stomach. I fall back asleep and, sometimes, I dream of the sea.

Four. Five. Six.

I am in the sixth grade and I go to Mother's factory to do homework after school. Sometimes, the women play hide-and-seek with me. Most of the time, I hide between rows of perfectly sealed dresses. I peek through and watch the women move their arms in perfect strokes across their machines. I imagine they are holding their breaths, too.

The artist's mother, Tae Ja, in 1973.

Mother can hold her breath for a lifetime.

I am twenty-three years old and attending my first year of graduate school in filmmaking. I am walking down the hall and a man says to me, "You better be careful or I'll have you deported back to China." I think, "I am an American citizen and I'm not even Chinese." But before words have a chance to form, numbness enters my throat and words fail to form. I do not trust this language. But, it is the only language I know.

I wonder how much longer I can hold my own breath.

Mother and Father can no longer compete with the imports from Korea or the illegal shops in Los Angeles. They declare bankruptcy. Only a week later, Mother continues her sewing from home.

Mother tells me that the "sea girls" dive even in the coldest days of winter.

It is the day of my first critique as a fine arts graduate student. I introduce myself and comment on the fragmented state of my work. One member of the panel says, "Fragmentation and dislocation seem to be the buzzwords of the day."

The film is bleached, sewn, cut, and repaired. The physical act of reconstructing this history is tactile and visible. Korean "breath-hold" diving women share space and time with the women in the sewing factory.

Helen Haejin Cho, still from Machine Dreams.

The soundtrack is of a woman drawing in a deep breath. Her inhalation is interrupted by a splash. The image of a factory materializes out of liquid. An empty chair padded with fabric scraps sits frozen, and three buoys float by. Images are interrupted. Almost impolite.

I smile and nod, my mouth opens to speak. Words trickle out of my mouth, but I am still unsure of what was said.

Seven. Eight. Nine.

I am told that my work's cultural specificity makes it difficult to understand. I am asked to consider a more global perspective to make my story more cohesive. I am asked why this work is not about all immigrant women and what my personal connection is to these garment workers.

The splices of the film are raw. The film reveals a history buried within the seams. The rhythmic sounds of machines and scissors match the rhythm of the frames. The movement of images outside the frame mimics fabric being pulled through a sewing machine.

Still frames suspend time, pans are stilted, and the splices are visible. The film is broken, painfully disrupted.

And for a moment a woman's hands run across a sewing machine in perfectly timed strokes. At twenty-four frames per second, the woman is almost real.

Helen Haejin Cho, still from Machine Dreams.

I try to form my lips to the shapes of sounds. I am uncomfortable in my words. I speak perfect English.

Ten. Eleven.

"I didn't speak English when we came to America. I learned to sew in a factory, then we opened our own factory. Most my life I felt shame that I sewed. I dreamed of being a painter," admits Mother. "There was no time for painting."

A fan coughs quietly in the corner. Rainbows sit in spools along the wall. As the steam clears, pink fabric spills to the floor.

Helen Haejin Cho, still from Machine Dreams.

"Now, I can see that I was given a second gift in life," says Mother. "Sewing is how we survived in America."

She gasps and air fills her lungs. I wonder if she was breathing the entire time.

The story becomes whole in its pieces. The story has traveled through time, space, and generations to be passed from mother to daughter. It is a story interrupted, told in translation, told in silence. This is a story of immigration, labor, cultural memory, and language from the perspective of a Korean-American woman's invisible labor and my relationship to it as a daughter and filmmaker. This story describes a longing for cultural connection to a history that exists where memory meets fiction, past meets present, silence meets speech.

With the absence of history or paradigms that speak to that which is feminine, Korean, American, and Other, I attempt to piece together a story lost in translation. At the intersections of U.S. labor and immigration policy, minority discourse, and cultural production lay a story of Korean-American women whose shifting identities do not conform to feminist, minority, or nationalistic narratives. Recovering the past through piecework speaks to the need to open spaces where choosing history is not complicit with suppressing identity.

I can hold my breath for one minute and twenty-three seconds.

Unraveling the history, politics, and language of the globalization of the garment industry has been a process of learning how cultural production intersects with the lives of Asian-American seamstresses in the United States. Recognizing that globalization makes it difficult to isolate specific locales and sites, this investigation examines where the immigrant seamstresses and their families encounter the social, political, and economic policies that perpetuate this underground economy and make reform difficult. Globalization in the U.S. garment industry is a clear illustration of the postmodern dilemma where labor, commodity, and laborer are dislocated. The complexities of the globalization of the garment industry force us to ask difficult questions concerning our cultural responsibility as citizens and consumers. These questions center on our complicity in the reproduction of material commodities as well as minority identities. Blind consumerism mimics patriotism in the sense that one must subordinate personal difference and responsibility for the promise of membership. American democracy is tied to the notion of equality among different constituencies. This ideology masks the very inequalities which persist for immigrant populations to whom it holds the promise of membership.

I draw in a deep breath and count . . . **One. Two. Three.**

Helen Haejin Cho, still from
Machine Dreams.

"Until the 1950s almost all of the nation's clothing was 'Made in the U.S.A.'"[2] In 1965, the relaxation of racially discriminatory quotas in America resulted in a significant increase in immigration from Asia, Latin America, Africa, and the Middle East.[3] These immigrants came from countries where labor paradigms no longer applied, and recourse was met with punishment. To improve the material conditions surrounding the garment industry, as well as worker lives in these countries, would have meant severe exclusion. "In Korea, organizing outside of the pro-government union federation is seen as a very radical act for which workers have been arrested, tortured and killed. In the People's Republic of China, although unions exist, they tend to support the party, government and management structure, and serve more of a social function . . . In Vietnam, unions are often seen as communist, and therefore bad."[4] To rise against unfair treatment as a collective would mean the rejection of citizenship and the loss of the American dream.

Four. Five. Six.

It is the winter of 1973 in Seoul, Korea. Mother packs our suitcases with a few photos, pots, and clothes. She leaves her paintings and brushes behind. I am one year old.

The artist's mother, Tae Ja, at the airport in Seoul, Korea, 1966.

"Historically, the labor force participation rate of Black, Latina, Asian, and/or immigrant women has run higher than that of white women." This trend "reflected the phenomenon that minority and immigrant men are not paid a 'family wage,' i.e., enough to support a family on a single salary."[5]

> **Mother can hold her breath for a lifetime.**

Father works as a high school custodian, tool and die maker, and machine operator. I make him peanut butter and jelly sandwiches for his lunch box every morning. He says they are delicious.

The artist with brother and mother in 1973.

> "Low wages and persistent patterns of occupational segregation make these families more dependent than ever on the work of female family members."[6]

Mother works in the garage sewing for subcontractors. Aunt Emo drops off fabric at the back door every Tuesday. She is not my real aunt, but I bow and thank her for the candy she brings on her visits.

> **I wonder how much longer I can hold my own breath.**

> "The influx of immigrants also reinvigorated the garment industry by generating a new wave of contractors. Just as sewing is the first job for many immigrant women, a sewing shop is the first business of many immigrant entrepreneurs."[7]

It is 1983. Mother and Father open their own garment factory in Los Angeles. They hire thirty-six women: thirty Asian, six Hispanic. After school, Father pays me $5 to write names neatly on the timecards: Elsa Sanchez, Maria Gonzalez, Sunny Lee . . .

> During the 1970s and 1980s, a provision in the U.S. tariff code called Item 807 permitted "U.S. firms to send cut pieces of fabric to be assembled 'offshore,' i.e., overseas, and then pay tariffs only on the 'value added,' which basically amounts to the cheap wages paid to foreign female workers."[8] This loophole led to the proliferation of export manufacturing plants called *maquiladoras* in Mexico.

Mother is proud that she pays her employees at least $4.25 an hour and ten cents per piece when they work overtime. Mrs. Kim only pays by the piece.

> "Between 1972 and 1988, national employment in the apparel industry dropped 23 percent, but grew by 56 percent in Los Angeles."[9] "During 1989 the volume of textile and apparel imports increased 13 percent. During the same period domestic employment fell 3 percent."[10] "Although the garment industry in the United States has suffered major job losses, Los Angeles' unique economic circumstances have led to a growth in jobs in this industry."[11]

Twenty of the employees in my parent's thirty-six-person shop are Latino and the rest are Korean. My mother's Spanish is better than her English.

> *Maquiladoras* in the garment and electronics assembly were "mainstays of Mexico's Border Industrialization Program (BIP) and the Caribbean Basin Initiative (CBI). Both the BIP and CBI were encouraged by the U.S. government to stimulate economic development so the countries could pay back their debts to U.S. banks, as well as bind their economies to U.S. markets."[12] Legally run shops in the United States. must compete with Third World wages paid to women overseas, as well as with illegal contract shops that pay women by the piece. Piecework is a variety of wage labor in which workers are paid per unit of production instead of by labor time.

Mother tells me that the "sea girls" dive even in the coldest days of winter.

This sale of labor is illegal in the United States. With only 800 Labor Department investigators nationwide to monitor all industries,[13] the practice of piecework proliferated in the United States to compete with overseas factories. Maria Echaveste of the Labor Department's Wage and Hour Division commented, "We know that every time we investigate contractors in California or New York, better than 50 percent of the time there are violations and usually it's better than 75 percent."[14]

My parents tell me they are losing money because they can no longer compete with the imports and illegal shops in Los Angeles.

In 1994, the Labor Department began to invoke the "hot goods" provision "to force manufacturers to monitor contractors for compliance with wage laws."[15] The provision monitored legal contractors, but could do little for the illegal contract sewing shops.

Mother brings home sashes with mistakes. She pays me ten cents per sash. I help pull apart Mother's mistakes, while she turns the sashes out.

Helen Haejin Cho, still from Machine Dreams.

Due to pressure from the North American Free Trade Agreement, or NAFTA, illegal shops mushroomed in the late 1980s due to global competitive pressures to cut costs.

Mother and Father declare bankruptcy. Mother sews in the garage and is paid by the piece.

America's workforce has become and continues to be increasingly female, minority, and immigrant due to the pyramid power structure of the garment industry. Unfamiliarity with American laws and systems of government, triple-day work schedules, family responsibilities, and the complex relationship between worker and employer, makes self-empowerment by the disenfranchised difficult. The pyramid structure of the garment industry maintains a power relationship that allows manufacturers to evade responsibility to the machine operators by using the contractors as a legal and personal buffer.[16] Although sewers only see the contractors as their employers, they do not report violations for fear of the Immigration and Naturalization Services (INS),[17] the unknown implication of joining a labor union, and their loyalty to their employer. The latter describes the complex paternalistic relationship that makes accountability difficult to determine. Jane Lii, a New York Times *reporter, wrote the following in 1995 about her one week in a New York factory:*

> *The owner was a former sewer. She does not pay minimum wage but she serves her workers tea. She makes them work until midnight, but she drives them home afterwards. She uses child laborers but she fusses over them, combing their ponytails, admiring their painted fingernails even hugging them. Ms. Zheng said she would love to pay her workers $4.25 an hour, the minimum wage, but as a subcontractor, she cannot afford to: the designers' middlemen do not pay her enough. The workers said they would love to earn minimum wage but would take what they could get. The children said it would be great to make their own money for their labor, but would be content to help increase their parents' earnings. Everyone quotes a Chinese saying: "The big fish prey on the little fish, the little fish in turn prey on the shrimp, and the shrimp can only eat dirt."[18]*

Seven. Eight. Nine.

It is difficult to locate accountability in an underground economy that is perpetuated by the slippery relationships between manufacturer, contractor,

1. Trinh T. Minh-Ha, *Woman, Native, Other: Writing Postcoloniality and Feminism* (Bloomington: Indiana University Press, 1989), p. 1.

2. Miriam Ching Louie, "Immigrant Asian Women in Bay Area Garment Sweatshops: 'After Sewing, Laundry, Cleaning and Cooking, I Have No Breath Left to Sing,'" *Amerasia Journal,* 18, no. 1 (1992), p. 2.

3. Ibid., p. 5.

4. Ibid., p. 16.

5. Ibid., p. 5.

6. Ibid.

7. Ibid.

8. Ibid, p. 3.

9. Richard Kim, Kane K. Nakamura, and Gisele Fong, "A Preliminary Investigation: Asian Immigrant Women Garment Workers in Los Angeles," *Amerasia Journal*, 18, no. 1 (1992), p. 71.

10. Louie, "Immigrant Asian Women in Bay Area Garment Sweatshops," p. 3.

11. Kim, op. cit., p. 71.

12. Louie, op. cit., p. 4.

13. The number of investigators in the U.S. Department of Labor Wage and Hour Division dropped from 921 in fiscal year 1975 to 788 in fiscal year 2004. Annette Bernhardt and Siobhán McGrath, "Trends in Wage and Hour Enforcement by the U.S. Department of Labor, 1975-2004," Brennan Center for Justice *Economic Policy Brief*, no. 3 (September 2005).

14. Joanna Ramey, "U.S. Maps Crackdown on Contractor Violations," *Women's Wear Daily*, March 2, 1994, p. 18.

15. Ibid.

16. Louie, "Immigrant Asian Women in Bay Area Garment Sweatshops," p. 7.

17. In March 2003, the United States Immigration and Naturalization Service was abolished. The newly created U.S. Immigration and Customs Enforcement, a part of the U.S. Department of Homeland Security, took over its investigative and enforcement functions.

18. Jane H. Lii, "Week in Sweatshop Reveals Grim Conspiracy of the Poor," *The New York Times*, section 1, March 12, 1995, p. 1.

19. Jeffery A. Trachtenberg, "My daughter, she will speak better," *Forbes*, October 6, 1986, pp. 68-72.

20. Homi K. Bhaba, "Signs Taken for Wonders," in Bill Ashcroft, Gareth Griffiths, and Helen Tiffin, eds., *The Post-Colonial Studies Reader* (New York: Routledge, 1995), p. 34.

Can You See Us Now?
¿Ya Nos Pueden Ver?

a project by subRosa

SubRosa's installation,
Can You See Us Now?
¿Ya Nos Pueden Ver?
at the Massachusetts Museum of Contemporary Art (MASS MoCA) attempted to map the often invisible intersections of women's material and affective labor in cultures of production (and production of cultures) in North Adams, MA, and Ciudad Juárez, Mexico.

What are the economic, cultural, and everyday life effects of the outsourcing of labor and globalization on towns like North Adams and Ciudad Juárez? Processes of global change are manifested locally where specific forces come together to shape the conditions of life. subRosa discovered that many aspects of the labor conditions and daily lives of women in North Adams resonated intimately with those of women in Ciudad Juárez.

In the museum installation, oversized map pins on large aerial photographs of North Adams and Ciudad Juárez denoted "points of visibility"—usually places of refuge or exploitation—in the two cities. A "forensic floor" concealed a dozen spaces beneath its weathered wooden surface. Visitors became active investigators as they discovered the objects, texts, and clues beneath the loose floorboards and made connections between the histories and present-day lived experiences of women working in both cities. Ephemera and interpretive artifacts documented women's struggles and resistance—from union organizing to subversive eavesdropping and the role of hairdressers as a gateway to refuge. Five posters (from a collection of sixty) by Mexican graphic artists expressed concern and outrage about the continuing murders and disappearances of Mexican women—many of them **maquiladora** (factory) workers in Ciudad Juárez—over the past decade.[1] A large pamphlet that unfolded like a road map provided texts, images, and bibliographical information that further explored the themes of the installation.

In MASS MoCA's front lobby, subRosa installed another work. A large dymaxion map with scissors tethered alongside invited museum visitors to trim off the tags from their own clothing and pin them to the map at the geographical point of manufacture or assembly for that article of clothing. Thus visitors actively explored and demonstrated their own participation and complicity in globalized labor conditions. Their participation in this simple action provided a multilayered geography lesson, as many of the most common assembly zones are in countries that have changed names frequently or have been de-/re-annexed as the forces of globalization and free trade have swept across their territories. Thick clusters of tags piled up anywhere the International Monetary Fund or other capitalist colonizing forces have traveled. The territories of "First World" nations such as the USA, Canada, and Western European Union member countries remained largely free of the tags, which typically represent oppressive labor conditions that mostly affect women and children.

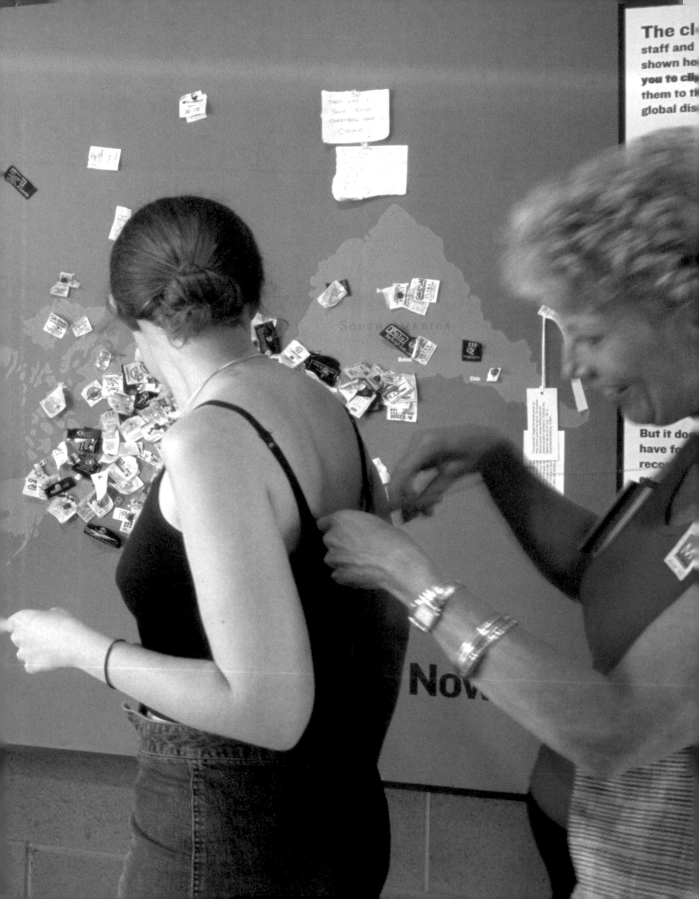

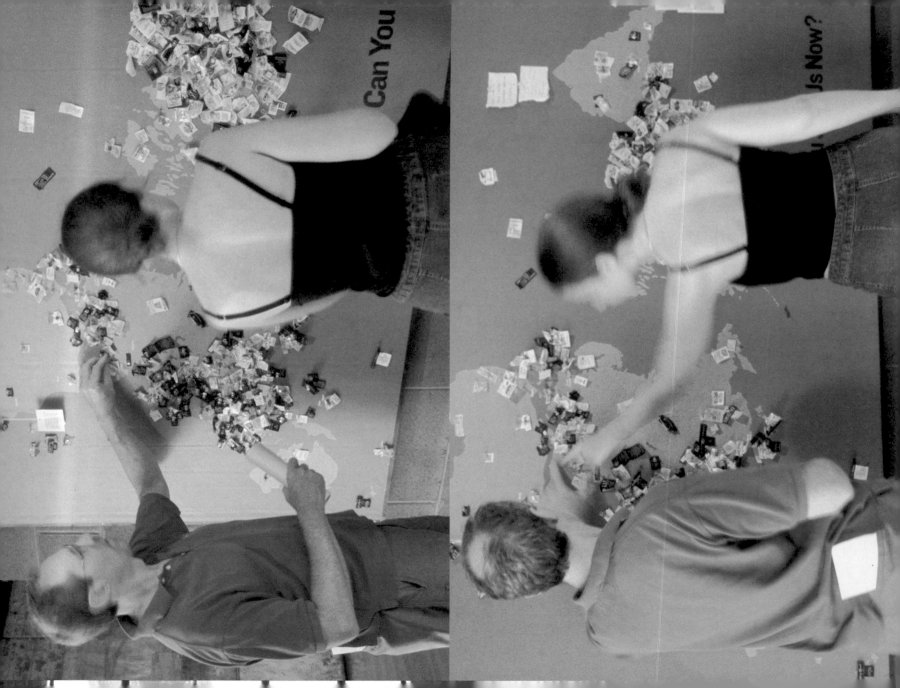

notes & credits

Can You See Us Now? ¿Ya Nos Pueden Ver? was created by subRosa for the exhibition "The Interventionists: Art in the Social Sphere," curated by Nato Thompson at the Massachusetts Museum of Contemporary Art, May 2004-April 2005.

subRosa's project was supported by a generous grant from the Creative Capital Foundation, NY. Special thanks to Smith College student collaborators, and Professors Lisa Armstrong and Donna Riley. Thanks also to Dale Waterman and the Western Gateway Heritage State Park, Ed Morandi, the Elizabeth Freeman Center, Gene Carlson and the North Adams Museum of History and Science, Joe Manning, Kathy Keeser and the Northern Berkshire Community Coalition, Larry Smallwood, the National Labor Committee, Professor Bob Foster and students at the University of Rochester, Professor Maynard Seider, Nato Thompson, Richard Criddle, and the Women's House of Peace.

1 The posters by Mexican artists were loaned for the exhibition by The Center for the Study of Political Graphics, Los Angeles, CA. The three shown in the gatefold spread were designed by Eduardo Barreda, Iris Salgado, and Ana Maria Iturbe.

Photography by Arthur Evans; last two images on this page by subRosa.

Margo Mensing

LACE CURTAINS FOR TROY

Troy, New York, has two claims to history. It is the birthplace of Uncle Sam and of the detachable collar. Invented in 1837, the detachable collar is merely a footnote to the history of textiles, but for eighty years the manufacture of these collars put this city on the map. Collar factories, and later shirt factories, fed, clothed, and housed most of Troy from the 1850s through the 1920s. The largest of the factories, Cluett Brothers and Company, still stands, but it is currently a real estate venture not a manufacturing site. No longer home to the hum of sewing machines and the hiss of irons, it is now subdivided into office spaces and productivity is measured in electronic transfer of information.

While textile manufacturing has shrunk to next to nothing in Troy, art is a burgeoning industry. Although the Rensselaer County Center for the Arts had been an active community site for thirty years, its regional importance accelerated in the late 1990s with the award of a large state grant. This funding and the purchase of several nineteenth-century retail stores enabled the newly renamed Arts Center of the Capital Region to move into spacious new quarters on River Street, downtown Troy's main street.

In January 2000, the Arts Center unveiled its new space at its inaugural exhibition *Showroom*. The title capitalized on the past commercial importance of this building complex as a furniture showroom. Twenty-three artists were invited to send works or create installations in keeping with the idea of display. As one of the invited artists, I chose to make an installation commemorating the detachable collar.

My first step was to research the history of the detachable collar and the shirt industry at the Rensselaer County Historical Society. The archive is rich with newspaper clippings, collar and shirt company sales catalogues, wood patterns for cutting the collars, and tiny boxes with miniature collars that salesmen showed to potential customers. For a month, I lost myself in this history. I surfaced with one collar pattern that I copied for the installation collars and transformed into curtains for the second-story windows of the Arts Center. I did not make the collars because I found someone who could cut and sew them more efficiently than I could. Although his presence was never manifest in the collar installation, it is the story of Chris Rielly, maker of the 266 detachable collars for my installation that I would like to tell. His story is typical of the textile industry at the turn of the twenty-first century and is embedded in the history of textile manufacturing in this part of the country.

Rielly's world is quite distant from the time when detachable collars supported Troy. He works in a small factory in Chatham, a half-hour drive southeast of the city. He calls himself a sewing contractor, a maker of other people's designs. He claims no vested interest in the goods that flow through his plant, or the plant itself, and owns nothing but his equipment, machines from the heyday of Rielly & Company, his father's business. In 1995 when Chris Rielly incorporated the bankrupt firm, his lawyer told him to come up with a new name. He called it PABKA, an acronym he grafted from his three daughters' names.

PABKA, INC.

My first encounter with Rielly was not about detachable collars, but the purchase of a sewing machine. As the head of the fibers area in the Department of Art and Art History at Skidmore College, New York, I was looking for an industrial sewing machine for the fibers studio. I found out about Rielly through Tommy Hinman, owner of Nice Hat, in Saratoga Springs. He mentioned he knew someone anxious to sell used sewing machines. Hinman designs, makes, and markets fanciful polar fleece hats, mostly for children. He makes his living wholesale, mainly at trade shows, but he adds to his income by selling out of his small retail outlet next door to his workroom.

At the PABKA factory in Chatham, New York, Chris Rielly cuts stacked polar fleece to sew children's hats for the Nice Hat company.

In the mid-1990s, Hinman made a few hats in the shapes of rabbits and moose, and the business took off. An artist with an MFA in sculpture and no textile experience, Hinman, like Rielly, operates with little capital. His equipment needs are minimal, a couple of sewing and cutting machines. He sometimes subcontracts hats to PABKA. He also uses space at the Chatham factory. During his busy season, he drives the hour and a half from Saratoga Springs a couple of days a week to use the twenty-foot cutting tables at PABKA. In one day he can cut more cloth than he could in a week at his cramped place.

At first glance, PABKA and Nice Hat appear to be twin success stories, small businesses that produce a single line of goods. They also demonstrate one dimension of what has happened to the garment trade since the decline of big factories in the northeast United States: little firms, owner operated, ply a single ticket item through an established marketing chain or through the craft and trade fair circuit. However, in reality, there is little similarity between Nice Hat and PABKA.

I met Rielly right after the Art Department purchased the sewing machine, and he came to Skidmore to give me a sewing lesson. He arrived with his youngest daughter on a sunny September afternoon. She soon settled down with her color crayons and paper and my lesson began. The machine was in perfect running order and it was easy to learn how to operate it. I had no familiarity with time-saving devices on industrial machines. The undercutter, a magic blade that severed both threads every time the pressure foot was raised, amazed me. A sewing machine with an undercutter

was nothing special to Rielly; PABKA owned plenty of them. He said he bought used machines in any condition from the many old factories going out of business, rebuilt them, kept the occasional one he needed, and sold off the remainder to cover his acquisitions. He found the Mitsubishi with three others in nearby Gloversville, once the capital of U.S. glove manufacturing. He added that he sold many of the machines that once filled his own factory. PABKA had no need for specialized machines, such as collar turners.

I imagined PABKA as a thriving business tucked in a tiny town in eastern New York. Rielly set my fantasies straight—PABKA was, he remarked, about to go under. A few more months and he would be out of business.

BLOOMERS, KNITS, AND BIG BUSINESS

The firm started in 1917 as Manny & Rielly. Chris Rielly's grandfather, Joseph Rielly, and his partner, Raymond Manny, made a fortune making bloomers. This is, perhaps, an overstatement. The firm certainly did well; it provided an income for the Rielly family's comfortable lifestyle in Forest Hills, New York.

Bloomers had been around since 1848, when Amelia Bloomer, a member of the Seneca Falls women's rights and temperance movement, wore a pair of loose fitting pants over her long skirt. This declaration of women's equality was also a practical garment allowing greater freedom of movement. Soon bloomers began to be worn under rather than over skirts. Many firms began manufacturing them, but Manny & Rielly was the firm that patented the name bloomers in the 1920s. The second reason Manny & Rielly gained the major share of the bloomers market was their fabric— comfortable knit jersey instead of traditional cotton sheeting.

The partners' first textile venture had been to sew cotton cuffs to work gloves. Rielly and Manny won a carload of rolls and rolls of tubular knitting in a poker game. They cut the knitted tubes into short lengths and attached them to readymade gloves. Cuffed work gloves soon caught on. When the serendipitous original carload was gone, they decided to buy knitting machines to produce their own material. Once they could manufacture their own fabric, they simply adapted jersey knit to fit the market. Bloomers were a logical next step. When bloomers fell out of fashion in the late 1920s, boys' t-shirts emerged. The knit underwear business gave way to knit sportswear. This quick listing summarizes four decades of textile production, but it wasn't that easy or that linear. From the beginning, however, knit jersey was the keystone of the Rielly textile business.

In the 1930s, Joseph Rielly bought out his partner and renamed the firm Rielly & Company. The U.S. government awarded a contract to the

company during World War II to make t-shirts for the army and navy. Gerard Rielly, Chris's father, began to work in the family firm when he returned from the war. Gerard Rielly had never imagined the family firm as his calling but, like his father, he had a real affinity for sales. He too was good at getting the goods to market. However, the industrial map had shifted decidedly in the 1950s. Joseph Rielly had traversed New England to keep Rielly & Company in bloomers and t-shirt orders, but the younger Rielly had to travel the whole east coast.

While the elder Rielly had leased factories, concentrating on machines and goods, Gerard Rielly added real estate. Sometimes he would lease a building but often he would buy it. The business continued to expand, as far as Bristol, Tennessee. By the end of the 1950s, the business operated factories in New York, Vermont, North Carolina, and Tennessee, but the bulk of the manufacturing was contracted to factories in the South. Gerard Rielly spent almost every week in Charlotte, North Carolina.

The business expanded, but it also experienced financial shortfalls. The cost of producing knit jersey had escalated markedly. Rielly & Company had never finished its knit cotton jersey, but sent it out to be dyed, shrunk, and sized. When these costs spiraled in the late 1950s, many textile firms consolidated or went out of business. Rielly's solution was to stop knitting fabric and, instead, purchase it and convert the business solely to contract sewing.

When his father died in 1960, Gerard Rielly found himself the head of a very different enterprise than the one his father had owned. When the Bristol factory burned down a short time later, he made his second move to consolidate, this one geographic. The original factory in Valatie, New York, which he had never been able to purchase, went on the market. He bought it, sold everything outside New York, and ended the commuting life. In 1963, the Rielly family moved from suburban Forest Hills to Kinderhook, a small town just a few miles from Valatie. During the 1970s and 1980s, Rielly & Company continued to sew men's, women's, and children's knit sportswear for Sears, Roebuck and Company and other big department stores, but the scale of operations was greatly diminished from the peak production of the 1920s and 1950s. By the early 1990s when recession set in, the business was reduced to the two factories in Chatham and Valatie.

ULTRACOOL VENTILATING UNDERGARMENTS

Chris Rielly grew up in Kinderhook in the 1970s and spent most of his summers and after school hours working at his dad's Chatham plant. Predictably his first job was custodial. He worked cleanup, sweeping up the

scraps of sixty sewers. He hated it and gladly went off to college believing he
had left that life behind. When he graduated in the early 1980s, he started
to work in a textile plant in North Carolina and realized he liked the busi-
ness. He came home to the Chatham plant and worked with his father. But
it was not a propitious moment; one contract after another was disappear-
ing. New contracts were not in the offing. The employee roll had shrunk
considerably and sweeping up wasn't the onerous task it once was.

When Rielly & Company folded in 1995 and Chris Rielly restarted the
business as PABKA, Inc., he was sure about one thing: he did not want to
be an entrepreneur. He had watched his father get caught in the snarl of real
estate and left with bolts of unused goods. Sewing machines were all he
wanted to own. PABKA emerged as a business with practically no capital.
The bedrock Valatie factory was gone. Even the Chatham factory had been
sold, and Rielly rented space in it from the new landlord. He owned no
inventory; he required his contractors to supply all goods, everything but
the thread. The payroll was slim, employing only four sewers.

At the time of its demise, Rielly & Company's most profitable contract
was the Ultracool Ventilating Undergarment. Worn under soft body armor,
such as the bulletproof vest, this polyester mesh undershirt has vertical ribs
in the front and back. These ribs make the garment unique; they push the
nonbreathing bulletproof vest away from the chest and provide air circula-
tion. Until recently, the Ultracool Ventilating Undergarment supplied a large
international market. Protected by an excellent patent, it survived as a rare
example of a product not undercut by offshore manufacture.

A sewer at PABKA completes
work on an Ultracool
Ventilating Undergarment.

Chris Rielly had won this contract for his father's firm. He had figured out a practical way to sew multiple ribs into the shirt. Hanging around sewing machines as a teenager, he taught himself how to rebuild them. He then modified an old sewing machine to wrap and sew all the ribs of cotton piping to the polyester mesh in one step.

The day I first met Rielly, he remarked that he was having a tough time making ends meet. Later I started going to Chatham to work with him on the detachable collars, and I could see the evidence. Inventory had run far ahead of orders. Boxes and boxes of cellophane wrapped Ultracool Ventilating Undergarments were headed for a warehouse to be sold at cut rate.

When he had PABKA, he hoped this one contract would sustain him until new contracts and new garments emerged. The cold facts were that only a few nibbles appeared. He had plenty of ideas for new products, ski jackets and children's clothing made from polar fleece. Even Santa Claus suits surfaced as a trial balloon. He made a couple out of gorgeous velvet with plush white curly trim. He had dreamed up this fanciful niche item with Hinman, but they found there were no buyers for high-end Santa Claus suits.

The cloth trade has always gone up and down, dependent not only on the vagaries of fashion, but also on who can make what most efficiently and where. For 100 years, the geography that suited these requirements was the northeastern United States. Bloomers and undergarments for bulletproof vests made the Rielly family a part of this history. With almost all garments now produced offshore, little firms like Nice Hat and PABKA contribute a share to the "Made in U.S.A." label.

Finished Ultracool Ventilating Undergarments ready for shipping.

COLLAR CITY

Strategically located 160 miles north of New York City on the Hudson River, Troy dominated industry and commerce in eastern New York state.

Troy is still called Collar City, named after the manufacturing enterprise that supported the city between 1860 and 1929. The detachable collar is a curious piece of clothing, neither garment nor accessory. Like the Ultracool Ventilating Undergarment, the detachable collar is nothing without the shirt for support. Yet unlike underwear, the detachable collar was meant to be seen. It signaled the wearer's social status and from this derives the phrase "white-collar worker."

When Hannah Lord Montague invented the detachable collar in Troy in 1827, laundry consumed much of a woman's week. Hours and hours of a woman's time were spent over tubs of scalding water, followed by many irons in the fire to press the shirts into stiff perfection. A husband's shirts were a good share of this work. Her grand idea occurred the day she cut the collar off a shirt and attached tapes to both ends of the collar. She could then launder and tie the collar to any collarless shirt, especially shirts that had already seen more than a day's wear.

The first manufactured collars were neither stylish nor special. They were unlined, unwashed, and unstarched. Women sewed collars at home as piece goods peddled on the street by merchants. Montague's husband, Orlando, didn't like seeing his neighbors profit from his wife's clever but unpatented idea. With a partner, he opened the first firm to make and market collars.

Reilly & Company factory in Valatie, New York, no longer a sewing manufacturing enterprise.

He was an ironmonger, an occupation that was as important to Troy's economy as collar production. His trade fitted him to adapt machines for collar production. He stamped the collars and packaged them in boxes, creating efficient distribution and a way to market them to the trade.[1]

In the 1840s, collar factories sprang up all over Troy. With the invention of the sewing machine in 1850, the collar industry ignited. Jefferson

1. See the exhibition catalogue, *The Arrow Man: Collar City Chic* (Troy, NY: New York State Arts Council, 1987). Gayle Johnson organized the exhibition for Russell Sage College Gallery in Troy, New York. Two catalogue essays discuss Troy's collar and shirt fame. James Morske's "And it all began with one woman," provides the history of the collar industry. Ken Johnson writes an accompanying essay on the illustrator J. C. Leyendecker who popularized the Arrow Shirt Man.

Gardner bought a sewing machine for his business, and his production rose 500 percent. Within four years, steam-driven machines replaced foot-driven ones, and buttons and buttonholes soon replaced tapes to attach the collar to the shirt.

Laundering and starching were so critical to the final appearance of the collar that the collar factories incorporated the process into the manufacturing. Initially the laundries operated as separate establishments. Horace Greeley reported in 1873 that:

> laundresses toiled in independently owned laundries or in the laundering departments of large collar factories. Like many nineteenth-century industrial workers, collar women labored for long hours under trying conditions. Laundresses' working conditions were especially harsh. Washers worked with boiling water, starchers had to contend with caustic starches and potentially dangerous detergents, and ironers handled hot, heavy irons.[2]

2. Horace Greeley, et. al., *Great Industries of the United States* (Hartford, CT: J. B. Burr and Hyde, 1873), pp. 614-15.

No longer a cottage industry, Troy sprouted big factories along River Street and north into Lansingsburgh. One of the most sizable firms was George B. Cluett, Brothers & Company, established in 1863. This firm grew, as did several others, by consolidating the process. Collar factories were "giant integrated places that produced a single finished product from beginning to end within a space especially designed for the purpose."[3] The women who worked there lived nearby, creating a mix of industry, commerce, and residence in the River Street neighborhood.

3. Morske, "And it all began with one woman," p. 7.

By the 1880s, the number of collar manufacturers reached thirty-three. The making of a collar required multiple sewing steps. In 1862, button sewing machines were invented and, by 1875, buttonhole machines were added to the factories. While such labor-saving machines reduced human hours, new styles multiplied the types of production needed and called for more employees to produce them. By the end of the century, the invention of the turning machine made for quicker, crisper collar points. More and more factory start-ups jumped into the business and soon produced excess. Consolidation was the inevitable result. Cluett merged several companies into Cluett, Peabody & Company in 1898.

In the process, the firm picked up a relatively unknown trademark, the Arrow collar. Before 1900, collars were linen, but the Arrow collar was cotton, something quite radical. The appeal of this cotton collar was its comfort. Initially, the cotton collar was disparaged because it could not maintain that fine crisp shape that linen provided. During the war, collar companies manufactured cotton collar and shirts as a single garment when the army ordered them for government issue.

However, shirts with attached collars could not compete with the detachable collar until shrinkage could be controlled. Cluett, Peabody & Company again played a role in textile manufacturing change. Sanford Cluett invented a machine that balanced the pulling action that occurred during manufacture with a pushing counteraction, and patented it as sanforizing. For a few years after the First World War, detachable collars held the market edge. They reached their peak in 1923 when 15,000 workers made collars valued at over $43 million. By the end of the 1920s, detachable collars were out of style, and disappeared completely when the Depression set in.[4]

4. Ibid., p. 9.

LACE CURTAINS FOR TROY: COLLAR CITY AT THE MILLENNIUM

When I read the history of Troy's garment manufacturing, I came to appreciate that Troy was not just Collar City. The evolution of men's dress shirts occurred here, from the detachable collar to the sanforized Arrow shirt. But the detachable collar, not the shirt, stood out in my mind as the object to reconstruct. Not only did it symbolize the city's former and foremost textile industry, but also stiff, starched collars could be assembled to create sharp lines and a simple pattern in the second-story windows of the Arts Center. However, I wanted my installation to acknowledge the present as well as the past. Therefore, I decided on two kinds of collars to create two curtain patterns in the windows. The first curtain type was made from detachable collars. The collar itself was replicated from a 1923 detachable collar, the Sherwood, which I found in a sales catalogue at the Historical Society. These collar columns covered seven windows, four in one room and three in the adjacent room. The second kind of collars I made was t-shirt collars. Not only is the detachable collar a thing of the past, but even the dress shirt is on the decline, so I chose the most ubiquitous shirttail today, the t-shirt. The t-shirt collars were stitched into a lacelike web and hung in the two large bay windows.

I planned to cut up used white t-shirts to salvage the neckbands, but I soon realized the futility of this. Rielly had a better idea. At the PABKA

Margo Mensing, Installation view of Lace Curtains for Troy: Collar City at the Millennium, *2002, 16 x 8 ft. T-shirt collars made into machine lace filled two bay windows of the newly renovated Arts Center.*

Margo Mensing, Lace Curtains for Troy *(detail).*

factory were rolls of readymade knit, a trial product for the Ultracool Ventilating Undergarments. He offered to sell me the fabric at cost. I cut the knit bands into twelve-inch strips and sewed them into rings. Then I embedded the rings in sheets of vinyl that dissolve in water.

I needed to make a sizable sweep of curtains, eight panels, each eight feet by four feet. Each panel required over fifty t-shirt collar rings. Sewing the rings together by stitching back and forth, over and over on the dissolvable sheeting, I soon realized the value of the undercutter. I moved my work to Skidmore's fiber studio to sew on the industrial Mitsubishi. It trimmed hours from the sewing. I also benefited from sewing help. Kelly MacLaury, my student intern, was skilled and quick, and she developed distinctive floral patterns as she stitched over and over the vinyl sheeting connecting the t-rings into machine lace. When I immersed each curtain panel in water, the vinyl dissolved into slithering jello and disappeared completely as it ran down the drain.

At the same time that I was sewing the knit bands into rings to make the lace-curtain panels, PABKA was making the detachable collars for the collar columns. When I measured and found that four of the windows were over twelve feet tall and that the other three were eight feet tall, I realized the time it would take me to sew enough collars. I asked Rielly if he would be willing to make collars. He agreed and set the unit price at $5.25, barely in the profit range. He instructed me to find the fabric and all other materials, but his generosity played a bigger part than his desire to make a profit. The fabric find was easy, but 200 buttons proved difficult. He had a stash of fine pearl buttons perfect for buttoning the Sherwood collars and gave them to me.

In January when I had finished hanging the columns of collars in the windows of the Arts Center, they registered clearly Troy's nickname: Collar City. However, the link to the history of a local textile firm, originally Rielly & Company and now PABKA, was not visible. Yet this story, the one that underlies the history of this region, is told here.

Beginning in the 1830s, the reform dress movement popularized loose garments and the unlaced body. Bloomers and collars were part of this shift to increased mobility and a more active life, for social reasons as well as for health ones. Modernity and mobility went together.[5]

5. See Mark Wigley, *White Walls, Designer Dresses* (Cambridge, MA: MIT Press, 1995), for a persuasive study of the influence of white in creating the modernist ideal of sleek cleanliness. Here Wigley relates modernist architecture to clothing.

Montague's invention of the detachable collar coincided with the shift to looser fitting and comfortable clothes. Yet the detachable collar only partially fulfilled the new ideal of comfort and freedom. It signaled social mobility more than actual mobility. The white-collar worker was a man who had achieved a particular status, an office worker rather than a factory laborer. However, the starched stiff collar chafed. In the 1920s, the switch to comfortable sanforized shirts with attached collars paralleled the popularity of bloomers. Women had bloomers, their own fashion statement, that likewise exercised freedom of movement.

The Ultracool Ventilating Undergarment is also about comfort; it helps keep the wearer of a bulletproof vest cool. They are also a fashion statement, part of a culture of surveillance. The market seemingly aims at law enforcement or military personnel, but those on the other side of the law or those who carry weapons as their right to self-protection also purchase bulletproof vests. Like collars and bloomers, bulletproof vests epitomize a moment in time, a moment that reveals clothing is more than fashion. Clothes and accessories unveil how a particular society constructs social codes. Bloomers and detachable collars, meant to be seen, offered greater freedom, though such collars could never be claimed comfortable. On the other hand, bulletproof vests, not meant to be seen, offer personal security. Protective armor is not new, but the bulletproof vest introduces a new slant. Because they are inner garments, the market for bulletproof vests plays to individuals operating in the public domain that either must or desire to arm themselves against real or imagined threat. While actual street violence has been greater at various times in the U.S.'s past, the culture of self-protection and surveillance is much greater today.

THE ARTS CENTER OF THE CAPITAL REGION: *SHOWROOM*

The new River Street home for The Arts Center of the Capital Region opened January 1, 2000. During the November and December before, PABKA sewers made Sherwood collars while producing their quota of Ultracool Ventilating Undergarments. At the same time, construction on the new Arts Center progressed quickly. In the mid-1990s, state and local agencies had allocated almost a half million dollars to fund the renovation and revitalization of the city's commercial core. First was the fortuitous purchase of five attached brick buildings to be gutted for a single interior. The architect's design retained each building's unique façade. The exterior paint colors, deep grays to warm mustards and reds, kept the character of each building yet unified all five.

The renovation of the interior was another matter. It called for complete structural change. The nonconforming heights of the buildings necessitated new floors, ramped to join the once separate buildings into a single interior. The main entrance was remade to open into a two-story space with a grand staircase leading to classrooms and studios for painting, drawing, jewelry, and metals. While the old building had provided studio opportunities for children and adults, the new building markedly expanded the program. Dance, culinary arts, ceramics, and paper making studios were added, as well as a black box performance space, and a studio and housing for visiting artists. The large enclosed gallery on the first floor provided ample space for exhibitions, but it was meant to be only one facet of an art center planned for multipurpose use.

Interior view of the painting studio windows with collar columns, part of installation Lace Curtains for Troy.

Close-up interior view of windows with collar columns, part of installation Lace Curtains for Troy.

Planning for the opening celebration began over a year before the January 2000 date with the selection of Ian Berry (at the time the assistant curator at the Museum, Williams College, Massachusetts), as curator for the inaugural exhibition. He had grown up in Delmar, a southern suburb of Albany. His Saturdays often focused on shopping trips to downtown Troy. This part of downtown was lined with home furnishings showrooms and stores; a huge Standard Furniture sign marked the big store that once occupied one of the buildings later converted into the Arts Center.

Berry titled the show *Showroom* to purposefully allude to the building's past. However, he had no desire to historicize the building or to display artifacts or memorabilia. Instead, the show focused on display as an act in itself. Certainly display is an issue common in contemporary art, often bound up with ironic takes on visual culture. For *Showroom*, Berry invited local, regional, and national artists whose work was linked to this idea.

Two works, my *Lace Curtains for Troy: Collar City at the Millennium* and Théodore Coulome and Alan Krathaus's *I WANT*, commented on the history of Troy, and were the only works in the exhibition made for the building's new façade. Coulome and Krathaus's banner displayed the familiar face of Uncle Sam and the words "I WANT." Missing was the "YOU." In its place were two barcodes, one with the numbers "01010," which corresponded to the date, January 1, 2000. The other number, "041917," commemorated the birth of Uncle Sam, during a time of marked patriotism. In the original, Uncle Sam's iconic presence called for a patriotic response for military volunteers, but more broadly a response from all citizens. YOU was the reason for WANT. Coulome and Krathaus's omission of YOU changes who to an

enigmatic what. What is wanted is not specified, only the state of wanting, an unnamed desire, pointing to commodities and consumerism through the artists' use of the barcodes. The face and words of Uncle Sam were more than a link to the history of Troy. The absence of YOU implicated Uncle Sam, and by implication the entire nation. For in making the icon just another consumer, along with the rest of the populace, Uncle Sam became part of the dilemma, another consumer.

Théodore Coulome and Alan Krathaus, I WANT, *2000, scotch print digital output on vinyl, 180 x 84 in. Displayed on Arts Center façade in* Showroom.

Obliquely, *I WANT* charted change in the compositions of downtowns throughout the United States from mixed use, industrial, commercial, and residential to predominately commercial. Residential use is presently coming back to downtowns, but industry has departed. This is not a condemnation but rather a recognition that the visual and performing arts have supplanted a moribund industrial climate. The granddaughters and grandsons of the collar sewers and ironers are the students, teachers, artists, and administrators of the new Arts Center. The new Arts Center did aid in the revivification of downtown Troy. The grand celebration, including the opening of *Showroom*, was a greater success than the planners dreamed. Over 5,000 visitors came to see the new building, facilities, and exhibitions on that first weekend. Classes have continued to fill and provocative exhibitions are mounted. Today in Troy and elsewhere, the business of art is an important component generating income in the business of running cities and towns.

Nostalgia beckons not only with images of Uncle Sam but also with visions of laborers sweating in factories earning livelihoods that will enable them to rise from harsh conditions, move out of the urban core, buy a house, and come downtown to shop. When the commercial core crumbled and shopping shipped out to the suburbs as well, cities had to find new ways to make downtown real estate work. In the new commerce, the art machine is one model that is helping to fill the gap. PABKA, a part of the history of the rise and fall of the textile industry in the northeast, is its own unique story, the legacy of a modest family enterprise rather than an exemplary tale of the scions of American industrial enterprise.

Notes on Damask, Notes on Luxury

"There seems to be no difference of opinion about the origin of the word *damask*. The fabrics originally so-called undoubtedly took their name from the ancient city of Damascus in Syria."

Irene Emery, *The Primary Structures of Fabrics: An Illustrated Classification* (Washington D.C.: The Textile Museum, 1996), p. 133.

"DAMASK: A self-patterned weave with one warp and one weft in which the pattern is formed by a contrast of binding systems. In its classic form it is reversible, and the contrast is produced by the use of the warp and weft faces of the same weave, usually satin."

Dorothy K. Burnham, *Warp and Weft, A Textile Terminology* (Toronto, Ontario: Royal Ontario Museum, 1980), p. 32.

"Linen history complemented the history of cotton. During the first phase, it was produced on two levels: in peasant households and as a homespun, and in urban workshops as a luxury."

Jane Schneider and Annette B. Weiner, *Cloth and Human Experience* (Washington and London: Smithsonian Institution Press, 1989), p. 181.

"The white figurated damask-cloth, introduced in the 15th century, took such a first position on all markets of luxury that the word damask in the Netherlands became synonymous with white linen dinner-tablecloth and napkins. It was even called 'silk damask' because of its shine, and indeed between caressing fingers the first qualities feel like silk."

G.T. van Ysselsteyn, *White Figurated Linen Damask from the 15th to the Beginning of the 19th Century* (The Haag, Netherlands: van Goor Zonen, 1962), p. 10.

Damask

Anne Wilson

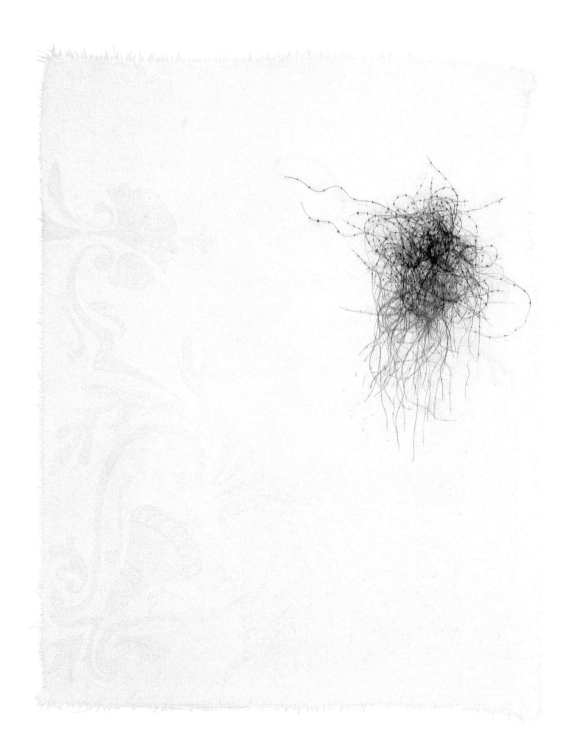

7·17

The stitched spot of hair and thread stands opposed to this refined cloth.
Like dirt or a stain, it does not belong there. A.W.

Anne Wilson, *A Chronicle of Days*,
1997–1998, cloth, hair, thread,
steel, and glass frames, 100 parts:
72 x 231 x 1 1/2 in. overall.
Collection 21st Century
Museum of Contemporary Art,
Kanazawa, Japan.

*These book plates are parts from
a larger project, composed of 100
hair-stitched damask fragments.
The stitching on each fragment was
completed within one day, thus the
overall project represents a kind
of physical time chronology of daily
labor. Each fragment is **dated with**
a month and a day indicating its
time of creation.*

Amazwi Abesifazane

Voices of Women

Carol Becker

*The Truth and Reconciliation's
greatest contribution was
to give back to South Africa
its heart.*—Wilmot James and
Linda Van De Vijver

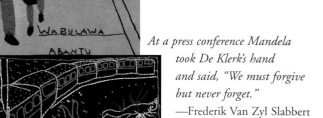

*At a press conference Mandela
took De Klerk's hand
and said, "We must forgive
but never forget."*
—Frederik Van Zyl Slabbert

How does one remember what one most wants to forget?
Why does one choose to remember at all?
How can a country traumatized by racial injustice become a nation?
What is the role of narrative—written and imaged—in such a process?
How does one construct an archive in multiple forms?

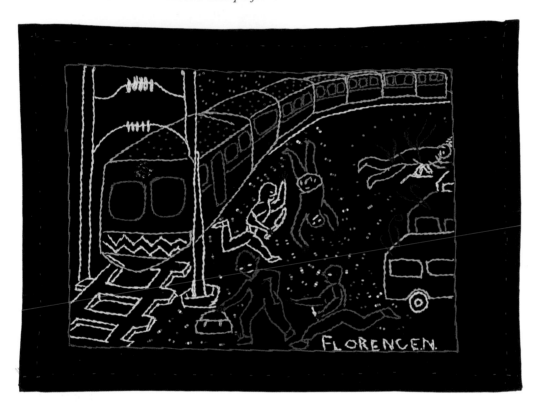

Alchemy and Memory

Apartheid had obliterated social history in South Africa. In order for the nation to move into the future, that history needed to be recovered. In 1996, the recently elected African National Congress (ANC) government established the Truth and Reconciliation Commission. Under the leadership of Bishop Desmond Tutu, this commission was given the task of reconstructing the history of life under apartheid with the purpose of setting the record straight and developing a cultural and historical archive. This history had either been hidden or destroyed because the ruling party could not afford to allow such information to be released—even to its own membership. As a result, South Africa had lost the record of its own past. In order to

Florence Mdlolo, Violence in 1996-1997: Train Victims, *2001-2002, cloth with embroidery and beadwork, 10 1/2 x 13 3/4 in.*

114

reconceptualize itself as a nation, the ANC, in conjunction with the courts, developed a plan to approach the nation's tortured past and rebuild collective memory.

This commission's mandate was to hear those narratives offered by the victims of apartheid (limited to the period between 1960 and 1994), and to determine who was, in fact, a victim (a term specific here to those brutalized by politically motivated violence). The goals were to record their stories, to bring to justice perpetrators of crimes against humanity, to have such perpetrators reveal all hidden information about their crimes, and then to orchestrate their requests for forgiveness involving those victimized as well as the families of those who were killed. The commission was also obliged to offer recommendations for how to compensate such victims.

At times, perpetrators did break down and admit their guilt. They wept in front of victims or their families and asked forgiveness, thus achieving one of the main mandates of the commission—to seek reconciliation. But this goal has also been the source of a great deal of criticism and cynicism. Some feel that given all that occurred, reconciliation was always an inappropriate goal for the commission. But the terms of the commission— the possibility for amnesty, the emphasis on truth, truth-telling, and reconciliation—were established before the end of apartheid. They were negotiated in the transfer of power, where it was determined that the government would not seize property and that there would be the possibility of individual amnesty, but no general amnesty. The process was completely dependent on the stories of individual South Africans.

Once the testimonies of the 21,400 people who came forward were transcribed and categorized, a full eighty percent were designated as the stories of "victims."[1] Perhaps most significantly, the hearings of the commission were transparent, taking place in open, public sessions that were available to everyone via radio and television. The whole society became immersed in this process. Many books have been written detailing the process in the name of the commission and by the commissioners themselves, as well as by journalists, political leaders, victims, and perpetrators.

The act of creating the commission and the years of public testimony and debate that followed changed South Africa. The new, progressive constitution guarantees that it will never be possible for South Africa to return to the repressed, fascist state it once was. Nor can it any longer hide the consequences of apartheid. But many have felt that the Truth and Reconciliation Commission has constructed a circumscribed version of the truth established through "narrow lenses" designed to "reflect the experience of a tiny minority of victims and perpetrators."[2] Because indigenous women,

1. Mahmood Mandini, "A Diminished Truth," in *After the TRC: Reflections on Truth and Reconciliation in South Africa,* eds. Wilmot James and Linda Van De Vijver (Cape Town: David Philip Publishers, 2000), p. 59.

2. Mahmood Mandini as quoted in Colin Bundy's essay "The Beast of the Past: History and the TRC," in *After the TRC,* p. 19.

for example, were not widely included in the process, their stories have remained hidden. It is into this environment of ongoing historical and psychological reflection, of debate about the past and its implications for the future, that *Amazwi Abesifazane*, or "Voices of Women," was imagined into being by sculptor Andries Botha. He hoped to bring focus into the often undocumented lives of indigenous women, many of whom are from the rural areas and townships that suffered extreme acts of violence during the decades of apartheid. Poet and essayist Njabulo Ndebele writes:

> *The homelands were another arena of gross violations of human rights.*
> *KwaZulu-Natal, the Ciskei, and KwaNdebele, in particular . . . suffered cyclical*
> *attacks and counter-attacks in which the line between victims and perpetrators*
> *blurred as comrades and vigilantes assumed both roles . . . In the townships,*
> *people experienced "necklace killings," the burning of houses of suspected spies,*
> *and a reign of terror by groups acting in the name of liberation.*[3]

3. Njabulo Ndebele, "Of Lions and Rabbits: Thoughts on Democracy and Reconciliation," in *After the TRC*, p. 149.

Such are the experiences that the women of *Amazwi Abesifazane* have recorded on cloth with embroidery and colored beads. When amassed, these memory cloths become a collective indictment of the maleficence of that system. And because they are visual and handmade, juxtaposing the vivid images created by these women with the devastating seriousness of what they depict through their disconcertingly direct narratives, they are able to stir viewers' emotions, often moving their audiences to tears.

The memory-cloth project, now involving thousands of participants—Zulu, Sotho, and Xhosa—has attempted to create a forum through which women might tell their stories, cultivate their own creativity, earn money from such work, develop their consciousness as women, occupy their rightful place in history, and connect with other indigenous and tribal women globally. Addressing the enormous health problems facing a large majority of South African indigenous women, the project now has expanded under the larger structure of the organization Create Africa South to include workshops about women's health, pregnancy, HIV, and AIDS.

The original project, however, was centered around the production of memory cloths: small, embroidered, sometimes beaded pieces of colored fabric. Each cloth attempts to represent narrative through embroidery. The process begins with workshops in which women are encouraged to write down their narratives (if they can) or to tell them to someone who then transcribes the stories. The subject given to them is "A Day I Will Never Forget." The representations must depict an episode they themselves witnessed or experienced. Almost invariably, their stories reflect the traumatic consequences of life under apartheid. The women are then

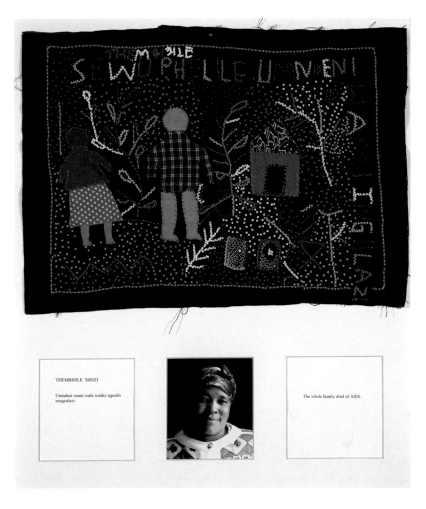

Thembisile Shozi, "The whole family died of AIDS," ca. 2001, cloth with beadwork and appliqué, 10 x 14 in. Mounted with photograph of the artist.

Zulu text: Umndeni wami wafa wonke ngesifo sengculazi.

English translation: The whole family died of AIDS.

encouraged to represent their stories visually. Many have highly developed skills with thread and beads, others are learning to embroider for the first time. Each woman makes one cloth for exhibition, sale, or both, and a second for the archive. Many of these cloths have been sold locally and internationally, encouraging the creativity of the women involved and in a small way helping them to achieve economic independence.

The cloths are cotton and of various colors, but the size is consistent: roughly ten by fourteen inches. The cloths recreate locality both in their visceral representations and in the stories themselves. The images frequently include traditional houses and dress: the colors and textures of daily

township life. The representation of landscapes domestic and wild, villagers, and animals positions the images within a social context, reflecting the degree to which these women so clearly see their lives as communal. The best way to view the cloths is to see a large number of them at once. One may be moved to tears by the sincerity of the effort to portray devastating personal loss, and it soon becomes clear how many women have been affected by multiple kinds of violence.

An exhibition of 100 such depictions, each mounted and framed with a photo of the woman and her written text, opened at the Durban Art Gallery at the time of the 2001 "Third World Conference Against Racism, Racial Discrimination, Xenophobia, and Related Intolerance," also in Durban. The exhibition, organized by and for indigenous women, ran parallel to the conference and was sponsored by *Amazwi Abesifazane*, the Self-Employed Women's Union, and the Women's National Coalition. A number of the cloths have also been shown in The Netherlands and Portugal and at Brandeis University, and the largest exhibition of cloths to date was held at the Betty Rymer Gallery at the School of the Art Institute of Chicago in 2004.

Process

Each cloth is a bit of archival information. Each act of telling—in this case, actually making the cloths—brings another story filled with important historical and cultural data into the public arena. In so doing, it links the history of each individual with those of other women in similar circumstances. It brings each woman into a process that is as much about the future as it is about the past. While the women do this concentrated work of telling and stitching, they reflect. While they are revealing the individual details of past lives to each other, the shared patterns of poverty and abuse become apparent.

The project also becomes as much about feminist concerns as about indigenousness and political issues. When women take charge of their own lives and come together, often around concerns that are very much connected to their relationships to men, family, and social structures, consciousness develops. These women begin to describe to one another how they have been treated within patriarchal structures, both by the systems of apartheid, which were invented and executed by white men, and also by systems of patriarchy within tribal structures that allow for the dominance of black men. In both, black women are at the bottom of the hierarchy, often sexually abused, abandoned, and economically exploited. Their children may be murdered or die from lack of resources. They are

left alone to raise families and then to grieve when those families are torn apart by the consequences of ignorance and arbitrary acts of violence.

It is through the telling of stories in words and images that women begin to understand that their lives are like those of many other women. This recognition is the beginning of feminist/social consciousness. Many of the goals of *Amazwi Abesifazane*, structured by women, have been designed to help all women understand their relationships to the family and society.

Another goal is to link women to global movements that have developed in Latin America, Canada, and the rest of Africa. Through such meetings indigenous women are able to talk to one another about their situations in their respective countries. Hence such women, who are often most excluded from conversations about globalization and its effects on their daily lives, have created a forum within which to debate the issues.

Increasingly, Create Africa South (the umbrella organization that houses *Amazwi Abesifazane* and works with the same groups of women) has also become a powerful force in the effort to improve the health of indigenous and tribal women, and to educate them about their bodies. Workshops led by trained leaders now take place in these rural communities, and women both learn to do their own breast exams and gain access to pelvic exams. Women are also taught about their personal rights in relationship to their bodies and encouraged to take all precautions to prevent HIV and AIDS, as well as venereal disease. Recognizing that change must occur on many fronts, Create Africa South's "Know Your Body" project (*Wazi Umzimba Wako*) has taken a radical step in Africa by also educating young men about their responsibility to women and their health issues in relationship to women.

At the historic Durban conference in 2001, indigenous women were able to speak to one another and to the world about their vulnerability as caretakers of the most at-risk members of society—children. The majority of narratives written and illustrated by the women for the project include the saga of home, family, extended family, their own children, and those of others.

The memory cloths give voice to these narratives. From them we not only learn each woman's individual trauma, but we are able to begin to grasp the weight of their collective plight. The narratives repeat images of humiliation, brutality, and the sheer randomness of tragedy among people who have few allies and fewer options. The cumulative archive adds to the voluminous body of information gathered by the Truth and Reconciliation Commission.

Reconciling Truth

The particular emphasis of the Truth and Reconciliation Commission (TRC) on victimization, although very significant, did not include crimes committed out of ignorance, rage, or greed, or constructed by those in power to aggravate township life. In other words, it omitted most of the horrors told by these women. The commission was not attempting to dissect the apartheid state and its systematic destruction of any semblance of normal life for black South Africans. Instead, it was more concerned with the extreme moments when South Africans were violated by the henchmen of the apartheid regime acting outside the law through murder, torture, and rape. But as a consequence of the stories—the testimonies of all those who addressed the commission—a picture of everyday life for black South Africans under apartheid begins to emerge.

From the stories represented in the memory-cloth project, we learn about the uneducated and underrepresented, left without resource or recourse. All it takes is the loss of one caretaker to create a disastrous situation for a child or a mother. One can never completely recover from these traumas. Thabisile Dlamini writes:

> Granny died while sleeping on her bed and I loved her as she
> loved me. She was doing everything for me as my mother
> had died while I was young. After that I went to stay with
> my aunt. Zinhle (who was my uncle's wife) who abused
> me saying that she had no place for orphans and she was
> not even giving me food. She made me leave school and
> look after her children. Sihle and Thando. Even my uncle
> Busani does not care about anything. However. I am still
> staying with them and there is nothing I can do because
> they are my relatives.[4]

We are told the same story again and again, how an occurrence that could probably have been avoided or overcome by a middle-class family in the city destroyed a poor family in the township. Under apartheid the world was a precarious place; a random act could lead to a tragedy from which an entire family might never recover. Fire is a good example: A torch may have been set to a home during an instance of township violence, or a fire may have spread while someone was cooking on a primitive stove or when a child racing through a space overturned a lantern. Without safety precautions to stop them, such fires easily rage out of control. And like water during a flood, they take with them people's few possessions. Once

4. All stories are taken from the *Amazwi Abesifazane* archive. I am grateful to Andries Botha, Brenda Gouws, and Janine Zagel for making so much information about the project available to me.

one loses a home under these conditions, it is almost impossible to secure another. The family then usually splinters—children are sent to live with one relative, the mother to stay with another. Or the mother may be a domestic worker during the week, living at the home of a white family, while her mother takes care of the children in her own home in the township. She may visit her children only on the weekend. But once her township home is lost, the mother may never be able to live with her children again. The father may already be absent because of the nature of work under the apartheid system, where black miners, for example, might be gone for months at a time. Or he may be absent because of the generic fragmentation of the male psyche, the result of such ritualized separations, or because of the omnipresent instability and humiliation bred under apartheid, and the way it affects men in particular.

In apartheid South Africa, blacks lived under a government that not only did not care about their welfare, but actively sought to destabilize them by keeping the majority black population uneducated and powerless while fomenting township violence through a campaign of fear. Njabulo Ndebele, the vice-chancellor of the University of Cape Town who has chronicled life in the townships, comments on the TRC report:

> *It shows how communities of the oppressed, torn apart by fear, suspicion and mistrust, desperate to build and preserve unity, were led to hunt down people thought to be informers and collaborators. They met a gruesome fate at the hands of others who were convinced that they were working in the interests of the community.*[5]

5. Ndebele, *Of Lions and Rabbits*, p. 149.

Muriel Linda, "At Amaoti, Inanda, in October 1997..." (detail).

The narratives recorded through *Amazwi Abesifazane*, though brief (sometimes just a few sentences), convey both subtle and overt abuses of power, and are as illuminating as they are devastating. The following stories offer only a glimpse of the breadth of daily life actually recorded in the project's archive. It is the specificity of each story and its consequences

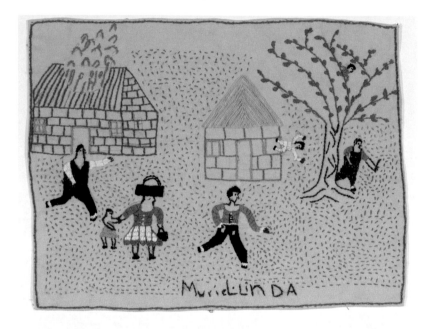

Muriel Linda, "At Amaoti, Inanda, in October 1997...," ca. 2001, cloth with embroidery, 10 x 14 in. Mounted with photograph of the artist.

Zulu text: KwakuseMaoti, eNanda ngo-October 1997, lapho kwakunekhansela elaizibekile, liphethe. Lalishaye umthetho wokuthi ligadwe zonke izinsuku ebusuku njengoba kwakukhona izinhlangano zamaqembu amakhulu abangayo, aphikisanayo. Ngalelolanga izingane zesikole zazilungiselela ukuhlolwa, ngakho-ke ngalolosuku zazingekho ukuzomgada ngoba zazitadisha. Yilapho-ke lelikhansela lathumela abantu ukuba babathungathe. Bafika kwamzala wami ingane yakhona ingekho. Yilapho-ke lapho bafika bashaya lomuzi nge-petrol bomb. Abantu babaleka, ngeshwa omunye umfana wadutshulwa wafa.

375 Muriel Linda

KwakuseMaoti, eNanda ngo-October 1997, lapho kwakunekhansela elaizibekile, liphethe. Lalishaye umthetho wokuthi ligadwe zonke izinsuku ebusuku njengoba kwakukhona izinhlangano zamaqembu amakhulu abangayo, aphikisanayo. Ngalelolanga izingane zesikole zazilungiselela ukuhlolwa, ngakho-ke ngalolosuku zazingekho ukuzomgada ngoba zazitadisha. Yilapho-ke lelikhansela lathumela abantu ukuba babathungathe. Bafika kwamzala wami ingane yakhona ingekho. Yilapho-ke lapho bafika bashaya lomuzi nge-petrol bomb. Abantu babaleka, ngeshwa omunye umfana wadutshulwa wafa.

At Amaoti, Inanda in October 1997, the community was under the leadership of a self-styled councillor. This councillor had instructed the community to provide him with bodyguards who would guard him at night on a daily basis as there was friction between two major political organizations. On a certain day the school pupils were not available to guard him as they were studying in preparation for the examinations. The councillor then sent people to go out and look for the school pupils. They came to my cousin's home only to find that her son was not at home. It was then that they attacked the house with a petrol bomb. The people ran away but, unfortunately, one boy was shot and killed.

English translation: At Amaoti, Inanda, in October 1997, the community was under the leadership of a self-styled councilor. This councilor had instructed the community to provide him with bodyguards who would guard him at night on a daily basis as there was friction between two major political organizations. On a certain day the school pupils were not available to guard him as they were studying in preparation for the examinations. The councilor then sent people to go out and look for the school pupils. They came to my cousin's home only to find that her son was not at home. It was then that they attacked the house with a petrol bomb. The people ran away but, unfortunately, one boy was shot and killed.

for each human life that makes witnessing the memory cloths most devastating. And it is the simplicity of the representation juxtaposed to these horrific stories that makes the entire project resonate visually.

In 1976, Muriel Linda was a domestic worker for a white family. Of this experience she writes:

> They had a big dog. which I had to give food to every time I left. They usually gave me bread and tea. One day he gave me food which was left over from the previous day. as they had had a party. When I sat down and ate. I was very surprised to find out that the food was in a bowl that I had used to give food to the dog. When I asked him why he did that. he said that there was no problem because a bowl gets washed. He. too. could eat from it. I asked to be relieved of my duties. They all laughed.

Nokwanda Ngobese writes:

> In 1991 I woke up as usual and went to Durban to look for a job. I left home with great enthusiasm. I rode a bus and alighted near a company that produces tea. I arrived there around six o'clock—before they opened. I waited there until eight o'clock. No one ever asked me whether or not they could help me or anything. I was starving and yet I could not even get water. All I could hear was laughing. coming from an office. Whites were laughing very loud. And they saw me. I was hoping that some white person would come out and nobody did. At one o'clock they started going out one by one. They were going out to lunch. While they were going out I was asking them if they could help me and nobody did. Eventually a white man came to me and said. "Go away from here. We don't want Blacks. We want Whites only." I left the area and went out of the gate disappointed.

Of life in Newlands in 1969, Mildred Mkhulise writes:

> Black people were being evicted from their land by whites who claimed they had bought that land: when black people produced some documents of their own to show that they had a right too to be on that land. that did not help. Police

vans with bulldozers came. They had dogs with them. They were harshly evicted. Their belongings were thrown all over the place. My home, too, was destroyed in that way. When we came back from school my uncle was sitting like that with our belongings.

Thobile Khumalo writes:

It was on the 6th of February, 1985, when I had a car accident at Monyonga . . . I was coming back from the river where I had gone to fetch some water with a twenty-five liter container. I was on the right side of the road but that car hit me down and I fainted. I woke up at the Provincial Port Shepstone hospital. The next day a nurse came and told me that I was not seriously injured and yet I stayed in hospital for three months. After the nurse had gone two police officers Mr. Bashise Ngubo and Mr. Ndaba came to get the details about the accident. I could not help them that much because I was still confused. My mother came to visit me and then she told me that the car that hit me down was that of Mngadi. My father, Shadi, approached Mngadi over this and Mngadi did not do anything and I was never compensated for my injuries.

Elsie Nyembezi writes:

My father was working in Durban and when my stepmother went to the hospital to give birth she left a message that I was going to leave school so that I would look after the baby and I did so but I was only in grade one. Even today I can't read and write and I don't forgive her because I can't get a job because she was abusing me. Her children, though, are well educated and they have good jobs.

The stories (now numbering several thousand) are written predominantly in Zulu but also increasingly, as the project expands beyond KwaZulu-Natal, in Sotho and Xhosa. They are translated into English, then archived in both their original language and in translation. They are cross-referenced by subject, tribal affiliation, geographical location, and other categorizations. From the stories come the images. The complexity of the narrative is illustrated

Zonke Ndlovu, "Themba Madela resided at K section in KwaMashu . . .," ca. 2001, cloth with embroidery, bead-work, and appliqué, 10 x 14 in. Mounted with photograph of the artist.

Zulu text: Uthemba Madela wayehlala kwa-K section KwaMashu. Wagwazwa wabulawa yiqulu labantu elalizibiza ngokuthi ngamaQabane, elaligaphansi kwe-UDF. Babemsola ngokuthi uyilungu lamaSinyora. Bamgwaza ebuya esikoleni ayefunda kuso, iZeph Dhlomo High School. Ngalonyaka kwakun-gu-1989 enyangeni kaMay. UThemba lona ngangimazi ukuthi akalona ilungu lamaSinyora ngoba ngangi-jola naye. Lokho kwangiphatha kabi ukwehlukana nesithandwa sami. Okubuhlungu ukuthi abantu abambulala bagcina bengaboshwanga kuze kube manje.

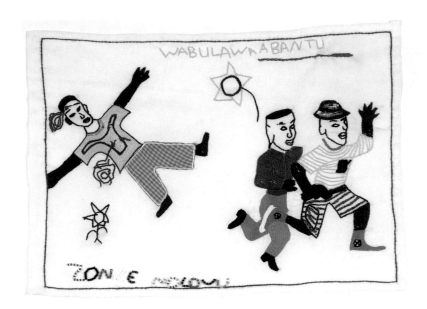

837 Zonke Ndlovu

UThemba Madela wayehlala kwa-K section KwaMashu. Wagwazwa wabulawa yiqulu labantu elalizibiza ngokuthi ngamaqabane, elaligaphansi kwe-UDF. Babemsola ngokuthi uyilungu lamaSinyora. Bamgwaza ebuya esikoleni ayefunda kuso, iZeph Dhlomo High School. Ngalonyaka kwakungu-1989 enyangeni kaMay. UThemba lona ngangimazi ukuthi akalona ilungu lamaSinyora ngoba ngangijola naye. Lokho kwangiphatha kabi ukwehlukana nesithandwa sami. Okubuhlungu ukuthi abantu abambulala bagcina bengaboshwanga kuze kube manje.

Themba Madela resided at K section in KwaMashu. He was stabbed and killed by a UDF aligned group known as amaQabane (or Comrades). They suspected him of being a member of amaSinyora gangsters. He was stabbed on his way from Zeph Dhlomo High School where he was schooling. This happened in May 1989. I knew Themba was not a member of amaSinyora because he was my boyfriend. This made my heart very sore, to part with my sweetheart. What is more disturbing is that the murderers were never arrested.

English translation: Themba Madela resided at K section in KwaMashu. He was stabbed and killed by a UDF aligned group known as amaQabane (or Comrades). They suspected him of being a member of amaSinyora gangsters. He was stabbed on his way from Zeph Dhlomo High School where he was schooling. This happened in May 1989. I knew Themba was not a member of amaSinyora because he was my boyfriend. This made my heart very sore, to part with my sweetheart. What is more disturbing is that the murderers were never arrested.

through stitches, design, and color. Some women have a greater facility for either telling or sewing, some are adept at both. The stories are often filled with a great deal of movement—people running or being beaten by police, crowds chasing and then killing a suspected spy, fire raging through a village, cars colliding. Intricate weavings of red thread are stitched around the dirt-covered head of a battered man to signify blood; miniature representations of underwear are depicted strewn around the naked body of a stick-figure woman who appears to have been violated.

Sometimes the woman herself is represented in the cloth, or she might tell the stories of others—but always something she has witnessed and cannot forget. In certain cloths every inch is covered in detail. In others, the images are sparse—alluding only to key factors in the story. As noted earlier, the horror of the cloths often rests in the almost childlike representation of figures drawn by women who may have little training in representation, in

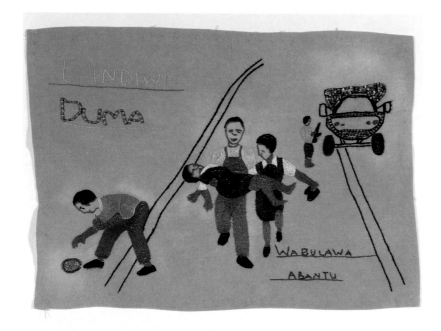

Lindiwe Duma, "Nonkululeko Shandu was 16 years old . . .," ca. 2001, cloth with embroidery and bead-work, 10 x 14 in. Mounted with photograph of the artist.

Zulu text: UNonkululeko Shandu wayeneminyaka ewu 16, efunda ibanga lesishiyagolombili eMandlenkosi, ehlala endaweni yase Lindelani esigcemen sakwa C. Wadutshulwa wabulawa abantu abangaziwa. Kwakuyimpi enkulu phakathi kuka Thomas M. Shabalala no Michael Zulu bebanga isikhundla sokuphatha okwagcina ngokuthi uMichael abulawe kwasala u Shabalala. Kwakuwu 1998 ngenkathi umngani wami ethi uziyela esikoleni, wabulawa washiywa lapho. Kwafika amaphoyisa amthatha, okubi ukuthi akuboshwanga muntu ngalokho. Wafa kabuhlungu umngani wami uNonku.

English translation: Nonkululeko Shandu was 16 years old and she was a learner at Mandlenkosi High and she was staying at Lindelani, section C. She was shot and killed by an unknown gunman. This was because a fight between Mr. Thomas M. Shabalala and Michael Zulu broke out. They were fighting over leadership in Lindelani and eventually Michael was brutally murdered. All this happened in 1998 and she was just going to school. Police came but it was too late for my friend. Police eventually helped to bring peace in the area. The saddest thing is that no one was ever arrested for this man.

contrast to the devastating astuteness with which they understand and recount brutality in its most overt and subtle manifestations. At times, the images even seem innocent, benign, beautiful, or playful in form and color, until one reads the fragment of text and understands the actual meaning of, for example, a small, awkward, male figure represented with a thick, black ring encircling his chest. The story tells us that he is captured and about to be set alight through "necklacing"—the township practice of placing a suspected "traitor" in a public space, forcing an automobile tire around his (or her) neck, and igniting it with kerosene.

All the women involved in the project have benefited enormously from the reflection on their lives the project encourages. But for one woman, Florence N. Mdlolo, the project provided a way in which to tell not just a bit of her story, but her entire story. Mdlolo wrote her memoir and then illustrated each episode (forty in all) with its own memory cloth. Some of her stories, like all those told, seem unimaginably brutal, and yet they occurred. At times they reflect township conflicts between the ANC and the Inkatha Freedom Party (IFP), which were very often fueled by the National Party (the governing party of apartheid). She writes of the years 1996–1997:

> Violence victimized us all. Families starved as stores closed. They were fighting over taxi routes. They never cared about innocent people. but their own selfish needs. The sad thing is that they burned my brother. When we came. they had just set him alight using petrol. His intestines were still outside and his head was all dark with smoke. but they had shot him first and his name was Zolile Mdlolo. This was evident because of the bullet cartridges. My cousin Xolani Gwele was also killed. He left behind one child and his fiancé.

> People hid at the seventeenth cemetery yard to try and save their lives. They had lost their conscience that graves are to be respected. One would find them there feeding their babies when one had come to bury a relative. Sounds of gunfire would be heard sometimes while they were cooking. Those who had a chance would run away with the food. Some were sleeping on top of the graves. The violence continued for three years.

Mdlolo also tells stories of complete helplessness on the part of those faced with natural disasters in remote locations:

Many children had been in the fields watching the newly seeded sorghum to keep the birds from eating the seeds. It started raining and they thought it "would pass quickly." but it did not. They never thought that the river, which they were going to cross back home, was getting fuller all the time. This was the "white" Umbolozi river. It continued raining, and there was thunder and lightening. Raining as it was, they tried to find their way back home . . . They walked down the river, the young ones started crying. The night came and it became so dark. People were stepping over stones, in the mud and others were slipping and falling all over the place. Others were holding onto the grass. Lightening was lighting the way. Children continued crying. Adults called their names and they responded . . . But the adults could not get to the children because of the flooding. Help did not come because it's in the rural areas. If it was in the cities or in town, telephones would have been used, helicopters would have come to rescue these children, instead an owl came and watched with no help . . . The adults continued to call the names of their children and the responses kept coming, but it seemed like there was no solution to the problem these kids were facing. After sometime, Musa Mdlolo shouted as well. "The tree we climbed on is moving sideways. And water keeps coming up and we cannot put our feet on anything now." "Do not climb down, just hold on to that tree." a voice responded from the dark . . . Children drowned and the trees they were holding onto went down the river with them.

Embedded within each narrative is the hopelessness of being neglected by a social system, of having no safety net, no infrastructure, not even the most minimal, such as telephones, motor vehicles, and clean drinking water. The lesson learned from the project is the same as that derived from the recorded testimonies made to the TRC: All people who lived under apartheid "are wounded people."[6] The tragedies they lived resulted from having neither economic resources, an understanding of how the system

6. Bishop Desmond Tutu as quoted in Ciraj Rassool, Leslie Witz, and Gary Minkley, "Burying and Memorialising the Body of Truth: The TRC and National Heritage," in *After the TRC*, p. 115.

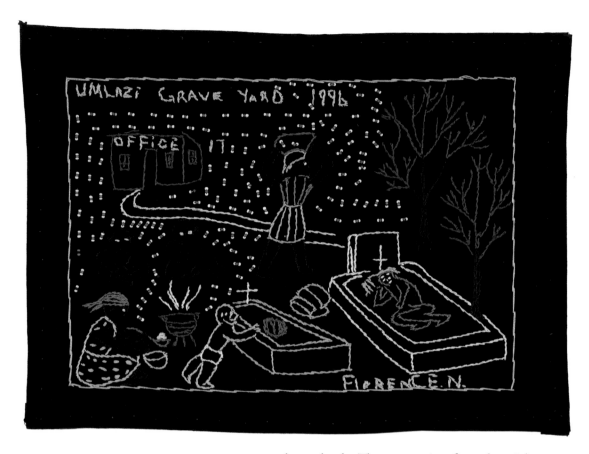

Florence Mdlolo, Political Violence, "Umlazi Graveyard 1996," *2001-02, cloth with embroidery and beadwork, 10 1/2 x 13 3/4 in.*

operates, nor access to those who do. These are stories of senseless violence enacted from the outside against helpless people, and stories about the senseless violence that oppressed people enact on each other. It is ironic and devastatingly tragic that Mdlolo died as a result of the same absence of infrastructure she writes about so lucidly.

The strength of the memory-cloth project is that it captures complexity under the guise of simplicity. It creates a safe environment in which women can tell these stories. It makes the equation among creativity, the reclamation of the past, and the development of consciousness, while providing a form that gives shape to the narration of tragedy—one important function of art. In his study *How Societies Remember*, Paul Connerton writes: "Lévy-Bruhl has stressed that the word 'represent' must be understood . . . in its literal etymological sense: meaning to re-present, to cause to reappear that which has disappeared."[7]

The particularity of the cloths reflects South Africa's past traumas through individual narration. The process of designing and producing them allows

7. Paul Connerton, *How Societies Remember* (Cambridge, England: Cambridge University Press, 1989), p. 69.

women to find their voices, hence the name *Amazwi Abesifazane* (Voices of Women). Together these voices demonstrate the miraculous resilience of indigenous women, who, although profoundly conscious of the injustices they have experienced, are able to believe in the possibility of a just society and, therefore, to anticipate an equitable future that does not yet exist.

The new South Africa will never know from whence it evolved, if these stories are not told. Were they to remain buried, they would only return to haunt the society, slowly, or not so slowly, eroding its underpinnings.

The women of *Amazwi Abesifazane* understand that the transformation of a society begins with creativity. The "object of their labor" is this work of personal reclamation in written and pictorial form. It is their ongoing contribution to a historical archive. For South Africa, remembering—personal and collective—has become a national project.

Dedicated to the memory of artist Florence N. Mdlolo.[8]

The epigraphs are from After the TRC: Reflections on Truth and Reconciliation in South Africa, *eds. Wilmot James and Linda Van De Vijver (Cape Town: David Philip Publishers, 2000), pp. 4 and 63.*

8. Florence N. Mdlolo suffered from asthma. On the day of her death her asthma pump was depleted. She and her husband had been saving to buy a refill. No one in her township could take her to the hospital. The one person with a vehicle wanted 500 Rand (at that time the equivalent of $50 U.S.) to do so. No one had the money to pay him. While they tried to find a solution, four hours passed. When she finally did reach the hospital, she was dead. She was one of the truly talented artists to emerge from the *Amazwi Abesifazane* project. A book commemorating her life in memory cloths and text has been produced.

Amazwi Abesifazane
Reclaiming the Emotional and Public Self

Andries Botha

History seems to suggest the inevitability of human conflict and reminds us of the obsession for possessions, conquest, or the persistence of social instability as a measure of our civilization. The resulting cultural collisions defined the metaphors for social transformation and contextualized humanity as an agent within this perpetual, conflictual social anthropology. The resulting socially engineered fault lines manifest the notion of conflict as integral to our understanding of structure, and define civilization as an unstable index of chaos within the ecological and social order.

Our understanding of the intersection points between the ecological order and the sociological imprint, that which is expressed by our cultural and political ordering principles, reveals our mapping and organization of terrain as manifestations of our principles of control and ownership. In the case of the *Amazwi Abesifazane* (Voices of Women) project, my site of investigation is African land, that which has become a metaphor for conquest

and ownership, a laboratory sample to be analyzed as a postcolonial fragment. I have always maintained that it is not premature to refer to tragedy as the product of social conflict when we observe the general process of history. In a sense, human desire for power would suggest the motif of chaos, that which is expressed as an idea of social management under the pretext of ordered social purpose. In this manner social and political structures are manifest as flawed reason in search of validation and moral justification, the panacea of order within a globality of chaos.

Postcolonial/apartheid South Africa created a hypercultural sensitivity about binaries and opposites, about the politics of the center and the periphery, and the need and mutual social responsibilities attached to the cultural dialogue of neglect and marginalization. The lesson inherent within this legislative experiment is the acknowledgement that diversity becomes a meaningful instrument in the culture of renewal. If social crisis should shift or challenge the language of exclusion, we should embrace it as part of the living human contract that enriches the entire process of cultural communication and renewal. In 1996, the Truth and Reconciliation Commission of South Africa was constructed as a legislative and cultural instrument that could facilitate the complex social need for political reconciliation and renewal. These assumptions are based on the conviction that a future can only be envisaged if the past is made visible and understood. Constructing such a collective moment of catharsis presents to cultural scholars a social construction that, at least in theory, proposes the legislative mechanism for a contested past to be transcended, and a political framework to be structured to manage and facilitate the establishment of a functioning democracy.

In order that violation and individual abuse are positioned beyond the human tendency for retribution, it is important that we grasp the political complexity and sophistication of these achievements by the victims of apartheid, those who endorsed the need for a complex political disclosure of violations as an essential precondition for a painful, flawed but functional national reconciliation.

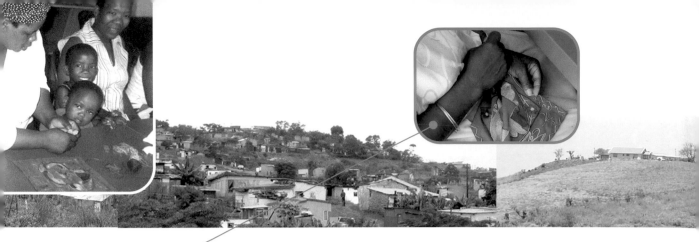

Mrs. Nkosi stitching a memory cloth.

The *Amazwi Abesifazane* project endorses these ideas and explores them as a creative and cultural work in search of new possibilities. Identifying women as vital, yet politically marginalized elements within the prevailing cultural debate, assumes that true democratic process can only be realistically achieved if women are acknowledged as essential elements of the social and cultural process that must be economically affirmed and politically empowered. In order for it to be relevant, the *Amazwi Abesifazane* project has been conceptualized and implemented around the premise that women provide the consistent, essential social building blocks of the emerging South Africa, providing stable, nurturing, and emotionally affirming shelter, where the physical and emotional needs of children can be met. We also believe these assumptions to hold true for all societies.

Entering the cultural debate around the positioning and reclaiming of lost identities remains one of the most important functions of the postcolonial discourse. It is a matter of public record that the destruction of National Archives subsequent to the unraveling of colonial rule presents some of the more complex political realities influencing the dignifying of discredited identities and, if not secured, does effectively equate to a loss of memory or invisibility. Equally, the holding of indigenous knowledge and information exclusively within the vulnerable oral archive, presents another similar challenge in this recovery process. The *Amazwi Abesifazane* project engages women in the complex task of recovering information and transforming memory into creative works that could serve as reference points for the repositioning of personal and collective history. Reclaiming an authentic version of history would suggest that a "visible self" must be identified as part of the "public self." This cultural endorsement of the individual as an element of the collective authenticates personal identity and paves the way to eradicate the indignity of postcolonial invisibility. These convictions would also necessitate challenging the prevailing modernist tendency for social and cultural categorization in order to identify difference, or one form of cultural production as superior to the other. In this context, it is also necessary to try to understand the purpose of a

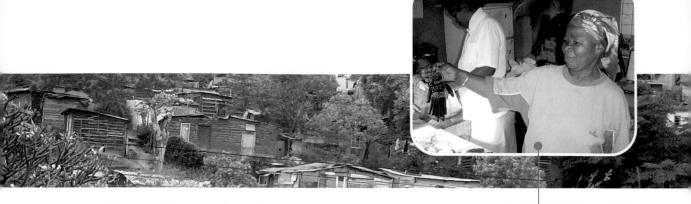

critical theory and practice that seeks to propose certain modes of thinking or creativity to be inferior.

The *Amazwi Abesifazane* project gathers together peer groupings of women where hidden or repressed aspects of personal, cultural, and political history are discussed, recorded, and translated. This difficult process is facilitated by trained coordinators drawn from the geographic area of operation. This historical information is written in the original indigenous language then translated into creative work. Each artist is photographed, and her personal biography noted as integral to the creative work. All of this information is then transferred onto a centralized computer database for future archival purposes. Enabling the complex process of emotional disclosure and creative transformation affirms the formal and conceptual relationship between individual experience and history, culture and social process, catharsis, creativity, and identity. Validating personal experience as integral to the cultural record, which is then subjected to formal and conceptual thought, presents these memory fragments as works of art. These, in essence, are the creative and cultural objectives of the *Amazwi Abesifazane* project.

Human reason would suggest to me imperfection, contextualizing our romantic, culturally defined notions of truth. This philosophical pretext also invokes the idea of morality politically implemented as a particular notion of truth. These contested realities are expressed as the collision between individual, territory, and social organizational principles. In this context, African land is historically appropriated and defines the idea of conflictual ownership and territory. This expanding horizon of human desire for accumulation introduces the philosophical idea of persistent contestation, that which is consistent with the dynamics of classic evolution, reminding us, grimly, that only the fittest will survive. In this respect the colonial subdivision of Africa would seem to be consistent with other natural and sociological examples of metamorphosing: global and local wars, territorial disputes, human conflicts, and social and individual dysfunction. The concept of tragedy is always manifested as reason in search of an imposed moral order, evolving a civilization in perpetual chaos and

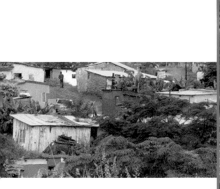

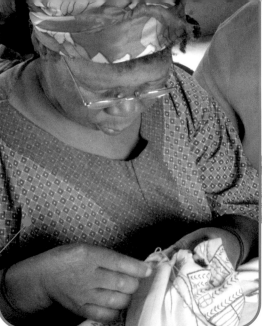

mutation. The concept of our shared humanity and the geography of the world confluencing as a philosophical or cultural metaphor of ownership or possession is interesting. It defines history as a product of human desire, lying just beyond our collective and individual comprehension and our ability to order our shared world into a functional, harmonious organism. In this context, it would suggest that human intelligence contests and prevails over other, lesser more vulnerable truths. If we consider territory and humanity as cultural metaphors, then one could argue that our human desire for ownership is revealed in the character of the land we occupy, a body that is a measure of our willfulness expressed as conflictual history and mutated geography. It would seem that we are adrift in a tide far greater than our imagined desires to capitalize and evolve beyond the opportunistic spoils of our natural and orchestrated disasters.

Within this context, it is safe to assume that our universe is constituted and governed as archetypal opposites. We refer to these binaries as local and global, but realistically it defines division—us and them, you and I. Ironically this divided world is linked. Wealth and privilege define poverty, and suffering, indeed, challenges the ethics of the culture of excess. In order that we grasp the complexity and cultural implication of poverty, we need to construct our individuality as an integral element of shared identity and social responsibility and render it part of our discourses around political globalism. Capitalism, defined as a prevailing social ordering principle, must consider the global, political implications of economic marginalization and the subsequent absence of individual and emotional security within a world that structures poverty as an essential element of profit. This conceptual flaw has enormous sociological, cultural, and

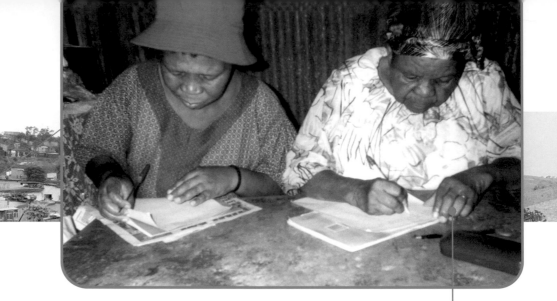

political consequences for us all if we are unable to render the significance
of individual experience as a factor of national or global life.

The philosophical challenge for us is to make a compelling cultural and
economic argument for a sense of individual and collective security to exist
between and within elements of our shared humanity, interdependent
within the context of a viable set of communal but differing values. This
translates as a dignified life to be lived within the sociological idea of
community, a life lived within a familiar emotional geography that can
contribute to an idea of individual security that is economically viable and
emotionally sustainable, that which can contribute to the idea of a feasible
cosmopolitanism. It is my opinion that only such a life can nurture the idea
of social interdependence in what has now become an inevitable globalism.

I believe that local and global sensibilities can and must be lived simultane-
ously. This idea defines, qualifies, and articulates the cultural complexity and
necessity of locality; positions individual identity within secure geographic
and emotional references; and defines the sense of place from which all
our other relationships with the world are contextualized and implemented.

In order that we arrive at a more comprehensive understanding of society,
this notion of intimate association must, by implication, embody the
cultural perspective of familiarity as essential to expressing our universal
and global associations. In this respect, we also need to embrace creativity
as part of the complex process of cultural location and perspective, that which
defines and explores individual experience as part of the general text of
globalism. It is also necessary that we deconstruct existing stereotypes that
position our cultural industries as mere gilt-edged commercial enterprises
and commodities, in order that creativity begins to embrace the conceptual

and material content that impacts on and responds to the conceptual and social world we inhabit. We need to embrace a more comprehensive definition for creativity that recontextualizes it as cultural artifact, reflecting on and engaging with collective life in a more comprehensive manner, rather than merely supplying it with contemplative objects whose value is either endorsed or discarded according to their commodity value.

Does our acceptance of the exclusive nature, practice, and principle of creativity do anything more than affirm and endorse an increasingly isolated symbolic terrain that qualifies exclusivity as our only measure of value, identity, and cultural citizenship? Is the positioning of symbolic modernity, which positions exclusivity as formal and conceptual distance from the objects and subjects represented, a measure of creative character? Does its suitability to philosophical interests lay elsewhere? The inability of cultural thinkers to develop and implement qualitative and thoughtful alternatives to these dominant models of individualism suggests a philosophical crisis or, worse, a resignation, co-option, and endorsement of a failing cultural system. Why do cultural practitioners accept that the museum-gallery-curator triumvirate exclusively negotiates their complex thoughts and emotions as creative commodification? Why do these particularly Western definitions of cultural practice become the desired role model, purpose, and value within an increasingly complex and diverse cultural world defined by unique and contested cultural realities?

South Africa is increasingly referred to as a global, political site of possibility and hope. In this regard, it is seen as an example of functional reconciliation and opportunity. The tragedy of its previous racial policies has been transformed into a legislative framework of government where the debilitating nature of racism is expressed and transformed within a functional social order. It is my contention that creativity and individual vision is integral to these social and political innovations that imagine a contested past to be engaged and socially transformed. These cultural complexities become the references from which South African identity negotiates its position within the idea of political globality, and from which this global

world must now deal with the particular nuances of South African identity. However, despite these remarkable post-apartheid achievements, South Africa continues to live with shocking social, cultural, and political statistics, and thus creates a particular cultural metaphor, context, and social condition within which African cultural thinking needs to respond.

South Africa sustains shocking statistics of mortalities, creating a framework for a special set of social and cultural circumstances. Statistics released by the Medical Research Council (MRC) of South Africa reveal that the road death toll for 2000 was close to 18,000. In that same year, it placed the murder rate at 32,482, which equates to eighty-nine people murdered daily. The release of HIV statistics in South Africa is highly contested, but we can argue that close to 40 percent of all deaths in South Africa are either directly or indirectly related to HIV/AIDS:

- In 1999, 32.8 percent of pregnant women in KwaZulu-Natal were HIV positive.

- The number of people estimated to be HIV positive in 2005 in South Africa was six million.

- The death rate in KwaZulu-Natal (due to AIDS) is now higher than the birth rate.

- In the midlands of KwaZulu-Natal, 75 percent of hospital beds are occupied by children with AIDS-related diseases, and 50 percent of childhood deaths are AIDS related in that area.

- By 2010, life expectancy in Africa will have plunged to thirty. In neighboring Botswana, it has already dropped from seventy-one to thirty-nine.[1]

- In sub-Saharan Africa, approximately 3.5 million new infections occurred in 2001.[2]

- The official unemployment rate in South Africa stands at about 45 percent.

1. Information for first five statistics taken from Doctors for Life International, Inc., http://www.dfl.org.za/issues/aids/aids_statistics.html (accessed 2004; site now discontinued).

2. Avert.org, http://www.avert.org/subaadults.htm.

Joyce Mhlongo reflecting upon her account of a significant event in her life.

3. More information about Create Africa South can be found at www.cas.org.za. More information about the *Amazwi Abesifazane* project can be found at http://www.cas.org.za/projects/voices.htm. Also on this site is an on-line gallery featuring 120 memory cloths, http://www.cas.org.za/gallery/gallery.asp.

The nature and scope of this social fragmentation begins to describe the locality of South Africa. I am convinced that these statistics are mirrored in one form or another throughout the so-called Third World, and are directly related to the indices of economic impoverishment. The chasm between the so-called center and periphery remains the important challenge for thinkers, activists, and philosophers to tackle in this millennium and, as such, implicates us all as both the problem and the solution.

The *Amazwi Abesifazane* project created under the umbrella of Create Africa South is an attempt to engage, understand, and learn from the nature and scope of these challenges.[3] I do not see this work as separate from or different to individual meditative creativity. This project is, in itself, a vast conceptual work occupying social as opposed to symbolic space, engaging the same symbolic and narrative concerns inherent to all creative thinking. For me, it merely conflates the cultural boundaries between studio and street, museum and place of work.

We are all concerned about widening the social and material divides that define our shared modernities, our contemporary world, and its cultural and political challenges. Failure for cultural thinkers and practitioners to challenge their co-option into the dominant strategic alliances between political philosophy, cultural hegemony, and global economic strategy does not bode well for the inevitability of our cultural plurality and individuality as constituent elements of our global citizenship. The inability or refusal of cultural practitioners to critically and strategically engage the homogenizing tendency and strategic social goals of globalism is symptomatic of the political fragmentation of the global diaspora, and the widening chasms between the wealthy and wretched of the world. Upon reflection, our

Personal experiences spoken about within the intimacy of a known community.

aloofness from these cultural realities and the continued inability of the idea of citizenship to broaden its social and political reference will prove as seminal to the relevance and value of our humanities and intellectual professions, as it will to the directions of the new millennium. Endorsing without precondition or critical challenge current global strategic thinking will spiral our fragile plurality out of control and set the stage for continued devastating confrontations. The endorsement of homogenization as the subtext of economic, cultural, and political globalism fails to comprehend the necessity of cultural difference, social individuality, or the need for a particular sense of place, belonging, and security that evolves out of the familiar and known. Prevailing critical thinking suggests that preoccupation with the local ignores the inevitability and sophistication of the global, that the universal or profound cannot be discovered in the familiar, or that the parochial is separate and inferior to the universal. The critical tendency to position the local into packaged stereotypes of the exotic Other is not dissimilar to the simplistic categorization of race, class, cultural and religious stereotype that defines the crude strategic binaries of difference between people. This tendency is the dominant political metanarrative of our time.

The negative positioning of cultural difference within a dominant modernity needs to be rejected and culturally challenged. These crude political tendencies of cultural marginalization promotes racial, intellectual, and cultural generalization, which in turn legitimizes and identifies difference between good and undesirable, low and high, moral and decadent. The critical need to promote qualitative difference between high and low goes deeper than our search for social and intellectual value and promotes

Elsie Nzama and Eunice Gambushe embroidering their cloths.

political expediency around notions of difference and preference. These political narratives of stratification have historical precedent, and it is obvious that we need to critically engage the global metanarrative that conflates modernity with a particular intelligence and sensibility.

The co-option of selected Others from the periphery into this dominant narrative, attempts to serve the symbolic gesture of assimilation, inclusion, and representation. The visibility of these Others are dependent on their being readily identified as part of the dominant cultural narrative, familiar with the formal and conceptual discourses that emanate from the center that is being represented. This selected inclusion suggests that the marginalized narrative is being critically engaged as part of a new expanded sensibility of cultural inclusion. Yet ironically, cultural and economic remoteness increases and parodies the social divides we claim to be engaging. The challenge to the dominant narrative is to acknowledge the value of dynamic autonomous geographic and cultural peripheries that engage within the center, as well as embracing the necessity for transformation as a result of this interaction. It is important that we acknowledge the cultural futility of repackaging the unfamiliar for consumption and critical endorsement as a precondition for inclusion into and reward by the dominant narrative. This level of critical assimilation remains dangerous and will render the Other increasingly remote and intractable, and fails to grasp the formal and conceptual merit of cultural diversity as a critical foil to the idea of homogenization, that which prevails as a global economic and cultural zone of activity.

The *Amazwi Abesifazane* project envisages gathering archival information from the entire geographic region of South Africa. To date, we have collected 2,300 fragments of memory. Of these, 1,300 are from the initiating province of KwaZulu-Natal, 400 are from the Eastern Cape Province, 500 are from the Free State Province, and 100 are from the currently targeted Gauteng Province. The apartheid history of South Africa forms part of the global conscience, and serves as the cultural and creative context of the project. What is significant to South Africans is the pervasive nature of social abuse that discredits individual memory or experience and erodes

141

dignity, reminding us of the global nature of racism under its various political guises of nationalism, economic sovereignty, national interests, or cultural dominance.

Searching for new cultural languages that engage these local and global discourses around identity must, by necessity, be the responsibility of all critical thinkers. The purpose of this archive is to serve as an enduring metaphor of memory in order that we may understand the tenacity and willfulness of people to survive, transcend, heal, and reclaim their lives.

Traditional healers dancing at a ceremonial launch.

The landscape photos on the preceding pages are of the following villages: KwaMashu township, Durban, KwaZulu-Natal, South Africa; Cato Manor township, Durban, KwaZulu-Natal, South Africa; Ugu District, south coast of KwaZulu-Natal, South Africa.

Visible Links

Lara Lepionka

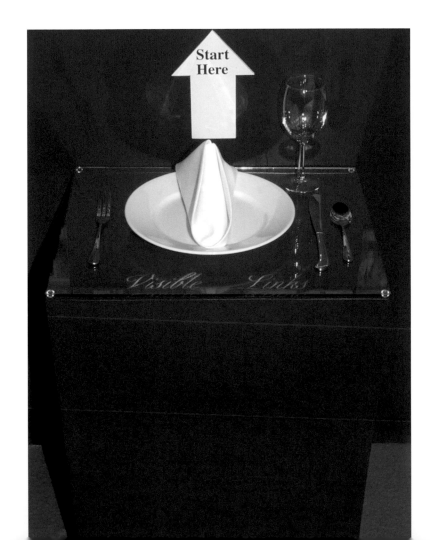

In the Visible Links project,
I researched the origin of an ordinary
place setting through photographs
of the actual workers who participated
in the manufacturing, transportation,
and distribution of those products:
a plate, a wineglass, a cloth napkin,
and a set of flatware.

*Olivia is a sewing technician
at Cotton Goods Company in
Chicago, where workers cut
the fabric and sew the hems
of the napkin.*

Workers at Marcona Ocean Industries in the Caribbean mine aragonite, a mineral used in the manufacturing of the wineglass. Wendell is a powerhouse worker at the mining site.

As a petrophysicist at Mobil Chemical Corporation in Texas, Jose works with geologists to locate new sources of petroleum that will eventually be used to manufacture the napkin fibers.

After making phone contact, I sent single-use cameras to the people and companies traced to the United States, **Poland, Indonesia, South Africa, and the Caribbean. The people I** contacted brought these cameras into their workplaces, such as a trans-Atlantic cargo ship delivering goods from Europe; a mining site in the Caribbean where my camera arrived via a prop plane; a shipyard in Gdansk where Solidarity members sent images of dockworkers; and a retail outlet store in Chicago.

At the Port of New Jersey, union dockworkers receive overseas goods, such as the plate and the flatware. Gail is the documentation clerk for the International Longshoremen's Association Local #1804.

As the new product coordinator at
Libbey Glass in Toledo, Ohio,
Jan oversees the development and
production of the wineglass and
other glassware products.

Tomislav is the A/B worker on a
Mediterranean Shipping Company
cargo vessel that carries the
plate from Gdansk, Poland, to the
Port of New Jersey.

Bill works with Gail at the Port
of New Jersey, where the plate and
flatware arrive via cargo ship.
He is an electrical mechanic for the
International Longshoremen's
Association Local #1804.

At Samancor in South Africa, workers
mine and process the chromium
that is used in the manufacturing of
the flatware. Petrus is the furnace
operator at the facility.

Nadine works with Jan at Libbey Glass. She selects and packages the wineglasses for shipment.

Workers at Mobil Chemical Corporation in Texas mine the petroleum that is processed into the chemicals that are used to make the napkin fibers. Carol works as a security guard at the production plant.

The installation, made up of over 600 photographs by participating workers, was formatted into a poster and sent back to all of the companies, unions, organizations, and individuals who were part of the project.

Paul is a production operator at U.S. Silica in Rockwood, Michigan. Workers here mine and process the sand that Libbey Glass uses to manufacture the wineglass.

Dave is the loading dock operator at Roadway Express, the trucking company that transports the wineglass from Toledo to Chicago.

As a chemical engineer for DuPont in Tennessee, Calandra helps process DMT, a petroleum-based product used to make the napkin fibers.

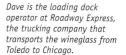

The plate and the wineglass were purchased at the Crate & Barrel Outlet store in Chicago. Blanca is a sales clerk who is responsible for restocking the shelves and working the cash register.

Lara Lepionka, Visible Links, *1999,
600 4 x 5 in. mounted ink-jet prints,
pedestal, cloth napkin, plate,
wineglass, and flatware, 10 x 16 ft.
Installation view from exhibition* Lara
Lepionka, Jennifer Talbot, Christine
Tarkowski, and Anne Wilson *at Gallery
400, University of Illinois at Chicago,
February 14 – March 11, 2000.*

**This project is dedicated to the employees and independent contractors
who participated in Visible Links:**

Brian Solomon, Train photographer,
 Burlington Northern Railroad
Calumite Company
Consolidated Rail Corporation
Cotton Goods Company
Crate & Barrel Outlet Store
DuPont Company
Equistar Chemicals
FMC Corporation*
Howard Ande, Train photographer
Inco Limited*
International Longshoremen's
 Association Local #1804
International Transport Workers Federation
Joel Jensen, Train photographer
Lechters Housewares
Libbey Glass Incorporated*
Maersk Incorporated
Marcona Ocean Industries
Mediterranean Shipping Company
Milliken and Company*
Mobil Chemical Corporation*
National Maritime, Section NSZZ Solidarnosc
National Mining Association*
POL Shipping Lines
PS Graphics Incorporated
Roadway Express Incorporated*
Samancor Mining Company
Stevens Brosnihan, Design consultant
Unimin Corporation*
United Parcel Service
United States Geological Survey
U.S. Silica Company*
ZPS Lubiana

* Indicates financial contribution to poster printing

*This project is partially supported
by a grant from the City of Chicago
Department of Cultural Affairs,
and the Illinois Arts Council,
a state agency.*

Sam Overton *(detail)*, 1997,
thread, fabric, and canvas, 19 7/8 x 15 in.

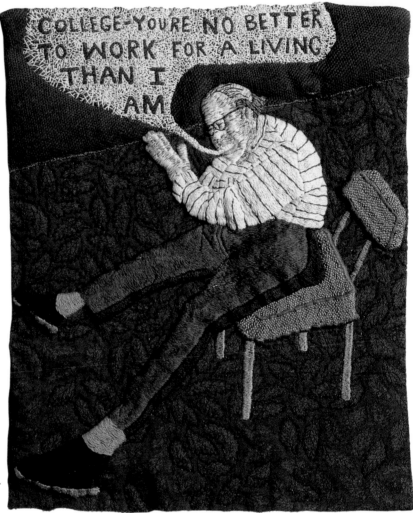

Daddy, 2001,
thread, fabric, and canvas, 9 7/8 x 8 in.

I always lie when I say I'm from
Barbourville, Kentucky. I'm really
from Trace Branch, three miles
outside Barbourville, a gravel road
where mostly my grandparents, their
children, and their grandchildren
lived. Growing up I had a continual
fear of working in the coal mines. It sounded like a fate worse than death. Almost all the men I knew
growing up were coal miners—my father, my uncles, their sons, and our neighbors. Every day of
the week they had to shovel coal in a dangerous, dark, damp hole that was too small to stand up in.

I got my first job because my father met the assistant manager at church. I was a stock boy at TG&Y, a
lower-class department store, kind of like K-Mart but smaller. As the full-time stock boy, I unloaded
trucks, took care of the plants, swept the floor, stocked shelves, priced things, got price checks, and asked
customers, "Can I help you?" about a hundred times a day. I was just out of high school and made
$3.05 per hour. I lived with my parents and didn't have a car for the first few months that I worked there.
I liked the job at first. It was nice to have your own money, especially when you didn't have any.

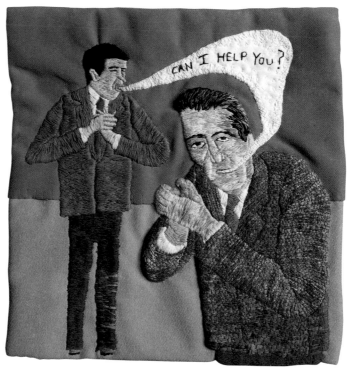

Can I Help You?, 1986,
thread, fabric, and canvas, 7 1/2 x 7 in.

I liked the other employees.
They were all really good people
who worked hard and were in
desperate need of the money.
Everyone had hopes of someday
getting the job they really wanted. We had a warm-hearted manager, then he was promoted to
a larger store. After six months, I was promoted. I got my own department, "Guns and Automotive
Supplies." So there I was, a strong believer in animal rights who had never shot a gun in my
life, selling guns to people I was afraid of.

The Vice-Presidents, 1995
collage, acrylic, and paper, 13 x 17 1/2 in.

The new manager was an asshole. Shortly after he replaced
the former manager, he called a store meeting for all employees.
He made new rules that included not talking to coworkers
about anything that wasn't about helping customers while on the
clock. Next, he outlined the new dress code: I had to wear a
tie at all times. He also gave a speech about our lack of "store
pride," which sounded like a speech he had given lots of times
before or had learned in a class. At the same time, we got
our yearly raises; I got a nickel more per hour.

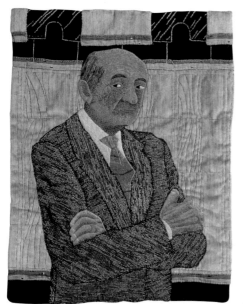

Later, I volunteered to work weekends because they were shorthanded and I needed the money. The store opened after church on Sunday. Hunting season just started and there were about three dozen hunters who came in for shells, and a few others to buy new guns. My coworker Donna came down from housewares to help me because my department had a cash register and I needed help checking out the customers. After the rush, I asked her how she was able to manage working full time and extra on weekends being a single parent. We only talked for a few seconds, but Donna and I were both fired for talking to each other during work hours. I used the unemployment compensation from this job to move and pay my rent, so I could start college. I had taken drafting classes at vocational school, but telling my parents I wanted to be a draftsman was like saying I wanted to be a movie star.

After the second year of college and receiving my AS in drafting and design technology, I got a summer internship at IBM in Lexington. I had to buy a car because I lived in Richmond, about forty miles outside Lexington. This was probably the most coveted job you could get in the state of Kentucky for someone my age. I received $425 per week; I thought that this was how much money people who went to college always made, even with an associate's degree. The five-story building was only two years old, and had a big lobby with lots of plants and a receptionist. I was issued a security pass that opened the door to the building, the floor, and the storage room where the drawings for the upcoming models of their typewriters were stored. Everyone wore really nice clothes, like the ones actors wear on soap operas.

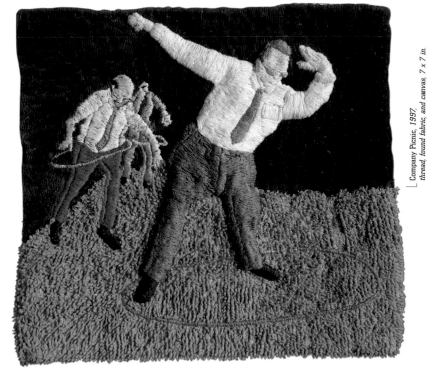

Company Picnic, 1997,
thread, found fabric, and canvas, 7 x 7 in.

I shared a huge office with only one other intern, Stuart. He went to the same college at the same university I did, but I didn't know him. He was kind of preppy. He was in a fraternity and he was working on a four-year degree in industrial design. We each had a huge state-of-the-art drafting table, a chair, a cabinet full of equipment, and an expensive individual lighting system. We went out for lunch every day with the managers and had a couple of drinks. There were fifteen or so full-time employees in the illustration department, only two who actually did any drawing. Everyone else was in some level of management. There was an assistant manager of drafting. The manager of photography was the only employee in his department. There was also a manager of technical writers who wrote things like, "How to take the typewriter out of the box." The research manager did things like videotape people taking typewriters out of the boxes. The department manager's job was to plan the illustration jobs, and to keep track of where we were in completing the job. He also kept track of supplies, employees' birthdays, and met with other assistant managers in other parts of IBM to ask how their projects were going. The two full-time illustrators, three contract artists, Stuart, and I took a typewriter apart and drew each piece to such exact specifications that, in the end, the drawings looked like they were done by the same person.

The first of August, I went into the department manager's office for my evaluation. He said my drawing was excellent and that my work, in general, was excellent, but I needed to "work on the way I dressed." I wore dress pants, a shirt and tie, but off brands that, I guess, looked cheap. In other words, I looked poor compared to the other workers, but then they didn't look right anywhere else, like out dancing or playing games at the company picnic. The department manager told me that if I stayed with IBM, I would become a manager in five years and would no longer be drawing. But I majored in drafting because I had always liked drawing and was good at it. I completed my internship. Stuart was asked back the next summer and was later hired permanent full time. After all, "He looked like an 'IBM-er.'" This job paid me the most I have ever earned.

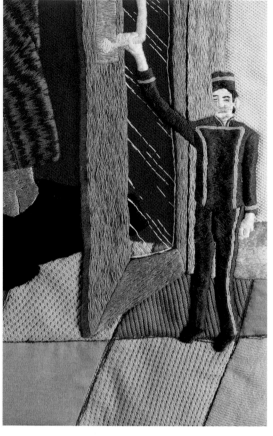

Allowed to Open the Door *(detail), 1992,*
thread, fabric, and canvas, 9 x 6 in.

Six months later, I completed my AS degree,
and for months could not find a job. When I
did finally get one, it was as an industrial
designer at Lectordryer in Richmond, housed
in a temporary building, basically a metal shell
on a concrete slab like the ones used to store
farm equipment. I was hired because they had
gotten several big jobs and they were very
behind. We were working six days a week and
ten-hour days. Even working this much, I
wasn't making as much as I made at IBM. We
did the drawings for the blueprints of industrial
dryers that remove the impurities from oil. Everyone was a redneck, racist, and sexist. I was one of
ten draftsmen, the only one who had a college degree and the only one who dressed up for work. They
hated me. I was told, "You're a really good draftsman, but we don't need drawings this good. We
need ones drawn more quickly." They said customers would never see the drawings and have to pay
extra for you to make "art."

Industrial designer, who was I kidding? I didn't
understand how the Lectordryers worked and
had a hard time knowing what to ask. I couldn't
even change the oil in my car. In school I just
concentrated on making beautiful drawings; I was
an illustrator. I had to ask the engineers about
the electrical systems, flow charts, and materials
lists. They were "real" men, and condescending
to me.

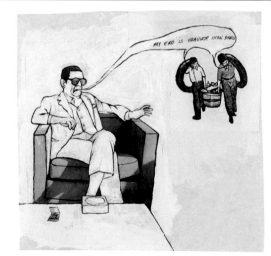

Main Boss, *1987,*
collage, acrylic, and ink, 8 1/2 x 8 1/2 in.

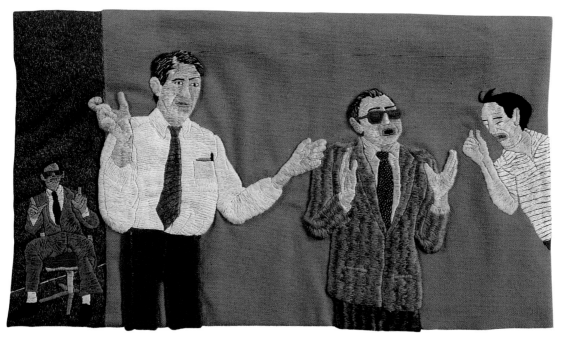

Mid Management, 1990
collage, acrylic, and ink, 6 1/2 x 15 in.

The other draftsmen were their fishing and hunting buddies, and I was very intimidated by them. I looked at getting information from them like detective work. I started photocopying all the information I could find and hoped to make sense of it later. The factory workers couldn't understand my drawings; I used too many "fancy" symbols. At the end of the year, they started laying people off because of the lack of work. I was the last hired, so I quit mainly because I felt so alienated. That was the last full-time job I ever had.

I went back to school in Lexington and began to work on my BFA. I got three college degrees, largely because no one would give me a job. When I couldn't find a job, I would go back to school; you could always stay alive on financial aid. As I became more educated, I was told by potential employers that I "wasn't right," was "over qualified," or would "get bored." All my adult life has been haunted by lack of money, even on occasions when I was ahead I tried to predict when I would be in need again and what I'd do. At the same time, I would think about how to avoid a job, so I could have time for my artwork. After finishing my MFA, I now work longer hours in my studio. My work sells for less per hour than I was making at my first job. I've done the math a few times. But money is just green paper, right? Still, most of my creativity goes into thinking about how I am going to pay for my life. I've learned to live on less, budget, and save. Each of my embroidered works costs less than $1.00 in materials to make, so what you see is mostly the labor.

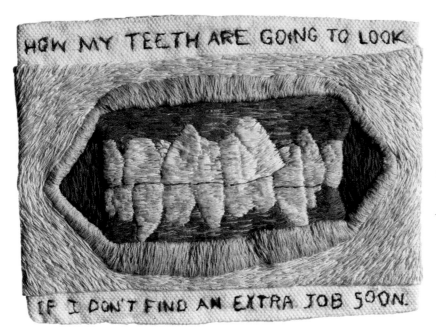

Teeth, 1997,
thread and canvas, 3 1/2 x 4 1/2 in.

THIS PROJECT IS PARTIALLY SUPPORTED BY GRANTS
FROM THE ILLINOIS ARTS COUNCIL, A STATE
AGENCY, AND THE ARTCOUNCIL AWARD, CHICAGO.

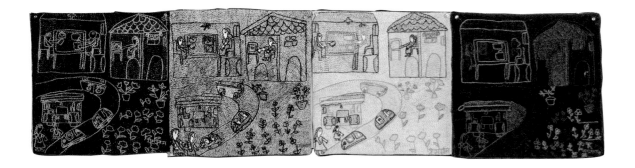

Stitching Women's Lives *Sujuni* & *Khatwa* from Bihar, India

Introduction

Rhymjim Kumari and Jaikali Devi, **Black and White in Colour Workshop Sujuni: Twenty-first Century Bhusara with a Road, Flower Farm, Hospital and College,** *2005, black and white mill cotton and embroidery floss, four panels, each 16 x 16 in., 105 stitches per square inch (above).*

Claiming an artistic and economic agency for themselves and their daughters, women in the northeastern Indian states of Bihar and Jharkhand have worked collectively to transform dormant textile traditions into a modern vehicle of artistic expression and economic empowerment. These women are involved with the *sujuni* and *khatwa* projects started by ADITHI, founded in 1988 by the late Viji Srinivasan, whose untimely death in June 2005 is honoured here. ADITHI takes its name from its mission to address Agriculture, Dairy, Industry, Tree plantation, Handicrafts, and the Integration of women in all of these sectors. One of the organization's first income-generating projects was the revival of *sujuni* in the Bihari village of Bhusura, an area tradition that had died out, leaving behind little documentation.

Sujuni is a term Bihari women use for straight-running stitch embroidery on layered cotton, occasionally accented with chain stitch. Known in other parts of India, particularly in Bengal and Bangladesh, as *kantha*, it has traditionally been made by women working in their homes, layering old worn-out saris and holding them together with fine coloured threads pulled from the saris' edges. Old Bihari *sujunis* depicted religious and secular narrative themes, as well as geometric patterns, flowers, and local life. *Sujuni*s were made for

births and marriages, and as gifts for family members. While *kantha* is characterized by radiating motifs and circular treatments of the field, *sujuni* patterning follows curved trails reminiscent of sharecropper fields. A typical *sujuni* is made with 100 stitches per inch; since 1998, some are made with 200 stitches per inch.

Following the success of the *sujuni* project, ADITHI introduced the *khatwa* project a few years later in the Bihari capital of Patna. *Khatwa* is narrative and abstract appliqué work that uses chain- and straight-stitch embroidery as a linear element. Old *khatwas* were typically made with interlocking designs, much like Celtic borders, with fields of stylized flowers, leaves, and architectural details. Contemporary *khatwas*, as produced by the group of approximately thirty Hindu and Moslem women working together in Patna, depict urban conditions during elections, weddings, religious festivals, and daily commerce. Today, *khatwas* are generally made of cotton canvas, coloured and printed broadcloth, and embroidery floss. Some *khatwas* have begun to incorporate naturally coloured silk produced by nearby women's cooperatives.

In 1997, while in India researching textiles, Canadians Dorothy Caldwell and Skye Morrison were introduced to the *sujuni* and *khatwa* work being made by women associated with ADITHI. Their excitement about this textile work led them to organize the exhibition *Stitching Women's Lives: Sujuni and Khatwa from Bihar, India* at the Museum for Textiles in Toronto, Canada (September 29, 1999–February 27, 2000). Recruiting twenty-two individuals and organizations from Canada and the United States to each support the commission of a new quilt, they gathered an impressive collection of thirty-eight textiles.

The following foreword and essays are reprinted from the catalogue accompanying the exhibition, with Morrison's essay updated to reflect recent developments within the projects.

**Adapted by Judith Leemann
from exhibition materials.**

Salma Mirandi, drawing; stitched by Nirmila Hansda, The Road Between: Story Stole, 2005, ground cloth: Ahimsa (nonviolent) tussar silk dyed with bark from local trees; appliqué khadi hand-spun/hand-woven silk, 24 x 80 in. (opposite).

Viji Srinivasan

Foreword

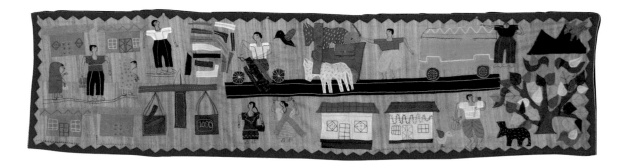

Her tiny lily-white hands are stiff and icy. Though the traditional midwife saved her from female infanticide at birth, the girl baby had to be brought to Patna on a rickety bus over vast expanses of wave-torn floods. It was too late. The pediatrician turned away. Tears welled in the mother's eyes. Her daughter was buried at midnight in the sands beneath the fast-flowing Ganga. The women sent her sweet, scented, white rajnigandha flowers. Widows are condemned to sorrow-filled lives in white saris, relinquishing their jewelry so that other men of the family will not find then alluring. Even when her husband was alive she was secluded by the veil that hid her face from the world. This is all done to prevent the birth of a child from another man: should such a tragedy occur, the funeral offerings of food would go to the other man's ancestors. Her husband's soul would wander in space, in hunger and in agony forever and ever.[1]

1. Source unknown, from the field notebooks of the late Viji Srinivasan.

Along with these frightening and restrictive ways of life for poor Bihari women, there is an intense desire for consumer goods. Whether for dowry demands, community status, or to insure an early marriage, the materialistic world is part of everyday life. The suffering that is a result of capitalist society's norms is etched onto the psyche of these rural and urban women. When *sujunis* or *khatwas* are introduced as income-generating projects, the craftswomen pour out their innermost feelings through their talented fingers, with the glorious threads creating stories of their lives. Whatever

they are unable to tell their husbands, fathers, and brothers, they are now telling the world.

In recent years the women's situation has improved. As wage earners, they are able to come out freely to the cities and even to other countries. *Purdah* (the restriction of married women to the home) has almost disappeared. The age of marriage has increased, and a few of the young women in the village insist on being married without dowry. Literacy and numeracy are improving. Yet, is there real structural change? Have the women conquered men's domination? Has the guilt of the men eased to dull remorse? Some of the men say, "These are our customs." Women retort, "Barbarism is camouflaged in the complexities of our diverse traditions." The local liquor merchant may have been shut down in Bhusura village but there are thousands of other villages where the move towards equality has not yet started.

*Sujuni*s and *khatwas* have opened the way for solidarity and collective action across caste boundaries. The ability to generate income has empowered women in their families and communities— economically and psychologically. Will this success last? How will these women take full control of their lives and be able to celebrate their future? It is the hope of everyone working at ADITHI that the successful planting of creative seeds in individual communities will flow into a wider consciousness about the meaning of women's working lives.

Nirmila Hansda, drawing; stitched by Elbina Tudu, Women and Farming in Santal Village: Story Stole, 2005, ground cloth: Ahimsa (nonviolent) tussar silk grown wild on trees; appliqué khadi hand-spun/hand-woven silk, 24 x 80 in. (opposite).

Archana Kumari, drawing; stitched by Gunita Gupta, Ramnagar, Bihar, Tsunami Sujuni, 2005, mill cotton and embroidery floss, 32 x 34 in., 105 stitches per square inch.

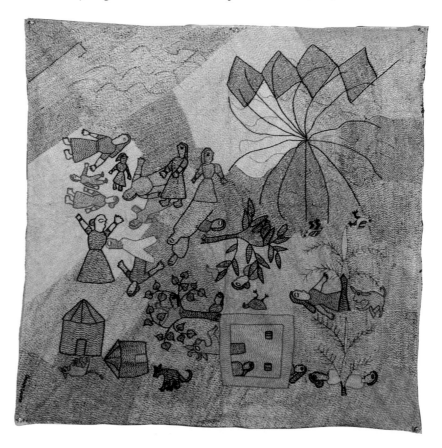

162

Dr. Skye Morrison

Stitching Women's Lives *Sujuni* & *Khatwa* from Bihar, India

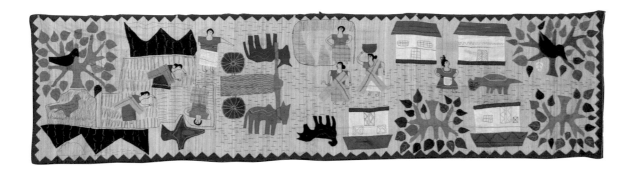

2. Henry Glassie, *Art and Life in Bangladesh* (Bloomington, Indiana: Indiana University Press, 1997), p. 1.

Art is the most human of things. Based in the genetic, in the creative intelligence and the nimble body, art is a potential in every individual. Nurtured in social experience, taught, learned, and bent against circumstance, art is a reality in every culture. Always unifying what analysis divides, art is personal and collective, intellectual and sensual, inventive and conventional, material and spiritual, useful and beautiful, a compromise between will and conditions. Art is, given the storms and pains and limited resources, the best that can be done.[2]

The low status of women in large segments of Indian society cannot be raised without the opening up of opportunities of independent employment and income from them. The Working Group on Employment of Women, 1978, had pointed out, "a policy of promotion of women's employment has to go hand in hand with the broader social policy of strengthening women's participatory roles and their ability to exercise their rights with autonomy and dignity." Otherwise, "the increased employability of women will only further increase the load on women and reduce them to mere beasts of burden."[3]

3. Nirmala Banerjee, *Indian Women in a Changing Industrial Scenario* (New Delhi: Sage Publications, Indo-Dutch Programme on Alternatives in Development, 1991), p. 133.

These two quotes represent the boundaries of the exhibition *Stitching Women's Lives: Sujuni and Khatwa from Bihar, India.* The intersection of art and commerce, the opportunity to create meaningful work that takes the maker out of the cycle of poverty and invisibility, and the wish to have this

work seen as artistic expression have all played their part in presenting the work of women from Bihar to the world. In 1999, the state of Bihar was divided into two parts creating the new state of Jharkhand. ADITHI has worked with Santal (Adivasi/tribal) women in the Dumka district, now part of Jharkhand since the early 1990s.

This story begins in 1996 when Dorothy Caldwell and I traveled to India on a textile research trip. In Bihar's capital city of Patna and then in the village of Bhusura, we discovered textile art forms based on traditional practices that transcended time and space. Dorothy and I arrived in Patna in February 1997. We were taken to *Mahila Harit Kala* (Eco-Friendly Store), ADITHI's retail shop, where we saw our first *sujuni*. We jumped at the chance to visit the villages where they were made. We visited the sharecroppers, fisher women, and *sujuni* workers in the small villages and began to understand the integrated approach that ADITHI took to the development of sustainable livelihoods. Before we returned home we were certain of two things: we wanted to have an exhibition of *sujuni* and *khatwa*, and we wanted more people in India to appreciate this work as art.

In 1998, I returned to Patna and Bhusura, ordered twenty *sujunis* and five *khatwas* and carried them back to Canada. Also in 1998, the Asia Society of New York received funding from the Ford Foundation to hold a *sujuni* exhibition in New York City. This exhibition emphasized the role of women in the community and highlighted local issues that affected their lives. In 1999, my trip to India included a trip with *sujuni* artists to Bombay for an exhibition of their work and an extended trip to Bihar to complete research and documentation.

Since the end of the exhibition *Stitching Women's Lives* in February 2000, Dorothy and I have continued to work with *sujuni* and *khatwa*. Dorothy incorporates the stitch into her workshops all over North America and, most recently, Australia. I return to India annually visiting Bihar and Jharkhand each trip. In 2004, I began a new project *Thread has a Life of its Own*, a collaboration with Santal *khatwa* workers in Jharkhand and Inuit women artists from Baker Lake, Nunavut, Canada, for Planet IndigenUs. Two women from each community came to Toronto for an exhibition and to create a collaborative work at Harbourfront Centre. A documentary film about the collaboration has just been produced. In 2005, I created an intensive skill up-grading workshop with the *sujuni* workers in Bhusura. Ongoing work with the Santal *khatwa* workers and the Bhusura *sujuni* workers will hopefully form the artisan-run core of a sustainable textile practice.

SUJUNI AND KHATWA SOURCES

In traditional wall paintings of Mithila (a region of north Bihar with an ancient practice of women painting the walls of the nuptial chamber), the act of drawing has always been separate from that of painting. An outline was first drawn and colours filled in subsequently; the whole tradition of painting in Mithila may therefore be described as "coloured drawings."[4]

4. Jyotindra Jain, *Ganga Devi: Tradition and Expression in Mithila Painting* (Ahmedabad, India in association with The Mithila Museum, Miigata, Japan: Napin Publishing Pvt. Ltd., 1997), p. 130.

Bhusura, the village where *sujuni* was developed, is less than 100 kilometers away from the centre of *Mithila* painting. *Sujuni*s are created using a similar process: the drawing is separate from the stitching or the colouring in. One person draws the design and many other hands do the stitching. The new tradition of *sujuni*s can, therefore, be described as stitched drawings. Similarly, *khatwa*s use one woman's drawings of the figures and the landscape. Scraps of coloured cloth are then appliquéd onto the drawing, and stitching is completed over top of the bold piecing. These are known as stitched and filled drawings.

The figurative and domestic imagery on *sujuni*s and *khatwa*s relate to *Mithila* and *Madhubani* painting in form and content. Figures are rounded, filled with patterned cloth, and given movement through the interplay of two- and three-dimensional space. Everyday objects such as *chulha* (stoves), *hasiya* (chopping knives), and a multitude of pots and pans abound. Instructive drawings of men and women in the nuptial chamber, a vital aspect of *Mithila* and *Madhubani* painting, are found in *sujuni*s and *khatwa*s as examples of the dangers of unprotected sex leading to AIDS. *Sujuni*s and *khatwa*s borrow from the private world of religious art and take it to the public marketplace. Just as *Mithila* painting expanded the life of individual Bihari women like Ganga Devi, *sujuni* and *khatwa* textiles permit the women of Bhusura and Patna to leave their homes, travel around India, and even represent their work abroad.

WORK AND ART

The old symbols, images, myths and legends now reappear in the works of these artists, in new roles, often acting as pictorial or poetic metaphors resulting in amazing artistic transformations . . . The resources harnessed in this search for new visual forms and vocabulary include the artists' observation of nature and contemporary life around them including impressions gathered from theatrical performances, cinema, textbook illustrations and calendars. These are not transplanted as collages (this may also happen once in a while) but are translated into their own pictorial idiom making their works at once products of their own contemporary existence.[5]

5. Jyotindra Jain, ed., *Other Masters: Five Contemporary Folk and Tribal Artists of India* (New Delhi: Crafts Museum and The Handicrafts and Handlooms Exports Corporation of India Ltd., 1998), p. 14.

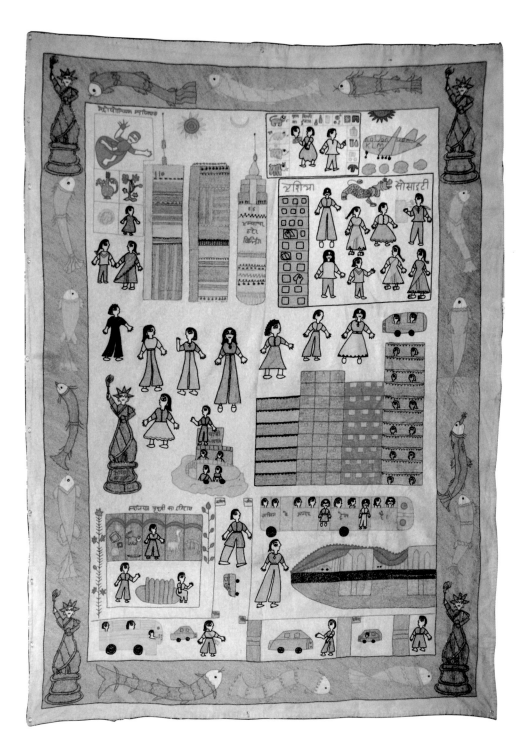

The British High Commission and the Ford Foundation in Delhi were the first to commission *sujunis* in the late 1980s. They ordered a series of wall hangings depicting observations and reflections of the lives of the women of Bhusura. By tracing the history of these early works, it appears that foreigners were dictating the designs. Insofar as they were asking for images of happy villagers, male children (when the women were concerned more about female children), and the romantic pastorals of village life, these first works and some of the current production are politically safe and highly decorative.

As knowledge of the *sujuni* work grows, more people are becoming interested in these pieces as a form of pictorial commentary on contemporary popular culture. The women of the village encounter many new things in their life experiences. Health workers from the World Health Organization come to Bhusura to talk to them about AIDS and show them how to use condoms. The problems of female infanticide and dowry death continue to affect the community. Access to radio, movies, and television gives the women many topics to discuss, including literacy, politics, women as role models, and the hectic pace of urban life. The physical environment, whether rural or urban, profoundly affects the quality of their lives, so it is frequently a source of inspiration. As the women have success with their work, and it becomes more central to their lives, *sujunis* and *khatwas* appear more frequently. The women draw and stitch images about these subjects through their own interpretations of the world.

Members of the Bhusura cooperative come frequently to Patna and Delhi where they are exposed to other groups of working women and other markets for their work. From five workers at the start of *Mahila Vikas Sahayog Samit* (MVSS or Women's Cooperative Development Organization) in 1989, the group was renamed *Bhusura Mahila Vikas Samiti* (BMVS or Bhusura Women's Self-Help Group). By 2004, there were over 500 workers stitching for all or part of their income. Unfortunately, the expansion of the *sujuni* cooperative was not transparent in terms of wages or making the groups independent through total participation. That same year, BMVS came under the control of men from the village and nearby city who stopped paying the women's wages.

Khatwa self-help groups have developed differently. Since they are part of a complex urban life, the community of *khatwa* makers in Patna is not as closely knit as the *sujuni* makers. For the *Stitching Women's Lives* exhibition three groups worked together at *Mahila Harit Kala*. But in 2000 after the grants ran out, *Mahila Harit Kala* closed down and groups had to deal directly with their clients. The group leaders kept the information

to themselves and became more like middle women for the group members, rather than sharing their business with the group. The *khatwa* groups in Patna have suffered a fate similar to the *sujuni* workers. In 2003, *khatwa* workers from Patna and Jharkhand, as well as *sujuni* workers from Bihar, participated in an exhibition at the October Gallery in London, England. After this exhibition, the prices of work varied greatly but the women in villages and cities were not properly paid. It was as if everyone suddenly decided that this was their moment to make money and forgot that the work was fundamentally for the improvement of the livelihoods of the women drawing, stitching, and storytelling.

Fortunately, the new *khatwa* group formed from Santal women for the *Thread has a Life of its Own* exhibition is based on an artisan-run transparent model. *Sirali* (Mother Earth) discuss every order, each person's contribution, and the larger context of commissioned work. The group has a strong sense of identity and recognizes *khatwa* as a form of cultural expression.

The crisis with *sujuni* was recognized only in February 2005. None of the women knew what their labour was worth or how the *sujuni* business worked. Thus, a new organization, *Sujuni Mahila Jeevan* (Stitching Women's Lives) was formed. This artisan-run, self-help group is made up of thirty-two women (half skilled older group leaders and half new young workers). Their payment scheme and business structure are transparent. They have experienced everything from product development to pricing and from stock lists to sourcing raw materials. This new empowering and self-directed model may rescue the making of *sujuni*, but it cannot solve the lost wage problem. Only political pressure and moral embarrassment of the people who have acted irresponsibly will bring the women their rightful wages.

Since *sujuni* and *khatwa* making have undergone such a crisis, it will take time to find and develop women who can travel to markets, take orders, and maintain timelines for production. This is neither fast nor easy because the women have limited literacy and innumeracy. Many have not traveled because of social restrictions. Each step of their independence and true empowerment must be monitored to promote success.

PERSONAL ENCOUNTERS

The more time I spend with these women, the more I realize that they are listening to the ideas and inspirations of others, then interpreting them with their own images. Two examples of this are the *Cow Dung Sujuni* and the *Hawkers and Vendors Khatwa.* In 1998, I took a copy of the

Nirmila Devi, drawing; stitched by six women from MVSS Bhusara, Bihar, Cow Dung Sujuni, *1998, mill cotton and embroidery floss, 60 x 90 in., 210 stitches per square inch (opposite).*

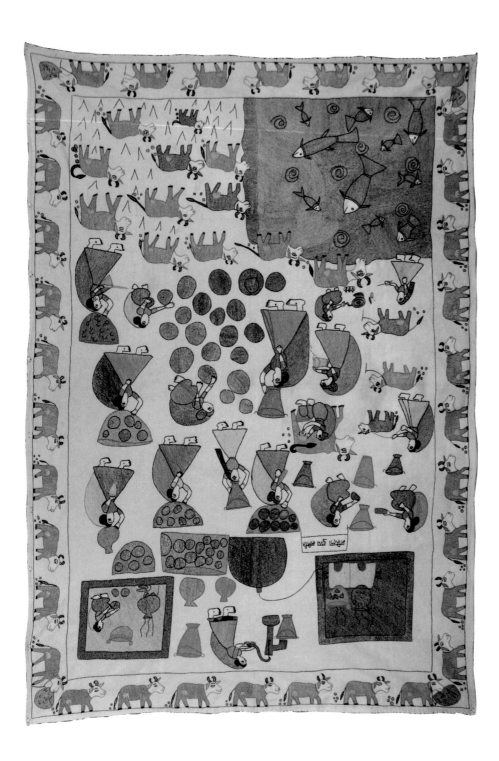

National Film Board of Canada's documentary *Who's Counting? Marilyn Waring on Sex, Lies & Global Economics* to Patna. Earlier that year, Marilyn Waring had given a brilliant talk at The Humane Village, an international industrial design conference in Toronto. The topic of this talk was cow dung as an industrially designed product:

I have watched women in many parts of the world following herds of animals to scoop up steaming dung in their bare hands, placing it in woven baskets which they then hoist onto their heads and carry. The loads they bend for, lift and carry are very heavy, and the work is very tiring. In the context of the lives of these women, dung is not a summer city-garden rescuer; access to it is a matter of daily survival. In addition to providing fertilizer, it is a primary source of cooking fuel and is also used as a building material and plaster.[6]

6. Marilyn Waring, *Three Masquerades: Essays on Equality, Work and Human Rights* (Canada: University of Toronto Press, 1996), p. 45.

Dung is not a primary product, whatever we might have assumed in the past. Dung itself appears to be taken for granted as a "free gift of nature." Nowhere have I found it recorded with milk, skins, meat, or animal by-products in a nation's livestock production accounts, or recorded in energy production accounts. In addition, we will not find the hours women spend in gathering, transporting, cooking with, processing, manufacturing from, or decorating with it recorded as work.[7]

7. Ibid., p. 47.

Wishing to see what the women thought of Waring, we arranged an evening at Viji Srinivasan's home where interpreters translated the film into Hindi. Women from many of the ADITHI groups (about twenty in all) came for the party. I asked the women of Bhusura to make a *sujuni* about cow dung as a response to the film. Other *sujunis* have been made about cow dung. When I asked about cow dung being added to the visual repertoire of *sujunis*, Nirmala Handsa said to me, "This dung is our work. You don't use it so many ways where you come from. You gave us the idea but now it is ours." This *sujuni* may be the first time dung has been recorded as a representation of work.

The *Hawkers and Vendors Khatwa* is a journalistic piece that records some of the issues of other poor working women in the city of Patna. Viji asked me to photograph a day in the life of the stainless steel pot sellers who traded pots for used clothing, which they then took to the secondhand street markets. She wanted a document that would give all the hawkers and vendors photo-identification so that they wouldn't be harassed by the criminal elements that were demanding bribes in exchange for space to sell their wares. We took two *khatwa* workers with us for the day. After visiting the hawkers in their curbside dwellings we drove to the lively street

market and held a photography session. The "business men" (criminals who demand bribes that will allow vendors to occupy public space) and eventually the police came to drive us out. It was an adventure that was then depicted in the *Hawkers and Vendors Khatwa*, including the "bad guys" black car and a flight of birds, which symbolize escape. The *khatwa* is made out of the used clothes that it depicts, making a literal connection to the story. The characters of the individual hawkers and vendors are drawn out through the stitching.

In 2005, the *Stitching Women's Lives* workshop took place during the Bihar elections. This meant a kind of state of Marshal Law as vehicles were commandeered for politicians to use and many materials were unavailable because trucks were stopped on the highway.

MOVING TO THE ART WORLD

The separation of *sujuni* and *khatwa* from works of art is extremely unclear. The urban viewer in India is likely to compare the stitching to that done on a sari or *dupatta* (a long piece of cloth used as a scarf, veil, or shawl) because it is first seen as a functional object such as a bed covering, and then as having a story with meaning. North American quilts (a parallel Western form of textile art) are seen primarily as meaningful art objects, which can fetch high prices in an art gallery. Viewers of both of these art forms have a responsibility to respect the makers' skills and consider their intentions. Scholars of popular culture and textile experts have judged *sujunis* and *khatwas* by comparing them to past examples of *kantha*, or to the newspaper headlines that are their topics, or by the number of stitches per square inch. Designers and craftspeople are expert at recognizing the highly developed technical skills and the rich surfaces created by the stitches. Some Western art critics are puzzled because just one person does not always make the work; this way of working has been known to fly in the face of the Western notion of the "original work of art."

Since *sujuni* and *khatwa* have enjoyed success in international markets and more women have been able to attend exhibitions in galleries and museums, they have become aware of the artistic merits of their work. Gradually work is being signed. Individual women are both drawing and stitching the work. Everything from woven labels (for identification) to postcards and hangtags with the stories of the pieces are beginning to appear. This is all part of the process of makers authenticating their work.

The creative expression of rural and tribal artists has always been seen by most of them (art historians) as a product of ethnic collectivity whose authenticity lies in the remoteness of time and space.[8]

If the artist's name was not inscribed on a work of art, it was not because his individuality as an artist was required to be eclipsed. Often the name of an individual artist was not mentioned in the work, either because there was a "mason mark" somewhere, or because he, being a part of a certain socio-economic system, had to be "sublimated" to highlight the role of the patron or the commissioner of the work.[9]

Nirmala Handsa's mother-in-law is known in the village as a good storyteller. She fuses the past, present, and future in narratives that include the family, neighbours, gods, politics, and the land. Nirmala is good at drawing. She tells her stories in pictures that are stitched into the *sujunis*. Archana wrote and then stitched the text of the story of the River Ganga that Nirmala's mother-in-law had told. Hindi text stitched alongside images is a recent phenomenon. At first, no one involved in the project knew how to write. Now everyone gathers around to listen to Archana read the story in a new form of folk communication. *Sujuni*s and *khatwa*s do not fit neatly into any category. This work is a record, a livelihood, and an art form. It addresses the lives of women, the issues that need to change, and the need for, as the nineteenth-century socialist and designer William Morris put it, "useful work versus useless toil."

Beginning as a revived craft practice *sujunis* and *khatwas* have transcended their original forms through the imaginations of the women in Bhusura and Jarmundi to become a new and, at times, uncompromising art. These textiles are *narratage* (visual media where one of the players is a storyteller). The woman drawing the story on the plain cloth is the storyteller. The women stitching, piecing, chatting, and changing that drawing into a *sujuni* or *khatwa* are listening to and transmitting the storyteller's narrative, while adding their own interpretations to the text. Just as folksongs or legends are passed on through oral traditions, these works are passed on from hand to hand through observation and conversation. They offer a unique glimpse of contemporary life. The linguistic, poetic, and aesthetic accomplishments of ordinary women with extraordinary visions of the world are at the heart of this work.

8. Jain, *Ganga Devi: Tradition and Expression in Mithila Painting*, preface.

9. Jyotindra Jain and Aarti Aggarwala, *National Handicrafts and Handloom Museum, New Delhi* (Ahmedabad, India: Mapin Publishing Pvt. Ltd., 1989), p. 10.

Salma Mirandi, drawing; stitched by Subarsini Soren, Sharing the Well: Story Stole, 2005, ground cloth: Ahimsa (nonviolent) tussar silk grown wild on trees; appliqué khadi hand-spun/hand-woven silk, 24 x 80 in. (opposite).

Laila Tyabji

The Story Behind the Stitches

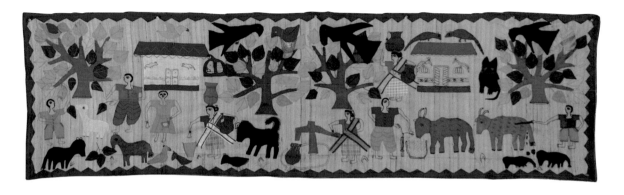

10. DASTKAR is a Delhi-based nongovernment organization for crafts and craftspeople, providing a variety of support services to traditional artisans, including training, credit, product development, design, and marketing, working with over 250 grass-roots producer groups all over the country. DASTKAR strongly believes in craft and the alternative sector as a social, cultural, and economic force of enormous strength and potential. Helping craftspeople, especially women, learn to use their own inherent skills as a means of employment, earning, and independence is the crux of the DASTKAR programme.

In Bhusura village the women sit in the winter sun, stitching their quilts. The quilts tell the story of the women's lives—marriage, working the fields, tending both livestock and children. Violence, rapes, infanticide, and dowry deaths are also a part of the quilts. So are the women's aspirations for the future: education, earning, and travel to far-off lands. But behind their slow stitches is another story, told through their craft and their own creativity, which is gradually reshaping their own lives.

For over two decades, DASTKAR[10] has been working with traditional Indian craftspeople, using their skills to draw them into the economic mainstream. As I write, I'm haunted by the words of Geeta Devi, one of the women who makes *sujunis*: "To work is forbidden, to steal is forbidden, to cheat is forbidden, and to kill is forbidden. What else is left except to starve, sister?" As per the going rate for female agricultural labour in Bihar, a woman would have to work seventy days a month in order to feed her family. Devi's embroidery stitches not only empower her; they have become her alternative to starvation. This is the context in which many Indian handcrafts are made. It is the context in which DASTKAR and I work, where the beauty and creativity of the product is second to the sheer economic necessity of its production and sale. Ironically, the disregarded, decorative activity done by women has turned out to be the

lifeline of their families. As Ramba Ben, an embroiderer from Banaskantha who specializes in mirror work once said to me, "The lives of my family hang by the thread I embroider." Mirror work or *Badla* work uses a stitched grid and then a circular blanket stitch to fasten small round or square mirrors onto fabric. This work is especially known in the Indian states of Gujarat and Rajasthan.

The state of Bihar where the *sujuni* quilts come from is a confused and sad place. The mixture of fatalistic apathy in the villages and mindless violence in the towns is depressing. But *sujuni* itself is a lovely craft, and North Bihar is physically beautiful and gentle, all green undulating groves and streams, which are deceptively and lushly serene. The media reports of violence, corruption, and intercaste tensions are at such variance with the outward passivity and karmic calm. The women who make *sujunis* are a paradigm of similar contrasts and contradictions: the fineness of their stitches contrasts with the poverty in which they work. The exhibition in Canada represented the reverse of their own society's disrespect, not only for their fine skills but also for women's lives in general. When I was last in Bihar, two craftswomen were talking (as we talk of which movies we last saw) of how often they have contemplated killing themselves. Only the thought of their children had saved them. The story behind the quilts is therefore both a parable and a paradox. Craft traditions are not only unique mechanisms for rural women entering the economic mainstream for the first time, but they also carry the stigma of inferiority and backwardness as India enters a period of hi-tech industrialization and globalization.

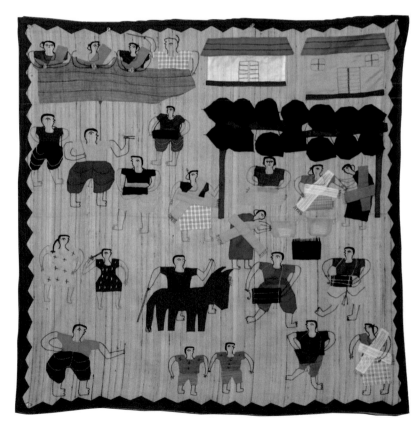

Salma Mirandi, drawing; stitched by Subarsini Soren, Of Weddings and Puppet Shows: Wall Hanging, 2005, ground cloth: Ahimsa (nonviolent) tussar silk grown wild on trees; appliqué khadi hand-spun/hand-woven silk, 24 x 24 in.

174

In the late 1980s, the first ADITHI designers had the interesting challenge of trying to create a whole new design idiom for *sujuni*. The original craft tradition had died without being documented and the women were not yet equipped to become their own designers. Solutions include the adoption of the *kantha* pictorial quilt tradition of Bengal (the two techniques and cultures have much in common), and the treatment of the *sujuni* quilt as a vehicle for social comment, a sort of comic strip poster illustrating social issues like family planning or dowry, rather than a decorative household accessory.

The *sujuni* and *khatwa* techniques lend themselves to pictorial story-telling but social and political comment should also be pleasurable viewing. In the first *sujuni* quilts social rhetoric replaced design, aesthetics, and even function. A condom quilt crafted in rural Bihar is an interesting, one-off cultural phenomenon, but when hundreds of women in dozens of villages have both the need and the capability to earn an income from *sujuni*, there is an imperative to develop products with a more universal appeal—products that are marketable, functional, and fun. DASTKAR's design and marketing intervention with *sujunis* is three-fold:

- To develop new products, including garments, accessories, and soft furnishings, which will add diversity to the *Mahila Vikas Sahayog Samit* product range.

- To help the women understand the basic concepts of product development in order to give their work an aesthetic as well as a sociological base.

- To encourage the embroiderers to be creative artists, rather than merely cheap labour.

Until recently, the women did not create their own designs. Rather, they were developed by designers employed by ADITHI or DASTKAR, and traced onto the cloth by two girls who were trained in this work. The DASTKAR design principle is to preserve *sujuni's* unique qualities and the spontaneity of its traditional style (which is almost like a child's drawing) while incorporating new elements and motifs; varying the colours and usages; and helping the *sujuni* women become the designers. Each spread, garment, or sari is made up of different small elements and motifs that are linked by freehand drawing, so that each piece is unique.

The quilts have become the means to learn how to combine colours, motifs, and designs and to help the women participate more fully in the creative process. We illustrate how the various images of their lives can be

incorporated into one harmonious composition, introducing the concept of colours as conveyors of mood and creators of pattern. This has led to the start of an animated discussion on structure, and the symbolic need for both design layouts and society to operate within a shared framework. In life and art, human beings and nature must interact together. Hopefully message and metaphor mingle harmoniously with art and end-usage.

When we develop designs, we play a game, encouraging the women to sort my bag of 100 coloured threads into piles of greens, reds, yellows, and blues. It is interesting how confusing they find it (unused to such a plethora of different shades) to place a pale green or misty blue into an appropriate colour group. Embroidering, too, they find it difficult to remember the rhythm of colour repeats. Choices, and their ability to make those choices, are both equally unfamiliar concepts. In one quilt, we were depicting one woman in various stages of her life. The idea that she should be the central figure in each square, distinguished by size or some other special feature, seemed strange to them. Obviously, unlike urban women, the *sujuni* workers don't see themselves in the "heroine" mode, or as markedly different from each other.

Sujuni quilting is an age-old craft skill, but ADITHI's revival and reinterpretation of *sujuni* in the Muzaffarpur district is only a decade old. It has taken the craft and the women into new, uncharted directions. It raises the whole issue of interventions, and points out some of the differences between this traditionally based practice and other DASTKAR projects where there are no existing craft and design traditions. Are we creating a new, indigenous craft tradition that will flourish and flower into the next millennium, or would *sujuni* in Bhusura die if ADITHI and DASTKAR were to disappear?

Does the end result justify the means? How do we justify our interventions? Is the choice of *sujuni* itself, as a vehicle to generate rural women's employment and earning, an appropriate one? It certainly is not a solution that arose originally out of the women's own skills, or the demands of the consumer. Once begun, the process cannot be reversed. Women, stitching their lives into their quilts, have changed their own lives in the process. The quilts, once simply a source of income, have become their means of conquering the confines of their landscape and their limited lifecycle— a *sujuni* worker's way of transcending the dependence and drudgery of her arduous, anonymous being. Through discovering a creative skill and strength that is uniquely hers, she has rediscovered her femininity, identity, and self.

Dorothy Caldwell

The Stitch Dorothy Caldwell Talks about *Sujuni* and *Khatwa*

Nirmala Devi, drawing; stitched by group Pregati *(Progress): Muni, Babli, Sanjula, Runa, Indu, and Gunja,* NABARD *Workshop Sujuni, 2005, natural color mill cotton and embroidery floss, 40 x 50 in., 105 stitches per square inch (detail).*

While preparing for my research trip to India, I was reading about the role of textiles in Indian culture. Many religious texts in India talk about the universe being seen as a cloth woven by the gods. I like the idea of an uncut cloth being seen as an organized universe. The warp and the weft—the uncut fabric—the whole cloth. India has a god and a goddess of tatters. You can take rags to certain temples and offer them to these gods and goddesses. Supposedly, you will receive a whole cloth back.

My first knowledge of *kantha* came from an article that Stephen Inglis (Head of Research at the Canadian Museum of Civilization in Quebec, Canada) gave me while I was studying Canadian quilts. It was given to me at just the right time. I learned that old *kantha* was made of recycled scraps of soft white saris and *dhotis* (men's garments made by wrapping a long piece of cloth around the waist and tying it through the legs), which were hand stitched together to create a larger cloth. *Kantha* intrigued me because women made these textiles by piecing together imagery from their own lives: religious events, social activities, and rituals. Within a similar format, each *kantha* has personality. This relates to traditional North American quiltmaking, where women constructed quilts with cloth that had a previous history and, using their own designs, worked in groups to stitch them together.

RESEARCH IN INDIA

Skye Morrison and I ended up in Bihar by chance, by luck, by whatever. When you have a focus, these things seem to happen magically. I spent two weeks in Calcutta, visiting various women's cooperatives that have revived *kantha*, and seeing the historical collections at the Ashutosh and Gurusaday museums. The cooperatives I saw in Calcutta were successful economically, and had high standards of craftsmanship, but they were either copying historical work or second-guessing what Westerners might like. I was not finding personal expression from women's lives.

Shirsendu Ghosh, my guide and interpreter in Calcutta, told me that he was involved with an organization called ADITHI, in Bihar. They were working on a *sujuni* project and he invited us to visit. Bihar turned out to be incredible. The first *sujunis* that I remember seeing were in ADITHI's Patna office. I thought, "These must be the really special *sujuni* quilts that they have put aside for their own collection." When I tentatively asked if they were for sale, they said, "Oh yes, we certainly would sell all of them!" We immediately bought two. We then went to the village of Bhusura where the project is based. In the building where the women keep their threads, meet, do their work, and store the quilts, they opened trunk after trunk of these quilts. Piles of them—it was overwhelming.

On our last day in Patna, Skye came across a *khatwa* in *Mahila Harit Kala*, the ADITHI shop. It was appliquéd and embroidered, and had been made by Hindu and Moslem craftswomen working together. My first reaction was, "Skye and I are going to have a big fight over this piece." It was a graphically stunning urban dowry quilt, with images such as cars, trucks, and computers. The comparable dowry quilt from the village was subtler, with more traditional images of cooking utensils and storage vessels.

To me, *sujunis* and *khatwas* are connected because women are working with personal subject matter in both cases. They are also starting to use materials from one another's co-ops, such as hand-woven silk and naturally dyed cloth. Each group can inspire the other and be supportive, which is good for the whole organization.

THE *STITCHING WOMEN'S LIVES* PROJECT

In order to commission the *sujunis* and *khatwas* for the exhibition, Skye and I found twenty-two individuals or groups to each sponsor a quilt. Talking to people in Canada and the United States about the women and what they are doing is satisfying. We feel that it is important that people

Nirmala Devi, drawing; stitched by group Pregati *(Progress): Muni, Babli, Sanjula, Runa, Indu, and Gunja,* NABARD Workshop Sujuni, *2005, natural color mill cotton and embroidery floss, 40 x 50 in., 105 stitches per square inch (opposite).*

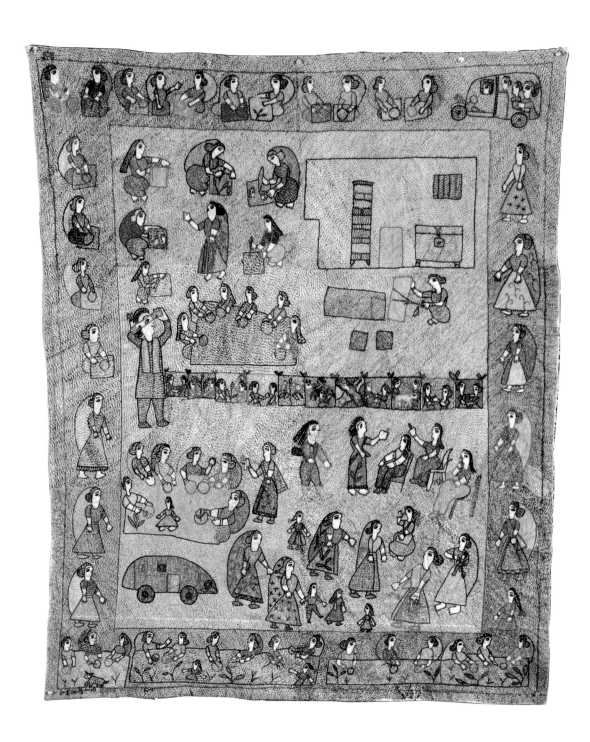

179

buy the work and thereby contribute to the women's economic freedom. The education and economic success that goes on through the quilts is profoundly affecting people's lives. The quilts are a living part of these women's history because they evolve continuously. No two are the same. *Sujuni*s and *khatwas* are journalistic records that have an impact on the maker's world view and on our understanding of their lives.

WORKSHOPS

As a result of my research in India, I have developed several stitching workshops that are tailored to quilting and embroidery groups as well as art, craft, and design students throughout North America. Students explore personal themes by analyzing a quilt and answering a series of questions about the imagery and the construction. *Sujuni*s and *khatwas* provide a way of investigating "the stitch" as a connection between utilitarian, decorative, and conceptual work. My workshops are all about "the stitch."

Traditionally, the stitching in *kantha* cloth was a practical way of connecting three or four layers of cloth together. The simple utilitarian straight stitch soon began to take on personal meaning as it evolved into images from the stitchers' lives. This method of accumulating stitches is the basis of my workshops. Students bring their lives to these quilts on many levels.

Experienced stitchers and quilters immediately see how *sujuni* is done. They are in awe when they come up close to the *sujuni*s and realize that the backgrounds are solidly stitched white on white. During the course of the workshop, they become used to thinking with the stitch. Art, craft, and design students respond most enthusiastically to the *khatwas*, which are dramatic, contemporary, and graphic. Everyone comes away with a heightened sense of the narrative potential of stitching.

FINAL THOUGHTS

The balance between what stitches do (patch, repair, connect, and hold layers together) and what stitches can become as narrative elements is key to understanding the artistic expression of the women in Bihar. This is where North American quiltmaking, *sujuni*, *khatwa*, *kantha*, and many other women's domestic arts share common ground. Art is the expression of one's life experiences and having others respond to that expression. It all comes down to communication. We listen to the women's stories and we make up our own stories to share.

...a **digitized field** of tools

INVENTORY

OF LABOR

Barbara Layne

Sue Rowley

1 M6770 Wire Brushes

38 M992.74.61.1-38 Needle Case
" The Penelope Knitting Pin Case"

12 M966.39.20
Sewing Box - Victorian

27 MAC 5009 Needle Holder

82 M9707 Implements
for Carding Wool

33 M18527 Work

13 M14966.-14970
Thread Winders

32 M996x.2.52 Housewife

62 M992.7.196.1-2
NiddyNoddy (Skeiner)

16 M981.11.14 Yardstick

2 M973.4.2.1-9
Thread Holder

68 M966.52.2.1-23
Lacemaking Pillow
with Bobbins

50 M19162 Sewing Kit

34 M992.56.9.3
Wool Winder

62 M992.7.196.1-2
NiddyNoddy (Skeiner)

3 M20577.1 Scissors

5 M996x.2.56 Ivory
Tatting Shuttle

24 M968.4 Sewing
Accessories

23 M996x.2.55(1-5)
Bodkin Case

21 M9595 Pincushion

4 M5946 Pincushion

13 M20577.2 Scissors

85 M965.65.1 Flax Beater

14 M9859 Scrapbook on Knitting

66 M992.56.13-14
Pair of Shuttles

1 M6770 Wire Brushes

22 M996x.2.252.1
Embroidery Hoop

36 M19351.1-13
Sewing Box in Form
of Piano

26 M7975.1-10
Sewing Case

6 M992.7.195.1-2
Flax Break and Flax

15 M21631 Pincushion

45 M966.36.1 Pincushion

9 M971.179.1
Needlework Case

64 M9859 Scrap Book
on Knitting and
Kindred Subjects

31 M5943 Buttonhole
Stamp

93 M993x.2.22 Needlework Case

7 M975.69 (.3)
Sewing basket

8 M996x.2.68 &.60
Crochet Hook
and Corkscrew

84 M979.84.1
Bluenose
Rug Hooker

44 M975.52 Darning Ball

19 M996x.2.96.1-2
Pair of Knitting
Needles

29 M17477
Netting Needle

27 MAC 5009 Needle Holder

41 M996x.2.345
Hooking Needle

39 M17703 (L) & M993x.2.33 Pin

53 M996x.2.246.1-2
Pincushion

63 M22008 Pincushion

40 M12647 Implement

91 M980.196.1-2 Swift

37 M17478.1-2
Netting Needle

62 M992.7.196.1-2
NiddyNoddy (Skeiner)

73 M976.128 3-6
Ivory bobbins

3 M20577.1 Scissors

48 M993x.2.30 Package
of Silk Floss

54 M15281.1-8 Housewife

52 M9859 Scrapbook
on Knitting

49 M7844 Raddle Loom

71 M993x.2.20
Strawberry

72 M975.61.297
Wool Carder

69 M15282.4 Sewing
Basket and Cover

65 M20577.1-3
Scissors and Case

66 M992.56.13-14
Pair of Shuttles

74 M976.128.1 Tatting

20 M989.144.1
Necessaire

84 M979.84.1
Bluenose
Rug Hooker

73 M976.128 3-
Ivory bobbi

18 M965.130-37.1-4
Bodkin set

59 Scrapbook
Knitting and
Kindred Subjects

82 M9707 Implements
for Carding Wool

17 M5927 Carved Ivory

43 M992.30.1 Pincushion

57 M2242.1 Embroidery Scroll

27 M963.1965.1-2 Needlework Case

53 M992.7.194.1-2 Container and Flax

61 M986.110 Needle Case

47 M989x.52 Pincushion

69 M15282.4 Sewing Basket and Cover

65 M966.52.2.1-23 Lacemaking Pillow with Bobbins

18 M965.130-37.1-4 Bodkin Set

9 M7844 Kajdel Loom

92 M976.128.12-29 Bobbins for Lacemaking

78 M971.153.10 Darner

20 M989.144.4 Necessaire

11 M14966.1-14970 Thread Winders

70 M996x.2.53.1-5 Embroidery Machine

22 M996x.2.252.1 Embroidery Hoop

67 M992.7.193.1-2 Hackle, Flax

71 M993x.2.20 Strawberry

51 M976.128.7-11 Bobbins for Lacemaking

86 M996.100.1 Spindle

77 M975.67.32 Lacemaking Pillow with Bobbins

62 M992.7.196.1-2 NiddyNoddy (Skeiner)

58 M992.56.17.1-2 Warping Paddle

83 M965.196.6.1-2 Needle Case

72 M975.61.297 Wool Carder

73 M976.128.3-6 Ivory Bobbins

85 M965.65.1 Flax Beater

89 M996x.2.332 Heddle

84 M979.84.1 Bluenose Rug Hooker

66 M992.56.13-14 Pair of Shuttles

65 M20577.1-3 Scissors and Case

30 M971.153.9.1-4 Darning Egg

82 M9707 Implements for Carding Wool

55 M992.52.19 Pincushion

45 M966.36.1 Pincushion

90 M993.115.1.4 Table Spinning Wheel, Distaff

64 M9859 Scrapbook on Knitting and Kindred Subjects

87 M996x.2.329.2-12 Bobbins

75 M976.155.1-20 Implements

7 MAC 5009 Needle Holder

36 M19351.1-13 Sewing Box in Form

2 M973.4.2.1-9 Thread Holder

10 M976.155.1-

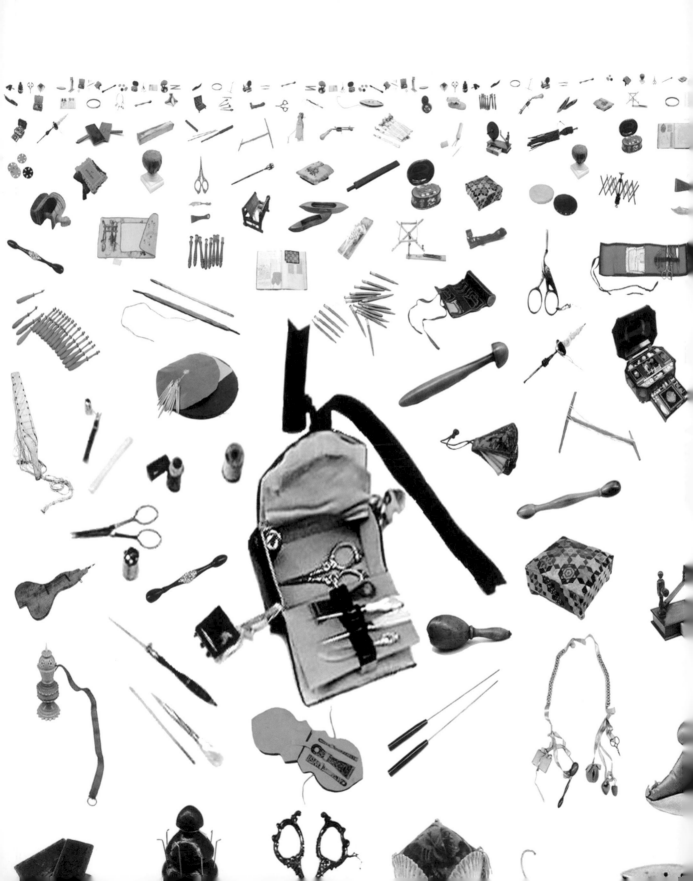

the fatigue of gestures and an infinity of desire.

The flat **plane of time** reaches backwards **to the horizon.**

Obsolescence and ornamentation **go hand-in-hand** while

scattered repetition suggests **the timeless presence** of memory...

All images of textile tools were digitally photographed in the collection of the McCord Museum of Canadian History in Montreal, Quebec.

Thanks to Nicole Vailleres, Directrice, Collection Management and Access Services; Conrad Graham, Curator of Decorative Arts; and Jacquie Beaudoin-Rose, Curator of Textiles. Thanks also to Neil MacInnis.

SIGNIFIERS

SAFE SEX FISTER	RED/WHITE CHECK
SAFE MASTER	BLACK/WHITE CHECK
SAFE S&M FISTER	BLACK/RED CHECK
HEAVY S&M TOP	BLACK
BONDAGE TOP	GRAY
WANTS HEAD	LIGHT BLUE
69-TOP	ROBIN'S EGG BLUE
COP	MEDIUM BLUE
FUCKER	NAVY BLUE
PILOT/FLIGHT ATTENDANT	AIR FORCE BLUE
SAILOR	LIGHT BLUE/WHITE STRIPE
COCK & BALL TORTURER	TEAL BLUE
FIST FUCKER	RED
CUTS	MAROON
TWO-HANDED FISTER	DARK RED
DILDO FUCKER	LIGHT PINK
TIT TORTURER	DARK PINK
INTO NAVEL WORSHIPERS	MAUVE
SUCK MY PITS	MAGENTA
PIERCER	PURPLE
LIKES DRAG	LAVENDER
WATERSPORTS/PISSER	YELLOW
SPITS	PALE YELLOW
HUNG 8" OR MORE	MUSTARD
TWO LOOKING FOR ONE	GOLD
ANYTHING/ANYWHERE/ANYTIME	ORANGE
BIG GUY	APRICOT
SUCK MY TOES	CORAL
COWBOY	RUST
SPANKER	FUCHSIA
HUSTLER (FOR RENT)	KELLY GREEN
DADDY	HUNTER GREEN
MILITARY TOP	DRAB OLIVE
DINES OFF TRICKS (FOOD)	LIME GREEN
RIMMER	BEIGE
SCAT TOP	BROWN
UNCUT	BROWN LACE
CUT	BROWN SATIN
LATEX FETISH TOP	CHARCOAL
OWNS A SUIT	GRAY FLANNEL
BEAT MY MEAT	WHITE
CUMS IN CONDOMS	CREAM
SHAVER	RED/WHITE STRIPE
FURRY BEAR	RED/BLACK STRIPE
LIKES AMERICAN BOTTOMS	AMERICAN FLAG
LIKES WHITE BOTTOMS	WHITE LACE
LIKES BLACK BOTTOMS	BLACK/WHITE STRIPE
LIKES LATINO BOTTOMS	BROWN/WHITE STRIPE
LIKES ASIAN BOTTOMS	YELLOW/WHITE STRIPE
LIKES WHITE SUCKERS	LIGHT BLUE/WHITE DOTS
LIKES BLACK SUCKERS	LIGHT BLUE/BLACK DOTS
LIKES LATINO SUCKERS	LIGHT BLUE/BROWN DOTS
LIKES ASIAN SUCKERS	LIGHT BLUE/YELLOW DOTS
SEX IN THE PARK TOP	RED/WHITE GINGHAM
HEADMASTER	BROWN CORDUROY
WEARS BOXER SHORTS	PAISLEY
LIKES MUSCLE BOY BOTTOMS	GOLD LAMÉ
STAR FUCKER	SILVER LAMÉ
HAS/TAKES VIDEOS	BLACK VELVET
VOYEUR	WHITE VELVET
HAS TATTOOS	LEOPARD
SMOKES CIGARS	TAN
LIKES TO NIBBLE	HOUNDS TOOTH
SKINHEAD TOP	UNION JACK
NEW IN TOWN	CALICO
HOSTING AN ORGY	WHITE/MULTICOLOR DOTS

100% COTTON RN #16429

RED/WHITE CHECK	SAFE SEX FISTEE
BLACK/WHITE CHECK	SAFE SLAVE
BLACK/RED CHECK	SAFE S&M FISTEE
BLACK	HEAVY S&M BOTTOM
GRAY	BONDAGE BOTTOM
LIGHT BLUE	GIVES HEAD
ROBIN'S EGG BLUE	69-BOTTOM
MEDIUM BLUE	LOOKING FOR A COP
NAVY BLUE	FUCKEE
AIR FORCE BLUE	FLY BOY
LIGHT BLUE/WHITE STRIPE	LOOKING FOR A SAILOR
TEAL BLUE	COCK & BALL TORTUREE
RED	FIST FUCKEE
MAROON	BLEEDS
DARK RED	TWO-HANDED FISTEE
LIGHT PINK	DILDO FUCKEE
DARK PINK	TIT TORTUREE
MAUVE	HAS NAVEL FETISH
MAGENTA	ARMPIT WORSHIPER
PURPLE	PIERCEE
LAVENDER	DRAG
YELLOW	WATERSPORTS/PISSEE
PALE YELLOW	LIKES SPIT AND DROOL
MUSTARD	WANTS A BIG ONE
GOLD	ONE LOOKING FOR TWO
ORANGE	NOTHING NOW
APRICOT	CHUBBY CHASER
CORAL	LIKES TO SUCK TOES
RUST	HIS HORSE
FUCHSIA	SPANKEE
KELLY GREEN	JOHN (LOOKING TO BUY)
HUNTER GREEN	ORPHAN BOY LOOKING
DRAB OLIVE	MILITARY BOTTOM
LIME GREEN	PROVIDES DINNER
BEIGE	RIMMEE
BROWN	SCAT BOTTOM
BROWN LACE	LIKES UNCUT
BROWN SATIN	LIKES CUT
CHARCOAL	LATEX FETISH BOTTOM
GRAY FLANNEL	LIKES MEN IN SUITS
WHITE	WILL DO US BOTH
CREAM	SUCKS IT OUT
RED/WHITE STRIPE	SHAVEE
RED/BLACK STRIPE	LIKES BEARS
AMERICAN FLAG	LIKES AMERICAN TOPS
WHITE LACE	LIKES WHITE TOPS
BLACK/WHITE STRIPE	LIKES BLACK TOPS
BROWN/WHITE STRIPE	LIKES LATINO TOPS
YELLOW/WHITE STRIPE	LIKES ASIAN TOPS
LIGHT BLUE/WHITE DOTS	LIKES TO SUCK WHITES
LIGHT BLUE/BLACK DOTS	LIKES TO SUCK BLACKS
LIGHT BLUE/BROWN DOTS	LIKES TO SUCK LATINOS
LIGHT BLUE/YELLOW DOTS	LIKES TO SUCK ASIANS
RED/WHITE GINGHAM	SEX IN THE PARK BOTTOM
BROWN CORDUROY	STUDENT
PAISLEY	LIKES BOXER SHORTS
GOLD LAMÉ	LIKES MUSCLE BOY TOPS
SILVER LAMÉ	CELEBRITY
BLACK VELVET	WILL PERFORM FOR THE CAMERA
WHITE VELVET	WILL PUT ON A SHOW
LEOPARD	LIKES TATTOOS
TAN	LIKES CIGAR SMOKERS
HOUNDS TOOTH	WILL BE BITTEN
UNION JACK	SKINHEAD BOTTOM
CALICO	TOURISTS WELCOME
WHITE/MULTICOLOR DOTS	LOOKING FOR AN ORGY

MADE IN U.S.A.

HOME WORK

Lou Cabeen

1. Subheadings in this essay are taken from a sampler verse dated 1813, found in Ethel Stanwood Bolton and Eva Johnston Coe, facsimile of the 1921 edition of *American Samplers* (New York: Dover Publications, 1973), p. 348.

Happy the Woman Who Can Find Constant Amusement in Her Mind [1]

Embroidered tablecloths, runners, doilies, and dishtowels fill junk stores, antique and thrift shops. Made a generation ago, they linger in our mothers' or grandmothers' homes, objects of forgotten utility—breadbasket cloths with their odd shapes, cotton rectangles and squares with perplexing proportions, too small for a table and too large for one's lap. Most of these objects are white. All of them are "worked," their borders embellished with stitched images of flowers, fruit, or women in fancy dress. Some of the embroidery is fine, some of it awkward, all of it the labor of women, stitching at home in their leisure time.

We see these textiles as craft in the lowest sense of the word—nonoriginal, labor intensive, and worked by amateurs. The doilies, tablecloths, and runners were purchased with the designs already stamped on them in water soluble blue dye that would disappear in the first wash after the stitching was completed. Or they were made using purchased designs printed on waxy translucent paper, which could be transferred onto a dishtowel or pillowcase by means of a hot iron. Either practice would seem to eliminate the possibility of the embroiderer's self-expression, and it is hard for us to imagine a pragmatic purpose for such quantities of laboriously decorated

197

cloth. Consequently, they are regarded as the quintessential female hobby artifact, the textile equivalent to paint-by-number kits. **I GREW UP IN A HOUSE FILLED WITH SUCH TEXTILES.** *Our pillowcases were embroidered. Each dresser had an embroidered "scarf." The buffet in the dining room had embroidered runners. Each end table in the living room had its own doily. We were not rich. These textiles were not made of linen, nor starched and pressed with a monogram stitched in understated monochrome. They were made from ordinary cotton, embroidered with conventional flowers in a range of colors. My mother washed and ironed them every week, and when one wore out there were more in the cupboard. In fact, in my grandmother's house there was a small room filled with these embroideries, stacked on shelves that stretched taller than I could see. And in my grandmother's house was the woman who made them, my ancient, frail great-grandmother, who sat in her rocking chair stitching with silent concentration.* Many of us have a personal or family history attached to examples of this kind of middle-class embroidery. We often assume that we understand how these embroideries came to be made, and why, and we are correct up to a point in that assumption. But these embroideries and the labor they represent are also reflections of larger social and ideological trends. To more clearly discern the object of this labor, this essay will discuss two major elements that shaped the environment of the women who created these embroideries—art and commerce. The art advocates, best represented by designers Candace Wheeler (1827–1923) and Gustav Stickley (1858–1942), were the American proponents of the art philosophies developed by the British Arts and Crafts Movement. This movement sought to eliminate the "alienated labor" of craft workers by fusing the roles of artist and artisan. It also sought to remove the distinction between fine and decorative art by emphasizing decorative art's potential for self-expression when the designer and the craft worker were one being. Commercial trends are seen in the activities of the needlework supply manufacturers. These suppliers were, of course, eager to sell the new needlework threads—silk and cotton—that improved trade and manufacturing methods had made available. To do so, they pioneered new advertising methods, promotional devices, and publications that provided attractive, stylish preprinted designs. While in direct conflict over the issue of originality of design, both the art advocates and the thread manufacturers

Lou Cabeen, Ambition, 1996, found textiles and stitching, 18 x 48 in. To better understand the role embroidery played in the life of my great-grandmother Sarah English, I began using her embroideries in my own artwork. This work is composed of six dresser scarves layered on top of each other. The text "If this you see will you remember me?" is stitched in white thread down the center of the piece and penetrates each layer.

were united in their adherence to the Victorian ideology of gender and class with which embroidery was identified. In this essay, I consider the cultural forces that sought to influence American women and their practice of embroidery, and contrast those influences with the actual practice of leisure embroidery in America from the late nineteenth century to the early twentieth century.

Embroidery has, in fact, long been a female trade, practiced for pay by working-class women, from guild workshops in the Middle Ages where masterpieces of liturgical and secular embroideries were produced,[2] to immigrant women, seamstresses, and milliners in the nineteenth and early twentieth centuries, who stitched countless embellishments on fashionable garments and household textiles. This aspect of embroidery's history is consistently overlooked, perhaps in an effort to claim its status as an art form, in other words, as a vehicle for unfettered self-expression. Consequently, embroidery's history is often traced through the activity of upper-class women, forming our fundamental assumptions about the practice. BUT TO WHAT CLASS DID MY FAMILY BELONG? What class was my great-grandmother? Class distinction is taboo territory for Americans, it seems. To reveal either wealth or need was anathema to these turn-of-the-century, immigrant ancestors of mine, and their Depression-era descendant, my mother. Trying to understand, I study a snapshot of my great-grandmother taken in the 1920s before her embroidery had become an obsession. She is standing among her sisters. She is the eldest, flinching from either the camera's gaze or the sun's glare. She is wearing a modest but attractive print dress, which I realize with shock was quite stylish for the period with its three-quarter sleeves, asymmetrical print, and soft cowl collar. Her sisters are wearing dresses from much earlier in the century. One looks markedly older, although she is the youngest of the lot. I am told she was married to a coal miner. Her life was hard. And it shows in her gaunt face and unfashionable clothes. But this great-aunt stands calmly, steadying my recoiled great-grandmother with one hand and staring pointedly at the camera. Although my great-grandmother's life had its hardships, they were of a different sort. The stereotype of embroidery as a quintessentially female creative outlet, produced in private for personal use, was created in the mid-nineteenth century. It was drawn by British historian C. H. Hartshorne, whose influential book, *English Medieval*

2. For a good introduction to this topic, see Kay Staniland, *Embroiderers: Medieval Craftsmen* (Toronto: University of Toronto Press, 1991).

Embroidery, was published in 1848. This was the first book to concentrate specifically on medieval embroidery, and was quoted extensively and uncritically by generations of subsequent writers. In it, Hartshorne portrayed embroidery primarily as an amusement for women of leisure, ignoring the historic and contemporary record of women in the artisan class who embroidered as paid professionals. The following scene sums up his romantic but inaccurate view of medieval embroidery, and its role as a creative outlet for isolated women:

> *Shut up in her lofty chamber. Within the massive walls of a castle or immured in the restricted walls of a convent, the needle alone supplied an unceasing source of amusement; with this she might enliven her tedious hours, and depicting the heroic deeds of her absent lord as it were visibly hastening his return; or on the other hand, softened by the influence of pious contemplation, she might use this pliant instrument to bring vividly before her mind the mysteries of that faith to which she clung.*[3]

3. Quoted in Rozsika Parker, *The Subversive Stitch: Embroidery and the Making of the Feminine* (London: The Women's Press, 1984), p. 24.

This proved to be a seductive image that successfully conflated passively pious femininity and domestic confinement, while portraying embroidery as the appropriate outlet for virtuous and nonthreatening middle- and upper-class female industry. Embroidering would be an indicator of virtuous womanhood in magazine illustrations and advertisements well into the twentieth century. Hartshorne, in fact, describes the "ideal" British Victorian wife in the passage above. Like Hartshorne's medieval lady, my silent, stitching great-grandmother was confined, first in her own home, then in her daughter's house. In middle age she had lost a leg to gangrene and had not been able to master walking with her artificial limb. She was enshrined in her huge (to my child's eyes) rocker, with snowy white cotton clamped in metal embroidery hoops covering her lap, immobile except for her fingers. The artificial leg stood unused in the corner. She was always stitching, every waking moment stitching. Even now, decades after her death, if I stop typing and hold myself completely still at the keyboard, I can still hear the sound of her needle puncturing and squeaking through the cotton, stretched taut and rigid in her hoop. In my childhood summers and winter holidays I never even saw her eat.

Thrice Happy She Whose Chief Enjoyment is Placed in Regular Employment

The American version of this ideology of gender, class, and embroidery is found in the writings of Candace Wheeler, a pivotal figure in the resurrection of embroidery as a practice in America. Wheeler and her American contemporaries saw the home as less secluded than a medieval tower although it still defined the parameters of a woman's life and creativity. In complete accord with the prevailing attitude of her time, Wheeler describes one's home in an 1893 essay as a woman's "natural" arena in which to "instinctively" practice her aesthetic skills.[4]

4. Candace Wheeler, *Household Art* (New York: Harper and Brothers, 1893), p. 13.

Women's personal contribution to the decorating of her home was, of course, embroidery. This was the form in which her instinct for art could find its most natural expression. In her book, *The Development of Embroidery in America*, Wheeler describes the history of the craft as a history of domesticity. She goes on to claim that through the study of embroidery's history one can chart woman's mental processes and intellectual growth, as well as deduce her emotional state through the ages. So closely are women, domesticity, and embroidery linked in Wheeler's world view, that the history of embroidery is, in her words "the story of the leisure of women in all ages written in her own handwriting" in addition to being "the story of family life."[5] Although published in 1921 near the end of her life, this belief permeated her writings from the 1870s onward.

5. Candace Wheeler, *The Development of Embroidery in America* (New York: Harper and Brothers, 1921), p. 4.

Women who embroidered for wages are completely absent from Wheeler's account. As we shall see, she was not ignorant of the financial pressures that could be relieved by such paid labor, thus one assumes that her insistence on embroidery's practice by leisured women is linked to her desire to discuss the practice as an art form peculiarly suited to virtuous women at home.

Wheeler's efforts to bring embroidery as an art form to American women began in the 1870s. At that time, embroidery was not widely practiced in the homes of the middle or upper classes, and had not been for half a century or more. For much of the nineteenth century, American housewives of the agrarian and middle classes were exhorted to use their needles only in the service of plain sewing. Catherine Beecher and her sister, Harriet Beecher Stowe, published their influential *The American Woman's Home* in 1869. They direct their comments to middle-class women in towns and rural areas, and mention embroidery only once, and do so grudgingly as an efficient way to add a little visual relief to an infant's undershirt while hemming the garment at the same time. Heavily influenced by a Puritan work ethic, the Beecher sisters assumed that the virtuous and industrious middle-class housewife would have no time or desire for the frivolities of decorative embroidery.

Godey's Ladies Book, the popular magazine for the well-to-do, included embroidery patterns for embellishing fashionable clothing. These would presumably be given to one's working-class seamstress or milliner for use when embellishing one's new clothes and accessories. The upper-class woman herself would produce "fancy work" as her creative outlet. The magazine's "Work Department" provided instructions for elaborate crafts projects with illustrations. These included ornate pin cushions, pen-wipers, or "tidies" that might have embroidered accents. More often, these projects involved the use of wax, feathers, shells, or hair that would be fashioned into flowers, fruit, or other three-dimensional decorative forms.

By conjuring an ancient connection between domestically happy women and embroidery, Wheeler sought to bring middle- and upper-class women to the practice of an art form she believed was their female birthright. On the one hand, she sought to overcome the middle-class view of embroidery as a frivolous pursuit of the self-indulgent. On the other, she sought to provide the upper-class woman with a worthy, but culturally acceptable art form. For both groups, she would champion embroidery as a vehicle for original self-expression.

In fact, Wheeler had an additional goal in presenting embroidery as an appropriate activity for upper-class women. She openly acknowledged the effects of ennui, the "disease that has no name," that debilitated so many well-off women confined by cultural expectation to lives of no consequence. She knew that those well-off women were often only one man away from poverty, which in the unstable economic climate of late-nineteenth-century industrialization was a specter that haunted the drawing rooms of many fashionable addresses. Historian Eileen Boris quotes Wheeler on the subject, and indicates the aim of much of her work:

> [Wheeler] encouraged more well-off women to learn the decorative arts "not indeed to prevent starvation of the body, but to comfort souls . . . who pined for independence." By professionalizing art for women, Wheeler intended to ease the dulling effects of wasted leisure, combat "the social and mental rather than a physical want" and provide the training necessary to counter the interruptions of a woman's life cycle.[6]

Trumpet Flower, *design from* **Embroidery Lessons with Color Studies**, *1901, an instruction book and product catalogue of the Brainerd and Armstrong Company, manufacturers of colored silk embroidery threads. Here, twenty-one different colors of thread were needed to achieve the illusionistic and figurative imagery championed by Candace Wheeler.*

6. Eileen Boris, *Art and Labor: Ruskin, Morris and the Craftsman Ideal in America* (Philadelphia: Temple University Press, 1986), pp. 100-101.

Wheeler became a strong champion of art training for women, but she saw embroidery as the most culturally acceptable form. As such, it could provide a means to deal with the financial, not the biological interruptions of late-nineteenth-century, upper-class women's lives. Embroidery, the long standing but culturally invisible trade available to the working-class woman, could become the means of financial rescue for the equally invisible impoverished upper-class female. The central difference, apparently, would be that the upper-class woman would be participating in an art form, by virtue of her originality of design, while the tradeswoman was still involved in alienated labor, working at the direction of another.

To accomplish these goals, Wheeler founded the New York Society of Decorative Art in 1877. Like its British counterpart, the Royal School of Needlework, it was dedicated to Arts and Crafts philosophy and aesthetics. The Society provided classes in drawing, design, and embroidery, often bringing instructors from the Royal School to New York to instruct members. In this way, women could be trained to produce their own embroidery designs that would meet the most advanced aesthetic ideas of the day. The Society also provided a showroom in which the needlework of its members, all upper-class women, could be sold to wealthy patrons. Although Wheeler was eager to foster respectability to upper-class women who sought remuneration for their labor, the Society carefully protected the identity of those women who consigned their work, since to admit that one was in need of income was, in Wheeler's words, to irrevocably "lose caste."[7]

Over time, the Society spawned a network of chapters in other cities, which maintained communication with each other via shared lecturers, teachers, exhibitions, and publications. These chapters heightened the awareness of art and aesthetics among the well-to-do, and served to foster a shared sense of culture at a time when America was eager to shed its rough-and-tumble, colonials-in-a-wilderness reputation.

Wheeler, however, soon found herself on the horns of a dilemma. She had almost single-handedly brought the idea of art embroidery to America. She had established a forum in which women could be paid for their creative efforts. But the benefit of these achievements were limited to upper-class women. There were many deserving women, not all of them from the upper classes, who needed a venue in which to sell the results of their labor in domestic crafts. Meanwhile, items were continually brought to the Society's showrooms by hopeful consignors that did not meet Wheeler's artistic standard. Philanthropy and art, she found, were uncomfortable partners. So in 1878, Wheeler broke from the Society and formed the New York Exchange for Women's Work, leaving the Society to "go on its art path without us."[8]

7. For a complete history of this movement, see Kathleen Waters Sanders, *The Business of Charity: The Woman's Exchange Movement, 1832-1900* (Chicago: University of Illinois Press, 1998).

8. Ibid., p. 54.

The New York Exchange was the first of what became another national network of organizations whose showrooms provided women with the opportunity to receive needed remuneration. But the Exchange showrooms were open to women of the working and middle classes, as well as less artistically inclined members of the upper class. In the Exchange, women could consign their work done in any of the domestic crafts, be it embroidery, knitting, baking, or the making of jams and jellies. Where the Society specialized in art embroidery, pottery, and china painting, the Exchange offered a dizzying array of objects, both utilitarian and decorative, to its well-heeled customers. The Exchange showrooms became as popular with wealthy customers as the Society showrooms. Both grew to become national organizations with showrooms in major cities from coast to coast. By providing a means for the well-off to acquire hand-embroidered textiles, both fed the fashion for such items and contributed to the ongoing assumption that hand embroidery in one's home was a significant indicator of taste and refinement, long after Wheeler herself was no longer on the scene.

IT WAS MY GREAT GRANDMOTHER'S GREATEST JOY, I WAS TOLD, TO PRESENT AN ABUNDANCE OF EMBROIDERY TO THE WOMEN OF THE FAMILY. *The new bride or the wife moving into a new house would receive piles of embroidered cotton—pillowcases, table clothes, buffet scarves and runners, doilies and dishtowels, all stacked in clean, neat folds and tied with a ribbon, a gift from her. But I wondered, since the stitching continued without pause, and since the gifts had been culled from the great storeroom that housed her work, if the joy in the gift came from the ability to contribute to the new house, or if it came from the knowledge that there was now room for more embroidery on the shelves that stretched so tall.* Wheeler's personal aesthetic dominated American art embroidery from the 1870s through the early twentieth century. It was a robust version of illusionistic realism. She considered flowers to be the quintessential subject for embroidery. The best known example of this aspect of her work is the set of bed hangings commissioned by British actress Lily Langtry, who came to Wheeler wanting something that would "overshadow all the modest and schooled productions of the [Royal School of Embroidery at] Kensington."[9]

Wheeler and her workshop produced a white canopy embroidered with full-blown red roses in draped clusters along the border. The accompanying

9. Candace Wheeler, *The Development of Embroidery in America*, p. 123.

bedspread was stitched with images of rose petals, which had seemingly just fallen from the bouquets above.

Wheeler's aesthetic is perfectly represented in what first appears to be an instructional magazine from 1900, *Embroidery Lessons with Color Studies*. It includes full-color reproductions of flowers and foliage stitched onto table linens of various shapes. There are articles on botany to help one understand the structure of flowers, as well as an essay on the history of embroidery, and one on contemporary uses for it. One would assume that this was another vehicle through which originality of design in embroidery was fostered. On closer examination, however, this magazine turns out to be a product catalogue for the Brainerd and Armstrong Company, manufacturers of silk embroidery threads, founded in 1880. All of the embroidery designs pictured were available for purchase, printed onto table linens complete with scalloped hems or decorative fringe. The color plates in the publication provided a model for the embroiderer to copy. Wheeler's aesthetic and the banner of embroidery

Lou Cabeen, Sanctuary, *1997, found textiles and stitching, 21 x 5 1/2 ft. This work is composed of all the flat textiles left from my great-grandmother's thirty-five years of obsessive embroidery. I have pieced them into a solid textile. I worked the following sentence, advice from an anonymous embroidery writer in the 1940s, onto each of them in white thread: "The things created with embroidery are an expression of yourself so personal and individual that they will always be cherished."*

as an art are heavily championed in this product catalogue. Although Wheeler is never mentioned by name, her calls for an art needlework based on originality of design are entirely subverted by the catalogue's encouragement of the use of their preprinted designs. The manufacturers join Wheeler in acknowledging what they refer to as the "secret remorse" of embroiderers:

> In these days when very few pieces of inferior embroidery are seen . . . it really seems a pity that so much handsome work must go upon the table, where it runs the risk of being damaged . . . Family and friends often take a greater pride in her work than does the embroiderer saying [that] it is handsome enough to frame . . . In fact, there is hardly an embroiderer who is not capable of work which will make a better appearance . . . than does much of the inferior brush work of the day.[10]

The customer is flattered and consoled. The validation of art can be had by methods other than those of leaving home for drawing classes and design training, decisions family and friends might not take pride in. The Brainerd

10. *Embroidery Lessons with Colored Studies* (New London: Brainerd and Armstrong Company, 1901), p. 94.

This page shows the embroidery patterns most popular with readers of The Modern Priscilla. *Earlier in this May 1921 issue, the editors outlined their role as "mediator" in bringing needlework recognition as "art."*

and Armstrong Company offers a less painful path to the remorseful embroi-
derer—that of preprinted designs and a color template to follow. It was
through this mix of art rhetoric, flattery, and assurance that the use of preprint-
ed designs won the regard of family and friends which marked the tone of the
needlework press throughout the early decades of the twentieth century.

In Works of Genius, Use or Taste, Nor Lets One Moment Run to Waste

Wheeler's ideas about art needlework took hold in the wealthy circles of
urbanites. But the works and philosophy of Gustav Stickley, to whom the
American Arts and Crafts aesthetic is attributed, are better known. From
1900 to 1916, Stickley's furniture, sold by mail order, and his widely
distributed magazine, *The Craftsman,* brought the philosophy of design
reform into the American countryside. His was a manly aesthetic, which
represented a decisive shift in the aesthetics of home decoration. In order to
serve as a refuge from the anxieties of social mobility, Stickley's home interiors
sought to reflect domestic stability through the use of geometric shapes and
uncluttered surfaces. This was a departure from earlier styles, which had
sought the same feeling of refuge through the introduction of rhythmic
patterns based on nature. According to historian Eileen Boris, Stickley
put a gendered reading on his design aesthetic:

> *At a time when most home decorators addressed their remarks to women, Stickley*
> *spoke to men . . . He suggested that his own home [designs] represented the*
> *personality of a man in contrast to [those] "built to meet the ideas of women*
> *whose tendency is still to emphasize emotion and to minimize reason."* [11]

11. Eileen Boris, *Art and Labor,*
p. 76.

Women's natural instincts and aesthetic inclinations towards the decorating
of their homes, so recently championed by Wheeler, now came under scrutiny.
 Stickley's interiors favored materials such as oak, iron, and copper. Textiles
were not recommended for use, even as upholstery; leather was deemed
more suitable. But Stickley did mention embroidery, and *The Craftsman* did
include articles on needlework. However, his aesthetic scheme demanded
"a more robust" kind of beauty than fine linen or silk in "delicate coloring." [12]
Illusionistically rendered roses were out of place in Stickley's masculine inte-
riors, and were to be replaced by simplified motifs worked in straightfor-
ward techniques. Stickley called for the use of a textured, dyed cloth
resembling lightweight, closely woven burlap, which he referred to as canvas.
He describes his distinctive *Craftsman*-style embroidery in a 1909 article:

12. Gustav Stickley, facsimile of
the 1909 edition of *Craftsman
Homes* (New York: Random
House, 1955), p. 168.

Our usual method of decorating this canvas is the application of some bold and simple design in which the solid parts are of linen appliqué in some contrasting shade and the connecting lines are done in heavy outline stitch or couching with linen floss.[13]

13. Ibid., p. 167.

Accompanying this article were pictures of pillows and table scarves ornamented with designs based on pinecones, ginkgo leaves, and dragonflies, worked with the simple stitches described above. On some of the pieces the solid parts of the design are filled in with widely spaced running stitches, referred to by Stickley as "darning stitch."

The use of appliqué has, of course, much to do with the shift in aesthetics from nineteenth-century illusionistic imagery to the twentieth-century preference for flattened semiabstract designs. But in *The Craftsman*, this shift in aesthetic was discussed in ideological terms, most notably by the magazine's needlework writer, Katherine Sanger Brinley. She recommends appliqué to:

[T]he modern needleworker [as] a method of much artistic value for the enrichment of textile surfaces. It demands a neat-handed worker and a significant design; which latter goes far toward eliminating that characteristic of so much modern embroidery—triviality.[14]

14. Katherine Sanger Brinley, "Art Needlework from the 16th Century," *The Craftsman* (April–September 1909), p. 472.

Brinley's comments on appliqué are distinctive for two reasons. She acknowledges that appliqué requires any skill at all. Appliqué does, indeed, require a "neat-hand" among a myriad of other textile working skills. Most writers on the subject recommend appliqué in terms of an easy, labor-saving device. But where Brinley acknowledges the technical skills of her readers in one phrase, she exploits their vulnerability in the next. Women readers of *The Craftsman* were held accountable for decorating their homes in a way that would shape the character of their families, not reflect their own, now somewhat suspect feminine taste. Embroidery, in its persistent conflation with femininity, was the arena for their personal contribution to that decoration. How was the female reader of *The Craftsman* to know whether she was choosing a "significant" design, when according to Brinley so many of her fellow moderns were indulging in triviality? What constituted a significant design in terms of *The Craftsman* aesthetic, other than the flattened motifs of nature described above? Even a cursory look at the titles of Brinley's contributions to the magazine—"Ornamental Needlework as Exemplified in Certain Pictures of the Italian Renaissance," "An Interesting Needlework Design Evolved from an Embroidery Detail in DaVinci's Painting of the Last Supper"—gives a clue. To put the art in art embroidery

NEEDLEWORK SHOWING ADAPTATION OF THE CRAFTSMAN DESIGNS

THE chief reason that we publish in THE CRAFTSMAN designs and instructions for various sorts of handicrafts is that we hope to inspire in our readers the desire to use them as a foundation from which may be worked out their own ideas, rather than as models to be exactly copied.

CURTAIN OF CRAFTSMAN CANVAS.

Therefore we are always gratified to receive examples of original and independent work done by readers who seek rather to understand the Craftsman principles than to make a precise application of the designs. In the illustrations accompanying this article we show an instance of such adaptation, for these pieces of needlework, designed and

TABLE SQUARE OF CRAFTSMAN HOMESPUN.

280

TABLE SQUARE WITH CRAFTSMAN DESIGN.

executed by Mrs. Eva R. Greeley of Abington, Massachusetts, are all done on Craftsman materials after original ideas suggested by some of the Craftsman designs.

The small curtain is made of ivory-tinted Craftsman canvas with an applied band of dull green canvas. The decoration is adapted from the well-known seed pod motif of the Craftsman needlework, and is done in appliqué of rose and green bloom linen with leaves of plain green linen. The stems are

BELT BAGS OF CRAFTSMAN BLOOM LINEN.

made of brown soutache braid with insets of green linen. The table square embroidered with conventionalized scarabs is Mrs. Greeley's own design embroidered upon gray homespun in blue, green and gold floss, the old-fashioned chain stitch being used as well as the darning and outline stitches. The other table square, also of gray homespun, shows a design adapted from the Craftsman dragonfly border, and two small bags are decorated after Mrs. Greeley's own ideas.

These items, designed and executed by Mrs. Eva R. Greeley of Abington, Massachusetts, appeared in the May 1901 issue of The Craftsman. *Greeley's work incorporates the qualities of "robust" embroidery favored by Gustav Stickley.*

meant to look to art history, then commit oneself to a substantial amount of experimentation and sampling in order to reproduce the same.

But it was the rare home worker who met this ideal of creating original designs, whether based on simplified images of nature or motifs from Renaissance paintings. Although the style of embroideries shown in *The Craftsman* caught on and became identified as "manly," the goal of producing original designs for one's embroidery did not. Here again, needlework suppliers and their publications provide insight into the relationship between the art embroidery advocates and the mass of American women. In the opening paragraph of the 1911 article "Presents Men Will Appreciate," the editors of *The Modern Priscilla*, another product catalogue in the form of a monthly magazine, give the following advice:

> *The simple conventional designs in inconspicuous coloring are the ones which usually appeal to men of good taste, so in embroidering Christmas presents for our brothers or other girls' brothers, it is well to bear this fact in mind, and not embarrass the recipient by giving him something so much ornamented that he had rather not use it.*[15]

15. *The Modern Priscilla* (November 1911), p. 11. In what may or may not have been unconscious irony, the article on the facing page to this one is entitled "Love Building" by no less an author than feminist Charlotte Perkins Gilman.

The initial item illustrated is a pair of cloth-covered bookends bearing a simplified and rather handsome design. The text informs us that they are formed of tin and slipcovered in canvas which has been worked in darning and outline stitch, the very materials and techniques called for by Stickley himself. At the end of the description, the cost of ordering the fabric, thread, and pattern are listed: "Stamped canvas, 30 cents, cotton for working, 20 cents, perforated pattern, 20 cents." In this case, Stickley's aesthetics and some of his ideology are reflected. His simplified, flat designs are portrayed as the mark of manly good taste. But as we have seen in the example of Brainerd and Armstrong above, the call for embroidery to become an art form via originality of design is completely sidestepped. There is a more insidious element as well: not only will the kit produce a pleasing, useful gift, it will also spare the embroiderer the possible humiliation of offering a handmade gift marred, in a man's eyes, by her female taste for over ornamentation.

Whether fueled by insecurity or other impulses, the trend towards using preprinted designs was relentless. The utopian fusion of artist and artisan that the art needlework advocates had worked towards since 1877 would not come to pass outside of art and design schools. By the turn of the century, most American women looked to the popular press for information, encouragement, and instruction in embroidery. Although embroidery is discussed as an art and the reader/embroiderer is assumed to be creative, it is also assumed that she will use commercially produced preprinted designs.

We gain insight into this relationship in a 1911 essay in *The Modern Priscilla*, where the editors articulated their role as "a medium" between their readers, popular embroidery, and art. Inspired by a visit to a traveling exhibition of Royal School of Needlework embroideries, they call for "that type of designing which will give our needlework its rightful place among the arts." However, it is not up to their readers to bring needlework to the arts.[16] They make it clear that it is the magazine's job, and the editorial concludes by saying: "It is *Priscilla's* function to act as a medium between you and the artist, not only to give you the design, but the artist's interpretation in color and stitch. Then it is the skill in your fingers that will make the vision live."[17] That is high praise, to be able to bring a vision into material being. And yet, this passage describes the classic divide between artist/designer and artisan/craftworker. Art, it seems, has nothing to do with this approach to needlework. Perhaps the banner of art was being used as an excuse in pragmatic, goal-oriented America for the otherwise inexcusable pleasure of decorative stitching. Or, perhaps, as we shall see, the self-expression

16. Christine Ferry, "Priscilla Speaks for Herself," *The Modern Priscilla* (May 1921), p. 1.

17. Ibid.

sought by the readers of *The Modern Priscilla* was of a different sort than that afforded by our current understanding of art. *Once, I was put in a corner of my great-grandmother's high-backed chair, and given my own cloth and needle. The cloth was green calico, and she had threaded the giant needle with bright yellow floss, with no knot at the end. Sitting close by her side and mimicking her movements, I repeatedly pushed the needle into my cloth and pulled it out. My great-grandmother's stitches built a flower on the snowy white canopy in her lap. My stitches made only lines, but lines that would magically form and disappear as the knotless yellow floss flowed through the calico in the path my needle made for it. Just that once, I entered the silence of my great-grandmother. The steady concentration of her stitching built a shield around us both. Silent and safely occupied, we both—the very young and the very old—became invisible to the middle aged as their harried and perplexing lives swirled around us. For the rest of my childhood it would be a mystery to me why no other adult was so comfortable to lean against.* ONLY IN MY OWN MIDDLE AGE HAVE I COME TO UNDERSTAND THE SANCTUARY HER STITCHING OFFERED US BOTH.

So Gentle Maid While Youth Shall Last, Eer the Gay Morn of Life is Past

The study of commercial enterprise has not been part of the art or textile history methodologies within which I, as an artist, work, and yet it has clearly been a fundamental force in the burgeoning phenomenon of home embroidery. Rachel Maines's study "American Needlework in Transition, 1880-1930," produced in 1978, outlines this connection and traces its impact on selected communities in the Northeast. In it, she comments that the very reason these decades of American needlework have been overlooked by historians is because of the increasingly close connection between the embroideries produced and commercial and manufacturing developments.[18]

The Brainerd and Armstrong Company, mentioned earlier, along with the Nonotuck Silk Company, The Belding Brothers and Company, and the Richardson Silk Company, supplied American needleworkers with silk during this period of transition. The raw fiber was imported from China, and reeled, thrown, or spun in the United States. The resulting yarns and threads had been available to those who could afford them throughout the

18. Rachel Maines, "American Needlework in Transition, 1880-1930," *University of Michigan Papers in Women's Studies* 4 (1978), p. 58.

nineteenth century. But after improved trade with China was established, the price of silk embroidery threads was lowered to record levels, bringing it within the means of many more home embroiderers.

Clark, J & P Coats, and The American Thread Company supplied needleworkers with cotton. Manufacturing innovations in the spinning of cotton made in the early nineteenth century had produced the fine, strong, tightly spun thread we are familiar with today. However, it was not produced in quantity until after the invention of the sewing machine at midcentury. By the end of the century, however, it had almost completely replaced linen as the thread of choice for regular sewing, and was seen as a more and more desirable innovative alternative to silk for use in embroidery.[19]

These innovations in manufacturing and materials led to innovations in marketing as well. In order to turn a profit on a product that retails for pennies, volume sales were required. To produce those volumes of sales, all of these manufacturers took advantage of the newly efficient postal service, and provided American embroiderers with numerous instruction pamphlets, booklets, and catalogues that featured the projects developed by their design staffs, as well as general instruction in needlework techniques. The threads, flosses, and other needlework supplies of these manufacturers were available to embroiderers through a range of small retail outlets, including dress-makers, tailors, and millinery shops, or through dry goods and variety stores. Sometimes these supplies were also available directly through the mail. For example, The Brainerd and Armstrong Company publication, while offering an exhaustive list of their products, exhorts the reader to purchase these materials from their local supplier, and to order from the company directly only if that supplier is unwilling to carry their products.

American women also had access to embroidery instruction, inspiration, and encouragement through the newly emerging needlework press. In fact, the manufacturers funded some of these publications; all were supported by their advertising dollars. Magazines such as *The Modern Priscilla*, founded in 1887, *Home Needlework Magazine*, founded in 1899, and *Needlecraft*, founded in 1909, offered pages of embroidery designs and instructions in addition to fiction and editorials.[20] Like their more general sister publica-tions, *Ladies Home Journal* and *Woman's Home Companion*, the needlework publications were essentially trade papers, offering women technical infor-mation of use in the tasks of housekeeping.[21] There were columns offering advice and instruction on a variety of home management topics. *The Modern Priscilla*, for instance, offered regular articles using the "Priscilla Proving Plant" as a backdrop. This was ostensibly a modern house, in which the editorial staff lived and in which young, uniformed women tested the

19. Ibid., pp. 67-74.

20. Ibid., p. 65.

21. For more information on this topic, see Mary Ellen Zuckerman, *A History of Popular Women's Magazines in the United States 1792-1995* (Westport, Connecticut: Greenwood Press, 1998), and Helen Woodward, *The Lady Persuaders* (New York: Ivan Obolensky Inc., 1960).

products offered for sale in the magazine, or received instruction in the use of the new technologies for the home. There are photographic sequences depicting the Proving Plant workers, crisp in their white uniforms and white headbands, receiving instruction in simple plumbing repair, as well as learning to use a gas range safely. There were also articles on the Exchange Movement, such as the 1911 series which described the workings of various big city Exchanges, and was titled "Marketing the Home Woman's Product." Although there does not seem to be direct advice on embroidering objects to consign in Exchanges, all of the women's publications run articles, advertisements, and advice columns directed towards the reader's need to supplement her husband's income while staying at home.

As we have seen, the line was often blurred between a magazine's entertainment and educational value and a product catalogue's sales emphasis. However, reliable needlework instructions in entertaining, informative publications were now being delivered to homes on farms and in small towns from coast to coast. Wheeler's portrayal of embroidery as a peculiarly appropriate outlet for American women was being brought to the widest possible audience.

Wheeler's and Stickley's ideal of creative self-expression through original design, however, was not. In all of the needlework publications, one would find pictures of household textiles of all kinds, marked with a design for the embroiderer to stitch. In fact, as the earlier comments from the editors of *The Modern Priscilla* make clear, the magazines actively assume that their task is to bring designs to their readership. This is actually an extension of the historic practice of home embroidery being worked from preexisting designs, rather than purely crass commercialism. Printed drawings for use in embroidery had been available to amateur embroiderers as early as 1524 in Germany, with whole books of such drawings available by the mid-sixteenth century in Italy.[22] In eighteenth-century America, many women would purchase designs, commission a drawing from a professional or a talented friend, or trace the floral patterns from imported printed chintz to provide designs for crewel embroidery.[23] In 1804, printed embroidery designs on graph paper became available resulting in the fashionable Berlin work (now known as needlepoint), a development textile historians and other commentators have universally deplored because of its commercial success. The art advocates call for originality of design was bucking four centuries of amateur embroidery practice, which had been, of course, exactly their point.

The innovation brought about by turn-of-the-century manufacturers of needlework supplies was to extend the convenience of purchasing designs by offering the designs already transferred onto cloth. For even more

22. Jennifer Harris, ed. *Textiles: 5000 Years* (New York: Harry N. Abrams, Inc., 1993), p. 205.

23. Susan Burrows Swan, *Plain and Fancy: American Women and Their Needlework, 1700-1850* (New York: Holt, Rinehard and Winston, 1977), pp. 105–108 and 204–205.

As this page from a 1916 edition of Collingbourne's indicates, textiles marked with fashionable designs were often given away to encourage the purchase and use of a manufacturer's thread. These table scarves were "free" when one purchased six skeins of Collingbourne's *Artzilk* thread for twenty-five cents.

convenience, these designs were not just on cloth, but printed on finished objects—doilies, table scarves, runners, or pillowcases—which had been cut and stitched to size, hemmed, or finished with decorative fringe. The textile construction work was complete. All the embroiderer had to do was stitch.

The actual textiles that were to be stitched upon are not discussed in any depth in the catalogues or magazines. They are pictured in photographs or drawings, shown "worked up" i.e., with the design filled in with embroidery, or just with the outlines of the design. They are rarely, if ever, shown in use, but rather they are pictured flat, to better emphasize the designs. They are inevitably inexpensive in comparison to the thread, and appear to serve simply as an inticement to sell the embroidery supplies. This suspicion is confirmed by looking at a 1916 issue of *Collingbourne's,* a catalogue for products made by a manufacturer of the same name that produced cotton flosses, threads, and crochet yarn. Textiles, stamped with designs to embroider, are offered free, with the purchase of a certain number of skeins of floss: "FREE lintex pillow top and back with purchase of 6 skeins of floss. The top is handsomely designed and artistically tinted—ready to be embroidered."[24] This strategy of offering the basic textile "ready to be embroidered" at no cost was also used by *The Modern Priscilla,* which at least as early as 1916 offered free stamped table linens as a bonus for subscribers. In both cases,

24. *Collingbourne's Encyclopedia of Technologic Art Needlework Instruction,* no. 15 (Elgin, Illinois: Collingbourne Company, 1916), p. 28.

the reader is offered a large range of designs to choose from, printed on stylish utilitarian household items made from bleached white cotton. *My great-grandmother always stitched on preprinted white cotton. My great-grandfather would buy the tablecloths, buffet scarves, and doilies at the drygoods store downtown. The woman who worked there would keep track of which designs he had purchased, marking them down in the manufacturer's catalogue so that my great-grandmother would not have to repeat a design she had already worked. It has never occurred to me that this was a frivolous pastime that the family indulged. Even in the self-absorption of childhood, I could tell that her concentration was too ferocious to ever be interrupted. The fruits of her labors were tended by the other grown-up women with care.* THEY WERE CAREFULLY IRONED, STARCHED, AND FOLDED BEFORE BEING INTERRED IN THE FRAGRANT CLOSET. It is these textiles, the ones offered at nominal or no cost by the thread manufacturers, that fill the thrift stores. These white cotton textiles, hemmed, fringed, or edged with crochet were available to working- and middle-class women everywhere. It is clear that American embroiderers faced with limited resources of time and money chose to protect their investment of both by eliminating the labor and inherent risks involved in the designing and finishing of a functional textile, preparing an original embroidery design, then transferring that design onto cloth. Manufacturers and merchants obligingly provided materials that allowed them to cut to the pleasurable chase of stitching.

Select Each Sweet With Care and Art To Feed the Head and Mend the Heart

Thanks to the art needlework advocates embroidery reemerged on the American scene as a worthy, even virtuous activity. Thanks to manufacturing and marketing innovations, attractive, dependable, affordable materials were available in abundance to American embroiderers. Faced with a myriad of voices offering advice, instructions, admonishment, and flattery, American women chose conservatively, following the historic path of home embroiderers for centuries to work copious numbers of textiles from purchased designs.

In the language of Arts and Crafts advocates Wheeler and Stickley, the roles of artist, who produces an original image, and artisan, who fabricates it, have not fused into the same worker, but have stayed separate. In that view,

the labor of the home embroiderer working a commercially produced pattern is trivial and alienated. Historically, the arts have taught us to see this as failure, a cop out for the artisan and a loss of control for the artist. This hierarchy based on a narrow definition of originality continues to inform much contemporary discourse, leading to labels that distinguish between the relative merits of the labor involved in "art," "craft," "hobby," and "kitsch."

On the other hand, we could consider the fact that working- and middle-class women in the early decades of the twentieth century were cognizant of the burden labor-intensive embroidery placed on their time. They could have chosen to save time by using techniques such as appliqué and "darning stitch." They could have chosen to abandon the practice altogether, as many of their own mothers or grandmothers had done. They chose, instead, to eliminate a different part of the embroidery process—the time consuming and anxiety-ridden process of drafting original designs. The results of that choice are found in the tide of embroidered white cotton whose residue greets us in the second-hand stores today. We can consider embroidery in a number of different ways. In one view, as a mindless hobby, the product of workers alienated from their labor because they did not control the production of the designs themselves. We can dismiss the countless women whose embroidery covers these cloths as lacking talent or creative initiative, whose work is, consequently, beneath notice. Or, these textiles can be considered carefree expressions of kitsch, a sign of the undirected use of a new abundance of leisure. These points of view are the traditional ones, dictated by the standard assumption that originality of design equals self-expression equals art.

The art bias of originality may have blinded us to an obvious truth. These women, blessed with an abundance of materials to choose from, opted not for the rigors of original self-expression, but for the pleasures of the work. Perhaps they were confident that there was plenty of room for self-expression in the individual choices that all embroidery work entails, such as the choice of colors and their placement, and the choice of stitches used to flesh out the thin, suggestive lines of the preprinted designs. There was also the sensuous pleasure of the work itself: cloth in hand, colored threads at the ready, the calming effect of repetitive motion, and the gratification of watching a form grow as if by magic under your fingers, the sense that you were, in fact, bringing it to life. Here, perhaps, is the element of self-expression sought by the home embroiderers.

If this sounds like an overly romantic description, remember that none of this work was necessary, none of it required for sustenance. This is not the unending, monotonous, and wearying labor of sewing to clothe one's

Lou Cabeen, Sanctuary *(detail).*

family that mid-nineteenth-century housewives endured. It is not the back-breaking, eye-straining labor of immigrant women using their needlework skills in the service of wealthy, fashion-conscious urbanites by doing piece-work for starvation wages. The piles of embroidered tablecloths and doilies, dresser scarves and runners that greet us in the thrift store are the evidence of work freely chosen—work that was chosen out of desire.

Which is not to say that such work, chosen for the pleasure of the working, was pursued in complacency. One of the pleasures of embroidery is that the embroiderer is allowed to be quiet with her own thoughts. Curator Marcia Tucker says it well in the catalogue accompanying *Labor of Love,* her exhibition of time-intensive works of art:

> *Women's products, particularly embroidery, were dismissed [after the Industrial Revolution] as decorative, "pretty" or mindless, that is without content. But according to all accounts, and as most personal experience confirms, what actually happens is that the meditative and self-contained quality of this kind of work reclaims and interiorizes the mind and body, returning them to the sole proprietorship of their owner. For women, as for the incarcerated, time and work can, for brief or long periods of time, become one's own.*[25]

The object of so much of this labor may, indeed, have been to reintegrate the self. In which case, the content of the work, its dimension of originality, consists in the internal chaos that the worker brings to it and the internal order with which she leaves it. Unlike Wheeler, I do not presume that the state of mind of the worker can be discerned from the work itself. I believe

25. Marcia Tucker, *A Labor of Love* (New York: New Museum of Contemporary Art, 1996), p. 53.

217

that content resides in the family stories, if known, that accompany the cloth. One object of the labor of this embroidery may have been to construct a memento of private experience that will remain indiscernible to everyone but one's self.

IT WAS CLEAR TO ME AS A CHILD THAT HER STITCHING HELD HER TOGETHER.

When she put down her stitching the grown-ups became nervous and alert. When she put down her stitching for good, she dwindled and died. She had worked enough cloth to supply four generations of households with embroidered table and bed linens. When I married, a decade after her death, my grandmother, her daughter, produced a stack of doilies, pillowcases, and dresser scarves for me from the seemingly bottomless closet that stored her work. Almost forty years after her death, I received in the mail a twenty-pound box filled with her stitching, and as my mother and aunt continued their own house clearings, more boxes followed. The tending of her legacy is the task of female blood-kin and I, the only female descendant of her only daughter, am it.

Whatever the maker's motivations, the quantity of the evidence is with us. Millions of women chose to stitch on table and bed linens, in good times and bad, for family occasions or personal pleasure, keeping company with embroidery, that quiet, clean, and responsive companion. Purchased embroidery patterns, inexpensive instruction manuals, and plentiful, dependable materials provided American women with a portal to the integration of mind and body that sustained handwork can bring. The object of their labors may have been simply the necessary pleasure of the work itself.

When I go into the fabric store,
I fantasize about all the things I can make.
I love going home with the notion that I can actually make something. *Sara Figlio*

*Sewing is ageless, nine or ninety, if you love to sew you can be an equal,
you can share the same experience. Marcella Swanson*

I think it has the quality of being self-reliant. *Terrie Wethie*

*I like to have all sorts of projects going at the same time
and have them in various stages.
I start three things on Sunday afternoon
and cut them out together. Bonnie Dodge*

If you know how to make it,
you can make it to your satisfaction. *Gregory Richmond*

*It's a personality kind of thing,
you like to make things. Rosemary Hargrove*

It's the ability to produce something that nobody else is going to have. *Minnie Bridges*

It just goes on and on:

What are you making?

Lisa Clark

ginghams,
calicos,
silks,
corduroy,
seersucker and oxford cloth,
taffetas,
satins and brocade,
cotton voiles,
curtain materials,
thimbles,
snaps, hooks and eyes, buttons,
quilters pins,
Velcro,
patches for jeans,
stitch witchery by the yard,
silk embroidery floss,
threads of every kind,
bridal satin, laces, netting, ribbons,
sequins, and those little seed pearls.
Any material you want. *Mary Ayers Reeves*

*Well, it's just that when it turns out well,
you feel you've accomplished something and it's rewarding. Irma Kirkpatrick*

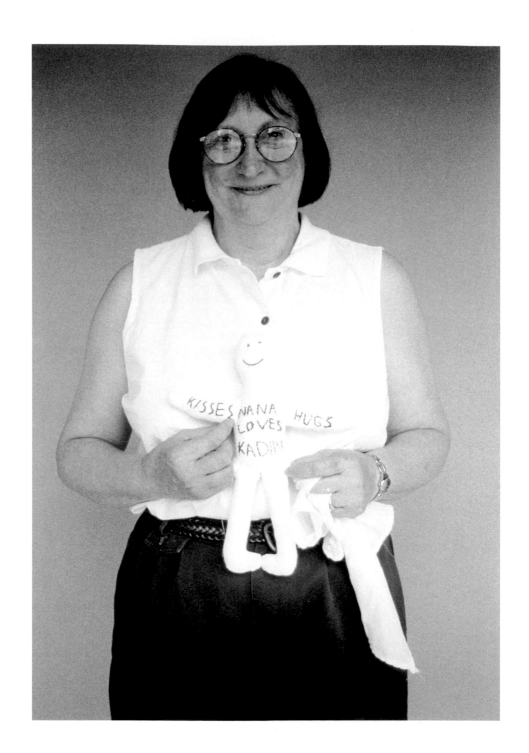

Susan True

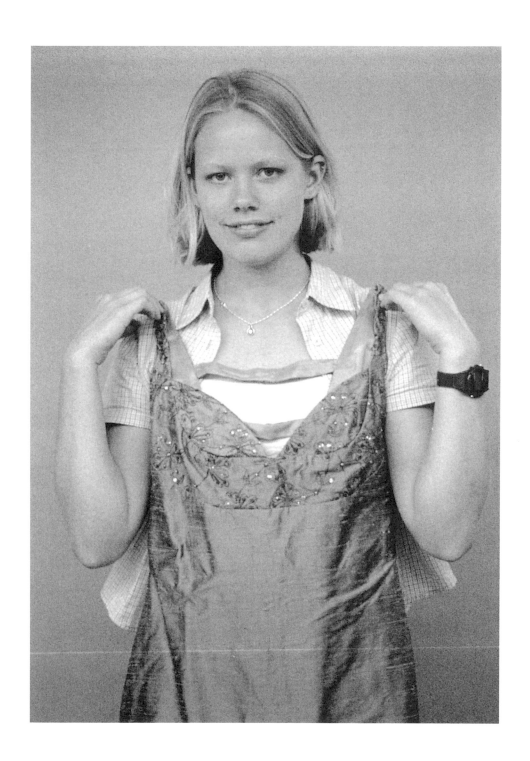

Laura Margaret Frazier

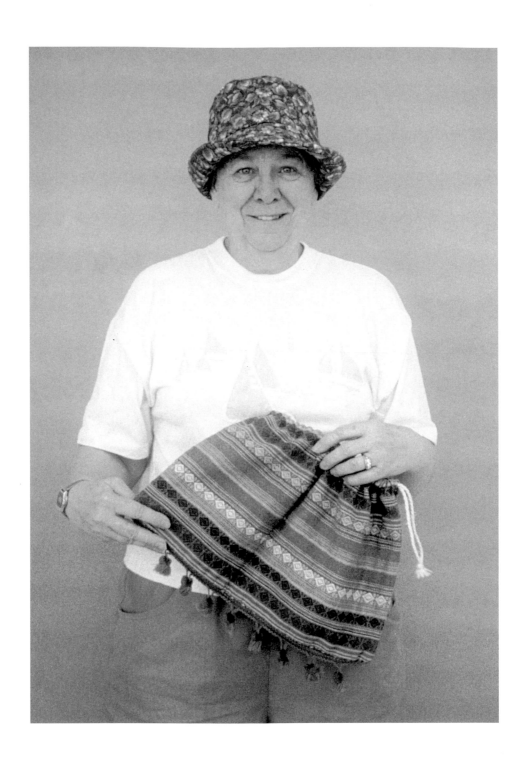

Terrie Wethie

Gregory Richmond

*The **What are you making?** project has included interviews and assistance from these organizations and individuals:*

The Chicago Park District
Chicago, Illinois

The Durham County Extension Homemakers Association
Durham, North Carolina

The Rougemont Extension Homemakers Association
Rougemont, North Carolina

The Cotton Boll
Chapel Hill, North Carolina

The Ayers Family, Walkertown Fabric Center
Walkertown, North Carolina

The American Needlework Association

The Durham Sewing Guild
Durham, North Carolina

**What does it mean—personally—
to make things in postindustrial time?**

Joy Apperson
Tom Ayers
Jane Boboroff
Minnie Bridges
Amy Butts
Katherine Bouldin
Mary Ellen Bowers
Lucy Carver
Cecilia Casas
Michaela Coglaiti
Megan Cornett
Ben Crews
Bonnie Dodge
Teresa Eliott
Sara Figlio
Shari Fischer
Laura Margaret Frazier
Laurel Fujisawa
Lois Gates
Sue Golba
Tomasz Gorzkowicz
Rosemary Hargrove
Herta Hlavac
Elois Johnson
Karen Joss
Irma Kirkpatrick
Jennifer Lapham
Pat Merriman
Linda Moore
Katie Newton
Jacquelyn Nouveau
Penny Paskoff
David Peczkowicz
Anna Pollard
Alma Poole
Linda Poole
Pietev Przeplova
Mary Ayers Reeves
Judith Reyes
Gregory Richmond
Martha Rueda
Patricia Russel
Olga Salas
Marcella Swanson
Arek Szyda
Davek Szyda
Susan True
Gretchen Tepperberg
Rebecca Vargha
Alexandra Vasilou
Gretchen Waldbauer
Doris Walker
Terrie Wethie
Natalie Yonan

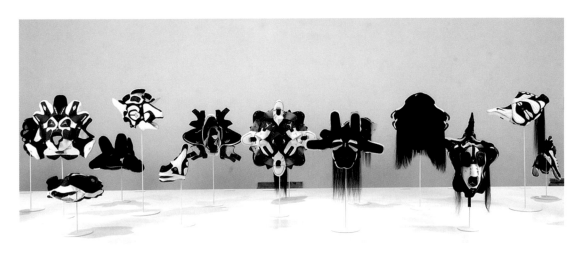

Prototypes for New
Understanding #1-23,
*1998-2005. Installation view
of* Brian Jungen *at the New
Museum of Contemporary
Art, New York.*

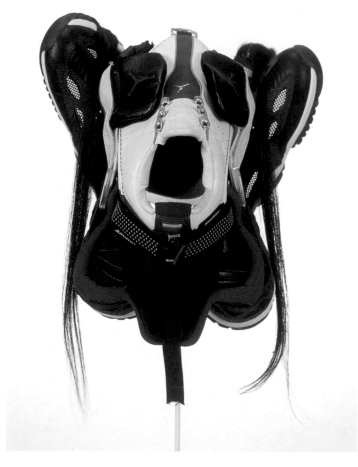

Prototype for New Understanding #14, 2003, Nike Air Jordans, human hair, and armature, 25 x 14 x 12 in. Collection of Lawrence B. Benenson, New York.

Prototype for New Understanding #22, 2005, Nike Air Jordans and armature, 34 x 21 x 9 in. Collection of Glenn Fuhrman, New York.

Brian Jungen has received significant international acclaim for his imaginative and critical transformation of consumer goods into anthropomorphic forms that evoke a range of contexts from Aboriginal sculpture to natural history museums and retail display. His installations integrate the complex circuitry of desire, mimicry, and fetishization that shape global, cultural, and economic exchange.

His series *Prototypes for New Understanding* (1998-2005) were produced by cutting apart Nike Air Jordan shoes, and reassembling them to suggest the formal qualities of Northwest Coast Aboriginal masks . . . Jungen writes, "It was interesting to see how by simply manipulating the Air Jordan shoes, you could evoke specific cultural traditions whilst simultaneously amplifying the process of cultural corruption and assimilation. The Nike 'mask' sculptures seem to articulate a paradoxical relationship between a consumerist artifact and an 'authentic' native artifact."

Jungen grew up in . . . British Columbia . . . in a family of Swiss and Aboriginal (Dane-zaa) descent. Yet, to read these sculptures as simple commentary on the commodification of Aboriginal culture would be a mistake . . . Jungen's assemblages suggest how in the global marketplace, cultural identification and aspiration increasingly collapse into forms of brand recognition.

Trevor Smith, Curator, New Museum of Contemporary Art

SEW YOUR OWN STUMP FLAG

Another *Susie Brandt* Creation

Display your flag proudly.

Flags displayed proudly.

Detail #1

Detail #2

FOREVER WILD?

To most of us "outsiders," it is inconceivable that New York State's Adirondack Park was ever anything but a natural wilderness. Yet long before it was designated a park in 1892, it had been the preserve of trappers, hunters, lumbermen, and even tourists. Ironically, many of the early advocates for preservation were also principal developers of the tourism industry.

This inherent tangle of contradictions and tenuous coexistence of public and private interests has come to define the Adirondacks. The area's natural beauty and seemingly plentiful resources exert an irresistible attraction to visitors and locals alike. Yet the very attributes which draw us to the region could lead to its destruction, unless the ever-present tensions between tourism and logging, visitors and residents, and preservationists and resource management advocates give way to a more permanent and mutually inclusive coexistence, one that is rooted in an understanding of and respect for the natural environment, its largesse and its limitations.

A local woman speaks about the Adirondacks' long history of "tourism," defining tourism broadly as "coming and taking." We see the effects on the region of "coming and taking" by commercial interests, tourism, and logging. What might we see if we learned to recognize the "strength and delicacy," as photographer Seneca Ray Stoddard wrote, of our shrinking wilderness, understood and made the best of it, stayed and gave?

— Carlos Gutierrez-Solana, Artist and Curator

C = Hadley, NY
D = Queensbury, NY
E = Chestertown, NY

Installation view of both Trials and Turbulence *and* Face to Face *at the Institute of Contemporary Art, University of Pennsylvania.* Trials and Turbulence, *2004, reconstructed courtroom, revolving door with bathroom fixtures, and various DVDs, 14 x 28 x 46 ft.*

Face to Face, *2002, reconstructed DHS offices, conference room, storage unit with home video, various DVDs, and audio, 14 x 66 x 32 ft.*

Face to Face *(detail)*.

Face to Face *(detail).*

Face to Face *(detail).*

In the exhibition *Trials and Turbulence: Pepón Osorio, An Artist in Residence at DHS* (2004), at the Institute of Contemporary Art (ICA), Philadelphia, Pepón Osorio gives trespass into worlds typically closed off from view, while transforming the social spaces of work into a site of artistic activity. The exhibi-tion's three interrelated installations *(Trials and Turbulence, Face to Face,* and *Run Mikey Run)* are based on a three-year artist's residency he voluntarily conducted at Philadelphia's Department of Human Services (DHS) from 2001 to 2004.

Before becoming known as an artist, Osorio studied sociology and worked as a caseworker for abused children. In the neighborhoods, social service offices, and courtrooms that constitute his expanded field of operations, Osorio focuses on the foster care system to examine one of the most vulnerable intersections between private life and public policy.

At ICA, viewers were granted otherwise forbidden access to these social institutions, although they were thwarted at every turn: first, upon entering the gallery, by a towering cage displaying a displaced family's possessions. In *Run Mikey Run* (2004), one spies, through a barricade made of wood salvaged from the streets of North Philadelphia, a video image of a boy running. *Face to Face* (2002) represents the offices of DHS. Here, viewers were allowed to snoop around workers' desks and files, peer into a conference room, and overhear a caseworker and client as recorded on an audio track. Passing a copy machine, viewers entered the next installation, *Trials and Turbulence* (2004), a reconstructed family courtroom.

To hold social services up for public view, by those both in and outside of the system, is no small triumph. Ultimately, Osorio makes welcome trespassers of us all; by penetrating the system and exposing it, his installations claim necessary means to change. This is the power of Osorio's art: to turn access into a form of intervention.

Ingrid Schaffner

TORN
FACE ANGER
&
MENDED

TEXTILE ACTIONS AT GROUND ZERO AND BEYOND

Nancy Gildart

In the days and weeks after the attacks of September 11, as I witnessed the rippling outward of the event, I was struck by the speed and spontaneity with which certain material gestures, which I came to call "textile actions," sprang up. In this essay, I examine these textile actions. I use this term to indicate responses to an event or situation that take the form of a real or metaphorical textile: a cloth banner, a carpet of flowers, a vinyl-ribbon decal on the back of a car. The term "action" refers to the efforts of the maker to get the work into the public domain as a part of the dialogue surrounding the event or situation, such as the wearing of a slogan-emblazoned cap or the on-line posting of a knitting pattern. I trace my own developing under-standing of why such actions were so ubiquitous and examine the associated issues of social space, memorials, branding, patriotic displays, and gifts of hand labor. Throughout, I explore the intended and unintended functions performed by these material communications in the immediate aftermath of the attacks. I do this from the perspective of a working artist trained in textile arts, and of a citizen, observing, interrogating, and reflecting upon what I witnessed.

239

TEARING

When the towers of the World Trade Center collapsed after the September 11 attacks, papers, along with ash, soot, and rubble, flurried down. They were caught in the trees of nearby St. Paul's Chapel churchyard, and swirled in the air as far as Brooklyn. Almost immediately, families and friends of victims started affixing what soon became a blanket of posters for missing persons, building spontaneous memorials. These were among the first textile actions or material responses to the disaster. Concurrently and throughout the country, responses appeared using the American flag. Quilts, needlework patterns, and clothing with memorial and patriotic themes emerged a week or two later.

When the smoke cleared, mourners began laying masses of flowers and other tributes at the foot of the equestrian statue of George Washington in Union Square, the closest anyone could get to the site. Along with flowers, people attached notes of raw, personal grief to public fences turning them into impromptu wailing walls. Fliers with the smiling faces of missing loved ones were everywhere.

Some of these faces formed "Portraits of Grief," a daily feature in *The New York Times* that ran regularly from the time of the attacks until December 31, 2001. The page had the look of a quilt: patchy with brief, evocative obituaries and small photographs, and layered with the subtext of grief. The daily delivery of this newsprint wailing wall evoked in me an emotion and curiosity not unlike what I felt walking for the first time among the panels of the NAMES Project AIDS Quilt. The NAMES Project's first panels were made in 1987 and the project remains a testament to the escalation of the AIDS crisis over decades; it has grown so large that it can no longer be shown in its entirety. Even the open public space of the National Mall, where it was on view in 1996, is not big enough. "Portraits of Grief," although spread only across my kitchen table and eventually finite, nonetheless had an immediacy that I found overwhelming.

Discussions concerning a fitting memorial to those who died in the World Trade Center attacks began soon after the event. Possible solutions ranged from the solidly physical (erect another tall building) to the ethereal (*Tribute in Light* by Creative Time, two beams of light that were visible during March 2002). While victims' families, artists, designers, and real estate developers pondered what form such a memorial should take, individuals across the country expressed themselves with the skills and simple materials at hand. Their actions included spontaneous memorials at sites throughout Manhattan, the *bricolage* of items such as photographs, letters, flowers, stuffed animals, candles, and ribbons left in parks, in commuter stations,

and along walkways and fences. People from all over the world came to Ground Zero to sign flags and banners. Many wore FDNY (Fire Department of New York) and NYPD (New York Police Department) caps and t-shirts. Others contributed squares for quilts and blankets posted on the Internet. Some posted patterns for scarves and socks—some patriotic, some not—on Web sites devoted to knitting; others offered their time and labor to turn those patterns into gifts for firefighters and rescue workers, then for children in Afghanistan. My growing curiosity about the central

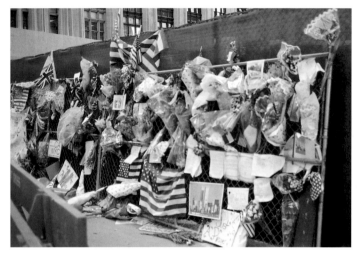

Ground Zero, November 2001. Mourners' offerings of flowers, American flags, photographs, and letters.

role textiles played in these spontaneous actions led me to search for historical precedents. That, in turn, led to interviews with makers and observers, whose stories unfold here.

HISTORY AND FUNCTION OF TEXTILE ACTIONS

Material or textile-based reactions to the attacks of September 11, 2001, ranged from the collective to the individual and from empowering to intimidating. These material reactions included wearable items and tributes to rescue workers and victims, flag-oriented expressions of both sorrow and jingoistic patriotism, as well as responses from artists.

Using textile actions as a form of emblematic communication during crises or times of collective concern is not a new phenomenon. Textile actions of the recent past include the wearing of red ribbons to commemorate those who died of AIDS, or pink ribbons to support survivors of breast cancer and remember its victims. In the beginning, the gesture of making and wearing the ribbon is the most important. Over time, the ribbon not only becomes a recognizable icon but also an object worth manufacturing.

241

What starts as a gesture inevitably becomes a commodity, for example, a piece of printed apparel, embroidered or embellished with images of red or pink ribbons, or jewelry shaped like ribbons and enameled or encrusted with paste and precious stones.

During World War I, families displayed service flags in front windows to let passersby know of their human contribution to the war effort. These flags were bordered in red and had a white field with a blue star for each member of the household serving in the military. (My great grandmother had one with three stars.) If one of those family members was killed, a gold star was superimposed onto one of the blue stars. Service flags were used during World War II as well, although not during the Korean or Vietnam wars. More recently, they have been displayed during the war in Iraq.

The textile actions following the immediate aftermath of 9/11 were not sanctioned by the cultural elite or mandated by political process. Instead, they sprang from a diverse spectrum of individuals whose first impulse was to express sorrow rather than to create a good design. It was more urgent to express these feelings—to get them out in the open with everyone else's— than to mediate them into something aesthetically pleasing, sophisticated, or stripped of its emotional ragged edges. These early responses also spoke of a need for community and collective participation. The fabriclike layers of flowers and letters, the assemblies of candles, all the stuff mourners brought to share with each other (including their tears), became ground for interaction among those whose paths would not otherwise cross.

Textile actions function to demarcate and establish social space. These homemade or appropriated indicators of solidarity act as lightning rods for a culture's conflicts over the roles of patriotism and dissent, and as a recognizable, useful, and readily available means of contributing one's labor. They also function as a material and conceptual basis for works of art.

SOCIAL SPACE

A key spot where mourners and supporters began leaving mementos during the early days of rescue and recovery was on the iron fence outside St. Paul's Chapel at Broadway and Fulton in Manhattan, adjacent to the Twin Towers. Seekers left photographs of missing loved ones. Supporters left flowers and flags. Friends visited Manhattan shortly after 9/11 and described to me what they had seen. I was interested in this spontaneous shrine and, hoping to see more, visited St. Paul's Web site. There I learned about the banners on the fence and a unique liturgical garment that now serves as a commemoration for those who helped in the recovery effort.

DISSOLVE FEAR

Krystyna Sanderson, image from Courage *series. Reverend Lyndon Harris of St. Paul's Chapel wearing the red chasuble stitched with patches from emergency crews who volunteered at Ground Zero. He stands in front of the banner* Courage, *2001, painted by Jessica Stammen.*

1. The New-York Historical Society: *History Responds,* http://www.nyhistory.org/ historyresponds.html.

2. Ibid., *Know where you live,* http://www.nyhistory.org/ historyresponds.html.

3. I called St. Paul's to see if I could find out more about this obviously commemorative garment. I spoke with Reverend Mitties DeChamplain. She encouraged me to call Sister Grace, a nun of the Society of Saint Margaret (an Episcopal order), who had been one of the leaders of the volunteer effort at St. Paul's.

The men and women of St. Paul's Chapel hung blank, white canvas drop cloths for visitors to Ground Zero to write thoughts of remembrance and messages of support, initiating a textile action whose invitation was immediately understood and accepted. In responding to a perceived need among those present, they also created an expectation of future visitors. Volunteers stood in attendance with mugs full of markers. Wanting to know more about their experiences with the banners, I emailed several of the volunteers who had left entries at the on-line volunteers' forum. So many people wrote messages that they put up new banners every day, often several times a day. These banners of grief and condolence, along with all the mementos people left at St. Paul's wrought iron fence, are now stored at the New-York Historical Society in its *History Responds* project that houses thousands of September 11 artifacts from which a half-dozen exhibitions have been installed.[1] This collection also holds objects from such diverse sources as New York City's police and fire departments, St. Vincent's Hospital, and Nino Vendome's Canal Street restaurant.[2]

In a photo I discovered on the Web site, Father Lyndon Harris of St. Paul's wore a red chasuble (a circular garment worn over the vestments of the celebrant) covered with patches from the uniforms of the emergency workers' crews.[3] The red chasuble (red is the color used for Passion Sunday, Pentecost, and feasts of the Martyrs) was a gift from a Roman Catholic priest, Father Mesa, in thanks for being allowed to help at the church. It was already an important memento for Fr. Mesa because his mother had made it for him to wear at his ordination in Ecuador many years ago. The

patches had been left out on the fence by workers and were sodden by the weather. Someone remembered the chasuble and pinned the patches on it, leaving a cross-shaped portion on the front empty. The front and back of the chasuble became so encrusted with patches that there was no room to add more. Fr. Harris wore it on St. Andrew's Day and Christmas Eve.[4]

Jessica Stammen, a third-year painting student at Cooper Union and a member of St. Paul's Chapel, was named informal artist-in-residence for the church. She was commissioned by Fr. Harris to make a series of banners to hang in the church courtyard as inspiration and support for the recovery workers. She gathered materials and, with the help of fifteen of her colleagues, made the six-by-six-foot banners that were simply designed and painted using red, white, blue, and gold paint. The banner *Courage* serves as the backdrop for photographer Krystyna Sanderson's *Courage* series, portraits of recovery workers and volunteers at St. Paul's, including Fr. Harris. The banner is layered with signatures. Stammen believes "very strongly that there is a need for people to leave their mark at this very sacred place . . . Bearing witness to this disaster and signing at the 'x' allows someone to claim this disaster as their own . . . so that the way is made for hope."[5]

Meg DiBiase, a volunteer at St. Paul's Chapel from West Haven, Connecticut, spoke of her time volunteering with the banners:

> I would wait and get a feel as to whether the person wanted a marker to write a thought or if they just wanted to read. Most wanted to write a few words of sympathy and support for New York and those lost, as well as [for] those left behind. The day we were there, Broadway had just been opened to the public, and the street was incredibly busy. The banners filled up very quickly. I would say we changed them every couple of hours, and we did a twelve hour shift.[6]

Another volunteer, Phillip Geliebter, from Philadelphia, said, "The only people I saw talk with each other were people that had come together. It was a very solemn and moving experience."[7] He also spoke of his conversations with pilgrims from all over the world: "One man wrote in Norwegian, one woman in Italian. A man told me he couldn't leave a message because he was from Mexico. I told him, 'Yes, you can.' He left a long prayer in Spanish."[8] People wrote; people read. Rescue workers stopped on their way in and out of the church to read the banners, sharing in the dialogue. Some 200 banners had been filled by the middle of December 2001.[9] These banners created a social space on what was once a busy pedestrian route where visitors could take a pause in silence with others. The labor of tending to the banners, replacing them with blank ones, and the consequent task of caring for these now sacred cloths, produced a palpable and contagious

4. Sister Grace in an email conversation with the author, January 27, 2002. She helped provide spiritual and corporeal sustenance to the rescuers.

5. Jessica Stammen in an email conversation with the author, January 29, 2002.

6. Meg DiBiase in an email conversation with the author, January 25, 2002.

7. Phillip Geliebter in an email conversation with the author, January 25, 2002.

8. Phillip Geliebter, as quoted in posting on St. Paul's on-line message board, December 11, 2001, http://www.saintpauls chapel.org/scripts/cgibin/ teemz/teemz.cgi?board= _master&forum=Volunteers (accessed January 2002; site now discontinued).

9. "Evaluating a Ministry for the Future," *Trinity News*, December 28, 2001, http:// www.trinitywallstreet.org/u/d/ News/alert_124.html.

sense of witness and caring still in the air when I visited six months later.

In my conversation with Reverend Mitties DeChamplain, she encouraged me to visit Manhattan and see St. Paul's and Ground Zero for myself, offering to act as my guide. I went to St. Paul's on Palm Sunday 2002. During the service, I could see that the walls were covered with banners from groups all over the country. Backs of pews were layered with letters and drawings from school children giving support and admiration to the recovery workers. The red chasuble was on display and I could see for myself the range of volunteer groups represented by the patches. That day, a new banner was unrolled and displayed from the balcony. Made by the workers themselves, with a bit of direction from Stammen, the banner was painted in bright, hopeful colors and carried such words as progress, tomorrow, gratitude, connection, and light.

On May 2, 2004, St. Paul's Chapel opened an exhibit called *Unwavering Spirit: Hope and Healing at Ground Zero.*[10] Not a memorial to the attacks or their victims, this ongoing exhibit is intended, instead, to celebrate the labor of those who worked during the long recovery of Ground Zero, including firefighters, rescue workers, volunteers, massage therapists, and clergy. Visitors can see letters written by children to the workers, items left on the chapel's wrought iron fence, the red chasuble, and many other artifacts from the recovery period. Edwin Schlossburg designed the exhibit with an interactive component allowing visitors to access stories from workers and volunteers, while sharing their own stories and images.

SOLIDARITY ON YOUR SLEEVE

Reactions to the events of September 11 were not limited to the immediate area surrounding Ground Zero. Nor were they limited to religious institutions or faith-based initiatives. In their first baseball games after the World Trade Center attacks, the New York Mets wore caps with police, fire, and emergency medical service insignia—a gesture and textile action honoring these workers. The team had to get special dispensation to wear these non-regulation items from Major League Baseball; they got permission for just two days. Not only did the Mets flout the rules and continue to wear their FDNY, NYPD, and EMT (Emergency Medical Technician) caps on the road, they also wore caps to honor the Port Authority Police, the State Court Officers Association, and the Emergency Squad of the NYPD. Some players wore camouflage caps. First baseman Todd Zeile remarked, "(T)hey're going to have to tear the hats off of us."[11] Copies of these caps quickly became sought-after souvenirs and were soon seen in cities across the country. They were also soon counterfeited and sold by street peddlers

10. "New 9/11 Exhibit For Ground Zero Pilgrims Opens at St. Paul's Chapel," *Trinity News,* April 29, 2004, http://www.trinitywallstreet.org/news/article_350.shtml.

11. Tyler Kepner, "Baseball: Mets Want to Stick with Array of Hats," *The New York Times,* September 22, 2001, sec. D, p. 3.

who set up shop on the sidewalks near the site.[12]

In these textile actions, the public and private intersect and blur. By wearing NYPD or FDNY baseball caps, whether genuine or counterfeit, some people felt they were honoring the sacrifices and bravery of public servants who helped office workers to safety on that dreadful day. Wearing garments that alluded to these public servants was a public, commemorative act that spoke volumes. Ordinary folks hoped that by doing so they could share in the heroism, as well as show their appreciation for the courage of these people. These bits of clothing allowed people to wear their hearts on their sleeves, making the private public.

FLAGPOLE OR LIGHTNING ROD?

Some of the most widespread public or textile actions involved the American flag. All over the country, American flags were dropped to half-mast just moments after the attacks. The next day, many newspapers carried a full-page, full-color paper flag suitable for posting on a bulletin board or store window. The slogan "United We Stand" often accompanied images of the flag on billboards, bumper stickers, and lawn signs.

In the days following the attacks, I saw American flags everywhere. Red-white-and-blue ribbons adorned lapels, as did miniature flags and flag-shaped pins. Flags flew from condominium balconies and tenement fire escapes. They were displayed in store windows, and flapped raggedly from car radio antennae. Many flags became so tattered from exposure that some veterans' committees and Veterans of Foreign War posts set up drop boxes for worn flags so that they could be ceremonially destroyed.[13]

On September 15, 2001, in Tucson, Arizona, 15,000 people wearing red, white, or blue t-shirts formed a human American flag in the outfield of Electric Park. An aerial photograph was taken and published in the *Arizona Daily Star*. KRQ-FM radio disc jockey Johnjay Van Es and his listeners devised the action that was sponsored by the radio station, *Arizona Daily Star*, and the local NBC affiliated television station. "We need to show that we're all Americans and we're all one big family and we're not going to let other countries just step all over us," said Sandra Fernandez, a clerk in Pima County's child-support office and a participant who brought fourteen young children with her.[14]

Writing words of grief and encouragement on an American flag constituted another textile action in which public and private intersected. The American flag, itself a commemorative and symbolic piece of cloth,

OPT TO LISTEN

12. Edward Wyatt, "Officials Irked as Merchants Cash In On Logos of Fire and Police," *The New York Times*, December 14, 2001, sec. A, p. 26. (Fire Zone, the educational facility of the New York Fire Department Safety Fund, sells a September 11 memorial t-shirt with a picture of a firefighter's helmet on the chest. This is also a place to buy the official FDNY cap.)

13. This note was seen by the author on a box at the Homewood (Illinois) Public Library: "If you wish to retire a worn American flag, please use this drop-off box. The flags will be properly handled by the Homewood Veterans' Committee."

14. Enric Volante, "Tucson shows its true colors," *Arizona Daily Star*, September 16, 2001, sec. A, p. 1.

served as a background for well-wishers' personal words of hope, love, and condolence. One particular flag was draped on a surviving building near the World Trade Center. No one knows who wrote first, but the red-and-white stripes were quickly filled with words. On the white stars people honored first responders by writing the names of some of the police officers who died in the attack, one name per star. This inscribed flag is an unmediated response to the World Trade Center attacks. Commenting on the spontaneous nature of this act, David W. Chen, a reporter for *The New York Times*, wrote: "At a time when the appetite for patriotic gestures seems to know no limit, few objects are more indelible than an impromptu, communal memorial cloth."[15] People came from far away and waited in long lines to sign the flag, an object that had become a catalyst for interaction, a maker of social space, as well as a commemorative textile. I spoke with Terry Huttelmayer of the American Legion's Americanism office, who told me that as long as the marking of the flag is done "in good taste and with dignity" the organization has no problem with it. "A lot of things are being accepted now."[16]

This rallying around a symbolic piece of cloth had the dual effect of being both unifying and alienating. On the surface was the sentimentality of Americans coming together and supporting each other in time of need. Beneath this veneer of unity, there flowed a dark current of xenophobia and prejudice against those who didn't look "American." Blaine Harden of *The New York Times* quoted Nabeel Abraham, an American-born anthropologist of Palestinian descent: "I see flags everywhere, yet my first instinct is apprehension . . . We don't know what to expect. We expect the worst."[17]

CONTESTED GROUND

Rebecca Fridae also felt apprehension when she saw the proliferation of American flags displayed. An elementary school teacher in Winters, California, she learned that people from ninety-one different countries were killed in the attacks. The following day she asked her students to make flags for each country. She displayed these flags in her classroom although many parents complained that she was being unpatriotic—and teaching their children to be so as well—by diverting attention from the "real" victims.[18]

Tai Moses, editor of *Metro Santa Cruz*, analyzed the display of patriotism this way:

Seeking solace, the country drapes itself in the American flag like a child in a superhero cape who plays at being invincible. From homes, vehicles and clothing to department store windows, billboards and television commercials, there are few places in the country where the Stars and Stripes has not found a purchase.

15. David W. Chen, "Flag to Carry Sentiments From Ground Zero to Afghanistan," *The New York Times,* November 26, 2001, sec. B, p. 1.

16. Terry Huttelmayer, of the American Legion, in a telephone conversation with the author, January 24, 2002.

17. Blaine Harden, "Ideas & Trends: Put 'Em Up; Flag Fever: the Paradox of Patriotism," *The New York Times*, September 30, 2001, sec. 4, p 1.

18. Rebecca Fridae in conversation with the author, August 17, 2002.

People who never gave the flag much thought except on the Fourth of July have become suddenly, passionately, patriotic. For some of us, patriotism is a complicated matter, linked with a dedication to the Constitution. But the now inescapable presence of the flag, supposedly a symbol of American pride and unity, sometimes looks suspiciously like overcompensation for a wounded ego. The flag is an icon, a brand that offers no more protection than the Nike swoosh.[19]

If there are brands, there must be things to buy. Shortly after the attacks, Americans were urged to inject new life into a faltering economy, through—what else?—shopping. Rudy Giuliani, then mayor of New York City, exhorted citizens: "Shopping is important. Do it!"[20] And to appeal to shoppers' new-found sense of patriotism, marketers and designers produced a host of flag-branded products. At Bloomingdales, I saw a Ralph Lauren sweater with an American flag on the chest and American flag neckties designed by Tommy Hilfiger. At the lower end, Frederick's of Hollywood sold a thong decorated with flags and the slogan "America the Beautiful."[21] A few months after the attacks, some American consumers seemed to be suffering from flag fatigue. I noticed that my local Filene's Basement was glutted with merchandise emblazoned with the American flag. Sweaters, umbrellas, chocolates, scarves, neckties, socks, underwear were all marked down by thirty to forty percent.

During the Vietnam era, those protesting the U.S. involvement in the war used the American flag in their protests. They burned it and stomped on it. They cut it up and made clothing out of it. They used flag stamps on their mail and, to symbolize a nation in distress, affixed them upside down. They redesigned the flag by placing a peace symbol where the stars were supposed to be. These protests made people very aware of the situation the United States had gotten itself into and helped turn the tide of public opinion against the war.

Born into a family with affiliations ranging from the John Birch Society and the Daughters of the American Revolution to the Progressive Party and the American Civil Liberties Union, I was bothered by something in the post-September 11 flag waving. The American flag is supposed to belong to all Americans, but the constant uttering of the phrase "United We Stand" only made room for those who were willing to conform to a certain compliant model of patriotism. It swept any discomfort or dissent under the red-white-and-blue. Old Glory was co-opted by the hawkish right as a symbol—indeed, a brand—of unquestioning conformity and a gag for those who dared to exercise their First Amendment Right to a dissenting opinion. The writer Barbara Kingsolver proposed:

19. Tai Moses, "Before and After: Sept. 11," in *After 9/11: Solutions for a Saner World*, ed. Don Hazen, et al. (San Francisco: AlterNet.org, 2001), p. 4.

20. Matthew Grimm, "Jingo All the Way? — national unity is a time of clichés," *American Demographics*, December 2001, p. 49.

21. Bet Power, "American Flag or Corporate War Logo?" *Portland Independent Media Center*, January 7, 2002, http://portland.indymedia.org/en/2002/01/6204.shtml.

I would like to stand up for my flag and wave it over a few things I believe in, including but not limited to the protection of dissenting points of view. After 225 years, I vote to retire the rocket's red glare and the bullet wound as obsolete symbols of Old Glory. We desperately need a new iconography of patriotism. I propose we rip stripes of cloth from the uniforms of public servants who rescued the injured and panic-stricken . . .[22]

22. Barbara Kingsolver, "And our flag was still there," *San Francisco Chronicle,* September 25, 2001, sec. A, p. 17.

Indeed, such a textile action might create a flag—perhaps the only flag—that all Americans could wrap themselves in without irony. This commemorative textile would be made of relics sanctified by the sweat and blood of those who helped. It would be an acknowledgement of the important job rescue workers did, a job they had trained for, but never dreamed they would perform at such magnitude. Tinged with soot and toil, this flag would be born out of the crucible of 9/11. The ubiquity of the American flag provided a sort of camouflage. Individual displays blended into a larger whole and anonymity was assured. Individual sentiment and, perhaps, dissent, was hidden by the ease of adopting a symbol that was so readily available.

THE IMPULSE TO CONTRIBUTE, THE INSTINCT TO MAKE

As an artist who uses hand-knitted objects in her installations, I wondered about makers' individual responses to 9/11. Because I do most of my knitting in solitude, and because the events of 2001 occurred before the swell of the twenty-first-century knitting wave, I wasn't aware, at least not firsthand, of any group projects or initiatives. I searched the Internet for needleworkers' responses and found that many chose to mark the event in individualized and personal ways. Many needleworkers took action through their own projects and provided the means and encouragement for others to do the same. Some designed patterns for warm socks and hats for recovery workers and provided clearing houses for charity needlework. Others designed patriotic-themed patterns for clothing and accessories. These textile actions helped ease participants out of the early stages of grief into acceptance. They allowed makers to distill their feelings into a tangible, commemorative object. Event and emotion were preserved through textile action and could be revisited easily. I corresponded with a few knitters to get more insight into the impetus for their process.

On her Web site *Warm the City,* Claudia Krisniski encouraged knitters to make dark-colored wool hats for the recovery workers to wear under their hardhats. She provided the pattern, as well as patterns for socks and mittens, and encouraged knitters to work a subtle purl-stitch heart into the fabric. "Knit in all the love and energy you can," she stated. "Who knows? Perhaps

the wearer will feel your strength and draw from it."[23] The response to this initiative was so great (over 400 caps and pairs of mittens were made and donated) that Krisniski retired her *Warm the City* Web site, and the project was absorbed into the on-going charity knitting effort at her shop.[24] She has established permanent links with two New York City shelters.

Another textile action was initiated by Ann Budd, an editor for *Interweave Knits*, a magazine for knitters. She designed a pair of socks called *Ladder of Life*, "to honor the men and women who work to save lives . . . not only during national crises . . . but every day."[25] Made and given in appreciation to local firefighters and rescue workers, Budd's socks were not red, white, and blue, but knitted in a dark, serviceable color so that emergency workers could wear them on the job.

Some textile actions began in a more private and subtle way. Kim Brody Salazar, a knitting expert and pattern designer, was between a state of wake and sleep the night of September 12, 2001. Suddenly, a pattern for a scarf commemorating the World Trade Center victims came into her head. She ran to her computer and typed it in, then posted it on the Web site *wiseNeedle*.[26] As of January 2002, she had knit only about a third of the pattern. According to Salazar, "Luckily my personal friends or family were not among any of the missing or injured, but I found more and more victims whose circles had overlapped mine . . . It became too overwhelming. I had to put the scarf down, only a third finished. I still can't pick it up again."[27] Salazar's design is not about patriotism; it is about loss. Within its stitches lies the skeleton of the World Trade Center. When the scarf is worn around the neck (it is meant to be worn inside one's coat), the two ends echo the superstructure of the Twin Towers.

Another response was at the Textile Museum of Canada in Toronto. In summer 2002, curators Natalia Nekrassova and Max Allen mounted an exhibition called *Living in Afghanistan*, a display of beautiful Afghan textiles. Their mission was to show visitors something of Afghanistan and its people beyond the events of September 11. To quote from the exhibition statement: "The Afghanistan shown on television seems to consist of furious men rioting or fighting, air strikes, ruined buildings and refugees. But there is another Afghanistan, whose culture is ancient, diverse and fabulous. We hope some of this 'Invisible Afghanistan' becomes visible through the textiles in this exhibition."[28] This neutral statement was the only reference made to current events. Susan Koenig, a docent at the museum, noticed that visitors generally appreciated seeing a positive side of Afghanistan, but that some American viewers were offended by it. "They

HONOR DIFFERENCES

23. As stated by Claudia Krisinski in Web site http://members.tripod.com/countrywool/wtc.html (accessed January 2002; site now discontinued).

24. Claudia Krisniski in an email conversation with the author, September 22, 2002.

25. Ann Budd, "A Gesture of Gratitude," *Interweave Knits* (Winter 2001-2002), p. 10.

26. A Web site for knitters, www.wiseneedle.com.

27. Kim Brody Salazar in an email conversation with the author, January 13, 2002.

28. Max Allen and Natalia Nekrassova, curators' statement from exhibition brochure for *Living in Afghanistan*, Textile Museum of Canada, June 19, 2002.

29. Susan Koenig in a telephone conversation with the author, August 12, 2002.

30. *Afghans for Afghans*, http://www.afghansforafghans.org/about.html.

31. Ann Rubin in an email conversation with the author, April 2006.

32. "Stitch-one-purl-two: American Red Cross Knits!" *Red Cross Virtual Museum*, http://www.redcross.org/museum/knitting.html.

thought we were glorifying the enemy," she said, "even though the U.S. is fighting *with* the Afghan people against the Taliban and Al Qaeda."[29]

Afghans for Afghans was begun by Ann Rubin to provide warm wool clothing and blankets to Afghan children.[30] Started in 2001, this project is still ongoing. Knitters and crocheters make hats, sweaters, mittens, and blankets out of colorful wool and mail them to an American Friends Service Committee office in San Francisco, where they are packed together and sent to Kabul by World Concern. There are two or three deadlines each year and the response has been enormous—38,000 items as of April 2006.[31] (I made twenty hats and three sweaters myself, the hand labor giving me time to think about the children of Afghanistan and knit thoughts of hope as well as items of warmth.) Rubin's textile action transcended nationalism and political alliances to send help where it was really needed. It gave a constructive outlet to those wanting to respond positively. *Afghans for Afghans* continues the tradition of knitting for refugees promoted by the Red Cross during both World Wars[32] and subsequent catastrophes. Though commercial, machine-made knitted items were certainly available then, the Red Cross appealed to individuals to knit sweaters and caps; each knitter contributing the labor of her own hands, as well as the cap or sweater to the cause.

Participatory textile actions did what a million American flags could not. They provided a space for actual and metaphorical conversation, and made those participating feel that they were a part of a larger whole. For example, by posting her scarf pattern on the Internet, Salazar hoped that others would make and wear this commemorative textile to show their solidarity with those who suffered losses. She shared a private act and made it public. Those who chose to make and wear the scarf became part of a conversation and a community. Those who chose to make anything were slowed in their thoughts and actions by the meditative quality of repetitive action and,

Ladder of Life socks knit by the author from a pattern designed by Ann Budd, managing editor of Interweave Knits.

perhaps, were less likely to exchange their sorrow with a desire for revenge.

Expressions of condolence and solidarity took the form of the ordinary and the utilitarian. They were unmediated responses to an event that took the world by surprise. Writing in *The New York Times* a month after the World Trade Center attacks, Karal Ann Marling, a professor of art history and popular culture at the University of Minnesota, said, "American art—fine art, that is—takes too long to serve us well in times of crisis. Fine art appears later, when the culture has achieved a consensus on the meaning of an event."[33] These textile actions were initiated by individuals and grew as others added their own flowers and flags to the mass of expression. Emotion impelled participants to add their own layers to this mourning cloth. It might have been an opportunity for making art, but this was not uppermost in their minds. There was not time for reflecting on the meaning of the event and responding to it in a considered and mediated way. As Marling stated further: "History and crises can't wait for artists to happen on the scene and mull it over. Crises call for psychic bandages, right now . . . I want those flags and stickers now. I need those bits of red, white, and blue to cope with how I feel, to elicit a thumbs-up from some stranger with a flag of his or her own. I need flags and shrines—and look forward to great art at some later date."[34] It was important for people to deal with the loss immediately—to rend their garments, as it were—and grieve.

DRESSING THE WOUND

What do you do with a hole? Patch it? Sew it closed? Let it scar? Hide it? Embellish it and make it beautiful?

Two days after the attack on the Pentagon, Anita Walsh, a Washington, D.C. area artist, thought, "If I were a child how would I feel about all these confusing messages? How do we start talking about it?"[35] She knew right away she wanted to use bandage strips to initiate a conversation with children about sensitivity around a wound or trauma.[36] After much experimentation and evaluation, she and her collaborators, Megan Maher, Katie Morris, and Adam Fowler, settled on sheer bandages (that blend with any skin tone) as the basis for their project. So began the conceptual art piece *SkinTalks*. Very labor intensive, it involved volunteers opening packets of bandages, affixing them in a predetermined grid format to a temporary substrate, and screen printing them with phrases such as "Opt to Listen," "Salvage Truth," and "Dissolve Fear." The bandages were then repackaged in glassine envelopes by clients of an agency that works with adults who have emotional and physical handicaps. At their first event on February 1, 2002, artists and volunteers gave away 500 packages of the screen-printed sheer

33. Karal Ann Marling, "Salve for a Wounded People," *The New York Times,* October 14, 2001, sec. 2, p. 39.

34. Ibid.

35. Anita Walsh in a series of email and phone conversations with the author, October 2002.

36. *SkinTalks* Web site http://www.skintalks.org/skintalks.html.

bandages in front of the Corcoran Gallery of Art in Washington, D.C.

The project has since grown through the enthusiasm of the volunteers and the interest of schools, camps, and other programs for children. The fourth giveaway was on September 11, 2002, as part of the citywide commemorative event 9/11: Arlington Remembers. Three thousand packages of bandage strips were distributed, and written responses were collected from community members. With large versions of the phrases on the bandages, these responses (for example, "I can be loving, giving & caring toward people I don't even know. We are all God's people."), were woven into banners. The artists called them "visual conversations" and they were meant to advance their goal of promoting dialogue. As of this writing, an exhibition venue had not yet been secured. Walsh has since created a digital conversation on the *SkinTalks* Web site,[37] and hopes to show the physical piece at a future date.[38]

The *SkinTalks* project supplied something vital during the first weeks and months after the attacks, creating a space for dialogue in which collaborators and viewers alike could begin to understand the enormity of the situation. Through conversation, participants began to sort out their complex emotions and, perhaps, become comfortable with them. The urgency with which the artists of *SkinTalks* undertook their project, creating vehicles capable of facilitating public conversation, took them out of the world of white box galleries, curators, and critics.

MENDING

Using hand labor to note the loss of both the World Trade Center and the victims of all the attacks of that day helped ease both individual and collective pain. The many needlework projects connected with the events of September 11 demonstrated a need to do something, to have control over some small activity and have something positive come of it. Simple hand labor does more than simply provide warmth or distraction. It mirrors the labor of others and, by doing so, honors it. Well-done hand labor honors all those at work or on their way to work at the World Trade Center, the Pentagon, or in the plane that fell in Pennsylvania. Hand labor also makes space for reflection. There is time during the formation of stitches to meditate on an untenable situation and the lives touched by it. There is space created by a community sewing session to find consensus and a sense of collectivity. There are opportunities during an artistic intervention or collaborative performance for conversation and reciprocation. There is space to remember.

In this place of making, the real work of mourning can take place.

37. Ibid., http://www.skintalks. org/conversations-flash.html.

38. Anita Walsh in an email conversation with the author, April 2006.

In the aftermath of September 11, the feeling of wanting to do something was a common one. Also common was to reach for what was close at hand—for materials with which to express solidarity or grief. Gathered in this essay is a particular set of such expressions. In examining these textile actions an important distinction arises between those involving extended labor and those involving the purchase and display of readymade sentiment. If we conceive of loss as a gap or hole and consider the impulse towards doing something as an effort to contend with that gap, the distinction becomes evident. Hand labor extends, and through its repetitive action holds open a space. The automatic purchase and display of a flag, an FDNY cap, or ribbon decal, on the other hand, closes down that space and short circuits the process of grieving. The purchase of objects is quickly achieved and the need to do something rapidly satisfied. Just as the blank banners in the yard of St. Paul's Chapel provided a ground for expression, hand labor also provides a substrate for the processing of trauma.

My intention here is to honor the work of those who catalyzed their individual grieving processes into actions—textile actions—that encouraged mourning to take its course untruncated by flag-waving societal pressures or the shrill call to arms. Theirs was the intensive and extended labor of witness and response. I hope, in recognizing their efforts, my own labor—in research and conversation—continues the work of collective understanding.

Weaving responses to the SkinTalks project into visual conversations at the commemorative event 9/11: Arlington Remembers, September 11, 2002.

254

ADA LOVELACE AND THE LOOM OF LIFE

Sadie Plant

1. Sigmund Freud, "Femininity," *New Introductory Lectures on Psychoanalysis,* Penguin Freud Library, vol. 2 (London: Penguin, 1977), pp. 145–69.

In 1933, Sigmund Freud made his final attempt to solve the riddle of femininity. "To those of you who are women," he wrote, "this will not apply—you are yourselves the problem."[1] Having written of femininity's wants, deficiencies, lapses, and absences, he had only a few more pages to write, just a couple of further points to make. "It seems," he wrote, "that women have made few contributions to the inventions and discoveries of the history of civilization." Thus for Freud, women lacked both the capacity and the desire to change the world. They weren't logical and couldn't think straight; they flitted around and couldn't concentrate.

Perhaps it was precisely at this moment that Freud, distracted by the rhythmic beat of a nearby machine, looked up to see his daughter Anna, a weaver and a spinster, working at her loom. Her mind had wandered off and was miles away, lost in her daydreams and the shuttle's flight. But the sight of her gave Freud second thoughts. When he took up the thread of his argument, he seems to have changed his mind:

There is, however, one technique which they may have invented—that of plaiting and weaving. If that is so, we should be tempted to guess the unconscious motive for the achievement. Nature herself would seem to have given the model which

255

this achievement imitates by causing the growth at maturity of the pubic hair
that conceals the genitals. The step that remained to be taken lay in making the
threads adhere to one another, while on the body they stick into the skin and are
only matted together. If you reject this idea as fantastic and regard my belief in
the influence of lack of a penis on the configuration of femininity as an idée fixe,
I am of course defenceless.[2]

2. Ibid.

Giving women credit for weaving was faint praise. Because Freud regarded the penis as a visible badge of identity that women consequently lack, he suggests here that the "unconscious motive for the achievement" of weaving lies in women's attempt to conceal their genitals and their own shame at the absence of a male member. If weaving was to count as an achievement, it did not belong to women. According to Freud, there is no creativity in this work. Weaving is an automatic imitation of some bodily function already beyond the weaver's control, and neither the woman nor her cloths are doing anything original: they are simply copying the matted tangles of pubic hair. The weaver is bound to weave a costume for the masquerade. She is an actress, a mimic with no authenticity. She has nothing to reveal, no soul to bare, not even a sex or a self to please. Freud pulls aside the veils, the webs of deception, the shrouds of mystery, and finds nothing there, only "the horror of nothing to be seen."[3]

3. Ibid.

Freud's comments epitomize society's tendency to marginalize both women and their work. Weaving, widely associated with women, has always fallen between the arts and the sciences, and has rarely been taken seriously. There is, however, always a point at which, as Freud admits, "our material— for some incomprehensible reason—becomes far more obscure and full of gaps."[4] As it happens, Freud's weaving women made far more than a small and questionable contribution to his great narrative of inventions and discoveries. Their microprocesses underlie it all. The spindle and the wheel used in spinning yarn were the basis for later axles, wheels, and rotations. Textiles also underlie the great canvases of Western art; even the materials of writing were woven in their earliest forms. They have also played a crucial role in the history of computing: the Jacquard loom was the first programmable machine, and the earliest mechanical computer was conceived as a vast weaving machine.

4. Sigmund Freud, *On Sexuality*, Penguin Freud Library, vol. 7 (London: Penguin, 1977), p. 320.

String dates as far back as 20,000 B.C., and is thought to be the earliest manufactured thread. This multipurpose material can be used for carrying,

5. Elizabeth Wayland Barber, *Women's Work, The First 20,000 Years* (New York: WW Norton, 1994), p. 45.

holding, tying, and trapping, and has been described as crucial to "taming the world to human will and ingenuity," and "the unseen weapon that allowed the human race to conquer the earth."[5]

Evidence of sophisticated textile production dates to 6000 B.C. in the southeastern regions of Europe and, in Hungary, there is evidence that warp-weighted looms were producing designs of extraordinary extravagance from at least 5000 B.C. Archaeological investigations suggest that from as early as 4000 B.C., Egyptian women were weaving linen on horizontal looms, sometimes with 200 threads per inch, and capable of producing cloths as big as nine by seventy-five feet. Circular warps, facilitating the production of seamless tubes for clothing, and tapestry looms, able to weave dense images visible in weft threads but so closely woven as to conceal the warps, were also used in Ancient Egypt, where individual artisans stamped their work with their own signatures, and trademarks and logos were woven in to indicate the workshop where cloths were produced. Here, cloths were used as early currency, and fine linens were as valuable as precious metals and stones. In China, where the spinning wheel is thought to have first turned, sophisticated drawlooms wove designs that used thousands of different warps at least 2,500 years before such machines were developed in the West.

Textile work may have been a necessity of life, but the innovations spurred by women's engagement with its processes went far beyond clothing and sheltering the family. There is evidence that even "Neolithic women were investing large amounts of extra time into their textile work, far beyond pure utility."[6] These prehistoric weavers seem to have produced cloths of extraordinary complexity, woven with ornate designs far in excess of the brute demand for simple cloth. This tendency to elaborate fueled continual exploration and the development of new techniques of dyeing, combing, spinning, and weaving. There is an obsessive, addictive quality to the spinning of yarn and the weaving of cloth; a temptation to get fixated and locked into processes which run away with themselves and those drawn into them. Even in cultures assumed to be subsistence economies, women who only did as much cooking, cleaning, and childcare as was necessary tended to go into overdrive when it came to spinning and weaving cloth, producing far more than was required to clothe and furnish the family home. In terms of quality, sophistication, and sheer quantity, the production of textiles always puts some kind of surplus in play. One of the first cottage industries in Europe was the production of homespun yarn and cloth, and the sale of surpluses often provided an independent income for spinsters and weavers alike. Although the necessity of spinning and weaving may

6. Ibid., p. 90.

have faded in the modern West, a wide range of needlework and sewing tasks are still popular and still fall within the domain of women's work.

Weaving has always been a multimedia event. Singing, chanting, telling stories, and playing games as they worked, weavers often used their work as a means of communication and information storage. The weaving of complex designs demanded more than one pair of hands, and textile production tended to be communal, social work that allowed plenty of occasion for gossip and chat. The women of prehistoric Europe, for example, "gathered at one another's houses to spin, sew, weave, and have fellowship,"[7] and also used the textiles they produced as records of the processes that fed their work. Thus, a piece of cloth is saturated with the thoughts of the people who produced it, each of whom can see it and be transported to the state of mind in which they worked. Cloths have also been woven for magical purposes, "to protect, to secure fertility and riches, to divine the future, perhaps even to curse."[8] In this sense, the weaving of spells is far more than a metaphorical device.

Culture and nature are intimately tied in the making of textiles. When sun-dried fibers are spun by hand, the spinsters' fingers and the spinning wheels follow a trend set by the way plants have already curled and died. When weavers interlace their threads, they do more than mimic the techniques witnessed in nature among tangled lianas, interwoven leaves, twisted stems, bacterial mats, birds' nests, and spiders' webs. In plaiting, spinning, and weaving, threads are assembled in ways that far exceed any of Freud's fantasies about women's pubic hair. Though he imagined there was only one small step involved in "making the threads adhere to one another," the techniques developed in order to make cloth from natural fibers led rather to increasingly complex processes and products.

7. Ibid., p. 86.

8. Ibid.

In Europe, there were several early and sophisticated innovations in weaving before the modern age. Drawlooms had been developed in the Middle Ages, and while many of Leonardo da Vinci's machines for spinning, weaving, twisting hemp, trimming felt, and making needles were never made, he introduced the flyer and the bobbin that brought tension control to the spinning wheel. But it was the "cloth capitalism" of the Industrial Revolution that quite literally changed the world. In the 1850s, it was said:

> If Providence had never planted the cotton shrub, those majestic masses of
> men which stretch, like a living zone, through our central districts, would have
> felt no existence; and the magic impulse which has been felt . . . in every

9. Asa Briggs, *The Age of Invention* (London: Longmans, 1959), pp. 21–22.

department of national energy, our literature, our laws, our social condition, our political institutions, making us almost a new people, would never have been communicated.[9]

While the Industrial Revolution made the break between hand-held tools and supervised machines, the handmade and the mass produced, the introduction of technology to more primitive textile techniques was both a break from the old ways and a continuation of the way in which women were already working. Even before its mechanization, the loom was described as "the most complex human engine of them all," not least because of the extent to which it "reduced everything to simple actions: the alternate movement of

Power looms weaving madras muslin using Jacquard cards, Darvel, East Ayrshire, ca. 1900.

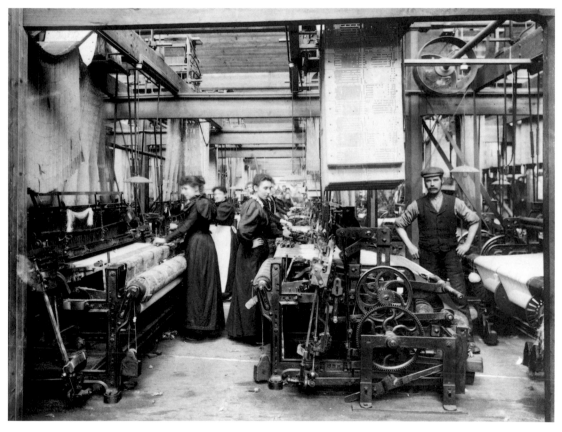

the feet worked the pedals, raising half the threads of the warp and then the other, while the hands threw the shuttle carrying the thread of the woof."[10]

Until the early eighteenth century, when mechanisms that allowed looms to automatically select their own threads were introduced, it could take a weaver two or three weeks to set up a drawloom for a particular pattern.

10. Fernand Braudel, *Capitalism and Material Life, 1400–1800* (London: Weidenfeld and Nicolson, 1973), p. 247.

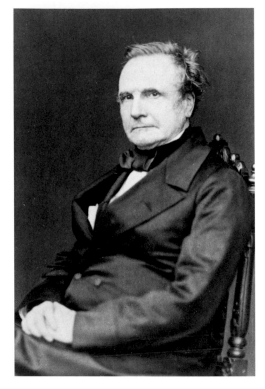

The new devices used punched paper rolls, and then, in the early nineteenth century, punched cards were strung together to make the loom the first piece of automated machinery. It was Joseph-Marie Jacquard, a French engineer, who made this final move in the early nineteenth century. Jacquard's loom could be programmed to weave even the most complex, figurative designs. It revolutionized textile production, and also influenced a different line of technological development in England, where Charles Babbage was working on a calculating machine or the Difference Engine. Although he struggled to find funding for his work, Babbage had no doubt about the feasibility and value of what he defined as "machinery to compute arithmetical tables."[11] Isolating common mathematical differences between tabulated numbers, Babbage was convinced that this "method of differences supplied a general principle by which all tables might be computed through limited intervals, by one uniform process."[12] By 1822, he made a small but functional machine, and in

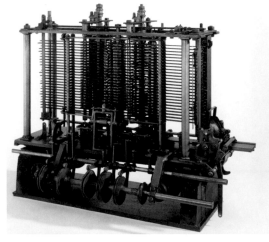

Charles Babbage's Analytical Engine (1834–71), the first fully automatic calculating machine. Shown here is a portion of the mill with a printing mechanism.

11. Charles Babbage, *Passages from the Life of a Philosopher* (London: William Pickering, 1994), p. 31.

12. Ibid.

13. Sir H. Nichols quoted in Babbage, *Passages from the Life of a Philosopher*, p. 64.

14. Lady Byron quoted in Doris Langley Moore, *Ada, Countess of Lovelace* (London: John Murray, 1977), pp. 43–44.

15. Sophia Freud quoted in Moore, *Ada, Countess of Lovelace*, p. 44.

1933, in what was later described as "an event of great importance in the history of the engine,"[13] a small part of the machine was put on public display. One of the people who came to see it work was a teenage girl named Ada.

Ada Byron, as she was then known, was the only child of Annabella, a mathematician who had been dubbed Princess of Parallelograms by her husband, Ada's father, Lord Byron. "We both went to see the thinking machine (for such it seems) last Monday," Annabella wrote in her diary. To the amazement of its onlookers, the machine "raised several Nos. to the 2nd and 3rd powers, and extracted the root of a quadratic Equation."[14] While most of the audience gazed in astonishment at the machine, Ada, "young as she was, understood its working, and saw the great beauty of the invention."[15]

Ten years later, Ada Byron (now Ada Lovelace) joined Babbage in his work on a second, more sophisticated machine, the Analytical Engine. In 1842, Louis Menebrea, an Italian military engineer, deposited a paper entitled "Sketch of the Analytical Engine Invented by Charles Babbage"

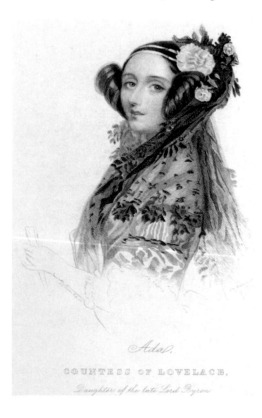

Ada Lovelace in an engraving by Joseph Brown, after a drawing by Alfred Edward Chalon, both ca. 1840.

in the Bibliothèque Universelle de Genève. Shortly after its appearance, Babbage wrote that Lovelace informed him that she had translated Menebrea's work into English. Babbage was most impressed, and invited her to join him in his work. "I asked why she had not herself written an original paper on a subject with which she was so intimately acquainted? To this Lady Lovelace replied that the thought had not occurred to her. I then suggested that she should add some notes to Menebrea's memoir; an idea which was immediately adopted."[16]

Babbage had a longstanding interest in textile production, and imagined his computer as a textiles mill, with the store and mill representing its memory and processing capacity. He also owned a portrait of Jacquard, woven on one of the Frenchman's looms at about 1,000 threads to the inch. The portrait was a five-foot-square sheet of woven silk, "framed and glazed, but looking so perfectly like an engraving," Babbage wrote, "that it had been mistaken for such by two members of the Royal Academy."[17] Babbage and Lovelace were fascinated by the fine-grained complexity of both the cloth and the machine that had woven it. It was this portrait of Jacquard that inspired them to hypothesize that if it was possible to program a loom to weave any design, then it must be possible to program a machine to perform any computation. It was, Lovelace wrote, "the introduction . . . of the principle which Jacquard devised for regulating, by means of punched cards, the most complicated patterns in the fabrication of brocaded stuffs."[18] This gave the Analytical Engine its "distinctive characteristic" and "rendered it possible to endow mechanism with such extensive faculties as bid fair to make this engine the executive right-hand of abstract algebra."[19]

While Babbage worked on what would now be defined as the hardware of the machine, Lovelace devoted her brilliant mathematical mind to its software, the programs that would run the machine. She and Babbage developed an intense and often stormy relationship. Although she was married with several children, her mathematical interests often meant that she was considered to be eccentric, wayward, unseemly, even hysterical—a condition that was, in the mid-nineteenth century, still associated with the "wandering womb" from which it takes its name. She was a gambler and, in common with most of her generation, a great user of opium. She was constantly frustrated by convention, and always hungry for stimulus and inspiration. She swung between self-deprecation and great self-confidence, signing her notes with her initials only, while at the same time writing: "To say the truth, I am rather amazed at them; & cannot help being struck quite *malgre moi*, with the really masterly nature of the style, & its Superiority to that of the Memoir itself."[20] In this respect, she was quite

16. Babbage, *Passages from the Life of a Philosopher*, p. 102.

17. Ibid., p. 127.

18. Ada Lovelace, "Notes to Sketch of the Analytical Engine Invented by Charles Babbage, by L. F. Menebrea, of Turin, Office of the Military Engineers," in Philip and Emily Morrison, eds., *Charles Babbage and His Calculating Engines: Selected Writings by Charles Babbage and Others* (New York: Dover, 1961), note a, p. 252.

19. Ibid., pp. 251–52.

20. Ada Lovelace in Dorothy Stein, *Ada, A Life and a Legacy* (Cambridge, Massachusetts: MIT Press, 1985), p. 123.

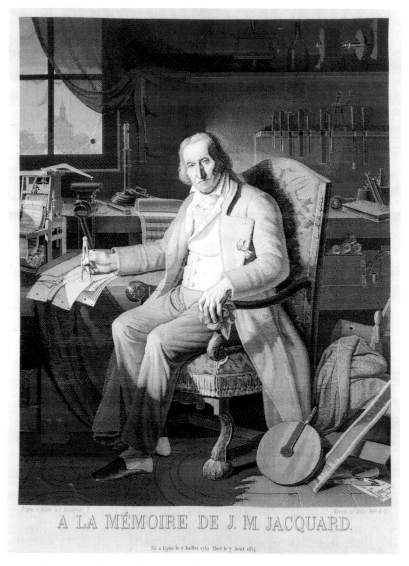

Silk Jacquard-woven picture of Joseph-Marie Jacquard, inventor of the Jacquard loom. Titled A la mémoire de J. M. Jacquard, *it was woven by Michel-Marie Carquillat and manufactured in 1839 by the firm of Didier Petit et Cie, Lyon, after an 1831 original oil portrait by Claude Bonnefond.*

right. The notes she made to Menebrea's paper turned out to be three times longer than the original text, and of far greater significance, as they contained the first examples of what is now known as computer programming.

Lovelace died in her thirties from cancer of the womb; it seems her "hysteria" really did wander. Babbage never completed his work on the Analytical

Engine, and it was not until the 1940s that the first fully functioning computers came into operation. Once again, the programmers were female: the American, Grace Murray Hopper, for example, not only programmed Mark 1, but also invented the term "computer bug" when she found a dead moth inside the machine. In the mid-twentieth century, just as it had been 100 years before, the role of programming computers was assigned to women because it was considered to be menial, minor, secondary work. The hardware of computing was considered to be far more important than work on the software, and it was not until the late twentieth century that the significance of software and the role of the programmer became clear. Only then was it possible to look back and see that the world's first computer programmers were women, and that the first of these, Ada Lovelace, had been inspired by the workings of a loom.

The pixelled screen, the World Wide Web, and other metaphorical associations with weaving are commonplace elements of today's digital culture. But weaving is far more than a metaphor in the history of computing, whose early days owe much to the history of textiles, the development of the programmable loom, and the engineering it inspired. Freud may well have considered weaving to be a minor historical sideshow, just as he would, no doubt, have agreed with what continue to be standard diagnoses of Lovelace as a melodramatic and hysterical young woman, and history as a neat set of causal relations between great discoveries, inventions, and the men who achieve them.[21] Such orthodox narratives have no time for what has been called "the dust of history, micro-history," generated by activities like weaving, the detailed workings of a material past whose complexity can only be obscured by simple linear narration.[22] But to attend to the subtleties, the twists and turns and, indeed, the gaps of this history is also to recognize the vital roles played by Freud's weaving women and their own softwares in what has become one of the most important inventions and discoveries in the history of civilization: the computer.

21. See, for example, Martin Davis and Virginia Davis, "Mistaken Ancestry: the Jacquard and the Computer," in *Digital Dialogues 2: Textiles and Technology*, special issue of *Berg Textile Journal* vol. 3, issue 1, guest edited by Janis Jefferies, March 2005.

22. Braudel, *Capitalism and Material Life, 1400–1800*, p. 442.

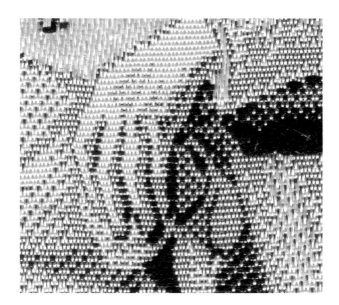

Hardaker Jacquard *(details), 1839,*

woven portrait

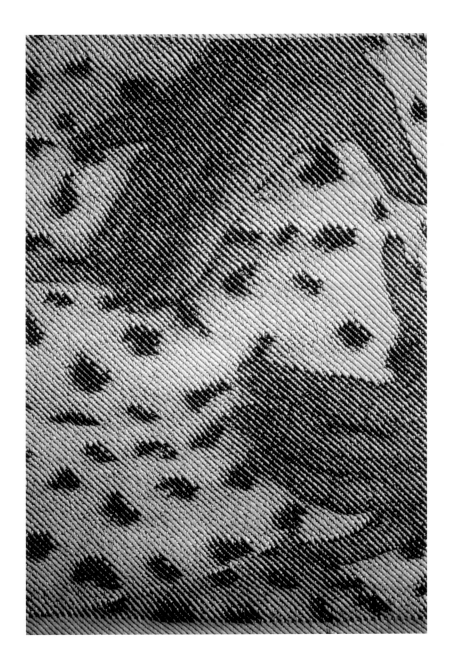

BITING
AND
CHEWING
IN CONTEMPORARY ART

Alison Ferris

Food, in its symbolic manifestations as well as in its relationship to the body, has been a major object and subject throughout the history of Western art. We might think, most immediately, of Leonardo Da Vinci's *Last Supper* (1498), Albrecht Dürer's *Adam and Eve* (1507), Pieter Breugal's *Wedding Feast* (1568), Juan Sánchez Cotán's S*till Life with Quince, Cabbage, Melon, and Cucumber* (1602), and Édouard Manet's *Le Déjeuner sur l'herbe* (1863). With such a long tradition of art depicting food and food ritual, it should come as no surprise that beginning in the 1960s American artists began to dissect this tradition, examining the many meanings associated with food, including, to a smaller degree, the acts of biting and chewing.

Until recently, biting and chewing, the most elemental and basic forms of human labor, were the least explored functions of the basic process for nourishing the body. Much more has been investigated by artists and scholars around the ritual of food customs, food itself, and food-related abnormalities, such as eating disorders. But biting and chewing are linked to this long tradition of depicting and exploring food in art, although we'll see in this essay that biting and chewing in contemporary art involve more than their obvious affiliation to this art historical tradition. I will discuss a select

number of major works created in the last thirty years and explore the ways that the labor of biting and chewing—the repetitive physical activity that our bodies are required to perform in order to sustain our mortal selves—is intrinsic to the meaning of these works. It is also suggested that biting and chewing when employed in the service of art and its making become acts of artistic labor.

The mouth is the organ that facilitates biting and chewing and, hence, it is an appropriate place to begin. Descriptions of the mouth range from the beguiling to the horrific in both art and literature. For centuries, poets and writers have described everything from the lovely shape of a beloved's mouth to the nips and bites of love play. One stanza from *Dolores* (1866) by Algernon Charles Swinburne provides a vivid illustration:

> *O lips full of lust and of laughter,*
> *Curled snakes that are fed from my breast,*
> *Bite hard, lest remembrance come after*
> *And press with new lips where you pressed.*
> *For my heart too springs up at the pressure,*
> *Mine eyelids too moisten and burn;*
> *Ah, feed me and fill me with pleasure,*
> *Ere pain come in turn.*

Pre-Raphaelite painter Dante Gabriel Rossetti depicted the voluptuous pouty lips of the beautiful Jane Morris in his *Astarte Syriaca* (1877) and in several other paintings. In other works, the mouth becomes horrific when it devours. Hieronymus Bosch's *The Garden of Earthly Delights: Hell* (1500-1505), for example, includes monsters engulfing humans and other creatures by way of grotesquely engorged mouths. Edvard Munch's *Vampire* (1895) is pictured the moment before she attacks her prey, a sleeping man, with a deadly bite.

Exaggerated mouths can be found in contemporary art, too, such as Rona Pondick's installation *Little Bathers* (1990-1991), consisting of hundreds of disembodied, grotesque, bubble-gum-pink mouths, complete with large, crooked, yellow teeth that litter the gallery floor. Anne Harris's paintings, such as *Portrait with Pink Eyelids* (2001) and *Portrait: Snake Eyes* (2001), depict adolescents whose thick, dry, exaggerated lips can only be described as needy, hungering to latch on to anything that might provide comfort.

The acts of biting and chewing in art are, to a large extent, visceral evidence of what the mouth can signify. That the artists discussed below choose to highlight the physical functions of the mouth undermines what, in art, is the primary association of the mouth: the site of sexual fantasy. Biting and chewing allow artists to delve deeply and complexly into issues of consumption, autonomy, fantasy, tactility, obsessiveness, and sexuality.

Vito Acconci and Hannah Wilke were some of the first artists to use biting and chewing in their work to express political positions, while simultaneously pushing the definitions of Conceptual art. Both artists began their works based generally on the assumption that anything that is edible can be converted into an economically appropriated possession. For instance, in *Trademarks* (1972), Acconci bit his own legs, arms, and shoulders, covered the indentations with printers ink, then made marks on paper with them. The work was reproduced in *Avalanche* magazine and included both photographs of Acconci contorting his body in order to bite himself, as well as a printed impression of one of the bite marks. Art historian Kathy O'Dell writes that in *Trademarks*, "[T]he bite mark is a sign of the circular ability of the body to acknowledge its material presence—its objecthood—through its own consumption and vice versa."[1] One of the first artists to participate in the creation of what is now known as Body Art, Acconci used his body as a "material object with symbolic potential." By biting his body, he was, in his own words, attempting to "stake a claim on what I have."[2] In other words and as the title *Trademarks* suggests, he was ironically offering his body, marked by the labor of biting, as an object of exchange value. Moreover, the documentation of the work, whether in the form of video or photographs, enters the economic sphere of the art market, performing a kind of double labor while increasing the work's value as a commodity.

From a feminist perspective, Hannah Wilke expanded upon Acconci's use of biting by equating that which is edible with a desirable erotic body awaiting consumption. Wilke used chewing gum to create small sculptural "cunts" (her signature form), which she then stuck to her face and naked body. *S.O.S.— Starification Object Series* (1974-1975) began as a performance, her body standing for a living sculptural object, and exists today in photographs. About her use of material, Wilke wrote, "In this society we use up people the way we use up chewing gum. I chose gum because it's the perfect metaphor for the American woman—chew her up, get what you want out of her, throw her out and pop in a new piece."[3] In this work, the gum functions as an erotic object depicting the vulva as well as a wound. Wilke labors to affirm her own body while simultaneously pointing to the problematic fact that the female nude, particularly the idealized nude, is desirable, available, and dispensable. Working at the same time as Wilke, some feminist artists, such as Mary Kelly, refused to depict female bodies in their art because they believed they would be refetishizing the female body, already demeaningly sexualized. Wilke situated her work directly in response to this position; for Wilke, the female body is always ambiguous and not always only sexual—it is something laboring and creative—a point which, in *S.O.S.—Starification Object Series,* is underscored by the chewed visceral gum.

1. Kathy O'Dell, *Contract with the Skin: Masochism, Performance Art and the 1970s* (Minneapolis: University of Minnesota Press, 1998), p. 19.

2. Ibid., p. 20.

3. Hannah Wilke quoted in Joanna Frueh, "Feminism," in *Hannah Wilke: A Retrospective* (Columbia, MO: University of Missouri Press, 1989), pp. 73-74.

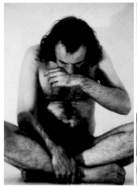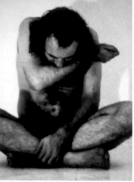

For Acconci and Wilke, the documentation of their biting and chewing functioned to further ideas being explored by their contemporaries also working in Conceptual art. As a process in and of itself, biting and chewing might be said to demystify creative acts and to democratize the artist's role in society. Biting and chewing are thus appropriate for Conceptual art as visual metaphors to explore social and political ideas, rather than formal or technical ones. The use of biting and chewing also challenges a particular kind of institutional framing of art and the hierarchical social structures that support the "artist-as-genius" myth in order to regulate the definition of artistic works by situating the work within the social and economic spaces of physical labor. Finally, both Acconci and Wilke introduced the body, their own physical mortal bodies, into the conceptual process: the use of biting and chewing particularly punctuated this move.

Biting and chewing have had other meanings for artists as well. For those artists working in the 1980s and 1990s, Freud was the touchstone. In reviewing Freud's writings on the oral stage, we are reminded that Freud considered the oral phase the first of two "pregenital" stages of human sexual life, that is, before the genital zones had fully developed. According to Freud:

> *The first of these is the oral or, as it might be called, cannibalistic pregenital sexual organizations. Here sexual activity has not yet been separated from the ingestion of food; nor are opposite currents within the activity differentiated. The object of both activities is the same; the sexual aim consists in the incorporation of the object—the prototype of a process which, in the form of identification, is later to play such an important psychological part. A relic of this constructed phase of organization, which is forced upon our notice by pathology, may be seen in thumb-sucking, in which the sexual activity, detached from the nutritive activity, has substituted for the extraneous object once situated in the subject's own body.*[4]

4. Sigmund Freud, *Three Essays on the Theory of Sexuality* (New York: Avon Books, 1962), p. 96.

5. Ibid., p. 76.

6. Ibid., pp. 76-77.

7. Joseph Litvak, *Strange Gourmets: Sophistication, Theory and the Novel* (Durham, NC: Duke University Press, 1997), p. 10.

8. Freud, p. 77.

9. Ibid.

What is only implied in this brief summary paragraph, but apparent earlier in the text, is that during this stage the infant strives to achieve "pleasure which has already been experienced and is now remembered."[5] As Freud himself observed rather wistfully, "No one who has seen a baby sinking back satiated from the breast and falling asleep with flushed cheeks and a blissful smile can escape the reflection that this picture persists as a prototype of the expression of sexual satisfaction in later life."[6] But this picture of bliss is only one aspect of the oral stage. Referring to psychoanalytic orthodoxy regarding the oral stage, literary critic Joe Litvak writes that, "the most important thing to do with the oral stage is to outgrow it: the badness of the mouth consists as much in its 'innocent' joys as in its voracious cruelties."[7]

Freud insinuates the "voracious cruelty" of the oral stage by describing it as "cannibalistic," thereby referring to the notion that, during infancy, the child strives to incorporate its object of desire. The only way the child understands incorporation is by seeking to devour, eat, or ingest its desired object. As suggested by Freud, frustration and want prevail during this stage, manifesting themselves in aggressive behavior, often in the form of biting others. This, too, can be seen in the nursing infant when, following the arrival of new teeth, the child experiments with them by biting, among other things, the mother's nipples, in order to discover what he (the baby) can and cannot ingest. But the goal of the oral stage, according to Freud, is to discover that sexual satisfaction and nourishment are detached, "a separation which becomes inevitable when the teeth appear and food is no longer taken in only by sucking, but is also chewed up."[8] The child inevitably understands, at the same time, that it can find just as much satisfaction from sucking its own skin, not only because it is more convenient but also because it makes him "independent of the external world, which he is not yet able to control, and because in that way he provides himself, as it were, with a second erotogenic zone, though one of an inferior kind."[9] For Freud, the mouth is, above all, the site of tireless want, deferred desire, and an aggression born of those deferrals.

Whereas Freud goes on to say that the failure to get beyond the oral stage leads to various forms of regression, Melanie Klein, a renegade Freudian, saw it differently. Mignon Nixon, who, in her essay "Bad Enough Mother," is one of the first scholars to identify biting and chewing within a theoretical model when discussing contemporary art, looks extensively to Klein. Nixon explains that for Klein, "psychic life is structured by unconscious fantasies

driven by bodily experiences, and these fantasies, present from early infancy persist not as states into which the subject may regress, but as ever-between positions in which . . . one is sometimes lodged."[10] For instance, a move from the gendered to the infantile body is a shift of position rather than a regression. Nixon goes on to explain that "by constructing a model of subjectivity around the infant, and so in relation to an immediate and fragmented bodily experience unmediated by language, Klein places at the center of her model not the unconscious, but fantasy—fantasy understood not as a work of the unconscious mind, but as a bodily operation."[11] Eating, Nixon suggests, "might produce a complex fantasy of incorporating a good object and devouring a bad one."[12]

Contemporary artists have adopted Freudian-based theories of the oral stage in a variety of ways. Sally Mann and Roni Horn explore it with respect to aggression and autonomy. In Mann's photograph *Jesse Bites* (1985), part of her series *Immediate Family*, we see Mann's young daughter embracing her mother's arm. On Mann's arm there is a fairly substantial bite mark which, as the title suggests, was Jesse's doing. This observation is played out in Mann's photograph with particular relevance to the dynamic of autonomy and aggression inhering in the relationship between mother and daughter. Vestiges of anger and frustration remain on Jesse's face and physically on her mother's arm. The bite can be read, in Nixon's words, as the girl's subjectivity forming around "an experience of loss enacted through destructive fantasies."[13] In other words, it depicts the symbiotic dependence of the mother and child, and the process in which the child ambivalently moves away from the mother into the world. The poignancy of the image registers both in how aptly the bite on the skin exemplifies the frustration in trying to make and understand this break, as well as the child's subsequent embrace of her mother's arm following the bite.

In the November 2001 issue of *Artforum*, a full-page advertisement announced an exhibition in Brussels featuring the work of Roni Horn. The ad consisted of a photograph by Horn of a young girl, who happens to be Horn's niece, with her mouth open confidently displaying her chewing gum. The photograph is one of ninety-six images of her niece from the work *This is Me, This is You* (1997-2000). One might guess from the girl's look of triumph that the gum represents the persuasive arguments she conjured to convince someone to allow her such a treat. This feat was followed by the process of chewing, of transforming the flat, stiff, yet delectable morsel into a malleable one. That the girl secured and transformed this piece of gum— and in doing so achieved a momentary sense (or fantasy) of autonomy—is something in which she takes evident pride. The gum itself, captive in her mouth, is in this way her trophy, her sculpture, her work of art.

10. Mignon Nixon, "Bad Enough Mother," *October: The Second Decade, 1986-1996* (Cambridge, MA: MIT Press, 1997), p. 159.

11. Ibid., p. 160.

12. Ibid., pp. 159-160.

13. Ibid., p. 160.

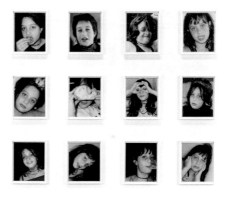

Roni Horn, This is Me, This is You *(detail), 1997-2000, twenty-four C-prints on RC-type paper, 10 1/4 x 12 1/2 in. each. Edition of six.*

Jesse Bites and *This is Me, This is You* are both part of photographic series that, in different manners, depict young children from the artists' families physically acting out fantasies. The question remains, however, whose fantasies are they: the children's? the artists'? or both? In terms of the artists, it could be that the images of biting and chewing, depicted in the photographs of young girls, represent a kind of autonomy-by-aggression, which capture, for both Mann and Horn, the kind of aggressively acquired permission that makes the production, the labor, of art possible. They see their own autonomy, as women and artists, reflected in the girls and in the cagey uses of their mouths.

A different and, perhaps, more direct take on the Freudian oral stage is expressed in Janine Antoni's *Gnaw* (1992), which consists of two blocks of chocolate and lard respectively. Antoni "carved" the blocks using her mouth, chewing on the corners and edges of each. The pieces of chocolate and lard that she bit off were then molded into heart-shaped trays that mimic the trays in which chocolate candy is packaged. The lard was mixed with pigment and beeswax in order to make lipstick. The blocks of chocolate and lard were exhibited next to the chocolate trays and lipstick, which were shown in a specifically constructed room that suggested a department store display. Critics initially writing about *Gnaw* focused primarily on how it raised issues about women and the compulsion to sculpt their bodies into unrealistic shapes and forms. Art historian Ewa Lajer-Burcharth, however, locates and elaborates on the oral stage in Antoni's work, observing that it is "a materialization of the psychic processes of the unconscious." She writes:

> *Distinguished by the obsessiveness of labor that had produced them, Antoni's objects solicit us to imagine the body that had shaped them not just as a physical tool but rather as an instrument of recognizable psychic mechanisms: compulsive biting or licking, for example, does not refer to eating as such but more precisely to the oral drive. Antoni's procedures evoke, moreover, particularly the early, pre-Oedipal stages of psychic development that are bound to the tactile and oral functioning of the body. It is the symbolic eloquence of this tactility and orality that the artist emphasizes when she imitates with her body the basic fine art techniques, such as chiseling (with her teeth), painting (with her hair), drawing (with her eyelashes), or modeling (with her whole body).*[14]

14. Ewa Lajer-Burcharth, "Antoni's Difference," in *Janine Antoni* (Küsnacht, Switzerland: Ink Tree, 2000), p. 50.

Rather than suggesting benign materials and tools of the trade (the marble and the chisel), Antoni's work insists upon the role that the artist's labor and materials play in the creation of meaning. Hence a "regression" or shift into the oral stage on the part of the artist, manifesting itself in the way the work of art is both conceived and created—Antoni's teeth marks are clearly visible on the blocks of chocolate and lard—opens up the work to more varied and complex social readings than those drawing solely on the question of women and compulsive beauty.

In Ann Hamilton's *malediction* (1991), the labor of chewing, equivalent here to the act of creating, is central to the meaning of the work. Here, Hamilton sat in a room at an eleven-foot-long refectory table, where she made an impression of her mouth by filling it with raw bread dough, then placing the dough into a large basket which, we later learn, is an antique child's casket. An audio recording of a woman reading Walt Whitman's poem *Song of Myself* accompanied the installation. Entering the installation when it first appeared in a gallery in New York's Soho, viewers were required to step over wine-stained sheets—a reference, according to curator Judith Tannenbaum, to the neighborhood's previous history as the hub of the city's rag trade. Tannenbaum suggests that "the twisted and wrung sheets might also have been interpreted as shrouds which related to the casket and the Civil War allusion of Whitman's poetry."[15] Reverent religious tones ring throughout *malediction,* especially those of penance. The artist's self-imposed sentence was to perform the task of filling her mouth with dough for hours at a time over a period of weeks. This performance, much like Antoni's, approaches, if not embraces, the obsessive. However, instead of being debilitated by the obsession, Hamilton transforms it into what curator Andrea Inselmann describes as "a working practice reflecting a highly regulated and systematized impulsiveness that, while not entirely escaping the fetishistic, broaches the ritualistic."[16] In Hamilton's work, obsessiveness is translated—through the adaptive mouth—into the very labor of art making.

The acts of biting and chewing underscore the inextricable links between object and maker, physical expression and materials, and the appetites and mortality of the human body. For Wilke and Acconci, the use of biting and chewing allows them to reveal and resist the ways that bodies are symbolically marked by and absorbed into the systems of capital—systems of production, labor, and consumption. Mann, Horn, Antoni, and Hamilton incorporate psychoanalytic aspects of biting and chewing in their work suggesting desire, aggression and, ultimately, fantasy. Following the line of these artists, one might contend that this last element—fantasy—is no less essential than eating itself to the maintenance of human existence.

15. Judith Tannenbaum, from exhibition brochure for *By Mouth and Hand: Ann Hamilton, 1990-2001,* at the Rhode Island School of Design Museum, Providence, Rhode Island, November 9, 2001-January 20, 2002.

16. Andrea Inselmann, from exhibition brochure for *Fixations: The Obsessional in Contemporary Art,* at the John Michael Kohler Arts Center, Sheboygan, Wisconsin, February 13-May 7, 2000.

My thanks go to Peter Coviello and Andrea Inselmann for reading and commenting on early drafts of this essay, and to Emily Shubert who assisted me on the research.

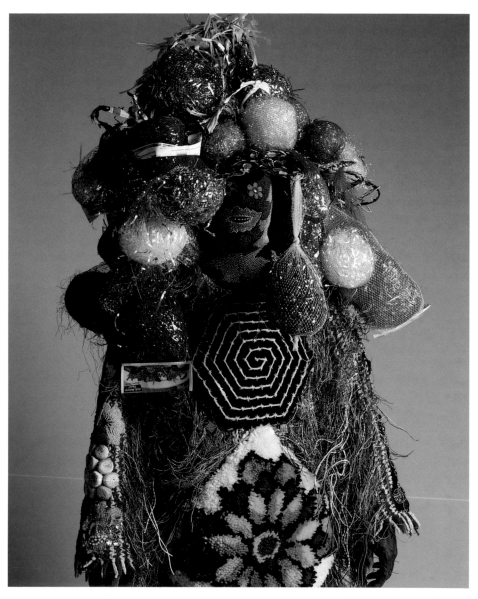

SOUNDSUIT, *2001, sisal,*
plastic-coated wire, mirror,
Easter grass, paint, appliqués,
and fabricated knit mask.

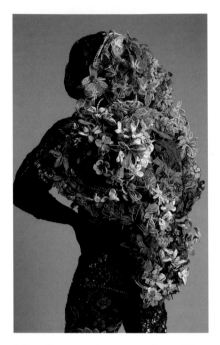

Nick Cave works to transform. The physical process by which he creates his work is inseparable from its concept and meaning, which evolve intuitively as Cave's hands and mind interact with the materials. Whether the outcome is costume, sculpture, printed fabric, or fashion, he works with materials and ideas in a meditative, ritualistic way to produce highly charged, symbolic works. The ritualized processes of choosing, collecting, arranging, and assembling are a labor of love toward something larger—the transformation of society's response to the marginalized. Cave's materials serve as metaphors for society's view of the African-American male: taken for granted, invisible, disposable.

Cave's ongoing series *SOUNDSUITS* honors that which has been cast aside, with surfaces so densely layered as to encumber the suit's wearer. Cave begins by collecting materials found on Chicago's streets and beaches, and by frequenting dollar stores and thrift stores for items he terms "trivial Americana," or cheap, mass-produced merchandise. He works quickly— arranging and assembling, creating a textile structure that incorporates twigs, rusty bottle caps, gourds, colorful pencils, feather dusters, plastic toys, even stuffed animals. In using mass-produced items, Cave reconfigures the simulated labor inherent to manufacturing processes by using his own handwork to honor what the hand used to do.

Viewed as a group, the suits present a compendium of cross-cultural references, ranging from tribal masks to ceremonial vestments and headgear. The use of layering and the artist's obsessive involvement with creating highly tactile surfaces result in sensual garments that delight as well as disturb. Worn in performance, the suits take on an additional power to transform both wearer and viewer, raising issues of defining oneself versus allowing society to define who one should be. This is shamanism in action. Cave speaks of "transferring resources from one object to another through the transformative process of labor— introducing something new, undefinable, unrecognizable."

Karen Searle

LABOURED CLOTH

Janis Jefferies

[A creativity which] celebrates hybridity, impurity, intermingling, the transformation that comes of new and unexpected combinations of human beings, cultures, ideas, politics, movies, songs . . . rejoices in the mongrelization and fears the absolutism of the Pure. Mélange, hotchpotch, a bit of this and a bit of that is how newness enters the world.[1]

—Salman Rushdie

1. Salman Rushdie, *Imaginary Homelands* (London: Granta, 1991), p. 394.

Why begin with such a quote? Partially it has to do with my proposition that hybrid practices—neither belonging to one thing nor another—blur and disturb categories of art practice. The concept of hybridity has often been received with suspicion, partly because of its association with other fields. In biological and anthropological discourses, the idea of hybridity presupposes a state of purity and authenticity. In the *Turbulence of Migration,* Nikos Papastergiadis gives a wonderful example of what is most often cited as a hybrid: the mule, the offspring of two "pure" species—the horse and the donkey. It is a particularly infamous example because its own infertility served as a prohibition against mixture. A more complicated view of hybridity contends that all forms of cultural innovation and exchange produce hybridic forms. In other words, cultural products and cultures are always in a process of hybridity.[2]

It is this complex reading of hybridity that is crucial to a postcolonial perspective. Stuart Hall directs our attention to the many ways in which colonialisation was never simply external to the societies of the imperial metropolis, but rather deeply inscribed within them, at one and the same, as it became deeply and indelibly inscribed on the colonised. Questions of hybridity are forefront in thinking through the complexities of experience to the extent that any return to ethnically closed or centered original histories is untenable and marked by movements across global-local inter-relationships.

This essay explores hybrid practices through my own work, as well as that of Mindy Yan Miller, Zarina Bhimji, and Yinka Shonibare, MBE, who mobilise a conscious awareness of how textile, cloth, fabric, and material are inserted into visual culture and the "origins" of cultural identity. A moment's reflection brings to mind any number of feelings and experiences, in which cloth, thread, and fabric are embedded in the metamorphic use of textiles to illuminate social and political relations.[3] Within this context, my own art practice takes textiles and cloth as a starting point, exploring the intersection between the personal and the political.

A social history of cloth and its everyday use is marked by the stains and sweat of working life—impregnated with the odors of labour; betrayed by the traces of gender, class, and race. The softness and ultimate fragility of cloth are linked to organic bodily matter and the vulnerability of humans, whose every relationship is transient, subject to the degenerative process of decay and death. In this essay, cloth also symbolises a set of human actions, economic survival, poetic metaphors, and political interrogations that are part of a complicated network of cultural exchanges. For me, the materiality of cloth (and clothes) lies in the way it receives the human imprint; cloth smells of mortality as much as it carries the signs of sweated (migrant) labour. As I have written previously, "we are always implicated as witnesses to the stories of these textile exchanges. They do not return us to some mythical dream of lost homelands or secure sites of production and fixed cultural identity."[4]

Peter Stallybrass points out in *Worn Worlds: Clothes, Mourning and the Life of Things* that in a cloth economy, "things take on a life of their own." In other words, "one is paid not in the 'neutral' currency of money but in material which is richly absorbent of symbolic meaning."[5] He argues that in a capitalist economy—an economy of new cloth, new clothes—the life of a textile takes on a ghostly existence, coming into consciousness at moments of crisis. Such moments of crisis recur as the trace elements of material life, and exemplify the manner in which clothing mediates the

2. Nikos Papastergiadis, *The Turbulence of Migration* (London: Polity Press in association with Blackwell Publishers, Ltd., 2000), pp. 182-83. See also Papastergiadis' *The Complicities of Culture: Hybridity and New Internationalism* (Manchester: Cornerhouse Communiqué, no. 4, 1994), in which he explores the incorporation of the term "hybridity" in art criticism and curatorial practice. In chapter 8, he extends and complicates his insights through a semiotic reading of hybridity in postcolonial theory. For further reference, see also Paul Gilroy's study *The Black Atlantic: Modernity and Double Consciousness* (Cambridge: Harvard University Press, 1993). This is a book about "the inescapable hybridity and inter-mixture of ideas" and the "instability and mutability of identities which are always unfinished, always being remade," p. xi.

3. Annette B. Weiner and Jane Schneider, eds., *Cloth and Human Experience* (Washington and London: Smithsonian Institution Press, 1968), pp. 1-26.

4. Janis Jefferies, "Introduction: Textile Transitions," *Reinventing Identity: Gender and Identity*, vol. 2 (Winchester: Telos Art Publishing, 2001), p. 2.

5. Peter Stallybrass, "Worn Worlds: Clothes, Mourning and the Life of Things," *The Yale Review*, 81, no. 2 (April 1993), p. 39.

relationship between an individual's body and the social institutions in which an individual participates. Memory is revived through the clothing of others. Through their stain and smell, clothes carry traces of another life. They are embedded with the memories of a life once lived or with the stories of the migrant limbs once housed within their folds. The smell of a body is deeply ingrained to remind us of all that has been lost. Vulnerabilities of loss are signified through the complexities of the material trace, i.e. the jacket loved by the father, the child's dress that remains to console the mother, the piles upon piles of clothing remnants belonging to the victims of the wars in Kosovo and Rwanda.

In his essay "Mourning and Melancholia" (1917), which explores the destruction of memory and the meaning of loss and mourning, Sigmund Freud observes that the subject sustains the idea of an innate violence and destructiveness as the essence of desire.[6] For many, a sense of self-worth may only be recovered through the process of mourning and self-transformation. In cultural and artistic terms, a work of mourning may enable a lost object to be recreated with the ego and become a love equivalent to the object, thereby enriching the ego and its return to the external world. An artist may have a particular ability to mediate works of mourning through a translation of their psychic or inner reality. This process could be described as an "ecstatic solace of communication" in order to produce "a shared community of representable worlds."[7] The possibility of shared solace may be achieved by identification via a sense of sight and physical sensation. Each of the senses may be activated by a circuit of interwoven memories, felt, perhaps, as shards or fragments of recall, triggered and registered by and in the bodies of both the artist and the viewer.

This has been a concern of mine in both my own studio practice and in the work of other contemporary artists for whom the materiality of textiles is a metaphor for the fluctuating character of experience of loss and self-renewal. From 1992 to 1995, my studio was located in a disused ward for the elderly at the Hackney Hospital in the East End of London.[8] The building had a previous life as a workhouse from 1729 to 1929, before becoming a general hospital. Within a few weeks of my arrival, the laundry attached to the hospital closed; washing took place elsewhere as part of the privatisation process of public utilities. I became obsessed with the hospital's derelict interior. I focused my efforts on documenting the laundry and the metaphors of meaning that could potentially be revealed. I photographed this deserted industrial-sized space, with its broken equipment and discarded heaps of bedding, to evoke a more personal poetics of loss.

6. Sigmund Freud, "Mourning and Melancholia" (1917), in *On Metapsychology: The Theory of Psychoanalysis,* trans. and ed. James Strachey, Pelican Freud Library 11 (Middlesex, Harmondsworth: Penguin Books, 1984), pp. 139-58.

7. Claire Pajaczkowska, "The Ecstatic Solace of Culture; Self, Not-Self, and Other: a Psychoanalytic View," in *Other Than Identity,* ed. Juliet Steyn (Manchester: Manchester University Press, 1997), p. 107.

8. For a vivid account of experiences shared as artists-in-residence during the period 1992-1995 and within Hackney Hospital, see Jane Roberts' essay "Between Art and Experience," in the exhibition catalogue *Care and Control: Rear Window at Hackney Hospital* (Rear Window Publishers, 1995), pp. 26-28. I am extremely grateful to Jane Roberts and the people of Hackney Hospital who supported my practice at that time.

My photographs, subsequently translated into semitransparent paper nylon prints and pigment caught in digitally impregnated linen cloth, act as reminders of a community of (invisible) women's labour. The illuminated and visible moments of a community slipping away is intensified by the material evidence of the overlooked detritus of the everyday: laundry bundles, discarded cloth, rags, and abandoned nurses' uniforms.

The work I made within the hospital environment was, therefore, partially conceived as a metaphorical exploration of labour. My practice was underpinned by Luce Irigaray's ideas of the feminine and the physical properties of cloth enfolding the signs of the (absent) woman's body. Gilles Deleuze has also written about the fold in that it "can be recognized first of all in the textile model of the kind implied by garments."[9] He did not see the repetitive labour of the laundry worker as a daily grind of ironing and folding reams of hospital cotton, but rather as a subtle maneuver, the act of folding equates to a reflective consciousness internal to the body. "Fabric or clothing has to free its own folds from its usual subordination to the finite body it covers."[10] This quote by Deleuze suggests that cloth is a pliable language, which is useful in the transformative metaphor of language. Cloth evokes a feeling of being more inside the body; cloth evokes the tactile caress of a long lost body, of the hands of many labours.

It is the sense of fingering the trace of the cloth, the stuff as it is already gone, that connects, I believe, my practice to that of Mindy Yan Miller. I know the work only in reproduction, but her insights bear an uncanny witness to my own experiences. For both of us, heaps of cloth strewn on the hospital's abandoned floor have many levels of significance: postindustrial and corporeal, institutional and intimate. Whilst I worked in a hospital in London, UK, Yan Miller worked in Canada. In her work *I Fell Asleep* (1990), Yan Miller collected abandoned clothing, bedding, and garments, with which she filled an empty warehouse.

9. Gilles Deleuze, *The Fold*, translated from the French *Le Pli* by Tom Conley (London: Athlone Press, 1993), p. 121, and cited in Victoria Mitchell, "Folding and Unfolding the Textile Membrane: Between Bodies and Architectures," *The Body Politic*, ed. Julian Stair (London: Crafts Council, 2000), p. 5.

10. Ibid., p. 6.

Janis Jefferies, Laundry Bundles II, *1997, serigraphic print with pigment on nylon paper, 84 1/4 x 59 7/8 in.*

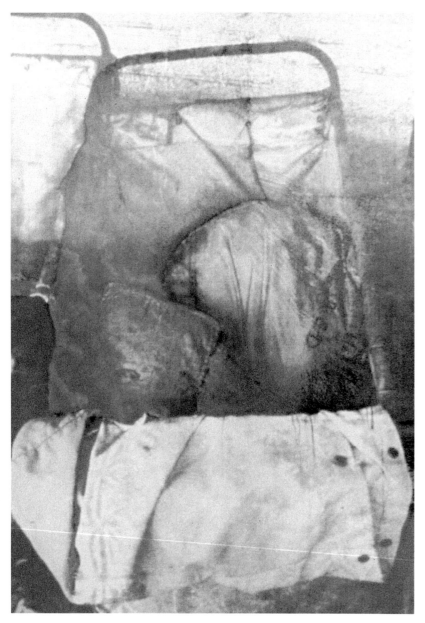

Janis Jefferies, Laundry Bundles II *(detail).*

Smoothing, pressing, folding, and stacking the piles of other people's worn clothing provides solace for Yan Miller. Her painstaking labour can be contrasted with the economic impermanence of the endless servicing and washing performed institutionally by the laundry workers during Hackney Hospital's operation. "Clothing is like our bodies," Yan Miller

Zarina Bhimji, I Will Always Be Here, *1992, burnt* kurtas *(shirts), detail of group installation, dimensions variable.*

writes, "it acts like a skin to protect us. Its fragility shows up on our own. The labour involved in textile production is not a mark left for perpetuity. It is simply caring for existence, for being in the present."[11]

Delicate, white cotton shirts with disturbingly beautiful burn marks, paper dresses, burnt cloth, and raw and manufactured materials (some stating an Indian origin) preoccupied the early studio investigations of Ugandan artist Zarina Bhimji. The materials she uses, hair and muslin, are unsettling in their sensuous appeal. Bhimji's complex installations employ a combination of small, white *kurtas* (embroidered white shirts) and photographs that refuse the deadness of representation. In her work *I Will Always Be There* (1995), the *kurtas* of three-year-old children hang as innocently as ordinary pieces of laundry from the gallery ceiling, out of the viewer's reach. The shirts assert the unpredictable cruelty of material scorched and defiled by burns. Bhimji mobilises the metaphor of clothing

11. Mindy Yan Miller, "I Fell Asleep," in *Harbour: The Journal of Art & the Everyday*, 1, no. 3 (1991), p. 11. With thanks to J. R. Carpenter for introducing me to Miller's work. For examples of the artist's work and writings, see also *Textiles, That is To Say*, catalogue for an exhibition of the same title, curated by John Armstrong and Sarah Quinton for The Museum for Textiles (Toronto: The Museum for Textiles, 1994).

burnt in war although she has defiled the material herself. The scorched *kurtas* evoke the artist's own childhood when her family hid her indoors during the civil war in Uganda in the early 1970s. Such intense attention to detail recalls vanished identities. Bhimji fled Uganda in 1974, two years after General Idi Amin's decree that all Asians holding British passports and nationals of India, Pakistan, and Bangladesh must leave the country. For Bhimji, everything was left behind save two dresses and a cardigan. As quoted by Bhimji from *The Times* as early as 1972:

> *Of the 80,000 or so Asians in Uganda, Britain has accepted responsibility for about 50,000 British passport holders. India and Pakistan have agreed to admit their own nationals. Now a new and entirely novel problem has been posed, the forced exodus of about 23,000 people who will almost certainly be stateless.*[12]

Bhimji's earlier work has probed the unstable points where unspeakable stories of subjectivity meet the narratives of history and culture; the country of Uganda she was exiled from and England who hosted her arrival. In her new project *The Wall Brooded* (2002), she inscribes this double diaspora or displacement in colour photographs and film. Traits of loss, second arrival, awareness, and remembrance are exposed through the metaphors of burning that have marked all her work. The lost landscape of her childhood in Uganda is revisited after an exile of more than twenty years. The ruined architecture, wrecked colonial villas, graveyards, airports, Amin's military barracks, and police cells are documented to conjure up several layers of experience, both real and imaginary. Bhimji's images are emotionally saturated with and complicated by their original reference.

The cultural theorists Sarat Maharaj and Gayatri Chakravorty Spivak have drawn on textiles, notably cloth, as a primary medium of cultural knowledge in which cultural exchange and translation play a significant role in their theoretical and significantly political work. Maharaj has contributed seminal ideas concerning cultural translation and difference through his experimental writings on textiles.[13] He insists that we pay attention to all the "unknowns" who are traveling, as waves of enforced nomadism exacerbate conditions of statelessness, and people who are displaced from homelands with bundled belongings on trucks occupy new European city spaces of "cultural translation."

In many of his writings, John Berger predicated that the twentieth century would be seen as the century of exile, migrancy, displacement, and enforced nomadism.[14] In *And Our Faces, My Heart, Brief as Photos*, Berger draws a parallel between the inner dynamics of the migrant and the transformations of the notion of home: "the displacement, the homelessness,

12. *The Times*, London, 1972, and quoted by Zarina Bhimji in her working title for *Out of the Blue* submitted on the occasion of the EAST international exhibition, selected by Mary Kelly and Peter Wollen. This work was renamed for Documenta XI as *The Wall Brooded*. I saw the *kurtas* restaged as part of Bhimji's solo show in Kettle's Yard at the University of Cambridge, London, in 1995.

13. Sarat Maharaj, "Arachne's Genre: Towards Inter-Cultural Studies in Textiles," *Journal of Design History*, 4, no. 2 (1991), pp. 75–96; "Perfidious Fidelity: The Untranslatability of the Other," *Global Visions*, ed. Jean Fisher (London: Kala Press, Institute of Visual Arts, 1994); and "A False Adamelegy: Artisanal Signatures of Difference After Gutenberg," *JURASSIC Technologies*, ed. Lynne Cooke, 10th Biennial of Sydney, Australia (Australia: Museum of New South Wales, 1996).

the abandonment lived by a migrant is the extreme form of a more general and widespread experience."[15] This experience is commonly known as "alienation," whether defined by Marx as "alienated labour" or by Julia Kristeva as "strangers to ourselves." For over thirty years, Berger has located modern anxiety over authenticity and the struggle for how "we" in the centers of the West make sense of living in modernity. "To emigrate," he says, "is always to dismantle the centre of the world, and so to move into a lost, disoriented one of fragments."[16]

It is imperative to pinpoint the locations where these experiences encompassing difference and authenticity are stitched and (loosely) woven inside the Western cultural space. The price is indifference, an insistence on assimilation as the response to the management of difference, and the result is repressive tolerance. In one of Maharaj's most recent essays, provocatively entitled "Dislocutions: Interim Entries for a Dictionaries Elementaire on Cultural Translation," he notes that in a rapid playoff between what is thought of as authentic and manufactured, true or fake, the foreign-familiar is seen as "different, foreign, displaced, immigrant, refugee" and tagged as from somewhere else but not from here, dislocated and dislocuted (a Joycean term). This occurs through stereotyped images of the exotic. Performers wear their "other identity" or dress in foreign costumes. Orientalist maidens cavort in Hollywood dream-factory harem dresses.

To quote Maharaj on a fashion image by John Galliano:

The model is wearing a sari-sarong draped casually, a synthetic and nylon Japanese print rather than a traditional silk or hand-spun cotton, a care-free rephrasing of the Paisley motif. She has on a Cockney barrow-boy T shirt, drop dead gorgeous trainers, piled-high Rasta dread-locks.[17]

By mixing and matching textiles, cloth becomes a tool for ironing out difference (what Maharaj calls the "logic of sameness"), which adds up to nothing more than cultural difference disguised as a global fashion trend.

In *The Politics of Translation*, Spivak sees her academic work as a professor of humanities in the United States and the fieldwork she does in villages in Bangladesh as worlds apart. She recounts that the high fashion of Rei Kawakubo or Comme des Garçons (not dissimilar to that of Galliano) is worn by those who visit museums, "the recognizable global subject."[18] This example is set against thousands of Bangladeshi women working in the global textile industry, whether they are the sweatshop workers in London's East End or the pieceworkers in the export-based garment industry in Bangladesh with whom they are seen to be in competition.[19]

14. John Berger and Jean Mohr, *A Seventh Man: The Story of a Migrant Worker in Europe* (Middlesex, Harmondsworth: Penguin, 1975). In this book, Berger explores the ways in which Europe's invisible migrant work force was indispensable to the European economy. For a full analysis of Berger's writings as they have impacted questions of cultural dynamics that connect art, migration, and exile, see Nikos Papastergiadis, *Modernity as Exile: The Stranger in John Berger's Writings* (Manchester: Manchester University Press, 1993).

15. John Berger, *And Our Faces, My Heart, Brief as Photos* (London: Writers and Readers, 1984), p. 38.

16. Ibid.

17. Sarat Maharaj, "Dislocutions: Interim Entries for a Dictionaries Elementaire on Cultural Translation," in ed. Jean Fisher, *Reverberations: Tactics of Resistance, Forms of Agency in Transcultural Practices* (Maaschrict: Jan van Eyck Akademie, 2000), pp. 32-48.

18. Gayatri Chakravorty Spivak, "The Politics of Translation" in eds. Michelle Barrett and Anne Phillips, *Destabilizing Theory: Contemporary Feminist Debate* (Cambridge, U.K.: Polity Press, 1992), pp. 177-200. See also *A Critique of Postcolonial Reason: Toward a History of a Vanishing Present* (Cambridge, Massachusetts and London: Harvard University Press, 1999), particularly pp. 338-47 for further elaboration on global fashion trends and the impact of new technologies on women in Bangladesh.

19. I worked with the artist and activist Shireen Akbar on the audiovisual production of *Field of Embroidered Quilt*, which we made for the exhibition *Woven Air: Textiles from Bangladesh* at the Whitechapel Art Gallery in London in 1998. It was a significant collaboration as we charted through our experiences and observations, the processes by which Bengal was transformed from the richest to the poorest part of the Indian subcontinent, and how they helped to finance and provide the necessary raw material for the British industrial revolution. We charted, wrote, and jointly narrated the work and were able to provide insights into the impact of British colonialisation on the sweatshops of London's East End.

Since the 1950s, the textile and garment industry has provided the major livelihood for the Bangladeshi community in the East End of London. It was in homeworking alone that Bangladeshi women found employment. Advertisements in English and Bengali read "Machinists Wanted: Outdoors and Indoors." Outdoor jobs were in so-called factories, small units that frequently resembled the sweatshops of the Victorian period. Such sweatshops were embedded in an intricate network of larger factories, warehouses, wholesalers, retailers, and import-export agencies.

As technology escalated and the service industries proliferated during the 1990s, these "enterprises" and many Bangladeshi businesses collapsed, additionally threatened by both the city of London expansion and the inexorable downward pressure on prices that lies at the heart of rapid globalisation. Paradoxically, in Bangladesh now over a million women work in garment industries that barely existed fifteen years ago. Before the establishment of the garment industry, few Bangladeshi women went out of the home, but now research conducted by Dr. Pratima Paul-Majumder, a specialist at the Bangladeshi Institute of Development Studies, shows that: "Women decide whether their children will go to school. The age at which they get married and the age that they have their first baby is two years later amongst garment women than the national average (19 years compared to 17 years)."[20]

Nonetheless, women remain toiling in factories until well into the night. According to recent statistics, normal hours in the capital city of Dhaka are from 8 a.m. to 10 p.m. In the twenty-first century, Asia imports the raw materials to make and export textiles and clothing, whereas it was

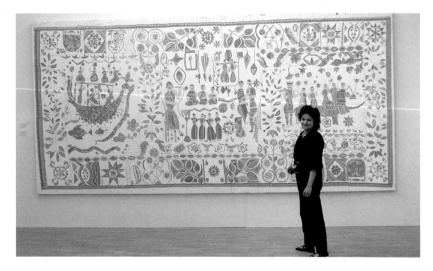

Shireen Akbar standing in front of Kantha wall hanging, Whitechapel Art Gallery, London, UK, 1998.

291

Yinka Shonibare, MBE, Dressing Down, 1997, wax-printed cotton textile and crinolene; display stand: aluminum, plastic, and felt; 59 x 59 x 69 in.

20. Duncan Green, *The Asian Garment Industry and Globalisation* (London: CAFOD, 1998), p. 20. The author interviewed Dr. Paul-Majumder in Dhaka, July 1998.

once its own source of raw materials, such as cotton, shipped for processing in the textile and garments factories of Europe. If this seems like a reversal of economic history, Spivak unravels the neatly stitched seam: "We must keep trying to deconstruct the breach between home and work in the ideology of our global struggle to reach this female ground layer that holds up contemporary global capital. We must consider the text of the textile as it manipulates textile."[21]

The sweatshop and the artist's studio, the fabric shop and the art gallery exist alongside one another or on the same street and cityscape.[22] The staging of these sites does not imply that each is translatable to the other in the language of its representations, histories, and geographies. Instead, their connectedness is to be found in their juxtaposition in conjoining their interdependence: the sweatshop and the artist's studio, the fabric shop and the art gallery. The collisions between these sites and languages become a source for contested readings and new interpretations.

In the artwork of Yinka Shonibare, MBE, for example, a link is established between the origins of cloth and his own origins as a Nigerian born in Lagos, his relocation to England, and his art education. Cultural theorist

21. Spivak, "The Politics of Translation," p. 2.

22. I am indebted here to my colleague Victoria Mitchell who first made the connection between my earlier research into labour and textile production and global markets with the writings of Spivak, and between the staging of art galleries, fabric shops, sweatshops, and artists' studios within High Street. See Victoria Mitchell, "Selvedges and Self Edges," *Selvedges, Janis Jefferies: Writings and Artwork* (Norwich School of Art: Norwich Gallery, 2000), pp. 11-16.

23. A term first used by Kobena Mercer to describe a complex shuttle process whereby artists are not fixed by their cultural identity. Similarly unfixed are the practices in which they articulate their diasporic experiences by being in neither one place nor another but rather in a space between the two, a "third space," a "hyphen space," where ideas of the hybrid formation occurs. See Kobena Mercer, "Imagine All the People: Constructing Community Culturally," *Imagined Communities*, essay written for the catalogue of the national touring exhibition organised by the Hayward Gallery and Oldham Art Gallery (United Kingdom: The Arts Council of Great Britain, 1995).

24. Janis Jefferies, "Dressing Down Textiles in a Victorian Philanthropist's Parlour: the Work of Yinka Shonibare," in *Re-Inventing Textiles: Tradition and Innovation*, ed. Sue Rowley (Winchester: Telos Art Publishing, vol. 1., 1999), pp. 59-73.

Kobena Mercer has named this experience an example of "a transnational generation of hyphenated hybrids."[23] Shonibare's research on textiles uncovers the legacies of imperialism and the colonial links between Lagos and London. In 1990, Shonibare started to work with "African" fabric that he bought in the street markets and fabric shops in Brixton, an inner-city area of South East London, an area where "ethnic minorities" make up twenty percent of the population in a fusion of fast food, world music, and street markets. Shonibare uses "African" fabrics as a preferred material in all his artworks as they fundamentally challenge claims of authenticity. The fabrics have a complicated set of histories that expose the complexity and impossibility of defining them using terms such as original and authentic. Thus struggle is parallel to Shonibare's own questioning of selfhood. In his work, the reimportation but strategic use of "ethnic" fabric reveals the complex web of relationships between Europeans (significantly British) and those they colonised. He shows us that fakes, similar to the original batik fabrics derived from Indonesia, are industrially manufactured in Manchester and Holland then exported to Africa and reimported to England via fabric shops and street markets.

The fabrics serve as mobile signs that refuse a final signified or final destination. In Europe, these "hybrid" fabrics, and Shonibare's use of them, evoke an exotic/erotic "African" Otherness; in Africa, the fabrics operate as signs of aspiration through the allure of imported goods. In postindependant Nigeria, they are a popular expression of postcolonial nationalism. As adopted by young British blacks, these textiles become symbols of Afro pride and identity.

Often autobiographical, Shonibare's work positions the artist somewhere within a shuttling process of constant translation, between colonialisation and trade, origin and authenticity, self and Other, gender and ethnicity, and high and low material practices.[24] Furthermore, his work stands for the recent preoccupation by artists with material and craft processes. This form of art making, as both an aesthetic and conceptual strategy, has become a significantly effective means to bridge the gap between high and low, fine and applied art and craft, gender and identity. Artists now take aspects of one practice or one culture, craft, insert, and rearrange them to coexist, disrupt, and revitalise the other. Artists are fascinated by and critical of hybridity. Their practice is interrogative and mimetic; through explorations of hybridity they reflect its contradictions and tensions back to their audiences.

In Documenta XI, Shonibare restaged a "grand tour" scene in his piece *Gallantry and Criminal Conversation* (2002). In the eighteenth century, the grand tour was a common rite of passage and an initiation of British

aristocrats into sexually charged behaviour. Various characters wear period dresses made of African fabric. They surround a horse-drawn carriage that is placed in the middle of the scene. Period dress points to the power structures of a class that transgresses that which has been traditionally high culture (silk/coloniser) and low culture (batik/colonised). Shonibare constructs two frames of reference for his audience. Firstly, the erotic African fabric is linked to the desire and transgressive behaviour of his characters, and secondly, an economic exchange is cited as an example of what happened on the grand tour.

The works of Bhimji and Shonibare demonstrate that any return to an authentic practice is as untenable as a return to an ethnically closed or centered original history. Both these artists bring an awareness of how textile, fabric, and material are inserted into visual culture and the origins of cultural identity. As with my work and that of Yan Miller, textile and cloth are embedded in the metaphoric use of textiles to illuminate social and political relations. Furthermore, the sweatshops of London's East End "tell a story of capital and trade centered from a European perspective as opposed to new ways of conceptualizing the ebb and flow of cultural exchange."[25] Whether this is acknowledged or denied is a matter of ideology and an absolutist faith in the fixity of things and ideas. Returning to the Rushdie quote that opened this essay, we must remember how newness enters the world.

With thanks to Ali, Holly, and Ann.

25. Stuart Hall, "When was the Post-Colonial: Thinking at the Limit," in eds. Iain Chambers and Lidia Curti, *The Post-Colonial Reader* (London: Routledge, 1996), pp. 242-62. This anthology contains a comprehensive account of the legacies and implication of Britain's colonial past and the impact on postcolonial narratives.

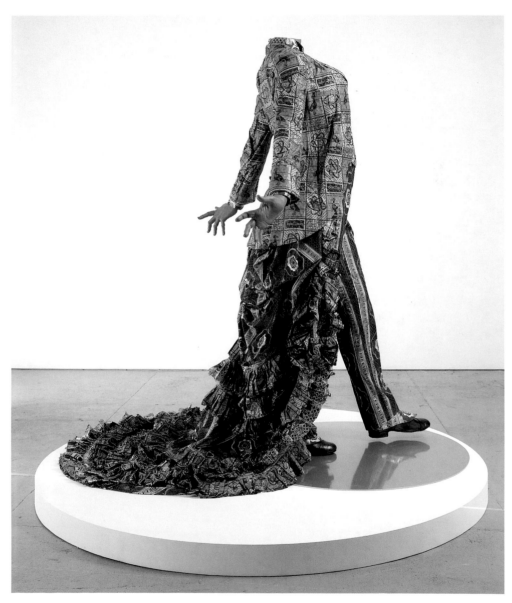

Big Boy, *2002, wax-printed cotton textile, fiberglass, 85 x 67 x 55 in.; plinth 86 in., diameter 5 in.*

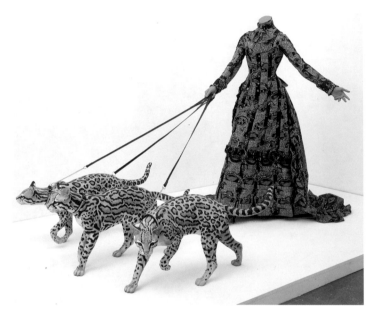

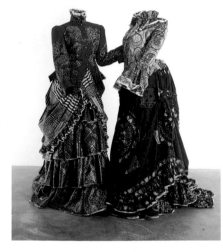

The origins of the fabrics are important because this kind of cloth is not indigenous to Africa at all. It is based on Indonesian printed batik designs, which were industrially manufactured in Holland and England and then sold to the West African market. Initially, when the Dutch went to Indonesia, one of their colonies, they adopted local batik printing, but to facilitate trade they produced the fabrics industrially. They tried to sell them in Indonesia, but such industrially produced fabrics were not popular there. So the Dutch tried them in West Africa, where they were extremely well liked. At this stage, as Africa was being colonized, people were being educated and moving into administrative types of work. So spending time hand weaving their fabrics on looms was not practical. It was faster and cheaper to buy something manufactured. Of course, now the printing technique has been adopted by Africans as well, but the origins of the designs are Indonesian. And, to add another layer of complexity, I purchased these culturally hybrid "African" fabrics from Brixton market in London, where they are popular with African-Europeans and black British people who want to identify with an idealized, invented homeland. Personally, I tend to prefer the fabrics now printed in Africa that include Western images, such as televisions and radios, things that express desires and aspirations. If you can't really afford these items, you can own the fabrics.

Yinka Shonibare, MBE

Still from Cities on the Move
– 2727 Kilometers Bottari
Truck, *1997, single-channel
projection, silent, 7 min.
30 sec. loop.*

Cities on the Move – 2727 Kilometers Bottari Truck, *1997, photograph of eleven-day performance throughout Korea.*

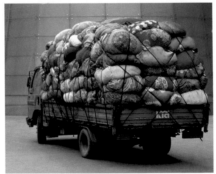

Cities on the Move – Bottari Truck, *2000, 2.5-ton truck, used Korean bedcovers, and clothes. Installation view from Rodin Gallery of Samsung Museum, Seoul.*

Cities on the Move is a globally conceived and constantly widening project by Korean artist Kimsooja realized in different media and contexts. From November 4-14, 1997, Kimsooja traveled throughout Korean cities to which she has a direct personal relationship, crisscrossing her homeland from north to south and east to west. The videos of this performance show the small *bottari* truck, on the bed of which a mountain of cloth bundles *(bottari)* is lashed together, as it slowly makes its way through town and country. In one video, Kimsooja sits atop the pile loaded onto the truck, traveling through the changing landscape.

The cloth bundles are an essential component of the performance. Classical *bottari* designate a bundle in which unbreakable objects like pieces of clothing, bed linens, household utensils, and books can be kept. In Korea, especially where people have often been forced to leave their homes in order to flee war or famine or to look for work, the bundles are historically charged and emblematic objects. They were used both by refugees and merchants who transported their wares in them. On a metaphorical level, the *bottari* also function as signifiers of mobility in unbound space, and thus are, at the same time, containers that include their own contents.

Yilmaz Dziewior

Mary Jane Jacob

MATERIAL MEMORY
With a MEMORY for MATTER

1. Arthur Danto, "The Tapestry and the Loincloth," 1996, an unpublished essay commissioned by The Fabric Workshop and Museum, Philadelphia, citing Plato, *The Republic, V,* 466a, p. 705. Danto goes on to talk about weaving's other metaphorical uses: "The metaphor of weaving is itself so woven into our conceptual schemes that it must constitute one of the *Ur*-metaphors we acquire with our language, and though weaving as such is an activity with which, in its original sense, very few of us have had much direct experience, it is difficult to see how, no matter how modern or even postmodern our form of life, we could imagine getting on without the metaphor . . . "

"The fabric of society." Why is this weaving metaphor everywhere, even though the act of weaving is far from our everyday experience? Arthur Danto wrote that Plato used the weaving metaphor because "each move made by the weaver has the whole fabric in view . . . The aim of state-making is justice, which means, in effect, weaving together the various social virtues without allowing one more than the other to dominate. And it is that which makes weaving so apt a metaphor for statesmanship."[1] Is it? Does weaving have a wide enough view to encompass culture in ways that, say, painting cannot? Paintings are paint turned into illusion, but in weaving, cloth is actual—material and meaning in one. Cloth, in practical and metaphorical ways, has played a key role both in daily life and in establishing social structures in diverse cultures for centuries.[2] Cloth is a mode of communication within and between civilizations, hence it was at the center of colonial trade. And, like language and art that have been records of history, cloth is a way of remembering.[3] But in today's Westernized, commercial, and technological world, cloth is no longer a medium of politics nor an instrument of social definition and imposition. Yet because of its long historical role and inherited references, cloth persists as a medium of

personal meaning-making and cultural memory. Applying the critical, perceptual tools provided by postmodernism, it can become a fertile site of embedded social meaning; as a critique in art's terms, it can provoke shifts in our perception of culture.

The three artists around whose work this discussion of cloth is based—Yinka Shonibare, MBE, J. Morgan Puett, and Kimsooja—are second-generation postmodernists who deconstruct dominant modes of thinking, asserting the specific histories of those forgotten in order to reconstruct universal ways of being. While their work exists between traditions of the past and critical practices of contemporary art making, they each employ cloth because of its fluidity to literally change shape and take on different meanings. They use the historical associations of cloth to point to power relationships and, as Sarat Maharaj puts it, their work "begins to map out an inside/outside space, an 'edginess.'"[4] By revealing meanings deep within the sources of their making, each artist moves between disparate terrains of culture and history to create a credible weave of place and time.

These artists are also driven by ideals of social justice and, with their work, aim to enlarge our view of cultural history and our place in it. Their critical practices are among those evoked by Lewis Hyde when he compares the artist with the trickster: that pan-cultural, legendary boundary-crosser.[5] Like Maharaj, who perceives that the aim of today's progressive textile practices is to throw "out of joint the received orders of difference of the arts,"[6] Hyde views the artist as a joint worker who "shifts the patterns in relations to one another, and by that redefines the patterns themselves."[7] For Hyde, this is axiomatic since he believes the very possibility of art is "the possibility of playing with the joints of creation."[8]

The projects by Shonibare, Puett, and Kimsooja that are the focus of this essay were all created at the same moment and place for the 2002 Spoleto Festival USA in Charleston, South Carolina,[9] an annual performing arts event. For over a decade, Spoleto has also served as a periodic forum for the critical practices of visual artists inspired by the deeply rooted stories of the people and places in this poetic landscape. A colonial capital of global reach, the ethos of Charleston is intrinsically bound to its role in history as the entry point of nearly forty percent of all African-Americans today, the so-called capital of slavery in North America. The site of the first shot of the Civil War, it was a political and economic power leading the state to be the first in the Union to secede. Other aspects of its past seem inconsistent with this history: Charleston had more free blacks before the Civil War than any other Southern city, and centuries-old familial bonds between blacks and whites live on.

2. See Annette B. Weiner and Jane Schneider, eds., *Cloth and Human Experience* (Washington, D.C.: Smithsonian Institution Press, 1989). This is an essential anthology in the field of material studies that examines "the properties of cloth that underlie its social and political contributions, the ritual and social domains in which people acknowledge these properties and give them meaning, and the transformations of meaning over time," p. 1.

3. It has been theorized by critic Gerry Craig that textile processes, like writing as we know it thousands of years later, "were no less than the structural and imagistic model by which humans developed linguistically." Gerry Craig, "Imagination and Sensation," *Fiberarts* (November-December 1995), p. 55.

4. Sarat Maharaj, "The Congo is Flooding the Acropolis: Black Art, Orders of Difference, Textiles," in *Interrogating Identity* (New York: Grey Art Gallery and Study Center, New York University, 1991), p. 38.

5. Lewis Hyde, *Trickster Makes This World: Mischief, Myth, and Art* (New York: Farrar, Straus and Giroux, 1998). Hyde states: "My own position, in any event, is not that the artists I write about are tricksters but that there are moments when the practice of art and this myth coincide," p. 14. He also traces an etymological lineage through words of the ancient *-ar root; from the Latin *articulus* he assembles a large group of related terms whose original meaning encompassed "to join," "to fit," "to make." The Greek word *harmós*, for instance, meant not only a joint in the body but more often joints made by artisans (artisan itself is an *-ar word meaning a joiner or maker of things). The Latin noun *ars*, from the same root, means arts in the sense of skill, artifice, craft, and crafty action; also a liberal art, a trade, a performance, and a work of art. And again from that root, articulate meant joining bones together or, as today, words well joined, p. 254.

6. Maharaj, p. 39.

7. Hyde, p. 257. Thus, Hyde adds, the trickster-artist seeks to change "the manner in which nature, community, and spirit are joined to one another."

8. Ibid., p. 280.

9. I commissioned these artists to create new works for the exhibition *Evoking History: The Memory of Water*, part of the program of the 2002 Spoleto Festival USA. Other participating artists were Marc Latamie and Nari Ward. For more information, see *2002 Spoleto Festival USA Program Book*.

While the use of fiber was not part of the artistic mandate for the exhibition in which they all took part, it is telling that each of these artists—in the context of this place—sought out cloth as their primary medium, finding it an appropriate and powerfully articulate means of addressing a complex historical and cultural story. But their attraction to cloth has links beyond Charleston, stretching through time and around the globe. In today's world, where fabrics are plentiful and various, it is difficult to imagine cloth as a scarce or rare commodity that was valued so much that it became a medium of value itself. But in preindustrialized eras, meaning accrued with making as family and cultural ties were literally woven into cloth and dependent upon its preservation. Cloth gained power through association with ancestors, and this power was transferred through ceremonies of investiture in which woven objects became vehicles for succession of authority. Prestige, another order of power, came with the oldest, most treasured cloths which, as today, may be highly regarded for their material attraction, novelty, or richness of threads. Possessing value in these significant, social ways contributed to the status of cloth as culture and currency.

With the rise of a capitalist system of industrially produced textiles, the symbolic potential of cloth moved to the esoteric or nostalgic reaches of Western culture, becoming identified with underdeveloped, nonindustrialized countries. A sequential system of producers—spinners, dyers, weavers, lace makers, seamstresses, and other craftspersons—became distanced from the product as their labor became harnessed to factory production. More available and removed from the family center, spiritual meaning evaporated and cloth lost value. The emergent meanings of cloth were, instead, a reflection of the system of power manifested in commerce and, with this, cloth was transformed from a medium of cultural preservation into a tool of cultural perversion.

Yinka Shonibare's
Space Walk

Yinka Shonibare, MBE, has looked to the massive social changes during the period of colonial trade and industrialization, examining the complex cultural interchange of textile production and exchange, and its formative role in shaping our expectations of black identity. Born in 1962 in England of Nigerian parents, he has benefited from living in both countries; being no less British than Nigerian, his work navigates between cultures. For his critique, he has developed a signature vocabulary of bold, image-laden batiks, referencing his own experience of migration, as well as the historic passage of peoples and goods. His use of batik satisfies his practice as an avant-garde artist participating in the redefinition of art by upsetting existing cultural hierarchies. Batik has been called "painted cloth" because of its elaborate hand-dyed process. By rejecting painting in lieu of painted cloth, Shonibare denies the preeminence of Western art history, with its pantheon of white male painters, in favor of identification with cultural production by so-called Third World artists and artisans left nameless in history.

Batik has been subject to a rich interweaving of tradition and a curious conflation of influences throughout the centuries. Dye-resist patterns can be traced back over 1,500 years, with evidences in the East, Middle East, and Africa, but it is generally held that it was on the island of Java, in Indonesia, that this handcraft reached its apex (nonetheless dependent on trade with India for cotton cloth). In local culture and through trading with surrounding countries and colonial companies, cloth served as a standard of currency and a means of amassing wealth. Dutch colonists began to export batik to Europe in the 1600s, replicated it back in Holland for sale in Indonesia where, under political control, they could restrict local production in favor of the sale of their own imported goods. But in a cultural and political reversal, Indonesians reclaimed local manufacture (along with the local cultivation of cotton) in the early 1800s, eventually

Yinka Shonibare, MBE, Space Walk, *2002, batik-printed cloth and mixed media shuttle. From the* Evoking History: The Memory of Water *exhibition at the 2002 Spoleto Festival USA.*

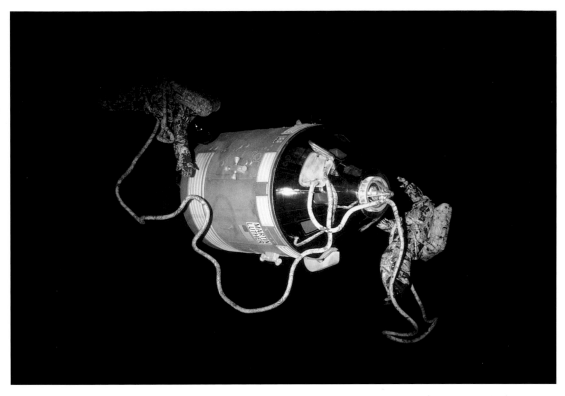

Yinka Shonibare, Space Walk
(detail).

10. The printed legend on the
highest quality products still
bear the name "Veritable Wax
Hollandais," produced by
Vlisco, founded in 1846 and
based in Helmond, The
Netherlands, of which there
are Nigerian-made "copies
showing up eight days" after
a new product line appeared
on the continent. See Matt
Steinglass, "Out of Amsterdam:
How a Dutch Company's Batik
Textiles Became the Basis of
'Traditional' West African
Culture," *MetropolisMag.com*
(December 2000), pp. 2-3.

overtaking Dutch manufacturing monopoly and then Dutch rule. Thus, batik
making was a political act, a reassertion of indigenous traditions and voice.

After the Industrial Revolution, machine-printed batiks were also manu-
factured in factories in Manchester, England. In response to the decline of
the Asian market, ships made port along the coast of West Africa seeking
buyers. There they found a lucrative market and, over time, these European
batiks incorporated vernacular images and local designs to appeal to and
stay in tune with the desires of a clientele of another culture. With its great
popularity, batik was dubbed "African cloth." Moreover, it became so closely
identified with African cultures that during the mid-twentieth-century period
of anti-colonist revolution, it was a symbol of African independence. Today,
it is still the "Dutch wax-printed fabric" that holds the greatest prestige,
thus Nigerian companies immediately copy the Dutch products.[10] This
practice colored the everyday landscape of the country in which Shonibare
was, in part, raised.

Shonibare looks to the many meanings that batik has taken on through
its long history, evolving across cultures, from its role as a colonial weapon
of power and subjugation and, conversely, to its use as a site of resistance

and as an icon of freedom. Perhaps the keenest figure in history to adopt cloth and clothing as a means to reposition political power was Gandhi.[11] Indian society, under British colonial rule until 1947, had become dependent on Manchester-produced cloth, enslaved by the forces of trade and fashion, and restricted from the use of local manufacture. Gandhi equated home production with home rule and, in his campaign, his choice to wear a loincloth was a powerful symbol to unite the populace and bring about social change. Shonibare's batik shares in this colonial story. But whereas for Gandhi, Indian-produced cotton was aimed at establishing national identity, Shonibare purposefully uses batik cloth for its cultural ambiguity. Rather than seeking social transformation through the expulsion of the oppressor (albeit, for Gandhi, in the quintessential nonviolent revolution), Shonibare looks toward cultural reconciliation and coexistence.

In the earliest work that brought Shonibare to international attention, he employed this painted cloth in the form of historic clothing worn by specially fabricated mannequins whose demeanor (even when headless) had an upper-class air. In Victorian ensembles and hunt scenes, figures flamboyantly attired in colorful batik were a mixed metaphor—a conflation of British elite and those subjugated by the Empire. He has carried his unlikely, unsettling characterization of blacks into grand-scale installations and into large-scale narrative photo series starring himself.

In *Space Walk*, Shonibare clothes two full-scale astronauts in batik, each poised at work on the Gemini space shuttle to which they are tethered. These present-day colonizers, who pursue scientific advances and serve the goals of private corporations in the name of national space programs, are the direct descendants of those who traveled the open-seas era under the employ of international trading companies or for the crown of governments. The astronauts' batik-covered lifelines are umbilical cords that connect many histories and cultures (Asian, European, African, American). Like the continuous cloths of Indonesia or Yoruba that wrap the dead to bind the past to the present and future, Shonibare's works are symbols of continuity across centuries and continents, then threaded into outer space.[12]

Like its African-made counterparts, the batik of the astronauts' spacesuits is printed (a faux version of the original, more labor-intensive dyed cloth); it was fabricated to the artist's specifications at the Fabric Workshop and Museum in Philadelphia. In acknowledgement of this collaboration and added layer of cultural migration, the design imagery is drawn from album covers of 1960s Philadelphia soul music. Once it was printed, the cloth was shipped to London where it was fabricated into costumes, then

11. See Danto, "The Tapestry and the Loincloth," n.p.

12. Weiner and Schneider, pp. 15-16. In some Indonesian bridal customs there is a cloth of endless warp that represents "the continuous threads of kinship and descent," and in Yoruban traditions of Nigeria, the Egungun cult depend on "tied, bound, or wrapped" fabrics to play a symbolic role in rituals where lineage of ancestry and solidarity are celebrated.

transported complete to Charleston. Thus, it made a kind of triangular passage, just as cotton harvested by African and African-American slaves in the South was sent to the North or England to be woven, returning as fabric or fashions.

Charleston's role in the story of slavery provided a rootedness for *Space Walk*. Here, too, Shonibare's reference to Philadelphia serves him for it was the Philadelphia Quakers—among the most active abolitionists—who established the first school for free blacks, the Penn Center in Beauford, South Carolina, just south of Charleston, in 1862. Moreover, evoking cloth as a colonial medium of exchange or merchandise, this work *remembers* that the story of slavery is one of global trade in human lives. Yet this artist's approach expunges a binary, quick-read along lines of black and white, oppressed and oppressor. Northern states, as well as those of the South, participated and profited in the slave trade. Northerners held slaves and their textile factories depended on slave-cultivated cotton; then, they set up their own systems of virtual enslavement in their treatment of mill women and children.

Out of this postcolonial critique emerges a future of possibility, born out by another iconographical element in the work. On the shuttle's exterior, the American flag bears the words "Martin Luther" (in place of "United States"), a reference to both the Reformation theologian and the Civil Rights leader, each of whom was led by their religious beliefs to bring about political and social change. Both historical figures placed great value on the role of the individual in determining their own fate. For Shonibare, this belief supports his claim that one's future is not culturally predetermined. The artist's choice of a fantastic image—astronauts in outer space—is a means of transgressing self and social stigma, extending in egalitarian spirit to both genders as Shonibare's crew is made up of one male and one female.

In this message of hope, Shonibare departs from the deconstructivist and damning stance of the 1980s postmodernist artists who sought to expose the evils and modern-day vestiges of colonialism. Instead, he responds to the painful experiences of Africans as objects of colonial trade by using "African cloth" to create an optimistic image of a race on the frontier of positive change, as well as a metaphor for all human aspiration. Thus, Shonibare puts back into cloth not only layers of meaning, but also spiritual power. As in ceremonies of investiture, he uses cloth as a call for universal fulfillment. With faith in the future, this work celebrates the personal enrichment that comes from cross-cultural experiences in a world of global interdependence.

J. Morgan Puett's
Cottage Industry

Like Shonibare, J. Morgan Puett uses clothing to counter conventional hierarchies, but her critique is not one of colonialism (although the subject of slavery did enter her work in Charleston). Rather, it lays in the cultural domain of another underclass—women. Bound through industry if not by institution, women have consistently been the main workforce of industrialized textile production and the subject of abusive practices of sweatshops that still exist today. The relationship of women to cloth and clothing is an ironic one: just as women have been subjugated in the factory, they are also intimately associated with the endearing domain of the home, where comfort comes through cloth (soft baby blankets, lovingly made clothes, handcrafted toys). Additionally, women are identified with fashion and dress as expressions of the feminine. Cloth and women, like cloth and slavery, exist in an uncomfortable relationship. This story extends from antebellum times to present day where Latina and African-American domestics in Charleston tend to the details of other people's home life or change the sheets of the many tourist hotel beds—rituals replicated each day the world over by Third-World women. Like Shonibare, Puett keenly insists on making

evident the social realities embedded in cloth and clothing, as well as the systems of manufacture that perpetuate power relationships and human inequities. She carries this out through the garments of the working class and their relationship to everyday life. Her art—in material and mission—seeks to give representation to those whose histories are categorically left out. Her earliest product line (beyond the art world, Puett is a recognized high-fashion clothing designer) was based on the unfashionable garments of an uncelebrated constituency—the American Depression-era clothes of Appalachian women—picturing them in photo shoots in the manner of photographers of the era, such as Walker Evans, Lewis Hine, and Dorothea Lange. Continuing to create clothing for the market (introduced

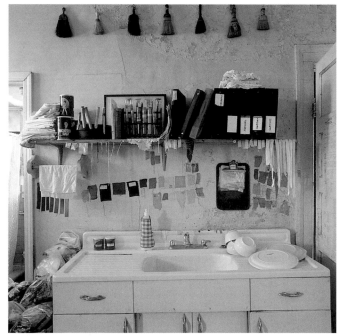

306

13. This practice has included: J. Morgan Puett, Inc., a small women's clothing business in New York's SoHo (1993-1997); a chameleon company called Shack, Inc., formed around concepts of installation art and process-based public art in order to undertake hybrid projects; and a collaborative venture on a New York-based experimental, retail-clothing manufacturing project (1998-2001).

in runway shows, sold in brochures and shops), she has created a reputation and clientele in both the fashion industry and in the art world.[13]

Cottage Industry, Puett's project for Spoleto, posited a rereading of social history by reasserting missing chapters of women's history, black and white. To carry out her revisionist undertaking, she undertook the creation of garments from all social strata. Her sources ranged from the luxury clothing of those women whose names are secure in history books to women who are forgotten, unknown, and for whom few traces remain. Both defining and dividing us along lines of difference, clothing is our outer skin; it is the interface between our private selves and the public realms we negotiate individually, with our bodies, and collectively, as a social body. Social messages are carried out through clothing because it is an accessible, nondidactic medium, open to interpretation. With our deep and intimate familiarity with cloth, multiple readings and associations emerge that engage, in subtle yet penetrating ways, our cultural consciousness. Like Shonibare's work, Puett's art embraces ambiguity, at once referencing the fashions of three centuries in Charleston and the South, and evoking a universal story of female power to transmit culture.

Scrupulously rooting her revisionist fashions in documented examples, Puett began by looking at the canon of history as told in museum collections of Southern states, then deconstructed garment artifacts into salient, component parts, translating them in extraordinary ways. Her garment references included: a sleeve from Eliza Lucas Pinckney's eighteenth-century silk dress, for which she raised the silk worms in the Lowcountry, took the fibers to England and had the cloth woven and three dresses made; a series of stomachers, each uniquely embroidered (one with a map of Charleston, ca. 1750); an eighteenth-century pocket, an accessory tied around the waist and used by all classes and races of women; a slave apron; and an early-eighteenth-century crotchless undergarment ("Bonney breeches") named for a female pirate of local lore. Producing each element in multiple fabrics, Puett multiplied meaning. One cloth, an early-nineteenth-century coverlet of wandering vine motif in the collection of the Charleston Museum, was even commissioned. One of the few extant slave-made and slave-used examples, it served as the source for Charleston-based artist-weaver Leigh Alexander's remarkable indigo-dyed homespun of wool-and-linen (linsey-woolsey).

Clothing—in this artist's formal language, communal processes of making, and social actions of dress—serves to animate history and make it live again. While her garments in the street-side room of the house, suspended midair from hooks or lining walls, seemed inhabited by ghosts, they came alive when worn. Puett built her fashion line and, thusly, a new history in

layers. An eighteenth-century undergarment, constituted of pieced strips of cloth and supplied with buttons all around, provided the foundation and a means by which one could attach other garment elements. The wearer was free to individualize an outfit in improbable, even unconceivable ways, not obligated to the fashions of the past. And as she consciously or unconsciously reconstructed history, fabric became the fluid medium of time.

This became most evident in the artist's fashion show/performance that was a part of *Cottage Industry*. Two models were clothed and unclothed in a continuously evolving motion by the seamstress-artists who were, themselves, clothed in the dressmaker's "muslins"—mere shadows of the finished garments. The reverie of the moment floated between states of individual identity and historic enactment. In suggesting the garments intended use and the wearer's options of mix-and-match, the artist not only pointed to our complicity in history, but also through palpable means, she offered a creative act of reestablishing continuity with the past.

Cottage Industry functions on a larger scale too. It was not just the individual garments or ensembles that were the works of art, but the entire commercial-artistic enterprise. Puett's practice transgresses art and nonart, traversing the otherwise exclusive territories of commercial fashion, fine arts, and architecture. She does not obscure or blur these distinctions to make clothing "art," but rather asserts the difference. Thus, *Cottage Industry* existed in many realms at once. The garments were fabricated and displayed in a house originally from 1852, although the house itself became an element of the work as the installation spread throughout six rooms. It was a home-based workshop; a temporary, small, clothing manufacturing business—a cottage industry—*and* a performance with other artists and skilled persons creating clothing in public view. It was a vision of Puett, as well as a collaboration of many artists working toward a common end *and* a group exhibition of works by those who contributed elements to the project (hats and patterns for sale, small works of art and artifacts also on display, a musical soundtrack, a Web site, fashion photographs).[14] It was a store *and* a history-museum display *and* a heritage center *and* a living archive *and* a family reunion site *and* a temporary public artwork *and* a local artists' space for gatherings and exchange. It was a carefully crafted representation *and* an open, generous act upon which others could inscribe their ideas and impressions.

The site of this project—a nineteenth-century house permeated by a rich layering of imagery and an aura of nostalgia—compelled us to remember while, with each step taken through these spaces, challenged viewers to place themselves in this unfolding story. Located near the shipping docks in historic

J. Morgan Puett, Cottage Industry, *2002, installation view (opposite).*

14. See also the artist's Web site www.jmorganpuett.com for full documentation of this and other projects.

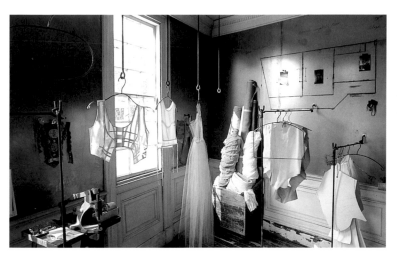

downtown Charleston, the house is one of only two surviving residencies of the once-thriving African-American community of Ansonborough (which former residents called "The Borough"). The homes at #35 Calhoun and its twin at #35-1/2 (dubbed "The Borough Houses" at the 2002 Spoleto Festival), are sites of resistance to never-ending waves of change, progress, and gentrification. They are also sentinels to the memory of the past from which emanates a local history of longshoremen, laborers, artisans, and their families. Deeper still are their roots in slavery.

Puett, a Southerner herself from Hahira in southern Georgia, takes as her protagonists for *Cottage Industry* Southern women of both black and white races. They have the power to make and weave, to retell and sustain history. It is fortuitous but, perhaps, not coincidental that Puett's first collaborators in this work were women—Rebecca Campbell and Catherine Braxton, the owners of "The Borough Houses." Along with Puett, they gave birth to this project, nurtured it, providing volumes of material (quilts, clothes, family belongings) through which they evoked memories as they aimed to reconstruct history and heal.

Cloth has a regenerative power. Dyeing or weaving in some cultures has been described as an analog to women's reproductive powers. Before the industrial period, lore had it that spirits imparted "socially binding protective powers to cloth," but such positive intent was twisted to a "malevolent message implicit in such a devil-pact," as in tales such as Rumpelstiltskin, the story of a woman's bondage in which she gives up her first child, that "pits the goals of production against the goals of reproduction."[15] With *Cottage Industry*, Puett aims to acknowledge and revitalize women's contributions as keepers of culture, and her use of cloth acknowledges its role in the transmission of sacred ancestry. Thus, Puett reaffirms the archetypal power of cloth in culture as a regenerative life force, imbued with social and spiritual meaning. The disenchantment of cloth making brought about by the shift from cultural to corporate systems of production that stripped it of its spiritual force may, with the work of Puett, become *reenchanted*.[16]

15. Weiner and Schneider, p. 13. In this same volume, see also the essay, "Rumpelstiltskin's Bargain: Folklore and the Merchant Capitalist Intensification of Linen Manufacture in Early Modern Europe," pp. 177-214. For a study of the relationship of indigo dyeing and concepts around menstruation, conception, and childbirth among the Kodi of rural Indonesia see Janet Hoskins, "Why Do Ladies Sing the Blues? Indigo Dyeing, Cloth Production, and Gender Symbolism in Kodi," pp. 141-273.

16. Weiner and Schneider, p. 13. Here we can contrast what Weiner and Schneider call "the 'disenchantment' of cloth manufacture under capitalism" with what Suzi Gablik develops as the thesis and paradigm shift of the "reenchantment of art," which is a reconstructive rather than deconstructive form of postmodernism. See Suzi Gablik, *The Reenchantment of Art* (New York: Thames and Hudson, 1991).

Puett dissects aspects of history, then pieces it back together to make a cultural story of whole cloth again. In cultures where cloth was a source of cultural or actual wealth, cloth was maintained in continuous lengths. Continuity transmitted a spiritual force, making sacred connections with the past, binding the present members of the society to their ancestral lineage, and strengthening the core of cultural history. By contrast, cut cloth is an operational practice of fashion which, by definition, is about style and the rapid overturns of identities. Fashion is the antithesis of continuity; it discards the old and disrupts memory in favor of the new. Cut cloth finds its equivalent, in production terms, in cottage-industry practices: the historical condition of nonorganized textile workers based in their own homes, paid by the piece, cut off from larger profit-making structures and industrial history, working on fragments in fragmentary ways, remaining unnamed, at unmarked locations, and invisible in the identity of the product. This system offers no spiritual connection to cloth and disempowers women.

Puett's *Cottage Industry* refutes, in physical and political terms, the severing of history. It makes its mode of production transparent with all stages of manufacture in full view, and it reveals the hidden value of the textile worker's labor. A shoe purchased at Nike for $100 bears no relation to the pay received by the Asian worker; garments bought for throw-away prices indicate just how low the price can go and still ensure a profit margin— even lower are the wages of the makers. By contrast, Puett asked her "workers," the artists and artisans with whom she collaborated on production, to record their actual labor in hours and in anecdotes of pleasure and frustration.

J. Morgan Puett, Cottage Industry, 2002, installation view.

Their journal entries recording daily activities hung from clipboards, and from these the "real price" of making a garment was calculated. In its breadth and complexity, *Cottage Industry* reassembled these facts and other parts of lived history. But this work was much more. It had an uncommon vitality indebted to cloth, with its meanings in substance and form. And it was from cloth that Puett created garments to *remember* and allowed for other meanings to accrue.

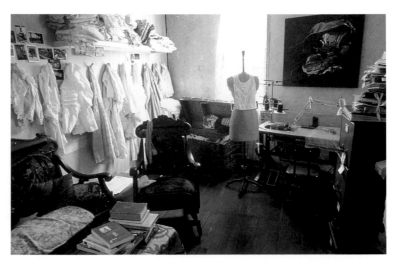

310

Kimsooja's
Planted Names

For Kimsooja, cloth and time are inextricably connected. Her art taps into the archetypal images and meanings of cloth as a force of creation and continuity, beginning with her work using colorful bedcovers from her native South Korea. Given to newly married couples as a promise of long life, happiness, love, and wealth, these quotidian fabrics are replete with meaning. They are sites of intimacy and sleep, newborn babies are swaddled in them, the dead wrapped in them. In the artist's words, they are the "frames of our bodies and our lives."[17] They have a memory. In her installations, she spreads them on the floor, hangs them like laundry, or ties them up to make *bottari* or bundles as one might to carry life's belongings. In *Cities on the Move* (1997), for example, she sat atop *bottari* piled high on a truck that followed a path through her homeland. It is also in the act of sewing, connecting fabrics together, that Kimsooja expresses human existence. Her video installation *Needle Woman* (1999-2001) placed the artist as the eye of a needle through which passed crowds of people in eight metropolises around the world.

Important to Kimsooja's Charleston project—a work in two parts—was cloth's ability to translate between generations over time, to transgress the realms of the living and the dead, and to mediate between the domains of past and present.[18] A continuous thread exists between family members and ancestors, and cloth can bestow a vitalizing power on the living or, invested with authority, be the means of passing on heritage through lineage.[19] Like the lifelines of Shonibare's astronauts or Puett's enfolding layers of women's history, Kimsooja attempts to evoke spirits across continents and centuries. She uses cloth, and allusions to it, to connect to the land and water, and to the stories these places tell of pride and pain. And while her background, geographically and historically, is more remote from Charleston than the other two artists, it is Kimsooja who knows best the pain of displacement. Her *bottari* had emerged as a reflection of growing up along South Korea's Demilitarized Zone, "always between danger and peace." It is she, as a South Korean, who actually lived through civil war.

One aspect of Kimsooja's Spoleto project was at Drayton Hall, a former rice plantation and a masterpiece of Georgian Palladian architecture, and a place "beautiful and humble," in the artist's words, where "I can feel the souls and spirits in this house." The Drayton family history is a continuous line from before 1742, when the structure was completed, to today. So, too, is the history of other resident families who labored there. Some are buried up the road, most in unmarked graves; some are the ancestors of Rebecca

17. This and following quotes are from a conversation with the author, June 2002.

18. Weiner and Schneider, pp. 6-7. The Sakalava people of Madagascar wrap their dead royalty in cotton cloth. They can return as spirits possessing the living and, in doing so, demand being wrapped in cloths appropriate to their status. The possessed person, thus clothed, becomes the reincarnation of the deceased through the power of these fabrics, *lamba*; they speak to the living, intervene in current events, make prophesies, and play a political role.

19. Ibid., pp. 7-8. In the funerals of the Kuba, in Zaire, cloth of sufficient quality and quantity is required for "peaceful transition to the afterlife" or else the dead will "interfere malevolently in the lives of the living."

Campbell and Catherine Braxton, owners of "The Borough Houses" that housed Puett's project.

At the plantation, Kimsooja sited *Planted Names*, four unique woven wool carpets. Each bears its own set of African and African-American names tied to this land: the two smaller carpets draw from the earliest extant inventories of the 1700s, while the larger pair form a single, continuous alphabetical listing of names from the eighteenth through twentieth centuries. White text on black creates a stark, simple presentation, signifying the interweaving of black and white cultures. Placed at one's feet, they are like grave markers to *remember* the names, in most cases, made public here for the first time. Situated in the symmetrical spaces surrounding the Great Hall, the artist transformed these rooms into places of meditation. As the names filled these areas, they also filled the imagination of visitors.

Creating a continuous line in history where records are scant is a process of interpretation and joint meaning-making. Initially, Kimsooja's story was to end with the Civil War, but dialogue with Drayton Hall's director George McDaniel raised other issues of pressing import. Taking the concept beyond:

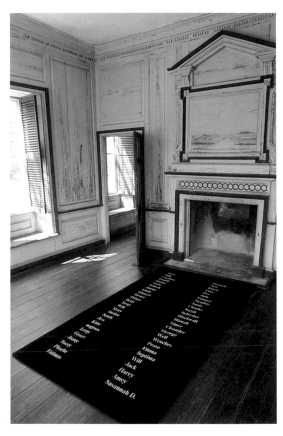

Kimsooja, Planted Names, 2002, one of four wool carpets. From the Evoking History: The Memory of Water *exhibition at the 2002 Spoleto Festival USA.*

Commemoration of those who lived outside freedom and who left home not by choice, maybe it's easier for us to think only of slavery. I hesitate to do so because that omits those who came after emancipation and who lived through the harshness and violence of the segregated South of the post-Civil War and onwards, and who had to leave in search of a better life elsewhere. Most of the depressions in the ground in the cemetery are probably the graves of those people. They, too, lived outside the officially recorded history . . . In regard to slaves, there's little to be done about hearing the story and passing it on, because most of the evidence has either been recorded or not. Ending about 135 years ago, the history of slaves is either in archives or not. But with those born later, there're still opportunities to hear stories and pass them on, so that they don't remain "outside history." I guess that's what concerns me about stopping at 1865. I want commemoration and action.[20]

20. George McDaniel in an email to the author, February 13, 2002.

In her past work, Kimsooja has used existing cloths, translating *objet-trouves* into art. But here, for the first time in her *oeuvre*, it was necessary to make the material new. Just as Puett discovered in her research of slave

artifacts in museums, so devalued were the lives of those in this class that little if anything remains. Out of this necessity, the literal act of weaving the carpets became intrinsic to the concept of the work. Their making became tied to the very sense of Drayton Hall as a place of production, a working plantation. It was echoed, too, in the artist's memories of houses in the Korean landscape where life was interwoven with nature through agriculture. Thus, the carpets, made on the loom, methodically row-after-row, were likened to the land cultivated row-by-row. Each movement of yarn through the warp was like the planting of a seed in the soil, each shoot of wool piling like a blade of the rice plant—a process that finally resulted in a woven carpet, a planted field. These carpets, planted on the floor, grounded the remembrance of others as they became a memorial to their labor, the forced labor that built this house and plantation.

Planted Names was deeply motivated by empathy arising from the artist's experience a few years back when she stood at the shore of Lagos and looked out from the other side of the Atlantic, and was overwhelmed by the image of the Middle Passage crossing. This tie across the ocean was consummated with a companion work, *A Lighthouse Woman*, that extended the metaphorical and historic line from Drayton Hall, past "The Borough Houses," into Charleston Harbor, and out to sea. Sited at the point where the Ashley meets the Atlantic, Kimsooja used a 60-minute computer

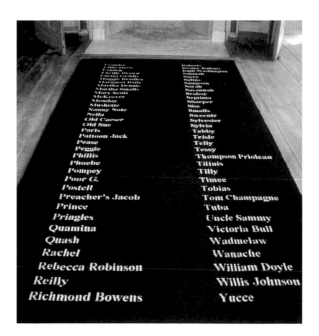

Kimsooja, Planted Names *(detail).*

program of changing, saturated-colored lights to transform this silent, solitary tower into a rhythmically breathing woman's body, inhaling and exhaling, moving with the tides. Like a needle through which lives have passed traveling to and from these shores, the lighthouse also became a memorial to the peoples of Africa and Europe who came to America, and to all their losses sustained through time. Yet while pain is evoked in the carpets and light-house, Kimsooja's personal and artistic response is not one of anger but compassion. Thus, in their solemnity *Planted Names* and *A Lighthouse Woman* are joined in spirit: one a witness to slave passage from the Old World to the new, the other a monument to slaves and others who have contributed to the low country and who all call Charleston "home."

The value of these works by Shonibare, Puett, and Kimsooja is transgression of place and time. While not from Charleston, these artists evoke powerful emotions of particular resonance there. At this juncture in art and cultural history, and with works such as those discussed, perhaps we have reached a maturation of the postmodern critique that allows for the coexistence of ostensibly contradictory states: the culturally specific and the universal.[21] In this endeavor, cloth has an extraordinary articulate quality to speak across borders, to be both local and universal. Hyde points to "a category of art, that occupies the field between polarities"—past and present, black and white, here and there—"and by that articulates them, simultaneously making and bridging their differences."[22] It is within this realm that these artists work, not so much to unify and resolve cultural differences, but to mediate them, serving as translators where there is little communication. Here, too, cloth is a powerful medium, possessed with a malleability to be both an expression of multiple, even conflicted meanings, and to bind us together in an expression of the universality of experience. In their common role as cultural translators, Shonibare, Puett, and Kimsooja use cloth as communication, fashioning material with memory.

The author would like to acknowledge The School of the Art Institute of Chicago's Roger Brown Residency Program for the space to compose this essay.

21. Stephen Batchelor, *Buddhism Without Beliefs: A Contemporary Guide to Awakening* (New York: Riverhead Books, 1997), p. 20. From a Buddhist point of view, Batchelor writes: "The challenge now is to imagine and create a culture of awakening that both supports individual dharma practice and addresses the dilemmas of an agnostic and pluralist world."

22. Hyde, p. 268. Hyde remarks: "The image could also be translated into political terms, in which case trickster becomes the agent of polycultural situations, those in which groups have a kind of commerce between them that neither turns to conflict nor brings unity, so that they may have separate identities without ever becoming wholly separated from one another. Most debates over 'multiculturalism' split into two camps: those who argue for unity (we have to be one nation!), and those who argue for separation (we must preserve our identity!), and thus fail to find the third position (*e pluribus unum*)," p. 267.

bell hooks

An Aesthetic of Blackness: strange and oppositional

This is the story of a house. It has been lived in by many people.
Our grandmother, Baba, made this house living space.
She was certain that the way we lived was shaped by objects,
the way we looked at them, the way they were placed around us.
She was certain that we were shaped by space. From her
I learn about aesthetics, the yearning for beauty that she tells me
is the predicament of heart that makes our passion real.
A quiltmaker, she teaches me about color. Her house is a place
where I am learning to look at things, where I am learning how
to belong in space. In rooms full of objects, crowded with
things, I am learning to recognize myself. She hands me a mirror,
showing me how to look. The color of wine she has made in
my cup, the beauty of the everyday. Surrounded by fields of tobacco,
the leaves braided like hair, dried and hung, circles and circles
of smoke fill the air. We string red peppers fiery hot, with thread
that will not be seen. They will hang in front of a lace curtain to
catch the sun. Look, she tells me, what the light does to color!

Do you believe that space can give life, or take it away,
that space has power? These are the questions she asks which
frighten me. Baba dies an old woman, out of place.
Her funeral is also a place to see things, to recognize myself.
How can I be sad in the face of death, surrounded by so much
beauty? Death, hidden in a field of tulips, wearing my face
and calling my name. Baba can make them grow.
Red, yellow, they surround her body like lovers in a swoon,
tulips everywhere. Here a soul on fire with beauty burns
and passes, a soul touched by flame. We see her leave.
She has taught me how to look at the world and see beauty.
She has taught me "we must learn to see."

Years ago, at an art gallery in San Francisco near the Tassajara restaurant, I saw rooms arranged by Buddhist monk Chögyam Trungpa. At a moment in my life when I had forgotten how to see, he reminds me to look. He arranges spaces. Moved by an aesthetic shaped by old beliefs. Objects are not without spirit. As living things they touch us in unimagined ways. On this path one learns that an entire room is a space to be created, a space that can reflect beauty, peace, and a harmony of being, a spiritual aesthetic. Each space is a sanctuary. I remember. Baba has taught me "we must learn to see."

Aesthetics then is more than a philosophy or theory of art and beauty; it is a way of inhabiting space, a particular location, a way of looking and becoming. It is not organic. I grew up in an ugly house. No one there considered the function of beauty or pondered the use of space. Surrounded by dead things, whose spirits had long ago vanished since they were no longer needed, that house contained a great engulfing emptiness. In that house things were not to be looked at, they were to be possessed—space was not to be created but owned—a violent anti-aesthetic. I grew up thinking about art and beauty as it existed in our lives, the lives of poor black people. Without knowing the appropriate language, I understood that advanced capitalism was affecting our capacity to see, that consumerism began to take the place of that predicament of heart that called us to yearn for beauty. Now many of us are only yearning for things.

In one house I learned the place of aesthetics in the lives of agrarian poor black folks. There the lesson was that one had to understand beauty as a force to be made and imagined. Old folks shared their sense that we had come out of slavery into this free space and we had to create a world that would renew the spirit, that would make it life-giving. In that house, there was a sense of history. In the other house, the one I lived in, aesthetics had no place. There the lessons were never about art or beauty, but always only to possess things.

316

My thinking about aesthetics has been informed by the recognition of these houses: one which cultivated and celebrated an aesthetic of existence, rooted in the idea that no degree of material lack could keep one from learning how to look at the world with a critical eye, how to recognize beauty, or how to use it as a force to enhance inner well-being; the other which denied the power of abstract aestheticism. Living in that other house where we were so acutely aware of lack, so conscious of materiality, I could see in our daily life the way consumer capitalism ravaged the black poor, nurtured in us a longing for things that often subsumed our ability to recognize aesthetic worth or value.

Despite these conditions, there was in the traditional southern racially segregated black community a concern with racial uplift that continually promoted recognition of the need for artistic expressiveness and cultural production. Art was seen as intrinsically serving a political function. Whatever African-Americans created in music, dance, poetry, painting, etc., it was regarded as testimony, bearing witness, challenging racist thinking which suggested that black folks were not fully human, were uncivilized, and that the measure of this was our collective failure to create "great" art. White supremacist ideology insisted that black people, being more animal than human, lacked the capacity to feel and therefore could not engage the finer sensibilities that were the breeding ground for art. Responding to this propaganda, nineteenth-century black folks emphasized the importance of art and cultural production, seeing it as the most effective challenge to such assertions. Since many displaced African slaves brought to this country an aesthetic based on the belief that beauty, especially that created in a collective context, should be an integrated aspect of everyday life, enhancing the survival and development of community, these ideas formed the basis of African-American aesthetics. Cultural production and artistic expressiveness were also ways for displaced African people to maintain connections with the past. Artistic African cultural retentions survived long after other expressions had been lost or forgotten. Though not remembered or cherished for political reasons, they would ultimately be evoked to counter assertions by white supremacists and colonized black minds that there remained no vital living bond between the culture of African-Americans and the cultures of Africa. This historical aesthetic legacy has proved so powerful that consumer capitalism has not been able to completely destroy artistic production in underclass black communities.

Even though the house where I lived was ugly, it was a place where I could and did create art. I painted, I wrote poetry. Though it was an environment more concerned with practical reality than art, these aspirations were

encouraged. In an interview in *Callaloo,* painter Lois Mailou Jones describes the tremendous support she received from black folks: "Well, I began with art at a very early stage in my life. As a child, I was always drawing. I loved color. My mother and father, realizing that I had talent, gave me an excellent supply of crayons and pencils and paper—and encouraged me."[1] Poor black parents saw artistic cultural production as crucial to the struggle against racism, but they were also cognizant of the link between creating art and pleasure. Art was necessary to bring delight, pleasure, and beauty into lives that were hard, that were materially deprived. It mediated the harsh conditions of poverty and servitude. Art was also a way to escape one's plight. Protestant black churches emphasized the parable of the talents, and commitment to spirituality also meant appreciating one's talents and using them. In our church if someone could sing or play the piano and they did not offer these talents to the community, they were admonished.

1. Charles H. Rowell, "An Interview with Lois Mailou Jones," *Callaloo,* vol. 12, no. 2 (Spring 1989), p. 357.

Performance arts—dance, music, and theater—were the most accessible ways to express creativity. Making and listening to black music, both secular and sacred, was one of the ways black folks developed an aesthetic. It was not an aesthetic documented in writing, but it did inform cultural production. Analyzing the role of the "talent show" in segregated black communities, which was truly the community-based way to support and promote cultural production, would reveal much about the place of aesthetics in traditional black life. It was both a place for collective display of artistry and a place for the development of aesthetic criteria. I cite this information to place African-American concern with aesthetics in a historical framework that shows a continuity of concern. It is often assumed that black folks first began to articulate an interest in aesthetics during the sixties. Privileged black folks in the nineteenth and early twentieth centuries were often, like their white counterparts, obsessed with notions of "high art." Significantly, one of the important dimensions of the artistic movement among black people, most often talked about as the Harlem Renaissance, was the call for an appreciation of popular forms. Like other periods of intense focus on the arts in African-American culture, it called attention to forms of artistic expression that were simply passing away because they were not valued in the context of a conventional aesthetic focusing on "high art." Often African-American intellectual elites appropriated these forms, reshaping them in ways suited to different locations. Certainly the spiritual as it was sung by Paul Robeson at concerts in Europe was an aspect of African-American folk culture evoked in a context far removed from small, hot, southern church services, where poor black folks gathered in religious ecstasy. Celebration of popular forms ensured

their survival, kept them as a legacy to be passed on, even as they were altered and transformed by the interplay of varied cultural forces.

Conscious articulation of a "black aesthetic" as it was constructed by African-American artists and critics in the sixties and early seventies was an effort to forge an unbreakable link between artistic production and revolutionary politics. Writing about the interconnectedness of art and politics in the essay "Frida Kahlo and Tina Modotti," Laura Mulvey describes the way an artistic avant-garde

> *. . . was able to use popular forms not as a means of facilitating communication but as a means of constructing a mythic past whose effectiveness could be felt in the present. Thereby it brought itself into line with the revolutionary impetus towards reconstructing the mythic past of the nation.*[2]

2. Laura Mulvey and Peter Wollen, "Frida Kahlo and Tina Modotti," in *Visual and Other Pleasures* (Bloomington: Indiana University Press, 1989), p. 96.

A similar trend emerged in African-American art as painters, writers, musicians worked to imaginatively evoke black nationhood, a homeland, recreating bonds with an African past while simultaneously evoking a mythic nation to be born in exile. During this time Larry Neal declared the Black Arts Movement to be "the cultural arm of the Black revolution." Art was to serve black people in the struggle for liberation. It was to call for and inspire resistance. One of the major voices of the black aesthetic movement, Maulana Karenga, in his *Thesis on Black Cultural Nationalism,* taught that art should be functional, collective, and committed.

The black aesthetic movement was fundamentally essentialist. Characterized by an inversion of the "us" and "them" dichotomy, it inverted conventional ways of thinking about otherness in ways that suggested that everything black was good and everything white bad. In the anthology *Black Fire,* James T. Stewart set the terms of the movement, dismissing work by black artists which did not emerge from the black power movement:

> *A revolutionary art is being expressed today. The anguish and aimlessness that attended our great artists of the 'forties and 'fifties and which drove most of them to early graves, to dissipation and dissolution, is over. Misguided by white cultural references (the models the culture set for its individuals), and the incongruity of these models with black reality, men like Bird were driven to willful self-destruction. There was no program. And the reality-model was incongruous. It was a white reality-model. If Bird had had a black reality-model, it might have been different . . . In Bird's case, there was a dichotomy between his genius and the society. But, that he couldn't find the adequate model of being was the tragic part of the whole thing.*[3]

3. James T. Stewart, "The Development of the Black Revolutionary Artist," in *Black Fire,* eds. Leroi Jones and Larry Neal (New York: William Morrow and Company, Inc., 1968), pp. 8-9.

Links between black cultural nationalism and revolutionary politics led ultimately to the subordination of art to politics. Rather than serving as a catalyst promoting diverse artistic expression, the Black Arts Movement began to dismiss all forms of cultural production by African-Americans that did not conform to movement criteria. Often this led to aesthetic judgments that did not allow for recognition of multiple black experiences or the complexity of black life, as in the case of Neal's critical interpretation of jazz musician Charlie Parker's fate. Clearly, the problems facing Parker were not simply aesthetic concerns, and they could not have been resolved by art or critical theories about the nature of black artistic production. Ironically, in many of its aesthetic practices the Black Arts Movement was based on the notion that a people's art, cultural production for the masses, could not be either complex, abstract, or diverse in style, form, content, etc.

Despite its limitations, the Black Arts Movement provided useful critique based on radical questioning of the place and meaning of aesthetics for black artistic production. The movement's insistence that all art is political, that an ethical dimension should inform cultural production, as well as the encouragement of an aesthetic which did not separate habits of being from artistic production, were important to black thinkers concerned with strategies of decolonization. Unfortunately, these positive aspects of the black aesthetic movement should have led to the formation of critical space where there could have been more open discussion of the relevance of cultural production to black liberation struggle. Ironically, even though the Black Arts Movement insisted that it represented a break from white western traditions, much of its philosophical underpinning reinscribed prevailing notions about the relationship between art and mass culture. The assumption that naturalism or realism was more accessible to a mass audience than abstraction was certainly not a revolutionary position. Indeed the paradigms for artistic creation offered by the Black Arts Movement were most often restrictive and disempowering. They stripped many artists of creative agency by dismissing and devaluing their work because it was either too abstract or did not overtly address a radical politic. Writing about socialist attitudes towards art and politics in *Art and Revolution,* John Berger suggests that the relationship between art and political propaganda is often confused in the radical or revolutionary context. This was often the case in the Black Arts Movement. While Berger willingly accepts the truism "that all works of art exercise an ideological influence—even works by artists who profess to have no interest outside art,"[4] he critiques the idea that simplicity of form or

4. John Berger, *Art and Revolution* (New York: Pantheon Books, 1969), p. 54.

320

content necessarily promotes critical political consciousness or leads to the development of a meaningful revolutionary art. His words of caution should be heeded by those who would revive a prescriptive black aesthetic that limits freedom and restricts artistic development. Speaking against a prescriptive aesthetic, Berger writes:

When the experience is "offered up," it is not expected to be in any way transformed. Its apotheosis should be instant and, as it were, invisible. The artistic process is taken for granted: it always remains exterior to the spectator's experience. It is no more than the supplied vehicle in which experience is placed so that it may arrive safely at a kind of cultural terminus. Just as academicism reduces the process of art to an apparatus for the artist, it reduces it to a vehicle for the spectator. There is absolutely no dialectic between experience and expression, between experience and its formulation.[5]

5. Ibid., pp. 62-63.

The black aesthetic movement was a self-conscious articulation by many of a deep fear that the power of art resides in its potential to transgress boundaries.

Many African-American artists retreated from black cultural nationalism into a retrogressive posture where they suggested there were no links between art and politics, evoking outmoded notions of art as transcendent and pure to defend their position. This was another step backwards. There was no meaning-ful attempt to counter the black aesthetic with conceptual criteria for crea-

ting and evaluating art which acknowledge its ideological lowed for expansive notions Overall the impact of these aesthetic and its opponents, production by African-Ame-medium with the exception would simultaneously content even as it al-of artistic freedom. two movements, black was a stifling of artistic ricans in practically every of music. Significantly, avant-garde jazz musicians, grappling with artistic expressivity that demanded experimentation, resisted restrictive mandates about their work, whether they were imposed by a white public saying their work was not really music or a black public which wanted to see more overt links between that work and political struggle.

To reopen the creative space that much of the black aesthetic movement closed down, it seems vital for those involved in contemporary black art to engage in a revitalized discussion of aesthetics. Critical theories about cultural

production, about aesthetics, continue to confine and restrict black artists, and passive withdrawal from a discussion of aesthetics is a useless response. To suggest, as Clyde Taylor does in his essay "We Don't Need Another Hero: Anti-Theses On Aesthetics,"[6] that the failure of black aesthetics or the development of white western theorizing on the subject should negate all African-American concern with the issue is to once again repeat an essentialist project that does not enable or promote artistic growth. An African-American discourse on aesthetics need not begin with white western traditions and it need not be prescriptive. Cultural decolonization does not happen solely by repudiating all that appears to maintain connection with the colonizing culture. It is really important to dispel the notion that white culture is "the" location where a discussion of aesthetics emerged, as Taylor suggests; it is only one location.

Progressive African-Americans concerned with the future of our cultural production seek to critically conceptualize a radical aesthetic that does not negate the powerful place of theory as both that force which sets up criteria for aesthetic judgment and as vital grounding that helps make certain work possible, particularly expressive work that is transgressive and oppositional. Hal Foster's comments on the importance of an anti-aesthetic in the essay "Postmodernism: A Preface" present a useful paradigm African-Americans can employ to interrogate modernist notions of aesthetics without negating the discourse on aesthetics. Foster proposes this paradigm to critically question "the idea that aesthetic experience exists apart, without 'purpose,' all but beyond history, or that art can now effect a world at once (inter)subjective, concrete and universal—a symbolic totality."[7] Taking the position that an anti-aesthetic "signals a practice, cross-disciplinary in nature, that is sensitive to cultural forms engaged in a politic (e.g., feminist art) or rooted in a vernacular—that is, to forms that deny the idea of a privileged aesthetic realm,"[8] Foster opens up the possibility that work by marginalized groups can have a greater audience and impact. Working from a base where difference and otherness are acknowledged as forces that intervene in western theorizing about aesthetics to reformulate and transform the discussion, African-Americans are empowered to break with old ways of seeing reality that suggest there is only one audience for our work and only one aesthetic measure of its value. Moving away from narrow cultural nationalism, one leaves behind as well racist assumptions that cultural productions by black people can only have "authentic" significance and meaning for a black audience.

6. Clyde Taylor, "We Don't Need Another Hero: Anti-Theses on Aesthetics" in *Black Frames: Critical Perspectives on Black Independent Cinema*, eds. Mbye Chom and Clair Andrade-Watkins (Cambridge: MIT Press, 1988).

7. Hal Foster, "Postmodernism: A Preface" in *The Anti-Aesthetic*, ed. Hal Foster (Port Townsend, Washington: Bay Press, 1983), p. xv.

8. Ibid.

Black artists concerned with producing work that embodies and reflects a liberatory politic know that an important part of any decolonization process is critical intervention and interrogation of existing repressive and dominating structures. African-American critics and/or artists who speak about our need to engage in ongoing dialogue with dominant discourses always risk being dismissed as assimilationist. There is a grave difference between that engagement with white culture which seeks to demystify, challenge, and transform, and gestures of collaboration and complicity. We cannot participate in dialogue that is the mark of freedom and critical agency if we dismiss all work emerging from white western traditions. The assumption that the crisis of African-Americans should or can only be addressed by us must also be interrogated. Much of what threatens our collective well-being is the product of dominating structures. Racism is a white issue as much as it's a black one.

Contemporary intellectual engagement with issues of "otherness and difference" manifest in literary critique, cultural studies, feminist theory, and black studies indicates that there is a growing body of work that can provide and promote critical dialogue and debate across boundaries of class, race, and gender. These circumstances, coupled with a focus on pluralism at the level of social and public policy, are creating a cultural climate where it is possible to interrogate the idea that difference is synonymous with lack and deprivation, and simultaneously call for critical rethinking of aesthetics. Retrospective examination of the repressive impact a prescriptive black aesthetic had on black cultural production should serve as a cautionary model for African-Americans. There can never be one critical paradigm for the evaluation of artistic work. In part, a radical aesthetic acknowledges that we are constantly changing positions, locations, that our needs and concerns vary, that these diverse directions must correspond with shifts in critical thinking. Narrow limiting aesthetics within black communities tend to place innovative black artistry on the margins. Often this work receives little or no attention. Whenever black artists work in ways that are transgressive, we are seen as suspect, by our group and by the dominant culture. Rethinking aesthetic principles could lead to the development of a critical standpoint that promotes and encourages various modes of artistic and cultural production.

As an artist and critic, I find compelling a radical aesthetic that seeks to uncover and restore links between art and revolutionary politics, particularly black liberation struggle, while offering an expansive critical foundation for aesthetic evaluation. Concern for the contemporary plight of black people necessitates that I interrogate my work to see if it functions as a force that promotes the development of critical consciousness and resistance movement. I remain passionately committed to an aesthetic that focuses on the purpose and function of beauty, of artistry in everyday life, especially the lives of poor people, one that seeks to explore and celebrate the connection between our capacity to engage in critical resistance and our ability to experience pleasure and beauty. I want to create work that shares with an audience, particularly oppressed and marginalized groups, the sense of agency artistry offers, the empowerment. I want to share the aesthetic inheritance handed down to me by my grandmother and generations of black ancestors, whose ways of thinking about the issue have been globally shaped in the African diaspora and informed by the experience of exile and domination. I want to reiterate the message that "we must learn to see." Seeing here is meant metaphysically as heightened awareness and understanding, the intensification of one's capacity to experience reality through the realm of the senses.

Remembering the houses of my childhood, I see how deeply my concern with aesthetics was shaped by black women who were fashioning an aesthetic of being, struggling to create an oppositional world view for their children, working with space to make it livable. Baba, my grandmother, could not read or write. She did not inherit her contemplative preoccupation with aesthetics from a white western literary tradition. She was poor all her life. Her memory stands as a challenge to intellectuals, especially those on the left, who assume that the capacity to think critically, in abstract concepts, to be theoretical, is a function of class and educational privilege. Contemporary intellectuals committed to progressive politics must be reminded again and again that the capacity to name something (particularly in writing terms like aesthetics, postmodernism, deconstruction, etc.) is not synonymous with the creation or ownership of the condition or circumstance to which such terms may refer.

Many underclass black people who do not know conventional academic theoretical language are thinking critically about aesthetics. The richness of their thoughts is rarely documented in books. Innovative African-American artists have rarely documented their process, their critical thinking on the subject of aesthetics. Accounts of the theories that inform their work are necessary and essential; hence my concern with opposing any standpoint that devalues this critical project. Certainly many of the revolutionary, visionary critical perspectives on music that were inherent to John Coltrane's oppositional aesthetics and his cultural production will never be shared because they

were not fully documented. Such tragic loss retards the development of reflective work by African-Americans on aesthetics that is linked to enabling politics. We must not deny the way aesthetics serves as the foundation for emerging visions. It is, for some of us, critical space that inspires and encourages artistic endeavor. The ways we interpret that space and inhabit it differ.

As a grown black woman, a guest in my mother's house, I explain that my interior landscape is informed by Minimalism, that I cannot live in a space filled with too many things. My grandmother's house is only inhabited by ghosts and can no longer shelter or rescue me. Boldly I declare that I am a minimalist. My sisters repeat this word with the kind of glee that makes us laugh, as we celebrate together that particular way language, and the "meaning" of words is transformed when they fall from the hierarchical space they inhabit in certain locations (the predominantly white university setting) into the mouths of vernacular culture and speech, into underclass blackness, segregated communities where there is much illiteracy. Who can say what will happen to this word "minimalist." Who knows how it will be changed, refashioned by the thick patois that is our southern black tongue. This experience cannot be written. Even if I attempt description it will never convey process.

One of my five sisters wants to know how it is I come to think about these things, about houses, and space. She does not remember long conversations with Baba. She remembers her house as an ugly place, crowded with objects. My memories fascinate her. She listens with astonishment as I describe the shadows in Baba's house and what they meant to me, the way the moon entered an upstairs window and created new ways for me to see dark and light. After reading Jun'ichiro Tanizaki's book on aesthetics *In Praise of Shadows,* I tell this sister in a late night conversation that I am learning to think about blackness in a new way. Tanizaki speaks of seeing beauty in darkness and shares this moment of insight: "The quality that we call beauty, however, must always grow from the realities of life, and our ancestors, forced to live in dark rooms, presently came to discover beauty in shadows, ultimately to guide shadows towards beauty's ends."[9] My sister has skin darker than mine. We think about our skin as a dark room, a place of shadows. We talk often about color politics and the ways racism has created an aesthetic that wounds us, a way of thinking about beauty that hurts. In the shadows of late night, we talk about the need to see darkness differently, to talk about it in a new way. In that space of shadows we long for an aesthetic of blackness—strange and oppositional.

9. Jun'ichiro Tanizaki, *In Praise of Shadows,* trans. Thomas J. Harper and Edward G. Seidensticker (New Haven: Leete's Island Books, 1977), p. 18.

325

Aesthetic Inheritances: history worked by hand

To write this piece I have relied on fragments, bits and pieces of information found here and there. Sweet, late night calls to mama to see if she "remembers when." Memories of old conversations coming back again and again, memories like reused fabric in a crazy quilt, contained and kept for the right moment. I have gathered and remembered. I wanted one day to record and document so that I would not participate in further erasure of the aesthetic legacy and artistic contributions of black women. This writing was inspired by the work of artist Faith Ringgold, who has always cherished and celebrated the artistic work of unknown and unheralded black women. Evoking this legacy in her work, she calls us to remember, to celebrate, to give praise.

Even though I have always longed to write about my grandmother's quiltmaking, I never found the words, the necessary language. At one time I dreamed of filming her quilting. She died. Nothing had been done to document the power and beauty of her work. Seeing Ringgold's elaborate story quilts, which insist on naming, on documentation, on black women telling our story, I found words. When art museums highlight the artistic achievement of American quiltmakers, I mourn that my grandmother is not among those named and honored. Often representation at such shows suggests that white women were the only group truly dedicated to the art of quiltmaking. This is not so. Yet quilts by black women are portrayed as exceptions; usually there is only one. The card identifying the maker reads "anonymous black woman." Art historians

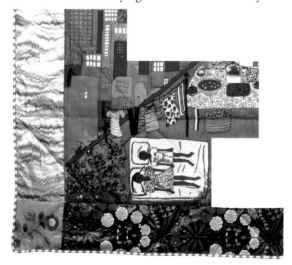

focusing on quiltmaking have just begun to document traditions of black female quiltmakers, to name names, to state particulars.

My grandmother was a dedicated quiltmaker. That is the very first statement I want to make about Baba, mama's mother, pronounced with the long "a" sound. Then I want to tell her name, Sarah Hooks Oldham, daughter of Bell Blair Hooks. They were both quiltmakers. I call their names in resistance, to

oppose the erasure of black women—that historical mark of racist and sexist oppression. We have too often had no names, our history recorded without specificity, as though it's not important to know who—which one of us—the particulars. Baba was interested in particulars. Whenever we were "over home," as we called her house, she let us know "straight up" that upon entering we were to look at her, call her name, acknowledge her presence. Then once that was done we were to state our "particulars"—who we were and/or what we were about. We were to name ourselves—our history. This ritualistic naming was frightening. It felt as though this prolonged moment of greeting was an interrogation. To her it was a way we could learn ourselves, establish kinship and connection, the way we would know and acknowledge our ancestors. It was a process of gathering and remembering.

Baba did not read or write. She worked with her hands. She never called herself an artist. It was not one of her words. Even if she had known it, there might have been nothing in the sound or meaning to interest, to claim her wild imagination. Instead she would comment, "I know beauty when I see it." She was a dedicated quiltmaker—gifted, skillful, playful in her art, making quilts for more than seventy years, even after her "hands got tired" and her eyesight was "quitting." It is hard to give up the work of a lifetime, and yet she stopped making quilts in the years before her dying. Almost ninety, she stopped quilting. Yet she continued to talk about her work with any interested listener. Fascinated by the work of her hands, I wanted to know more, and she was eager to teach and instruct, to show me how one comes to know beauty and give oneself over to it. To her, quiltmaking was a spiritual process where one learned surrender. It was a form of meditation where the self was let go. This was the way she had learned to approach quiltmaking from her mother. To her it was an art of stillness and concentration, a work which renewed the spirit.

Fundamentally in Baba's mind quiltmaking was women's work, an activity that gave harmony and balance to the psyche. According to her, it was that aspect of a country woman's work which enabled her to cease attending to the needs of others and "come back to herself." It was indeed "rest for the mind." I learned these ideas from her as a child inquiring about how and why she began to quilt; even then her answer surprised me. Primarily she saw herself as a child of the outdoors. Her passions were fishing, digging for worms, planting vegetable and flower gardens, plowing, tending chickens, hunting. She had as she put it "a renegade nature," wild and untamed. Today in black vernacular speech we might say she was "out of control." Bell Blair Hooks, her mother, chose quiltmaking as that exercise that would give the young Sarah a quiet time, a space to calm down and come back to herself. A serious

quiltmaker, Bell Hooks shared this skill with her daughter. She began by first talking about quiltmaking as a way of stillness, as a process by which a "woman learns patience." These rural black women knew nothing of female passivity. Constantly active, they were workers—black women with sharp tongues, strong arms, heavy hands, with too much labor and too little time. There was always work to be done; space had to be made for stillness, for quiet and concentration. Quilting was a way to "calm the heart" and "ease the mind."

From the nineteenth century until the present day, quiltmakers have, each in their own way, talked about quilting as meditative practice. Highlighting the connection between quilting and the search for inner peace, the editors of *Artists in Aprons: Folk Art by American Women* remind readers that:

> *Quiltmaking, along with other needle arts, was often an outlet not only for creative energy but also for the release of a woman's pent-up frustrations. One writer observed that "a woman made utility quilts as fast as she could so her family wouldn't freeze, and she made them as beautiful as she could so her heart wouldn't break." Women's thoughts, feelings, their very lives were inextricably bound into the designs just as surely as the cloth layers were bound with thread . . .*[10]

In the household of her mother, Baba learned the aesthetics of quiltmaking. She learned it as meditative practice (not unlike the Japanese Tea Ceremony), learning to hold her arms, the needles—just so—learning the proper body posture, then learning how to make her work beautiful, pleasing to the mind and heart. These aesthetic considerations were as crucial as the material necessity that required poor rural black women to make quilts. Often in contemporary capitalist society, where "folk art" is an expensive commodity in the marketplace, many art historians, curators, and collectors still assume that the folk who created this work did not fully understand and appreciate its "aesthetic value." Yet the oral testimony of black women quiltmakers from the nineteenth century and early twentieth century, so rarely documented (yet our mothers did talk with their mothers' mothers and had a sense of how these women saw their labor), indicated keen awareness of aesthetic dimensions. Harriet Powers, one of the few black women quiltmakers whose work is recognized by art historians, understood that her elaborate appliquéd quilts were unique and exquisite. She understood that folk who made their own quilts wanted to purchase her work because it was different and special. Economic hardship often compelled the selling of work, yet Powers did so reluctantly precisely because she understood its value—not solely as regards to skill, time, and labor but as the unique expression of her imaginative vision.

10. C. Kurt Dewhurst, Betty MacDowell, and Marsha MacDowell, *Artists in Aprons: Folk Art by American Women* (New York: E. P. Dutton, 1979), p. 53.

Her story quilts with their inventive pictorial narrations were a wonder to behold. Baba's sense of the aesthetic value of quilting was taught to her by a mother who insisted that work be redone if the sewing and the choice of a piece of fabric were not "just right." She came into womanhood understanding and appreciating the way one's creative imagination could find expression in quiltmaking.

The work of black women quiltmakers needs special feminist critical commentary which considers the impact of race, sex, and class. Many black women quilted despite oppressive economic and social circumstance which often demanded exercising creative imagination in ways radically different from those of white female counterparts, especially women of privilege who had greater access to material and time. Often black slave women quilted as part of their labor in white households. The work of Mahulda Mize, a black woman slave, is discussed in *Kentucky Quilts, 1800—1900*.[11] Her elaborate quilt *Princess Feathers with Oak Leaves,* made of silk and other fine fiber, was completed in 1850 when she was eighteen. Preserved by the white family who owned her labor, this work was passed down from generation to generation. Much contemporary writing on quiltmaking fails to discuss this art form from a standpoint which considers the impact of race and class. Challenging conventional assumptions in her essay "Quilting: Out of the Scrapbag of History," Cynthia Redick suggests that the crazy quilt with its irregular design was not the initial and most common approach to quiltmaking, asserting,

11. Jonathan Holstein, *Kentucky Quilts, 1800-1900* (New York: Pantheon Books, 1982).

12. Cynthia T. Redick, "Quilting: Out of the Scrapbag of History," *Women Artists News* vol. 6, nos. 6-7 (Dec. 1980 – Jan 1981), p. 14.

"an expert seamstress would not have wasted her time fitting together odd shapes." Redick continues, "The fad for crazy quilts in the late nineteenth century was a time consuming pastime for ladies of leisure."[12] Feminist scholarly studies of black female experience as quiltmakers would require revision of Redick's assertions. Given that black women slaves sewed quilts for white owners and were allowed now and then to keep scraps, or as we learn from slave narratives occasionally took them, they had access to creating only one type of work for themselves—a crazy quilt.

Writing about Mize's fancy quilt, white male art historian John Finley's comments on her work made reference to limitations imposed by race and class: "No doubt the quilt was made for her owners, for a slave girl would not have had the money to buy such fabrics. It also is not likely that she would have been granted the

leisure and the freedom to create such a thing for her own use."[13] Of course there are no recorded documents revealing whether or not she was allowed to keep the fancy scraps. Yet, were that the case, she could only have made from them a crazy quilt. It is possible that black slave women were among the first, if not the first group of females, to make crazy quilts, and that it later became a fad for privileged white women.

Baba spent a lifetime making quilts, and the vast majority of her early works were crazy quilts. When I was a young girl she did not work outside her home, even though she at one time worked for white people, cleaning their houses.

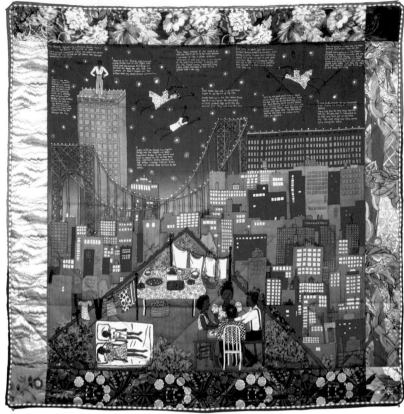

Faith Ringgold, Tar Beach 2 *from* Women on a Bridge Series #1, *1990, silk screen on silk, 66 x 66 in. Collection of the Philadelphia Museum of Art, Philadelphia, Pennsylvania.*

13. John Finley, from *Kentucky Quilts 1800-1900*, pp. 25-27.

For much of her life as a rural black woman she controlled her own time, and quilting was part of her daily work. Her quilts were made from reused scraps because she had access to such material from the items given to her by white folks in place of wages, or from the worn clothes of her children. It was only when her children were adults faring better economically that she began to make quilts from patterns and from fabric that was not reused scraps. Before then she created patterns from her imagination. My mother, Rosa Bell, remembers writing away for the first quilt patterns. The place these quilts had in daily life was decorative. Utility quilts, crazy were for constant everyday use. They served as bed coverings and as padding under the soft cotton mattresses filled with feathers. During times of financial hardship, which were prolonged and ongoing, quilts were made from scraps left over from dressmaking and then again after the dresses had been worn. Baba would show a quilt and point to the same fabric lighter in color to show a "fresh" scrap (one left over from initial dressmaking) from one that was being reused after a dress was no longer wearable.

When her sons went away to fight in wars, they sent their mother money to add rooms to her house. It is a testament to the seriousness of Baba's quiltmaking that one of the first rooms she added was a workplace, a space for sewing and quiltmaking. I have vivid memories of this room because it was so

unusual. It was filled with baskets and sacks full of scraps, hatboxes, material pieced together that was lying on the backs of chairs. There was never really any place to sit in that room unless one first removed fabric. This workplace was constructed like any artist's studio, yet it would not be until I was a young woman and Baba was dead that I would enter a "real" artist's studio and see the connection. Before this workplace was built, quilting frames were set up in the spacious living room in front of the fire. In her workplace quilts were stored in chests and under mattresses. Quilts that were not for use, fancy quilts (which were placed at the foot of beds when company came), were stored in old-fashioned chests with beautiful twisted pieces of tobacco leaves that were used to keep insects away. Baba lived all her life in Kentucky— tobacco country. It was there and accessible. It had many uses.

Although she did not make story quilts, Baba believed that each quilt had its own narrative—a story that began from the moment she considered making a particular quilt. The story was rooted in the quilt's history, why it was made, why a particular pattern was chosen. In her collection there were the few quilts made for bringing into marriage. Baba talked often of making quilts as preparation for married life. After marriage most of her quilts were utility quilts, necessary bed covering. It was later in life, and in the age of modernity, that she focused on making quilts for creative pleasure. Initially she made fancy quilts by memorizing patterns seen in the houses of the white people she worked for. Later she bought patterns. Working through generations, her quiltmaking reflected both changes in the economic circumstances of rural black people and changes in the textile industry.

As fabric became more accessible, as grown children began to tire of clothing before it was truly worn, she found herself with a wide variety of material to work with, making quilts with particular motifs. There were "britches quilts" made from bought woolen men's pants, heavy quilts to be used in cold rooms without heat. There was a quilt made from silk neckties. Changes in clothing style also provided new material. Clothes which could not be made over into new styles would be used in the making of quilts. There was a quilt made from our grandfather's suits, which spanned many years of this seventy-year marriage. Significantly, Baba would show her quilts and tell their stories, giving the history (the concept behind the quilt) and the relation of chosen fabrics to individual lives. Although she never completed it, she began to piece a quilt of little stars from scraps of cotton dresses worn by her daughters. Together we would examine this work and she would tell me about the particulars, about what my mother and her sisters were doing when they wore a particular dress. She would describe clothing styles and choice of particular colors. To her mind these quilts were maps charting the course of our lives. They were history as life lived.

To share the story of a given quilt was central to Baba's creative self-expression, as family historian, storyteller, exhibiting the work of her hands. She was not particularly fond of crazy quilts because they were a reflection of work motivated by material necessity. She liked organized designs and fancy quilts. They expressed a quiltmaker's seriousness. Her patterned quilts, for example, *The Star of David,* and *The Tree of Life*, were made for decorative purposes, to be displayed at family reunions. They indicated that quiltmaking was an expression of skill and artistry. These quilts were not to be used; they were to be admired. My favorite quilts were those for everyday use. I was especially fond of the work associated with my mother's girlhood. When given a choice of quilts, I selected one made of cotton dresses in cool deep pastels. Baba could not understand when I chose that pieced fabric of little stars made from my mother's and sister's cotton dresses over more fancy quilts. Yet those bits and pieces of mama's life, held and contained there, remain precious to me.

In her comments on quiltmaking, Ringgold has expressed fascination with that link between the creative artistry of quilts and their fundamental tie to daily life. The magic of quilts for her, as art and artifice, resides in that space where art and life come together. Emphasizing the usefulness of a quilt, she reminds us: "It covers people. It has the possibility of being part of someone forever." Reading her words, I thought about the quilt I covered myself with in childhood and then again as a young woman. I remembered mama did not understand my need to take that "nasty, ragged" quilt all the way to college. Yet it was symbolic of my connection to rural black folk life—to home. This quilt is made of scraps. Though originally handsewn, it has been "gone over" (as Baba called it) on the sewing machine so that it would better endure prolonged everyday use. Sharing this quilt, the story I tell focuses on the legacy of commitment to one's "art" Baba gave me. Since my creative work is writing, I proudly point to ink stains on this quilt which mark my struggle to emerge as a disciplined writer. Growing up with five sisters, it was difficult to find private space; the bed was often my workplace. This quilt (which I intend to hold onto for the rest of my life) reminds me of who I am and where I have come from. Symbolically identifying a tradition of black female artistry, it challenges the notion that creative black women are rare exceptions. We are deeply, passionately connected to black women whose sense of aesthetics, whose commitment to ongoing creative work, inspires and sustains. We reclaim their history, call their names, state their particulars, to gather and remember, to share our inheritance.

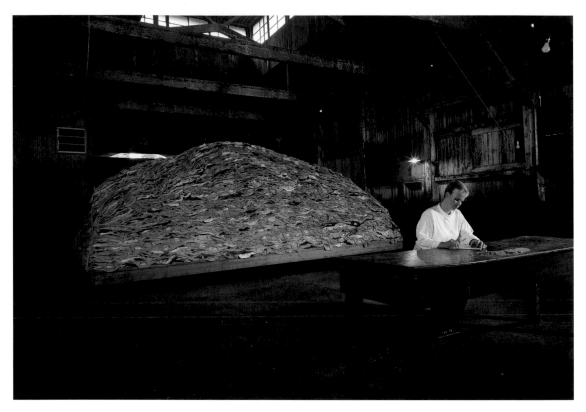

indigo blue, *1991, installation, two rooms; overall dimensions: ground floor (above) 20 x 36 x 67 ft., second floor (opposite page) 8 x 8 x 10 ft. Materials: blue work clothing; steel and wood base; wood table; chair; light bulb; books (military regulation manuals, blue bindings); saliva; Pink Pearl erasers; erasures; net sacks; soybeans.*

Commissioned for Places with a Past: New Site-Specific Art in Charleston, *Spoleto Festival USA, South Carolina, May 24-August 4, 1991.*

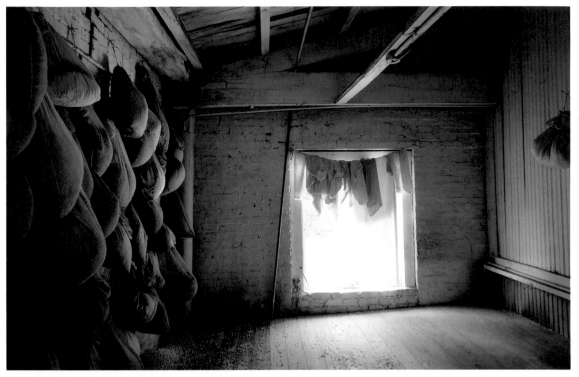

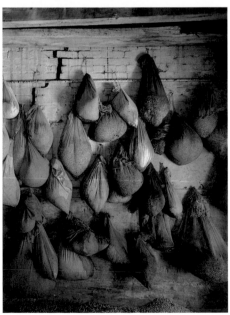

indigo blue *(detail of net bags with soybeans from second-floor installation)*.

indigo blue *(detail of book from ground-floor installation)*.

Located in an old garage off the center of the historic district of Charleston, South Carolina, *indigo blue* was part of the 1991 Spoleto Festival USA that commissioned artists to select sites and work in response to the social history and contemporary context of the city. Responding to my perceptions of the selective memory that the city markets as a tourist industry and my concern with a history that is based more in the somatic experience of the body than in the accounting of events and facts, this piece was informed by the experience of living for six weeks in Charleston and more than a year of readings in American labor history. In the center of the space, a large steel platform was piled with 14,000 pounds of company-owned recycled work clothing. Built layer by layer, the pile was formed by laying out and smoothing successive layers of pants and shirts until a semitruck of clothing was used. Obscured by the pile from the front, at the back of the space a figure sat erasing slim blue books seated at a table borrowed from the central market that once housed one of Charleston's pre-Civil War slave markets. Using a Pink Pearl eraser and saliva, the books were erased back to front with the eraser waste left to accumulate over the duration of the piece. Although the space was entered at ground level, a window in the small upstairs office of the garage gave another view of the pile and the activity at the table. One wall of the office was hung with udder-sized net bags of soybeans which sprouted and later rotted in the leakage of summer rains. With the humid weather, the space was filled with the musty smell of the damp clothes and the organic decomposition of the soybeans.

Ann Hamilton

DECO-JAMMING *is* *Eco-glam!*

Neil MacInnis **In collaboration with Judith Leemann**

SEXY-WORK

Deco-jamming is Eco-glam! explores the idea of *sexy-work*, or queer labour, by evaluating filmic representations in which the central characters engage their work in a distinctly queer manner. Particular attention will be given to the characters' idiosyncratic relationships to textile objects and practices, and to the way in which the protagonists in these films use textiles as material support for the transformation of their individual circumstances. The characteristic adaptability of textiles becomes especially evident when employed within constraining circumstances where it unleashes a tremendous potential for disruptive reinvention. The three films under consideration are: *Sister My Sister* (1995), *Pink Narcissus* (1971), and *Boys Don't Cry* (1999).

In these films, the development of character, plot, and meaning is accelerated through careful manipulation of the potent visual and symbolic references carried by textiles. The textile objects and references deployed

throughout these films are also imbued with sexual overtones, iterated through filmic devices that function to communicate in the service of the directors who created them. As such, these filmic devices assist with the construction of individual characters, who themselves employ textiles or make reference to them within the narrative contexts of their work-a-day worlds. Herein, manifests *sexy-work*, where the impulse to decorate, adorn, and express potentiates a kind of bridge between private, inner desires and the demands of work through the performance of costume and interior. Of course, any job held by a queer person qualifies as work or labour, but that is not what is meant here by the terms queer labour or *sexy-work*. Instead, the term *sexy-work* is used to emphasize the conceptual importance of how the protagonists in each of these films *queer* the work associated with their job, or lack thereof (in the case of those characters who are, technically speaking, not employed).

INTERVENTIONIST INTENTIONS

Naomi Klein discusses and defines various practices associated with culture jamming in her book *No Logo*. Evaluating a history of phenomena associated with jamming since the 1930s, Klein looks to Mark Dery's essay *Culture Jamming: Hacking, Slashing and Sniping in the Empire of Signs*,[1] for an understanding of the resurgence in popularity of contemporary ad-busting, especially widespread among the less-than-thirty-something set. Klein writes, "For Dery, culture jamming is anything, essentially, that mixes art, media, parody and the outsider stance."[2]

Because queers have only recently had access to and been widely represented in advertising, the option and, therefore, impulse to jam has largely been expressed by them through other media, including film, fashion, interior décor, video, and the Internet. Nonetheless, analysis of these other practices with the use of Dery's theory promises to be fruitful, especially considering the rich history of queer subversive practices extant, also known as camp.

MINCING WORDS

Taking cues from the film characters' intentional reuse and misuse of textiles, this essay aims to jam academic writing in similar fashion. Thus, I have devised a special nomenclature to articulate the concept of *sexy-work* in celebration of the brave and adventurous personalities inhabiting the films under discussion. Ostensibly, I have chosen to fool with words (i.e., *sexy-work*,

1. Mark Dery, *Culture Jamming: Hacking, Slashing and Sniping in the Empire of Signs* (Westfield, N.J.: Open Magazine Pamphlet Series, 1993).

2. Naomi Klein, *No Logo: Taking Aim at the Brand Bullies* (New York: Picador, 2000), p. 283.

Deco-jamming, and *Eco-glam*), in hopes of inventing constructs capable of furthering the exploration of queer subversive practices, which remain somewhat invisible, even today. By using bits of literary embellishment to address the content of these films, I hope to refresh and enliven an important discourse.

DECO-JAMMING AND ECO-GLAM

The title *Deco-jamming is Eco-glam!* was conceived as a snappy catch phrase capable of supporting new ways of thinking about these three films. *Deco-jamming* refers to the practice of "jamming the everyday" through decorativist interventions, whether in the form of objects, practices, or places, in which decorative elements play a crucial, performative role—drawing the viewer's attention to a given surface, idea, or experience that subverts the status quo. Decorativist reaches a step beyond decorative in its emphasis on strategic, intentional, and active deployment of decoration. It insists on an agency and intelligence not usually associated with décor, which has been popularly dismissed as shallow or devoid of meaning.

Eco-glam is the ideology that reinforces the practice of *Deco-jamming,* positing an aesthetics in which the glamorous is both a focal point and a mode of critique. It is the aesthetically and spiritually charged state of consciousness that manifests when recognition of the potential within *Deco-jamming* has been achieved and acted upon through *sexy-work.* Embedded in the concept of *Eco-glam* is the consideration of glamour in relation to the environment, understood, for the purposes of this text, as the social spaces of our collective experience. The glamorous enhancement of private and public social spaces to support non-normative interactions has enormous potential to disrupt entrenched paradigms. Viewed through the lens of *Eco-glam,* community gardens in once-abandoned lots and graffiti, for example, simply anchor opposite ends of a continuum—both are ways of interrupting habitual perception and use of public space. *Eco-glam* holds that aesthetic enhancement or beautification, driven by desire and achieved through artifice, can be deployed to improve the well being of individuals and groups.

IS IT THE RUPTURE?

When a hegemonic, largely invisible paradigm holds sway over a culture, any rupture or crack in its surface, however small, must be recognized, celebrated, and the method of its facture studied. In the films under

discussion we witness such ruptures effected by self-organized individual and collaborative queer labour. It is important that we recognize *Deco-jamming* as, in fact, a form of work, specifically a form of queer labour. Largely unrecognized and unpaid, *sexy-work* is, nonetheless, essential cultural labour.

In the film *After Stonewall* (1999), rock star Melissa Etheridge remarks that the most significant cultural contribution made by transgender, lesbian, gay, bisexual, and queer persons may have been "coming out of the closet."[3] *Deco-jamming is Eco-glam!* takes this contribution one step further by demonstrating that the process of "jamming the everyday" through decorativist interventions continues to assist remarkable transformations within the social orders of Western societies, for queers and nonqueers alike.

By no means exemplary citizens, though certainly compelling personalities, the characters in these three films add significant dimension to the idea of *Deco-jamming* and, consequently, to the theory of *Eco-glam*. The *Deco-jamming* celluloid hero(in)es populating these films possess a remarkable power to effect paradigmatic ruptures that, in turn, generate a psychic space essential to their own survival. Complicating this empowerment narrative are the titillating and eventually fatal pursuits in which they find themselves embroiled as they attempt to meet the danger and demands of *sexy-work*. Both the potential and the problematics of subterfuge engendered in sartorial expressions of sexuality are considered, as selected moments from these films give rise to questions about modes of representation, concepts of labour, and the diversity of today's panoply of sexualities. Through the dual lenses of invented nomenclature and attention to textiles as carriers and makers of meaning, I hope to reveal the specific operations by which *sexy-work* jams the reigning paradigm.

3. *After Stonewall.* 16mm, 88 min. After Stonewall, Guildford, Vt., 1999.

LACE, LUST, AND LABOUR

SISTER MY SISTER (1995), directed by Nancy Meckler, UK

Subtly told through the intimate revelations painfully shared between two conspicuously reclusive, French servant sisters, Nancy Meckler's *Sister My Sister* recounts a poignant tale of quiet gentility ruptured by a retaliatory act of horrific violence. Brutal and garish in its dramatic depiction, this based-on-a-true-story adaptation plays up the deference of two sisters preoccupied by an almost licentious taste for needlework against the climactic slaying of their tormenting employer. Providing refuge from the doldrums of indentured, domestic labour, the sisters painstakingly stitch during the precious moments left at day's end, eventually accumulating an impressive

collection of valuable lace needlework. Reputedly lovers, perhaps not really sisters, the beauty of their handiwork and the love shared between them may have provided their only recourse against the institutionalized humiliation endemic of working-class social life in southern France, circa 1932.

Probably knitted with remnant yarns, a child-sized blanket used to swaddle their treasured doll makes its seemingly innocuous appearance during the opening scene of the film. When the two sisters are reunited years later, Christine, the older of the two, disdains the blanket as a form of vulgar needlework, though for Lea, the younger sister, the blanket functions as a surrogate for their absent mother. Split apart after having been sent off to live with nuns in convents where Christine acquired her skill for fine needlework, the blanket symbolizes Lea's nostalgia for their happy childhood, as much as it does Christine's estrangement from any sense of joy or comfort. Cathartic in its role as a symbol deployed to mark a decisive break from the past, the sisters eventually tear the blanket to pieces in a jubilant frenzy of self-liberation. Having agreed not to spend their Sundays off visiting with their mother, they also decide not to share with her their meagre but hard-earned wages, reluctantly paid out by their stingy employer Mme. Danzard. The intensity of their reckless abandon soon gives way to a tender exchange of intimate caresses, encapsulating the film's thematic fusion of sexuality, labour, and needlework.

Rivalled in excellence only by their housekeeping skills, the sisters take solace from the drudgery of domestic labour by focusing their attention on fine, handmade, delicately stitched lace undergarments that they assemble, almost secretly, in their spare time. Extending a welcoming gesture to Lea, Christine presents a near finished camisole to her as a gift, which also performs a symbolic function, as much as an erotic one.

Scene from Sister My Sister *(1994). Lea is enraptured with Christine's lace needlework; just moments before Christine is about to make a special gift of lace to Lea.*

341

Beautifully crafted, this scene is shot in their gabled bedroom where gobs of sunlight jiggle and shimmer, flickering upon the sisters' hair and sparkling on pristine white bed linens and the natural earth tones of the room's many wood surfaces. Enamoured with Christine's gift of lingerie, Lea succumbs to her own forbidden desires, subsequently instigating the first session of passionate lovemaking between the sisters and, thereby, inaugurating the beginning of their unorthodox rapport. But their idyllic bliss is soon shattered because Christine is unable to protect Lea from the carelessness of Lea's youthful innocence and enthusiasm.

Lace making comes to interpolate the cultural and the sexual as a mode of escape between the sisters. Having skilfully accessorized their Sunday dress with needlework embellishments, the sisters decide to have their portrait taken by the town photographer. Subterfuge, achieved through the sisters' sartorial finesse, is dramatized when the photographer taking their picture condescendingly remarks, "you don't look like servants." Similarly, Mme. Danzard later gripes with haughty indignation, "they don't even look like servants." The problematic and contradictory blending of occupation with class, and the subtle hints at their lesbian sexuality, together suggest mutually exclusive values.

As Mme. Danzard incessantly harps on her daughter Isabelle, the sisters perform their duties with exponentially increased detachment and silence, while in the presence of their employer. All the while, the passion and fervour shared between them escalates, too. A series of incidents unfolds throughout the film that gives bloom to the full and complete nature of the sister's infatuation with one another, fraught with the usual jealousies, accusations, and confessions. Meanwhile, a concurrent series of ridiculous incidents unfolds downstairs that further estranges Mme. Danzard from the two servant sisters, causing her to grow increasingly impatient with them.

Highlighting a downward shift in tone from the upbeat, Meckler positions the use of a pink wool cardigan at a strategic point in the film's narrative. Lea, wearing the sweater, opens a scene in which she is seen downstairs cleaning the Danzard's house. The sexy, lacey quality of Lea's pink sweater indicates that it is not a practical component in keeping with the chaste appearance of her servant's uniform, but rather that it functions as a fashion statement, which in turn emphasizes this turning point in the film's narrative.

The nerve of Lea's gesture annoys Christine, who is alarmed by Lea's thoughtlessness, sure that wearing such an ostentatious garment would affront Mme. Danzard's sense of propriety and decorum. Lea's sweater does, in fact, offend Mme. Danzard, who wonders aloud in her sour tone whether she might be paying the sisters "too much." Mme. Danzard is perplexed at

Scene from Sister My Sister *(1994). Christine admonishes Lea for wearing a beautiful wool sweater in the presence of the Danzards, who are scandalized by such an ostentatious display on the part of a servant.*

how the sisters can afford such fine luxuries as French wool yarn for making sweaters. Lea's *faux pas* manifests as a decorativist intervention because she chooses to wear such a delicate, pink lace sweater to clean in. Additionally, Lea wears the sweater downstairs in the presence of the Danzards; clearly, the sweater is both personal and valuable.

In *Sister My Sister*, Meckler creates contrasting scenes that show the sisters engaged in a variety of tasks, including scrubbing dirt and dusting, which she cleverly alternates with moments of unbridled passion in which they are shown tearing one another's clothes off (while wearing sexy lingerie, something one might expect of the upper class.) Meckler's ingenuity with narrative is extremely important because *Sister My Sister* goes so far as to postulate a potent formula in which lesbianism and incest are associated with dirt and passionate lovemaking, while affluence and leisure are associated with envy and boredom. The bind that interconnects these opposing experiences is their relationship to the need for and dependence on servitude in the form of labour.

Lea's foray into upwardly mobile dress shifts the power dynamic of cleaning and servitude, reshaping them into an almost leisurelike activity that, in turn, refocuses Mme. Danzard's obsessions with dirt and imperfection to Lea's ability to "pass" as a nonservant. Lea successfully jams both class and servitude by appropriating, even if only for a moment, the wealth, leisure, and desirability of the Danzards, while simultaneously evoking a centuries old tradition in which servants wore their master's garments, either as hand-me-downs or, in their absence, to parody or mock them. The sweater

incident also resonates with the moment of bonding shared between the sisters earlier in the film when they tear apart their childhood blanket. While the blanket is interpreted as coarse, vulgar knitted work, Lea's sweater (also given to her by Christine) is perceived as an extremely refined, sexy garment, certainly one befitting adult tastes.

The use of a knitted object to signal Lea's sexuality during such a critical moment in the film is fascinating considering the fact that mechanized knitting assisted the revolution of fashion in the twentieth century. Christine and Lea are empowered by the ability to make garments which, like their skills with food and interior décor, plays an important role in winning the social recognition enjoyed by the Danzards among their neighbours and peers, and underscores the dependency issue between the Danzards and the sisters. In a glamorous moment of unabashed shamelessness, Lea, the prettier of the two sisters, diffuses their negative dependence on the Danzards by creating, at least momentarily, the possibility for herself and others to rise above their lot which, in turn, hypothetically frees the Danzards from their own bondage of servitude.

Meckler's meticulous construction of visual referents in combination with a subtle but charged script provide the vehicle for superb performances from all of the actors featured in this film. An almost "lesb-erotic" appropriation of lace, and the dexterity necessary to realize such fine constructions, provide the point from which the two sisters leap from their fate as servants into the abyss of attempted middle-class experience. Subverting notions of virginal purity and youthful innocence, the sisters' penchant for delicate white lingerie, enjoyed for their own selfish pleasure, not only serves to challenge the strictures of their times, but also repudiates the expectations of labour and class placed on them.

ARCHETYPES, ARTIFICE, AND HUSTLING

PINK NARCISSUS (1971), directed by Anonymous (James Bidgood), USA

Created at a time when explicit queer content was still subject to censorship, persecution, and blacklisting, James Bidgood's *Pink Narcissus* might just be the brainchild of a queer visionary who struggled to communicate within a discourse that may have been sensed but not yet articulated. Cinematically devised to enthral viewers, *Pink Narcissus* is a tribute to scenic innovation, with its carnivalesque assortment of stylized vignettes that demonstrate the director's exuberant genius for over-the-top decorative treatments. Featuring shrinelike assemblages that include artfully tailored

costumes and magnificent backdrops, this film was obviously created as a set piece to showcase the talent and beauty of Bobby Kendall, a demi-god who inhabits Bidgood's lust-infused tableaux.

Kendall animates various scenarios in which he portrays archetypes of queer desire. Whether or not Kendall's personae fulfil the job requirements of a 1960's callboy, or illustrate the diary of a bourgeoning sexual-libertine-wannabe, remains uncertain. Nevertheless, the suspension of Kendall within this state of celluloid fantasy generates enticing speculations about the nature of *sexy-work* and the production of erotic imagery in pre-Stonewall New York, during the 1960s.

Celluloid beauty and star attraction Kendall struts before Bidgood's camera in endless takes of pouting and primping, while donning his signature, virginal white go-go boy outfit, channelling the innocent youth Narcissus and modelling psychedelic fashions typical of the era's sex-work industry. Of course, so taken is Kendall's Narcissus with his own youthful beauty that he is seen repeatedly in depictions that confuse fiction with reality, portraying himself and sometimes his own love interests, albeit with the necessary costume changes scripted in to carry the plot along.

Using costume changes to drive the plot forward is just one of the ways in which Bidgood relies on textiles to communicate that which cannot be spoken. Much of the film is seen through or in front of translucent cloths. The outer wall and front door of Kendall's apartment, for example, are constructed of a barely visible scrim stretched over a thin wooden frame. Across this scrim are appliquéd pieces of lace, patterned to suggest architectural detailing. The john who comes to see Kendall enters through this flimsy excuse for a door, speaking to the visibility and vulnerability of Kendall as a sex worker. In another scene, Kendall, dressed as a toreador, waves a cape that flickers from one cut to the next between opacity and transparency. It is unclear whether Bidgood is warning us how thin artifice really is or whether he is saying it hardly matters that we see through the disguise. That artifice can be convincing even as we see through it is suggested further by the hand-painted, bedazzling appearance of the sets. This approach is in line with the decorativist impulse to treat each and every surface, whether body or boudoir, as a platform of strategic expression.

Bidgood, who was employed by day in New York as a well-known professional set-dresser and costumer, constructed all of the sets for his film works from scratch in his tiny Manhattan apartment where he successfully and playfully created the illusion of space, atmosphere, and movement with calculated trickery and visual persuasion. Presiding from the gold-scarlet-pink-white boudoir where Kendall is seen constantly dressing and

undressing himself, the actor escorts the viewer to magical and mythic locations around the world.

Perhaps the most vexatious aspect of Bidgood's engagement of the moving picture concerns the chaotic and disjunctive style of editing, which unravels this film's narrative in a staccato pattern of jolted sequences. Cobbled together as if born of uncertainty, it is difficult to guesstimate to what extent this film's pastiche of vignettes is a result of later edits and studio mismanagement, or merely the obsessive impulses of a control freak who micromanaged every detail of his work in an attempt to achieve his vision of perfection.

Paired scenes of rupture frame the disjointed vignettes of *Pink Narcissus*. In the film's opening sequence, the camera pans across the lush ground of a forest, in the process scanning across several well-strung spider webs. At the conclusion of the film, a crashing sound accompanies a fracture appearing to break the surface of the film. As the lighting changes, the fracture reveals itself to be a spider web—torn and in need of repair. The camera pulls back further to reveal the same forest ground depicted at the film's start, leaving the viewer to consider what unseen flight has produced this tear. Whatever other functions this image has in holding together the film, the gesture of damaging the archetypal woven trap is useful in understanding the kinds of ruptures that *Deco-jamming* aims to effect.

Bidgood treats viewers to the seductive power of Kendall's fantasy life early in the film, when Kendall assumes the persona of a toreador who squares off with a biker boy clad in black vinyl in a scene shot in a public toilet, refigured as a bullfight ring. What links the first few scenes is the way in which Bidgood has treated his background surfaces. As if cut from the same template, a line of rectangular mirrors with ornate rounded frames is replaced by a wall of urinals of identical scale and composition as the mirrors. These, in turn, are replaced by the painted phallic arches of a bullfighting ring, of the same scale and composition as the urinals and the mirrors before them. By the end of these first scenes, we come to expect that clothing and scenery will change in tandem. In this calculated coding of surfaces, Bidgood both relies on and rewards viewers' ability to recognize sameness.

Bidgood doesn't stop short, having wittily assigned specific attributes to Kendall's traditional and contemporary personifications of Narcissus. In one scene, Bidgood mounted a fluttering butterfly on Kendall's genitals, suggesting that the transformative power of self-realization achieved through the experience of love may be accessed in communion with one's own sexuality. In subsequent scenes, Kendall's enchanting encounter with a boy Scheherazade further underscores Bidgood's wink and nod to a long history of queer

Scene from Pink Narcissus *(1971). Bobby Kendall in a hall of mirrors that will soon transmogrify into a bullring of phalli.*

iconography subversively couched within popular tropes and artfully staged with sophisticated arrangements of costumes and sets.

The perception that Kendall does not work, or do anything except make himself beautiful and available and, thus, seemingly engaged, casts Kendall as a fantasy figure anchored only by the degree to which his outfits match his surroundings. Kendall's constant availability is emphasized through at least a half dozen lingering shots of him taking off his pants. In one sudden close-up, the entire screen is filled by Kendall's fingers undoing the top button of his pants.

The use of kitsch in the film's interior décor supplants the need for a cohesive narrative, or even dialogue, because it provides charming visual distractions that function as metaphors for the viewer's desire as well as Kendall's flesh. Thus, the vacuous magnificence enshrining Kendall augments his role, whose job is to represent himself as a perpetually desirable entity. The undeniably artificial yet remarkably believable interiors and surfaces also function as a queer metaphor for the colloquial interpretation of sex workers as jaded narcissists who are often thought to be pretty on the outside but lacking in substance on the inside.

Kendall's Narcissus epitomizes *Deco-jamming* by spurning the societal pressure for a faggot to embark on some kind of conventional career, instead making his beauty and gayness the locus of his work. Because Kendall's job is to create the impression that he enjoys the attention focused on him

through his work, Kendall jams desire itself, first by consenting to be looked at and, secondly, by self-consciously positioning himself so that he can be looked at, both as a callboy (his character) and as a porn actor. These doubled layers of performance are what make him both a sex worker, as commonly understood, and a *sexy-worker*. While porn requires performance, it does not necessitate acting per se, unlike drama and narrative which usually position emotions as a focal point, inevitably distracting viewers from the unreality of the director's product. Thus, Kendall's portrayal in requisite scenes raises an important question as to whether he succeeds in validating a sex-positive queer sexuality or if his incarnations are merely a vehicle through which the consumer vicariously experiences the idealized thrill of a callboy's work day.

Bidgood's masterpiece of erotica exemplifies the ideology of *Eco-glam* by suggesting that beauty, desire, fantasy, and fulfilment are constructed and, thus, attainable, because they can be artificially built and accessed through the imaginative manipulation of one's environment and attire. Perhaps it is this immersion in the heightened aesthetic and spiritual consciousness that is *Eco-glam* that gives Kendall that constant, far away, dreamy look.

Sexy, titillating, gorgeous, breathtaking, and ingenious, Bidgood's work has been estranged from the popular mainstream because of its queer edge. Performing a kind of posthumous restitution to the legions of closeted queer practitioners who laboured anonymously in the film, as well as fashion and media industries pre-Stonewall, Bidgood succeeds in portraying queer erotic content despite the repressive dictates of both a homophobic society and industry. In *Pink Narcissus* he pays homage to the obsessive craft of preparing detailed simulacrum for celluloid, so that viewers might be transported on worldly voyages into time and space. His filmic confections seamlessly integrate explicit erotic imagery of queer male subjects into archetypal decorative schemas that successfully conjure centuries of mythical narratives and images. In this way, he reflects and doubles the *sexy-work* of his main character, creating in *Pink Narcissus* a bridge between his everyday paid work and his queer desire. Of as much interest as the film's pictorial content are the extremes to which Bidgood must have gone in order to complete this film. As the final credits roll, it is Anonymous who is credited with all but the smallest tasks of making the film.

BOYS DON'T CRY (1999), directed by Kimberly Peirce, USA

Gut-, heart-, and mind-wrenching scenes of personal realization transform the life of the now deceased Brandon Teena, believably acted and lovingly directed in Kimberly Peirce's *Boys Don't Cry*. Peirce's film tells the true story of Brandon Teena, born Teena Brandon, but identifying from a young age as male. The film follows the teenager as he leaves his home in Lincoln, Nebraska, and moves to Falls City, Nebraska, where he is accepted as the boy he understands himself to be. The detailed nuances achieved in Academy Award winner Hilary Swank's brilliant portrayal of Brandon, foreshadow the crass circumstances that positioned him within a social context almost completely devoid of hope. Brandon was a modern-day Oscar Wilde, himself a warrior who resisted the inappropriate expectations that were imposed upon him at birth merely because of his gender.

Like Wilde, the real-life Brandon realized that to be true to himself he would have to construct his manhood from scratch, through pure invention, by any means available, and at any cost. Except that the resources available to support his quest for personhood were so limited that he resorted to living under false pretences with an assumed identity, while on the run from police for petty theft. *Boys Don't Cry* is the devastating, true tale of a young person's defeated attempts to achieve love through his own personal celebration of working-class male identity.

The words valorous and debonair come to mind when pondering the legacy of Nebraskan petty criminal Brandon Teena. That he was not able to extricate himself from the trajectory of happenstance that led to his rape and, finally, his murder, is as distressing as it is tragic. So fraught with tell-tale signs of danger were the interactions among his rag-tag gang of pals, including ex-convict John Lotter, as well as Tom Nissen and Lana Tisdale, that even a casual bystander might have sensed the danger that led to terror. But this may be precisely why Brandon was not able to get out when the getting was good. Nebraska was all he knew. Falls City, Nebraska, with its rowdy, bumper-skiing shindigs and a smattering of pretty girls, even if hardened, must have seemed like a big adventure in the wild Midwest for someone like Brandon, who was on the run from the law for grand theft auto and fraud. Though Brandon and new-found girlfriend Lana dreamed of escaping to destinations beyond, the tough, raunchy, and macho domain of *Straightsville, USA*, where this story takes place, must have presented an appealing challenge to him, as he made his first serious attempts to pass.

Peirce's riveting filmic depiction of Brandon, during which he is shown performing his daily toilette, succeeds at conveying the sexy, sensual nature of transgender ritual, convincingly performed by Swank and courageously devised by Brandon himself. What is most remarkable about the process that Brandon engaged to affect such a believable gender transition was that the accoutrements he dispatched to achieve his desired illusion were as common day as drug store sundry items would allow. In an early scene, Brandon convinces his cousin to cut his hair short. He stands, dressed in jeans and a plaid shirt, admiring himself in the mirror—a real cowboy. His cousin looks him up and down, notices the bulge in Brandon's jeans, and chides him that it looks like a deformity. Brandon reaches in, pulls out the rolled up pair of socks, removes one, and rolls the other back up, carefully tucking it into his pants. His face glows with success; he is convincing.

Brandon's seamless blending into his surroundings hardly calms viewers' sense that this is a fragile success and that the smallest slip will unravel into disaster. This crystallizes in a scene in which Brandon wakes up to find menstrual blood has stained his pants. We see him in the bathroom trying to wash the blood out and looking for someplace to hide a tampon wrapper. The disguise is vulnerable, the cloth holds evidence, and later in the film, it is finding this stain that confirms for Brandon's friend Candace that she's been deceived. Cloth, which enables transformation, is itself vulnerable to being transformed. It is permeable and carries its history with it. Here, Peirce uses this blindingly ordinary fact to enact a key turn in the film's narrative. The dual nature of cloth, with its ability to transform what it covers and its inability to hide its own history, is echoed in Brandon's own dual nature—gloriously passing even as his history keeps threatening to reveal

Scene from Boys Don't Cry (1999). Brandon Teena checks himself out in the mirror as he gets dressed for the day.

350

Scene from Boys Don't Cry *(1999). A nurse cuts off Brandon Teena's chest wrap after he is brutally raped by Tom Nissen and John Lotter.*

itself. This is the dual nature of every kind of *sexy-work*, profoundly empowering while, at the same time, putting the worker in constant danger.

This potential for cloth to simultaneously disguise and express figures throughout the film. In one scene, Brandon emerges from the shower wrapped in a towel. A second towel, this one bundled, is set on the bed and unfolded to reveal the simple tools of Brandon's transformation: a rolled-up sock, an elastic bandage, a dildo, a comb, condoms, and a wallet. We watch Brandon wrap the bandage around his chest to conceal his breasts. Later in the film, after having been brutally raped by John and Tom, Brandon shudders in a heartbreaking scene as a nurse gingerly cuts away the elasticized bandage. Peirce's attention to Brandon's bandage emphasizes its metaphoric importance, not only as a key instrument used by Brandon to substantiate his identity as a male, but also as swath to help heal a deeply wounded soldier.

It is remarkable that the simple and fragile objects that Brandon manipulates to project his semblance of manhood facilitate such powerful responses in relation to his identity, effectively changing the lives of those around him forever. Like Peirce's metaphor of the bandage, the innocuous nature of Brandon's tools of transformation underscores the fact that sex does not define gender and that gender is an unfixed phenomenon with a propensity to shift.

Brandon's boy haircut, denim-and-flannel duds, and "bottle-of-beer-and-a-cigarette" props would hardly seem sufficient markers of gender. Yet in Brandon's hands they are, and his conviction is contagious. When Lana tells her friends about an evening with Brandon, concluding "and then we took off our clothes and went swimming," we understand that she is joining her belief to his. Given what we know about Brandon, we hear something different than Lana's friends in the reference to taking clothes off. Although

we can't know whether Lana is aware of all that the viewer knows, she moves into new territory with her claim to have been naked with Brandon, a claim she uses later in the film to try to protect him from John and Tom. Brandon's clothes, which until now have functioned primarily as outward communicators of his male identity, take on a new role, metaphorically marking the boundary between those who believe in the supremacy of desire and those who insist on biological realities and fixed identities. Lana crosses over and Brandon is no longer alone.

Peirce portrays the roadside spaces where Brandon is socialized in white-trash bonding rituals in mostly public, utilitarian locations, such as karaoke bars, highway truck stops, trailer parks, parking lots, garages, the county courthouse, a factory lot, and a river bank. Even though the costumes and locales are low budget, Peirce manages to achieve glamorous results by successfully attaching our experience as viewers to selected costumes and interiors/exteriors that help shape the persona of Brandon into a believable and lovable person. It would be easy to underestimate the performative capacity of such ordinary settings and clothing. Peirce uses these drab settings to make evident just how transgressive Brandon's actions are, and to heighten the sense of danger we experience watching Brandon drawn into these settings. At first glance jeans and flannel could hardly be considered glamorous, but seeing Brandon's expression as he checks himself out in mirror after mirror we see clearly the charged pleasure and pride he gets from achieving this midwestern, blue-collar aesthetic.

That Brandon was able to convince those around him that he was a guy, despite the intangibility of his gender, attests to his sophisticated ability to navigate social interactions of all kinds, in which he ultimately jammed midwestern, blue-collar heterosexuality. This is one of the most significant accomplishments of Brandon's work, achieved alone in small-town America, without the benefit of like-minded colleagues and a big urban ghetto.

Where in *Pink Narcissus sexy-work* takes decorativist intervention into high gear, here we see a manifestation similar to that in *Sister My Sister*, with its emphasis on the play between plain and decorated. If *sexy-work* is the labour of bridging inner desires and the demands of the outer world in the service of self-realization, and if, in a decorativist vein, we recognize the performative role of surfaces, then one could claim Brandon's unobtrusive, everyday midwestern guy duds as an instance of *Deco-jamming*. Jamming must happen in relation to a particular context, and the same is true of passing. Brandon's labour is one of keen observation and selective mimicry. Without the money to pay for sex reassignment surgery, Brandon makes do with what he has—cheap props and abundant courage. That this transgres-

sive bridging of inner desire and outer manifestation, this *sexy-work*, carries risks and powerful repercussions when it goes wrong, is all too evident in Brandon's eventual rape and murder.

In the cascading discovery of Brandon's deception, Lana's admirers, again John Lotter and Tom Nissen, discover a small-time news report that Brandon Teena, who had been arrested on a misdemeanour charge for cheque forgery, is really Teena Brandon. One week later, feigning outrage at the prospect that his deceit has cast an evil and sickening pall over the sanctity of their manhood, John and Tom publicly humiliate then brutally rape Brandon in an effort to assert their dominance over the boy/girl who so easily fooled.

Peirce's portrayal of the ironic events involving John and Tom cast Brandon's innovative gender play as so confounding that the two assailants repeatedly scream epithets at him, alternately referring to him as both a faggot and a dyke. The debacle in which the boys prove that Brandon's biological sex is contrary to his gender occurs between John, Tom, and Brandon in Lana's bathroom, where they violently beat then strip-search Brandon, conducting an invasive appraisal to determine the true nature of his/her vile offence. It is in this violent strip search that the film finally trips from the looming threat of violence into actual violence. John and Tom's rage at having been deceived explodes as they tear away Brandon's clothing. Only by doing this can they strip away the performative to determine the "true nature" of the person before them. Peirce's depiction of the force of their need to know powerfully evokes the repercussions and risks that accompany transgressive expressions of self. The boys don't stop there, however. In an escalation of violence and violation they go from strip search to rape. One week later, at point-blank range, they brutally execute Brandon, as well as their friend Candace and her houseguest.

HIGHWAY HUNK

Brandon must have been cognizant of blue-collar, working-class labour to have successfully jammed blue-collar, working-class heterosexuality the way he did. Until recently, popular conceptions associated the core of blue-collar culture with the protestant work ethic that promises success and good fortune to those who work hard and go to church. The joy of Brandon's accomplishment was that he made himself and others around him feel good. His real-life girlfriends wholeheartedly attest to Brandon's charms, according to Peirce.

Brandon's demeanour challenged the dysfunctional behaviour rampant in Lana and John's family because he made the authentic expression of emotions the focal point of his interactions with others, especially Lana. Further, Brandon fortified his game of dress-up through decorativist interventions that undermined the mechanics of masquerade in which the male, heterosexual need to master self-control places us all under pressure to conform in our appearance, instead demonstrating that beliefs can supersede empirical data. Brandon's presence refocused those around him on the process of believing itself, as in the great American dream, a belief in the ability to succeed at one's self-defined goals, regardless of circumstances.

Though Brandon held menial jobs along the way, the real work that he performed in his role as an unconventional male doesn't yet have a name. Might there be a way in which one could consider deception a form of social work? In his strategic mimicry of his surroundings, Brandon was able to make himself what he wanted to be. In the breakdown of that deception, he performed an unintended and unwanted service—showing those around him how slippery the real can be and how much we rely on surfaces for our sense of what is.

Peirce's film broadens the way in which we understand *Deco-jamming* and *Eco-glam*. Both Peirce's and Brandon's *Deco-jamming* emphasize that it is not appearance in any absolute sense that is most important, but rather the potential power of manipulating appearance in relation to environment. The labour of attention and imagination in crafting the bridges one needs to realize oneself is at the core of *sexy-work*. Brandon's evident pride in producing the appearance he wants, and the state of being this evokes in him, are deeply attractive to others. This heightened state of being is *Eco-glam* at its purest.

Recognizing Brandon's efforts as a form of work, rather than as the manifestation of an identity crisis, posits the heroic aspects of his accomplishments alongside those of Florence Nightingale and Martin Luther King. Brandon achieved the same ends, though on a smaller scale. He managed to bring people together, challenging them to refocus their values and beliefs in the name of integrity and compassion. Spiritual healer, maybe? Perhaps that might work as a job title for Brandon, who wouldn't be the first to have met an untimely death while in the line of duty.

That which is decorative manifests brilliantly within the performative realm, especially when textiles are deployed to construct such artifice. Textiles and their associated uses assist a formidable repertoire of phenomena that has been crucial to the expression and endurance of civilization. Until recently, the historical impulse to sanction an agenda of persecution under the charge of sodomy has thwarted the emergence, development, and expression of diverse sexualities, thus centuries of association between the homosexual/sodomite and textiles has been subject to obscuration.

The primary characters in each of these films, all of them queer, elaborate an indisputable and significant dependence upon textiles toward the successful performance of their duties in relation to the demands of work—labour, in turn, providing a central element in the construction of their individual realities. Additionally, all of them engage in illegal activities as a function of their work, or as a consequence of it. The stereotype of the self-destructive miscreant that has plagued representations of queers in film, literature, and television has cultivated the expectation that queers are creative, yet unsavoury citizens. The spectacle of this anomaly implicates the queer person in relation to the authority of the heterosexual context, sometimes to the benefit of and sometimes at the expense of the individual's own safety. The instatement of queers as first-class citizens with the same legal rights and responsibilities as the heterosexual majority is the only antidote that will rectify this imbalance.

Deco-jamming is Eco-glam! is an attempt to extrapolate and emancipate the meaning engendered in this rich, disturbing history of queer identity and labour. Inventing the necessary nomenclature, this paper seeks to make visible the queer labour of the films' characters and of the filmmakers themselves. It represents an effort to liberate the furled power of queer consciousness, examining, as these filmmakers have, *sexy-work* and the power of its small gestures to unsettle hegemonic certainties about gender and sexuality. The violence unleashed in response to such gestures is one indicator of the tremendous and volatile forces with which *sexy-work* must contend. The filmmakers are rigorously honest in reflecting both the glamour in such acts of transgressive self-expression and the real danger to self of such work: danger from self-destruction, danger from others' violent responses.

Textiles play a special role here, their everydayness making them an ideal substrate for the perpetration of these identity crimes. Textiles, in particular clothing, carrying meanings with such certainty that a girl with her breasts

bound and her hair cut short needs only jeans and a greasy shirt to be a boy. A callboy needs only a red square of cloth to be a toreador. A servant need only wear a delicate pink sweater to be an affront to her employer and to trigger an escalating battle of position resulting in murder. What threatens here is the mutability of social identity—how little it takes for one thing to be another. How much we rely on surfaces and clothing as short-cuts in constructing our sense of reality, and how violent the response when that certainty is revealed as fragile, susceptible to deception. This labour of deceiving and then revealing is itself a form of jamming the everyday.

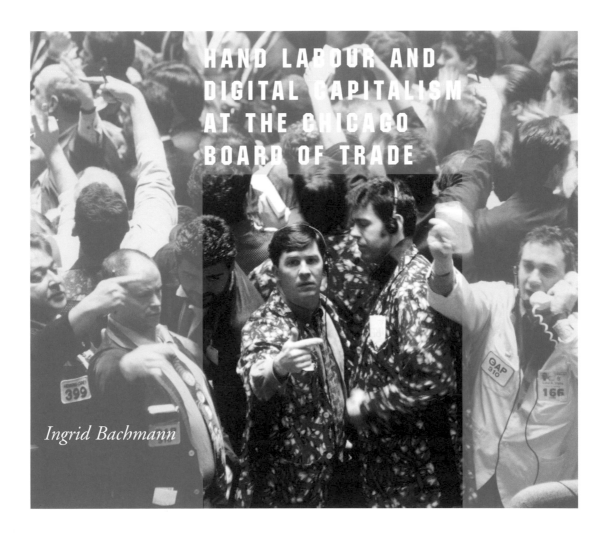

HAND LABOUR AND DIGITAL CAPITALISM AT THE CHICAGO BOARD OF TRADE

Ingrid Bachmann

Every weekday morning, elegantly clad men and women in formal business attire enter the landmark forty-five-story limestone Art Deco building at 141 West Jackson Boulevard in the heart of Chicago's financial district. Moments later, these same distinguished looking men and women emerge wearing outrageously patterned and brilliantly coloured jackets, looking more like carnival barkers than businesspeople, to take their place on the floor of the Chicago Board of Trade.

The Board of Trade is the site of futures trading, where grain, corn, soybeans, and other agricultural products produced on America's farmlands are auctioned in an open outcry system. It is a unique site where seemingly

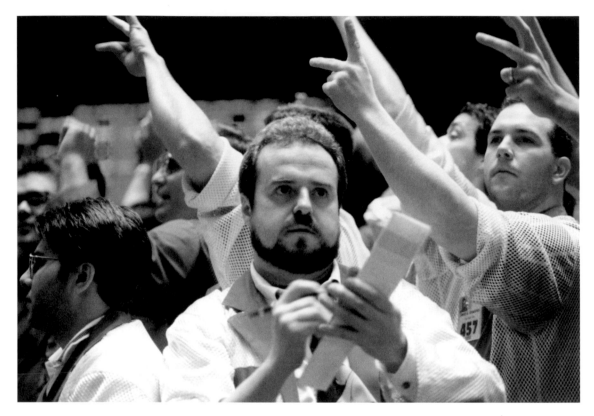

contradictory elements converge, where contradictions between the material
conditions of daily life—the physical and tangible labour of farming and
sewing—meet the immateriality of futures contracts, market economics,
and digital communications technologies.

Traders on the floor of the Chicago Board of Trade.

The carnival or circuslike atmosphere of the trading floor, with its kalei-
doscopic brilliance of colours, patterns, and elaborate sign systems, contrasts
starkly with the sophisticated systems of information technology that transmit
a continuous data stream of information over 10,000 miles of telephone
cables, monitors, and price boards that surround the trading floor.

In this essay, I use the Chicago Board of Trade as a trope to explore the
complexities around issues of labour in an increasingly digital culture, the
relationship between hand and industrial labour, and the shifting relationship
between material and immaterial culture. I want to consider the erasure of
human labour, and by extension hand labour, in the rhetoric and discourses
around digital and information technologies. This rhetorical erasure is
notable since human labour is intrinsic to the production and distribution
of these same technologies.

The Board of Trade provides an excellent, if unintentional, model of this separation of information from the physical and material processes that produce it, offering a compelling site to discuss production, signification, consumption, and embodiment. It is a site where the physicality of the manual labourer—the farmer, the seamstress, and here I include the trader—is played against the virtuality of futures trading and information technologies. It is also a site where the entanglement between the physical and economic base is problemmatized, and the apparent opposition between the material and the virtual is reinforced and even exaggerated. This conspicuous positioning of material and virtual as oppositional rather than interdependent ideologies is reiterated on every level at the Board of Trade: in the contradiction between the traders' restrained public wardrobe and the garish attire worn on the trading floor; the disparity between the austere, elegant, and even prim architectural façade and the frenetic activity within; the contradiction between the uncontrollable forces of nature that bear enormous influence on the Board's activities and the sophisticated, highly streamlined technological apparatus that controls its daily operation. But within these exaggerated oppositions, contradictions, and polarities arises the opportunity to examine issues around hand and industrial labour in an increasingly global and digital economy.

BUY @ ¼ ¢

Hand gesture used by traders to signal "buy at one-fourth of a cent."

The media revolution has radically changed the market economy as industrial capitalism transforms into digital capitalism. Agricultural products and financial markets number among the sectors of society revolutionized by this shift to an information paradigm. This new economy is often called the information society, the communications society, or the telematic society. All of these terms contain the idea that this new impetus in technology—

namely digital media—will lead to the replacement of industrial capitalism as we have come to know it. This new market economy is characterized by acceleration, dematerialization, decentralization, and globalization. These terms also have resonance and currency in contemporary cultural theory and continue the deeply rooted myth of the separation of material from information, an idea with roots long before Descartes' famous dictum, "I think, therefore I am." The Board of Trade allows us to challenge this myth and rethink embodiment in an age of desired virtuality.

According to cultural theorist N. Katherine Hayles, the effect of this shift to an information economy creates "a highly heterogeneous and fissured space," one in which "discursive formations based on pattern and randomness jostle and compete with formations based on presence and absence."[1] I would like to apply Hayles' paradigm of pattern and randomness to the material and virtual polarities exemplified by the Board of Trade to question some of the binaries that remain so firmly inscribed in contemporary cultural thought, primarily oppositions between nature/culture and material/information, and to explore the reasons for their persistent iteration.

1. N. Katherine Hayles, *How We Became Posthuman: Virtual Bodies in Cybernetics, Literature, and Informatics* (Chicago & London: University of Chicago Press, 1999), p. 28.

This split is revealed by Theodor Adorno, who believes that culture, like philosophy, is marked by the "original sin" of the division between manual and mental labour.

> *Cultural criticism is, however, only able to reproach culture so penetratingly for prostituting itself, for violating in its decline the pure autonomy of the mind, because culture originates in the radical separation of mental and physical work. It is from this separation, the original sin as it were, that culture draws its strength.*[2]

2. Theodor W. Adorno, *Minima Moralia: Reflections from Damaged Life,* trans. E.F.N. Jephcott (London: Verso, 1984), pp. 49-59.

The Board of Trade remains, in many respects, a site of virtual transaction and exchange where the physical world of farming and agricultural production are dematerialized to chits or information patterns, exchanged frenetically on the trading floor. It also provides an opportunity to revisit Marx's concept of base and superstructure within complex systems of information and commodity exchange, specifically in the digital realm where information has replaced the object of its material base. The Board of Trade serves as an example of late capitalism's infiltration of the Marxist model of base (material or economic determinants, in this case, agricultural production), and superstructure (ideology and representation signified through futures contracts). The commodity trader never sees the materials—corn, soybeans, grains— that he or she sells or buys. The farmer who produces those goods never meets the traders who buy and sell those goods. But farmers and traders are all subject to the tangible effects and caprices of local weather conditions, global politics, government policies, and the forces of supply and demand.

Marx's concept of base and superstructure is one of his most contentious and fiercely debated ideas. But it provides a unique framework for looking at those binaries deeply imbedded in Western cultural thought and how they may be, if not dismantled, at least reconfigured. The most common metaphor used to illustrate base and superstructure is a house and its foundation. The base, or foundation, is the economic system or the modes of production in society. The base determines what superstructures can be built upon it. The superstructure includes all the legal, moral, political, and ideological aspects of society, and the base determines the superstructure. According to Marx:

> *In the social production of their existence, men inevitably enter into definite relations, which are independent of their will, namely relations of production appropriate to a given stage in the development of their material forces of production. The totality of these relations of production constitutes the economic structure of society, the real foundation, on which arises a legal and political superstructure and to which correspond definite forms of social consciousness.*[3]

3. Karl Marx, in the preface to *A Contribution to the Critique of Political Economy* (Moscow: Progress Publishers, 1977), p. 1.

Hand gesture used by traders to signal "buy at a half cent."

BUY @ ½ ¢

4. Fredric Jameson, *The Jameson Reader,* eds. Michael Hardt and Kathi Weeks (London: Blackwell Publishers Ltd., 2000), p. 120.

In Fredric Jameson's interpretation of the distinction between base and superstructure, he states, "everything changes when you grasp base and superstructure not as a full-fledged theory in its own right, but rather as the name of a problem whose solution is always a unique, ad hoc invention."[4] When applied to the Board of Trade, Jameson's interpretation collapses the base and superstructure paradigm in an interesting way and challenges myths of a virtual realm of information separated from the physical realm. When viewed as a problem and not as a dialectical opposition between presence and absence (or in this case, base and superstructure), it suggests

an active and organic model, one of reciprocal interaction and interrelatedness of previously determined opposites – material/virtual, base/superstructure, nature/culture.

It is not so much about collapsing binaries, but trying to reveal what the political and social investments are in maintaining them. What does the upholding of these entrenched and outdated historical oppositions support? One might argue that they serve to provide a smokescreen to ignore or even hide the realities of production under global digital capitalism. The questions who made it? where was it made? under what conditions was it made? and for whom was it made? are much easier to ignore, particularly if the answers are problemmatic or if the site of production is not apparent. Questions of accountability on such contentious issues as genetically modified crops, agricultural biotechnology, and environmental impact may also be easily deflected.

BUY @ ³/₄ ¢

Hand gesture used by traders to signal "buy at three-fourths of a cent."

The Board of Trade functions as a centralized marketplace for members of the exchange to buy and sell agricultural commodities and financial instruments for themselves or their customers. It was formed in 1848 in Chicago to provide a centralized location where farmers and merchants could meet to exchange their goods. Chicago's location at the base of the Great Lakes, close to the farmlands of the Midwest and land and water transportation routes, made it an ideal location. Originally, grain was brought to regional exchanges scattered throughout the Midwest. Farmers who brought their goods to the markets at a certain time each year often found that the immediate supply outweighed the demand. In 1865, the Board of Trade developed standardized agreements called futures for crops not yet planted. At that time, transactions were recorded by hand on a large chalkboard, a striking contrast to the technological sophistication of today's Board of Trade.

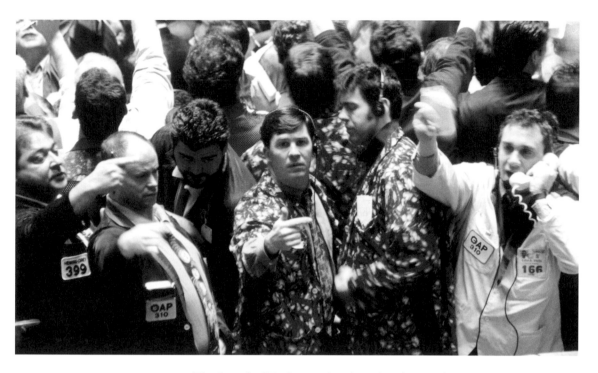

Traders on the financial floor of the Chicago Board of Trade.

The Board of Trade is a closed marketplace and seats on the exchange are sold. Incoming members require two sponsoring members and must meet stringent requirements for credibility, stability, financial responsibility, and integrity. Access is limited to those who can afford a seat or to those who can afford a broker attached to a member firm. At the time of this writing, a seat on the exchange sold for $1,950,000. Unlike a stock exchange, where stocks, representing partial ownership in the company that sells the stocks, are bought and sold, at a futures exchange, futures contracts are bought and sold. Goods are bought and sold at the Board of Trade often before farmers have even begun to plant their crops. Futures represent the virtuality of these goods and reference the invisibility of labour in a global economy, whether it is the labour of the farmer who plants, tends, and harvests the crops, or the global labour force in the textile and information technology industries.

Futures contracts are legally binding agreements made on the trading floor of a futures exchange to buy or sell a commodity, for example, corn, soybeans, or treasury bonds, at some future date. The terms of a futures contract are standardized by type (corn, wheat, etc.), quantity, quality, and delivery time and place. The only variable is price, which is determined through a process called price discovery that takes place on the exchange floor.

Open outcry is the name of the auction system for buying and selling futures at the Board of Trade. Open outcry is an elaborate system of hand signals coupled with verbal bids. There is no central auctioneer. The trader shouts the quantity of the commodity he or she is buying or selling and the corresponding price he or she wants. Trading is thus accomplished using this specialized sign language that clarifies the trader's verbal bids and offers, necessary when trading is highly active. For example, an outstretched hand, palm extended outward, signals a desire to buy, while an outstretched hand with the back facing outward signals good to sell. Amounts also have specific symbolic gestures.

The act of trading is in itself an intensely physical activity. High decibel levels and a frenetic pace have led to high stress levels among traders. In 1998, an electronic trading system was introduced to trade financial futures, but the open outcry system accompanied by hand signals remains the most effective and primary trading system, and is still used for the trading of agricultural products. Efficient, reliable, and fast, open outcry provides an example of information that is exchanged through the latest technological means, as well as through the proprioceptive and kinesthetic workings of the human body. Proprioception is a form of embodied knowledge and refers to the way that we use information from sensors in the body to know where our limbs are. Scientists drawing on several sources, but particularly neurobiology, have concluded that the mind, our reasoning, and our

Trader in flag-patterned jacket on the financial floor of the Chicago Board of Trade.

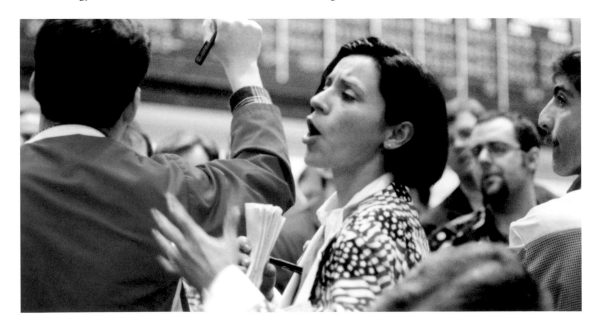

364

knowledge are embodied. They propose that our physical experience of the world—our spatial awareness, our bodily movement, and the way we manipulate objects—provides the pattern for how we reason about the world. In *Descartes' Error: Emotion, Reason, and The Human Brain*, neurologist Antonio Damasio makes a case for the embodied mind. He refutes the idea of the disembodied mind in Western medicine, this Cartesian split that pervades both research and practice, and the current notion of the mind as software and the body as hardware. From case studies involving neuropsychological research in humans and animals to understand the neural underpinnings of reason, Damasio has found that "the body contributes more than life support and modulatory effects on the brain. It contributes a content that is part and parcel of the workings of the normal mind."[5] The intense and often frenetic choreography of the trader's movements on the trading floor invokes the more tangible labour of the farmer. In this carnivalesque ritual, the physical labour of agriculture in the material world is transferred symbolically to the virtual and performative realm. This serves as a timely reminder that all information is embodied, and reveals the material base that this culture has so much investment in negating.

5. Antonio Damasio, *Descartes' Error: Emotion, Reason, and the Human Brain* (New York: Avon Books Inc., 1994), p. 226.

Hand gesture used by traders to signal "buy at a full cent."

BUY @ 1¢

The trading floor itself is comprised of several recessed octagonal pits. Locations in the trading pit refer to months of the year. All traders dealing within a certain delivery month trade in the same area. For example, a trader who wishes to sell in August will stand in one section of the octagon; someone wishing to buy in January will stand in another section. No spots are assigned in the pits. Brokers, who work for institutions or the general public, typically stand at the edges of the pit. From this position, they can easily see other traders and have an unobstructed view of the firms' trading booths from which they may receive flashed orders.

Traders also wear custom-designed jackets. These jackets function as another important signaling device. While jackets and ties are required by exchange rule, the classic business suit is not suitable for the physical demands of the trading pit. The trading jacket is a loose fitting jacket, often of polyester fabric, that allows the trader to move freely. More notable is the spectacular garishness and boldness of the traders' jackets—cow prints, psychedelic paisleys, wild florals—needed to distinguish traders from each other and to make themselves clearly visible. There exists an odd hierarchical reversal of pattern, colour, and taste. The most garish and flamboyant jackets are reserved for the traders, who are among the most powerful members of the exchange, while the subdued, simple, and cleanly tailored jackets in uniform blue, green, and burgundy are reserved for the runners who figure among the least powerful. Company runners are persons hired to relay information from telephone, fax, and computer lines sent by customers, brokers, and sellers to the traders on the floor. The traders also wear two different coloured badges attached to their lapels that give the identity of the trading firm as well as the individual.

The majority of traders' jackets are made by the Chicago-based company Peco Incorporated. Jackets can range in price from $50 to $200, depending on the style and fabric. The most common fabric type is a 65/35 percent cotton-polyester blend. The wild prints used in traders' jackets come from sources around the world, but the shirts are all produced in the Chicago factory. Jackets are replaced after six months or may last several years, depending on the individual trader. The iconographic signaling and physicality of the trading floor in this age of ones and zeros recalls the labour of the seamstress and sewer, and reminds us of the invisibility of such hand labour in digital economies. In the highly codified ritual of the trading floor, the spectacle of a more primal ritual is evoked.

The exchange floor at the Board of Trade is an apparent mass, and mess, of contradictions and juxtapositions. Performative and theatrical, it suggests the chaos and hubbub of a traditional marketplace or bazaar. It resembles a giant, moving quilt; a cacophony of dazzling pattern, noise, and display; a seething, teeming mass of colours, sounds, and gestures. The animated gestures of the traders in their wildly patterned jackets, the movements of the colour-coded runners madly rushing across the trading floor, the din of the trading floor, and the vibration of the electronic displays, create a vibrant, living display reminiscent of a carnival or marketplace, part of the unofficial world of popular culture. Constantly changing wall displays of scrolling LCD screens extending 680 linear feet and bearing over 62,000 characters circulate around the perimeter of the trading floor. Price boards

display the over 90,000 price changes that take place per day, and major newswire services provide a constant flow of information regarding weather conditions and market reports from other commodities exchanges. Ten thousand miles of telephone cable, 27,000 miles of low voltage cable, and 20,000 electronic devices, including computers, voice and video devices, can be used simultaneously, as well as one of the world's most sophisticated electronic routing systems.

Amidst this formidable display of technology, a gigantic television monitor, devoted exclusively to weather conditions, dominates the entire trading floor. Weather is the major factor affecting all of the activities at the Board of Trade, and the success or failure of a crop is inextricably connected with prevailing weather conditions. Weather is the crucial element in the growth of plants and crops, at the same time it can be one of the most destructive forces in the development of these vital crops. The goods traded at the Board of Trade are the fundamental staples in the world's diet. All the latest technology available cannot counteract the devastating impact of nature. Events in distant places—monsoons and flash floods in India, a lowering of the variability of soil water in Iowa, insect infestation or crop failure in Zambia—have as much, or more, impact on the activities of the Board of Trade as do global market conditions and politics. Here, both the interdependency of and the contrast between the physical world of farming and the virtual realm of market economics are revealed.

Despite this impressive collection of some of the world's most sophisticated electronic information systems, the trading floor invokes the random and frenetic industry of a psychedelic beehive on overdrive rather than the cool, sanitized efficiency most often projected by digital technology and financial markets. The Board of Trade is a semiotician's dream, a festival of communication, simultaneity, and spectacle with its rich material and synesthetic presence. This sense of spectacle is heightened at the Board's visitor centre. From its fourth-floor vantage point, it offers a generous glass-enclosed viewing area where the ritualized choreography of the trading floor is visible to the general public.

The building itself confirms this contradiction between appearance and reality. The Art Deco building designed in 1930 by the architectural firm of Holabird and Root is an architectural landmark. Elegant and austere, the exterior architectural rhythms and motifs are repeated in the smallest details in the interior, from the translucent glass-and-nickel wall sconces to the elevator display board, a miniature replica of the façade. The sleekly geometric and abstract exterior provides a startling contrast to the chaos of the trading floors. A thirty-one-foot, 6,500-pound statue of Ceres, the Roman goddess

of grains and harvest by sculptor John Storr, graces the top of the building. Unlike the traders inside, she is a model of simplicity and elegance. Clad in classical drapery, she holds a sheaf of wheat in one hand and a bag of corn in the other.

Contradictory and paradoxical, a site of exclusion and wealth, the Board of Trade is a unique space where the often imposed separation between the physical and virtual, the digital and tactile, farms and futures, erodes and is made visible. In this gap, there is a small but timely reminder of the interdependence and penetrability of these previously designated binaries. It is worth considering the consequences of this lack of ideological investment in our material world, whether it is in the plight of labourers who work anonymously in sweatshops or in agricultural fields around the globe, or the environmental impact of multinationals who function without accountability.

The agricultural pit of the Chicago Board of Trade after hours.

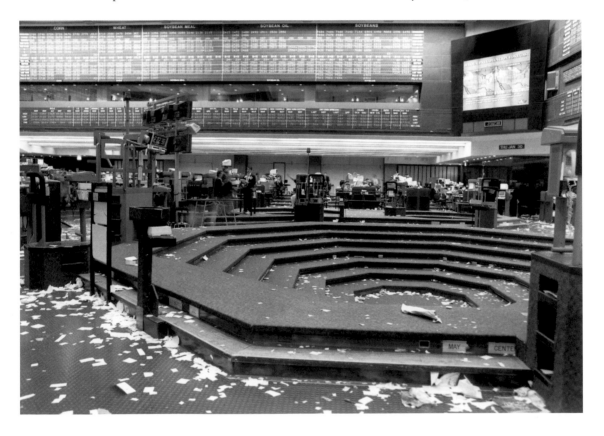

IRON INTO *lace*

INTO *lace*

Merrill Mason

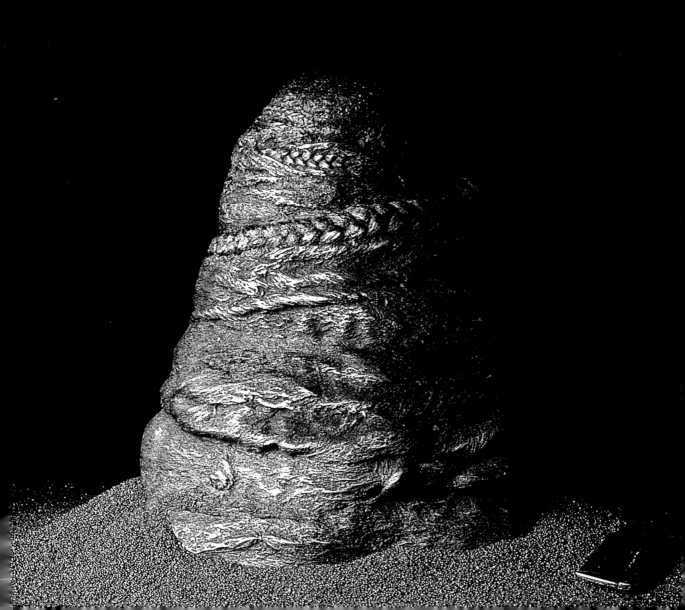

Merrill Mason worked alongside
ironworkers during two residencies at the
Kohler Corporation's iron foundry in
Wisconsin as part of the John Michael
Kohler Arts Center Arts/Industry Program.
This program invites artists to make
artwork using the extensive industrial
facilities of the Kohler Corporation, one
of the nation's leading manufacturers of
plumbingware. During these residencies,
Mason transformed found textiles into
cast iron. The textiles included lace and
finely embroidered blouses, collars,
handkerchiefs, linen towels, and
handbags. The completed iron textiles
function as sculptures and as central
objects in photographs that place the
sculptures in relation to the human body.

Iron Into Lace considers the irony of
textiles — especially ones associated with
cleanliness, femininity, and the upper
classes — as they become translated
through a masculine, working-class
inferno. The resultant sculptures are
informed by workers' labor and, in the
context of this artist project, are
perceived as representations of both
beauty and strength.

ARTIST AS INSECT

Kevin Murray

In 1888, when asked by a U.S. customs officer if he had anything to declare, Oscar Wilde responded with his legendary wit, "Nothing, except my genius." Wilde stands proudly in a lineage of artists who placed personal inspiration above the norms of their time. Then, an artist had to find a space outside mainstream society in order to be creative. The twenty-first century, a culture of reality television and networked communities, has brought an end to the concept of artistic genius, which today seems patriarchal, romantic, and self-indulgent.

However, where does art come from if not from an individual? Traditionally, creativity is thought to emerge from a solitary inner journey—in the studio, at the bench, or on the writer's desk. Today, people are becoming increasingly less isolated. Communication devices such as telephones, faxes, e-mail, and text messaging saturate daily life. In developing a less individualistic

concept of artist, we must search for new paradigms of creativity within the collective processes of an information society.

One potential paradigm lies in a form of life that has previously been considered the antithesis of humanity—the insect. Operating not as an individual but as part of a colony or hive, the insect manages feats of astounding beauty, such as the precise beehive hexagon, the delicate spider's web, and the baroque termite mound. In developing a concept of "artist as insect," rather than "artist as genius," we need to reform our attitudes toward insect life. This new paradigm serves to herald a generation of bold experiments in creativity.

· · · GOD'S JEWELS · · ·

In the Christian world of Western culture, the work of insects is viewed as testimony to the divine beauty inherent to nature. For the natural religions that evolved in eighteenth- and nineteenth-century England, the intricate designs and vivid colours of insects were proof of God's bounty. In the language of *Proverbs*, insects "are little upon earth, but they are exceedingly wise." Theologians such as William Paley promoted interest in the natural order of things as testimony to God's existence. The skill of the divine craftsman was especially evident in the fine detail, as argued in the anonymous religious tract *The History of Insects*:

> *The wisdom of the workman is commonly perceived in that which is of little size. He who has stretched out the heavens, and dug up the bottom of the sea, is also He who has pierced a passage through the sting of a bee for the ejection of his poison. This saying is well deserving remembrance: "The Lord of hosts is wonderful in counsel, and excellent in working."* [1]

Admiration of insects is not limited to theologians. Naturalists have testified to the technological skills of insects. In his chapter on insect arts in *Animal Architecture*, Karl von Frisch writes that the millions-year-old history of engineering "owes its existence not to the inspired genius of great artists, but to the unconscious, unremitting activity of life itself." [2] Lewis Mumford argues that innovations in the technology of containers were much greater among insects than early humans, at least until Homo sapiens. [3] It was enough to cast an admiring eye over the life of bees—with their precise engineering, collective intelligence, and self-sacrifice—to recognise that humans do not have an exclusive license on ingenuity.

There are also ways of understanding insect life as a transcendence from the human condition. Human activity has often been compared to the

1. *The History of Insects* (London: The Religious Tract Society, 1842), p. 6. This aesthetic dimension of nature was celebrated in the Victorian period with jewelry inspired from insect forms, and use of components, such as beetle wings, as decoration. During the Art Nouveau period, René Lalique's dragonfly-woman gave this erotic overtone by merging the insect with a naked female form.

2. Karl von Frisch, *Animal Architecture* (New York: Hutchison, 1975), p. 2.

3. Lewis Mumford, *Technics and Human Development* (San Diego: Harcourt Brace Jovanovich, 1967), p. 5.

378

4. "Salman took one look at the dark hexagonal exterior windows and labeled it in his mind a beehive. What he saw and heard inside confirmed his impression —so much buzzing energy in everyone's rapid strides and to-the-point conversations." From Po Bronson, *The First $20 Million is Always the Hardest: A Silicon Valley Novel* (New York: Random House, 1997), p. 106.

5. Maurice Maeterlinck, *The Life of the Bee* (London: G. Allen, 1901), p. 49. See also W. G. Sebald, *The Rings of Saturn*, trans. Michael Hulse (London: Harvill, 1998), chapter 10, for an outline of how the silkworm was often used as a model of clean and industrious action.

6. "After fifty years more of continuous progress even the final remains of all substance will have disappeared, if nothing else comes to the world other than the stain of progress, if through commerce, newspapers, schools, factories and barracks the urban-progressive contamination has driven into the furthest corner of the world, and the world satanically overturned, the world of America, the ant-world, has finally established itself." Stefan George quoted in Michael Zimmerman, *Heidegger's Confrontation with Modernity: Technology, Politics, Art* (Bloomington: Indiana University Press, 1990), p. 10.

7. Robert M. Pirsig, *Zen and the Art of Motorcycle Maintenance: An Inquiry into Values* (New York: Bantam, 1975), p. 15.

beehive's mutual understanding between fellow workers. In *The Aeneid*, the beekeeper and poet Virgil described the scene of Carthage as like "bees at the beginning of summer," busily erecting buildings throughout the city. More recently, Silicon Valley writer Po Bronson depicted activity inside a technology start-up company as a "beehive."[4] Beyond these poetic allusions are more meditative thoughts on the metaphysical links between humans and insects. The symbolist writer Maurice Maeterlinck presents the beehive as a mirror of human society, inviting the reader to self-reflect:

> *Were we sole possessors of the particle of matter that, when maintained in a special condition of flower or incandescence, we term the intellect, we should to some extent be entitled to look on ourselves as privileged beings, and to imagine that in us nature achieved some kind of aim; but here we discover, in the hymenoptera, an entire category of beings in whom a more or less identical aim is achieved.*[5]

Maeterlinck transfers this fascination for the hidden purpose of the hive to human society, and considers what equivalent cosmic function we might fulfill. The contrast in scale between the tiny insect and humankind heightens the metaphysical belief in a hidden purpose that pervades the gamut of life forms. While this realisation of grand design might appeal from a distance, for those individuals blindly following the collective will, such realisation can be threatening. God's jewels become the specter of industrialisation.

··· FUTURE MASTERS ···

While late Victorian society continued its fascination with insect life, the rapid development of machines both promised and threatened to take manufacturing from human hands. In the course of time, the relentless force of capital emerged as the underlying purpose behind all things, from human progress to natural evolution. Insects now feature in this sinister turn—not just as evil creatures that attack human values, but also as symbols of our own cultural transformation.

In the predigital era, the ultimate triumph of machines was to reduce humans to the status of ants. In 1911, the German poet Stefan George characterised this modern dystopia as an "ant-world."[6] Even the equanimous 1960s writer Robert Pirsig takes a righteous stand against the entomoid lifestyle of factories. In *Zen and the Art of Motorcycle Maintenance*, Pirsig draws the line at a technology that dwarfs its subject: "All this technology has somehow made you a stranger in your own land . . . [and] what you see is the NO TRESPASSING KEEP OUT signs and not anything serving people but little people, like ants, serving these strange, incomprehensible shapes."[7]

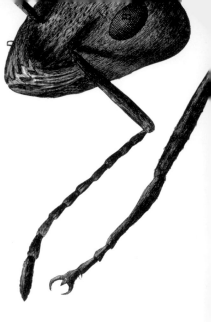

By raising consciousness, Pirsig hopes to rescue us from insectlike subordination to the factory-colony.

Today, the insect world of machines has become a standard scenario of science fiction. Films such as *Starship Troopers*, *Mars Attacks*, and *Matrix* present the imminent threat to humankind as cold, sticklike creatures. While this depiction conveniently absolves humans of any remorse over the enemy's violent destruction, it also limits any possibility of dialogue with our "insect Other."

The *Next Generation* series of *Star Trek* offers a more reflective interaction with insects. In this series, the crew of the Starship Enterprise engage with an android colony called Borg—humans who have been implanted with a device that links them to a collective intelligence. The experience of any one Borg is accessible to all Borgs. As they seek to assimilate all in their path, their encounters with the crew become increasingly close, to the point where the captain himself becomes a Borg. Paradoxically, the Borg alternative is true to the ideals of the Starship Enterprise: complete dedication of individuals to the collective good, just as members of the crew show a selfless devotion to the mission of their starship. Inevitably, each Borg adventure concludes with an individual who manages to assert himself or herself against the collective and, thus, reaffirms the power of human freedom over the forces of conformity.

The Borg adventures in *Star Trek* support the same mythology that locates the identity of an artist as someone outside society. Clement Greenberg traced the origin of the solitary artist back to the Renaissance, when artists were distinguished from their medieval forbears by the status of being "lonely in their art."[8] Artists have autonomy from the rest of society thanks to a special gift that elevates them above others. An understanding of their work is thus tied to an appreciation of their inner worlds. As Henry James claimed, "the deepest quality of a work of art will always be the quality of the mind of the producer."[9]

The romantic construction of an artist thus looks for unique inner powers that render his or her work singular. The German poet Rainer Maria Rilke identified in the sculptor Rodin the unique trait of patience: "There is in Rodin a deep patience which makes him almost anonymous, a quiet, wise forbearance, something of the great patience and kindness of Nature herself, who, beginning with some negligible quantity, traverses silently and seriously the long pathway of abundance."[10] These individualistic traits contrast with the mindless absorption in the colony that characterises the expendable nature of an insect's life.

8. Clement Greenberg, *Art and Culture* (London: Thames & Hudson, 1973), p. 29.

9. Henry James, "The Art of Fiction," *Henry James: Selected Literary Criticism*, ed. M. Shapira (Harmondsworth: Penguin, 1968), p. 96.

10. Rainer Maria Rilke, "The Rodin Book," *Rodin and Other Prose Pieces*, ed. G. C. Houston (London: Quartet, 1986), p. 7.

The idea of "artist as hero" in struggle against society is no longer relevant today. Creativity is now found in the collective mind. This reversal is typical of any power relationship. In Hegel's master-slave dialectic, for example, the master's superordinate status collapses when he or she recognises that power lies only in the slave's submission. Today, we recognise that the aloofness of the artist from the world is itself a social construction. The locus of creativity moves from the "solitary genius" to the "hive mind."

--- A WORLD MADE FLAT ---

In what is loosely termed the "posthuman" age, our traditional hierarchical understanding of nature and its life forms has been displaced by a flattened world in which many parts act together. This restructuring occurs across a range of disciplines. Chaos theory helps us to understand irregular phenomena, such as turbulence, as the play of contrary forces. Cellular automata provide a systems-theory approach to the operation of independent agencies. Neo-Darwinist accounts of evolution reduce life to a competition between genes, and the modular theory of the mind defines intelligence as a federation of skills rather than a centralisation of consciousness. In each of these scientific frameworks, nature is viewed as the product of self-interested units, whose free play organises into stable forms.

It is not surprising that this view also reflects transformations occurring in the social sphere. The reduction of the social whole to independent operating units is found in a variety of devolutions. Since the fall of communism in Central Europe, we find the break up of the nation-state into tribal units. Current management practice entails reengineering companies so that their divisions have more autonomy under a flattened control structure. The direction now in the development of new software is to build programs as a modular series of applets rather than a totalised system. In the case of economies, state utilities are broken up and sold to competing private enterprises.

This epochal process of macadamisation reaches its apotheosis in the evolving global network of computers. In contrast to other knowledge systems, such as the catalogued library, there is no central governance operating the Internet. Rather, it results from many independent nodes operating in conjunction. It is in these circumstances that popular writers use the term "hive mind" to describe the evolving consciousness of a networked society.

The phrase "hive mind," like "moving into the twenty-first century," is also a rhetorical device used to accelerate change. A necessary condition for the rapid transformation of organisations is the ability of individuals to "let

go" their preconceived notions of how things should be done. Previously, it was inevitable that companies attempted to guarantee profit and security by restricting the use of their technology to licensed customers. Today, the opposite principle holds: the more widely used a software technology is, the more sophisticated and valuable it becomes. Examples of "open-source" software, such as Linux and Netscape, commit to a research capacity for users, rather than producers. As the *Encyclopedia of the New Economy* argues:

> To let light and competition back in, more and more companies are buying open-systems technologies, whose inventors give up the role of gatekeeper in the conviction that, ultimately, they will gain more in competition-driven growth and innovation than they will lose in proprietary advantage.[11]

The *Encyclopedia* is published by *Wired* magazine, whose editor, Kevin Kelly, is a prominent exponent of the "hive mind." In *Out of Control: The New Biology of Machines*, Kelly charts various fields of inquiry, mainly biological, to expound a free-market approach to information: "Ours may always be a flashy type of creativity, but there is something to be said for a slow, wide creativity of many dim parts working ceaselessly."[12] Here, Kelly aligns nineteenth-century wonder in insect life with new digital technologies. His view of nature supports an American commitment to democracy as the foundation of nation: "The marvel of 'hive mind' is that no one is in control, and yet an invisible hand governs, a hand that emerges from very dumb members. The marvel is that more is different."[13]

The hive metaphor relates to what the European sociologist Elias Canetti defines as a crowd symbol.[14] Like other symbols such as "rain" or "cloud," the "hive" serves to mirror the crowd to itself, celebrating its strength. This is demonstrated most dramatically in the Mexican wave seen at sporting events: individual spectators follow the basic rule that if a neighbouring person stands, they stand up briefly too. While each individual action is insignificant, on a collective scale it produces a marvelous ripple of people that circles around the arena. This phenomenon creates a spectacle by which the crowd might represent itself. What distinguishes the "hive mind" from other crowd symbols is an implicit historical narrative that places it in an evolutionary line of human knowledge. Thanks to distributed knowledge systems, human intelligence has the capacity to pool its resources. In this context, the intelligence of the individual unit matters little. What counts, instead, is the sum of its parts—in other words, quantity, not quality. For technology theorists Derek Leebaert and William Welty, this contemporary phenomenon of distributed knowledge heralds a new level of collective genius:

11. Kevin Kelly, in *Encyclopedia of the New Economy*, http://www.hotwired.com/special/ene.

12. Kevin Kelly, *Out of Control: The New Biology of Machines* (London: Fourth Estate, 1994), p. 5.

13. Ibid., p. 16.

14. Elias Canetti, *Crowds and Power,* trans. Carol Stewart (Harmondsworth: Penguin, 1960).

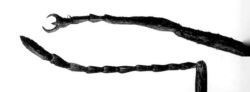

Of course, Newton attained the greatest single intellectual feat of man by working alone in candlelight with a quill pen. Leibniz could add to the wonders of knowledge by traveling in solitary coaches along the washboard roads of the Holy Roman Empire. What even they could not achieve was the effortless mobilization of lesser intellects.[15]

From this point of view, the prospect of *entomorphosis*—turning into an insect—is no longer presented as the nadir of human spirit. We all inhabit a network of information that feeds us ideas and expressions. French cybertheorist Pierre Lèvy articulates an intelligence that is distributive rather than central and, in so doing, recuperates the reputation of ants: "although individual ants might be 'stupid,' their interaction results in an emergent behaviour that is globally intelligent."[16] In order for human society to realise its collective intelligence, to achieve "a new stage of hominisation," Lèvy argues that we need to "let go" from our usual self-containment.[17]

Used to the hype of the digital revolution, we may well be skeptical that talk of the "hive mind" is a symptom of the previous millennium fever rather than a genuine mode of creative action. We need to consider carefully how such a concept might translate into meaningful art. We can categorise this paradigm into three phases that increasingly internalise the model of insect into the creative process. It begins with art made by insects, although controlled by humans from a distance. Artists themselves, then, begin to create like insects in a literal way, drawing on their own bodily substances. And, ultimately, artists shed their individual identity and find ways of making art from the collective consciousness of a "hive mind." The future phase of this evolution, yet to be realised, is a "romantic return" to lone individual creativity.

・・・ ART BY INSECTS ・・・

"Insect art" emerges out of a long tradition of manufacturing. Silkworms have been used in the production of textiles since 3000 B.C. There have been attempts to adapt the natural processes of sericulture to the manufacturing of fabrics, rather than the production of simple raw material. Charles Babbage, thought by some to have invented the digital computer, developed a technique for caterpillars to make lace. In the Daioh Temple of the Daioh Mountain in Japan, they breed silkworms that spin onto flat paper surfaces. The temple creates these special paper charms, called "Sankenshi," for those who attend its service.[18]

Contemporary artists also harness insect skills to create art. French artist Hubert Duprat uses the caddis worm to create jewelry. The caddis worm is

15. Derek Leebaert and William Welty, "Knowledge and the New Magnitudes of Connection," *The Future of Software,* ed. Derek Leebaert (Cambridge, Mass.: MIT Press, 1995), p. 284.

16. Pierre Lévy, *Collective Intelligence: Mankind's Emerging World in Cyberspace* (New York: Plenum Press, 1997), p. 16.

17. To an extent, the popular ant films *Bug's Life* and *Antz* convey stereotyped images of insect life as anti-individualistic.

18. A full description is available at "Daioh-in's Silk Paper Charm," http://www.thezen.or.jp/spaper.html (site now discontinued).

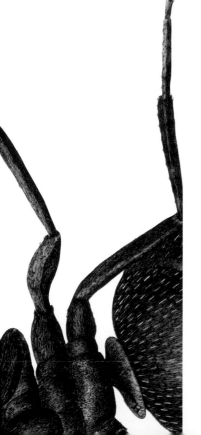

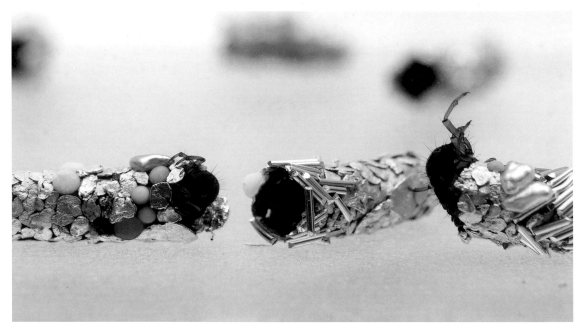

an especially skillful insect. In larvae form, it constructs a portable case for itself out of whatever it can find, including sand, shells, and plant debris. The artist utilises precious materials such as gold spangles, turquoise beads, opal, lapis lazuli, and coral, as well as rubies, sapphires, diamonds, hemispherical and baroque pearls, and tiny rods of 18-karat gold.[19] These elements are bound together by a silky substance secreted from the worm's labial glands. Upon metamorphosing into a fly, it leaves behind a precious legacy that the artist displays as glittering sculptures.

Duprat operates within a post-Aristotelian framework: the formal basis of nature is expressed in art rather than blind causation. In a strict evolutionary logic, all organic nature can be understood as the maximisation of ability to reproduce. Within this perspective, nature has no inherent form beyond this practical function. Through the case-building activities of the caddis worm, Duprat asserts the purposive capacity of nature. However, this activity represents a form of artistic expression for its own sake, rather than the operation of divine purpose.

Both the destructive and constructive capacities of insects have their use in contemporary art. American artists Christopher Leitch and Stephanie Sabato collaborated on a work that placed decaying vegetable matter over yards of fine silk. When the microorganisms feasting on the rot eventually died, they left coloured traces. The work, entitled *The River is Not Sacred for*

Herbert Duprat, Jewelry of the Caddis Worm, *1980-1996, aquatic caddis fly larvae with cases, gold, pearls, and precious stones, 3/4 x 1/8 in.*

19. **Hubert Duprat and Christian Besson, "The Wonderful Caddis Worm: Sculptural Work in Collaboration with Trichoptera," www.leonardo.info.**

Her Purity, but for Her Acceptance of It All (1994), undoes the fine work of insects in creating the precious silk. The Chinese expatriate artist Xu Bing created the installation *Language Lost* (1995), in which silkworms moved slowly over printed pages, weaving cocoons and destroying pages of text. In *The Opening* (1998), Bing arranged mulberry leaves in a vase with silkworms. Bing's sculpture operated like a performance, as the insects consumed the work of a human.

In a more crude manner, Yorkshire artist Patrick Smith makes prints out of maggots. The maggots are turned out onto a metal plate with a waxy surface. The plate is plunged into nitric acid, which highlights the traces of their movements, and is then used to make prints on paper. According to Smith, "I just saw the movement of the maggots and it was just incredible—and I thought that's chaos—I've just got to use it."[20] While an artist like Jackson Pollock drew on his own wild energies to create chaos, Smith harnesses the seething movements of larvae to achieve a similar effect.

Electronically, "insect art" has its corollary in the deployment of virus-like programs that construct their own patterns. Australian artist Dave Sag has developed a program for colonies of software called "Photobots" that slowly eat images.[21] From a selection of iconic images, such as the Macintosh Apple logo, these artificial bugs feed off screen pixels, gradually leaching the original of colour. Like its equivalent in insect decomposition, the work celebrates the inevitable victory of decay.

With some exceptions, insects are used in contemporary art as agents of entropy. They serve to destroy meaning and form in creative ways. The mission of the artist is to set this force loose onto the work of art in an act of creative destruction. This is an external application of insects. The next phase in the insect model is more self-reflective, and entails fabricating work from human substance.

··· ART BY HUMANS AS INSECTS ···

After the use of insects to make art, the next step is to have artists make work in an insectlike manner. This may seem an obvious model for the weaver. The craft operations of spinning and weaving have obvious parallels with the web building of creatures like spiders. However, the insect model holds a greater challenge for artists. The more radical entomorphosis is to make art out of bodily substances, such as hair, skin, and tears. What distinguishes insect manufacturing from its traditional human equivalent is self-sufficiency. The German philosopher Friedrich Schelling stated this

20. "Worming into the Art World," from BBC News, http://news.bbc.co.uk, January 25, 1998.

21. Dave Sag, "March of the Photobots," http://www.portablewhole.com.

more directly: "The bee produces the material of its edifice from within itself; the spider and the silkworm draw the threads of their webs from within themselves. Indeed, if we go even deeper, the artistic impulse merges completely with anorganic external deposits that remain in cohesion with the producing agent or animal."[22] The human version of this would entail use of bodily substances, such as nails and hair.

Chicago-based artist Anne Wilson gathers hair to make her textile works. Her work *Chronicle of Days* (1997-1998) contains 100 framed pieces of tablecloth, each with a fingerful of hair sewn into a small spot. In the Web site *Hair Inquiry*, Wilson solicits stories about hair loss.[23] These stories provide the spoken text in a sound installation created in collaboration with A. B. Foster, entitled *Told and Retold: An Inquiry About Hair* (1998).

The "insect" character of Wilson's hair projects is evident in three ways. First, the obsessive nature of the daily routine of sewing reflects a spider's never-ending toil in reconstructing its web each day. The resultant form has a random blot that we might associate with insect labours, such as clothes' moths or aphids on roses. Second, the material of Wilson's work is drawn directly from the human body, just as an insect makes its constructions out of substances secreted by itself and others. Third, and most critically, the artist collects stories about hair loss into a central database, which can be heard through headphones when exhibited. For this database, there is no canonical account of hair loss, but an open series of individual narratives about how people relate to the matter produced by their follicles.

While the use of bodily substances bears similarity to insect manufacturing, its critical link to the "hive mind" lies in the shared nature of this material with the audience. The immediacy of hair as a material invites the audience to participate in the gathering of its experiences. The final sound installation provides a compelling instance of the human hive—a multitude of voices articulating a common theme.

Sydney artist Sue Saxon also constructs work about the shedding of a bodily substance, in this case, tears. Her installation *The Tears I Cried for You* (2000) contains thirty-five vessels modeled on the Roman lachrymatory, originally used in mourning rituals. These vessels have been filled with tears shed by a wide range of donors, including children, prisoners, Jews, Buddhists, Catholics, and migrant groups. The lachrymatories are hung on an aluminum framework, each with a tag identifying the cause of weeping. This clinical aesthetic contrasts dramatically with the emotional aura of the work. What results is a transformation of intense individual experiences into an objective physical framework.

22. Friedrich Schelling, *The Philosophy of Art*, trans. D. W. Scott (Minneapolis: University of Minnesota Press, 1989), p. 163.

23. Installation from 1998 is on-line as Anne Wilson "*Hair Inquiry* archived responses," http://www.artic.edu/~awilso/.

Anne Wilson, Told and Retold: An Inquiry About Hair, *1998, an interactive audio installation, in collaboration with A. B. Forster.*

To some extent, both Wilson's and Saxon's installations act as bridges between the material arts and the electronic arts. In the "human as insect" phase, the artist attempts to use bodily substances rather than artistic materials, while addressing the common human plight of being held captive by our physical bodies. The third phase of "insect art" transcends the human condition, and it is in the digital realm where the "hive mind" is most readily apparent.[24]

24. See David Blair's *WaxWeb,* http://jefferson.village.virginia. edu/), and Jane Prophet's *Swarm,* http://www.ucl.ac.uk/ slade/swarm/.

✦ ✦ ✦ HIVE ART ✦ ✦ ✦

A number of artists working in digital media have used the insect metaphor to describe the processes used in their work. David Blair, an American artist based in Paris, developed a collectively authored narrative called *WaxWeb*

(1995-2000) based on the fictional medium of bee television. English artist Jane Prophet's site *Swarm* (1997) uses the civilisation of bees as a metaphor to encourage visitors to act as insects in depositing stories to a common database. In the early life of the Web, the insect metaphor provided a bridge to the construction of new paradigms of creativity that involve the diffuse operation of many rather than the focused deliberation of one.[25]

Some on-line works have forged new frameworks for artistic production. Post-Soviet artists Komar and Melamid were among the first established artists to utilise the Internet. In their Web site project *The Most Wanted Paintings* (1995), they developed a questionnaire then solicited users to state their most preferred characteristics in a work of art.[26] In summing the different variables, they were able to create the ultimate "democratic" painting. U.S. audiences preferred a "dishwasher-size" landscape painted in a Gainsboroughesque style that also contained historical and contemporary figures. Dutch audiences chose "magazine-size," colourful abstract works. Although intended as tongue-in-cheek, Komar and Melamid show how the Internet provides a field for collective action—the source moving away from individual taste to collective vote.

As the Internet grows, the methods for collecting knowledge also evolve. The collectively developed art project *Persistent Data Confidante* (1997) is a particularly canny manipulation of the "hive mind" and goes further than most "hive art" by acknowledging no authorship.[27] Before visitors can enter the site, they are asked to contribute a confession. After their confession, visitors are then required to rate a sample of other confessions according to interest. The database is constructed so that the top five percent of confessions are retained. What evolves then is the "cream" of human curiosity.

The Web work *SiSSYFiGHT 2000* was developed by New York artist Eric Zimmerman for *word.com* on-line magazine.[28] Visitors take the role of school children who have to survive a game similar to rock-paper-scissors. A preliminary period of chat enables players to either form alliances or egg each other on. Each round of action offers players the alternatives of teasing, hitting, hugging, or ignoring. These actions gain or lose points depending on how others act. The last child remaining wins. As in reality television, the events in *SiSSYFiGHT 2000* have no author. The artist operates like a legislator who defines rules by which interesting interaction and competition between others will occur.

On the surface, these art forms resemble various community art projects, such as the NAMES Project AIDS Quilt. But there is a critical difference. While communal works contrast with the singular authorship of the art commodity, they retain the same basic unit of creativity—an individual

25. For more concrete connections between insect life and the small screen, see two papers "Glass Angels and Data Insects," http://www.kitezh.com/texts/isea.html, and "Mouse: Where is Thy Sting?" http://www.kitezh.com/texts/mouse.html.

26. Komar and Melamid, *The Most Wanted Paintings on the Web*, http://www.diacenter.org/km/.

27. *Persistent Data Confidante*, produced by Erik Nyberg, Paul Vanouse, and Lisa Hutton, http://pdc.walkerart.org/.

28. Eric Zimmerman, *SiSSYFiGHT 2000*, http://www.sissyfight.com/.

Sue Saxon, The Tears I Cried for You *(detail), 1999, thirty-five glass vessels, cork, wax, tears, aluminum, brackets, 7 3/4 x 3/4 in. (diameter) each.*

attempts to express, in this case, his or her grief in visual form. The communal dimension is the gathering together of these discrete expressions into one work. By contrast, entomological art changes the fundamental unit of creativity beyond individual control. It entails, instead, the wild processes of "insect life" and the "hive mind."

··· THE ROMANTIC RETURN ···

In terms of the insect-human dialectic, there are many artistic endeavours that have reversed the traditional privilege of the human as sole repository of creative spirit. But where does this place the individual artist? In all these works, the individual artist has far from disappeared: each work of "insect art" implies the presence of an individual. He or she may only have partial control over the course of the work, but the initial framework is the artist's

Gwendolyn Zierdt,
Unabomber Manifesto, *1997,*
mercerized cotton and silk,
10 x 6 ft.

responsibility. Rather than drawing from their inner depths to create a masterpiece, these artists are more like beekeepers who create matrices in which the audience participates in the production of the work.

The spirit of this arrangement is particularly well illustrated in the work of Seattle fiber artist Gwendolyn Zierdt. Her *Unabomber Manifesto* (1997) draws on the opening paragraph of the book by Theodore Kaczynski, who

in the late twentieth century came to epitomise technological paranoia. Zierdt transforms his words into tapestry by first translating them into ASCII code, then feeding them into a computerised dobby loom. Athough Zierdt has no control over the patterns produced, her simple labour of weaving casts this machine language into a human context, reflecting the twin evolution of computing and weaving. Such works herald the fourth and final phase of the insect model, "the romantic return," in which the artist as an isolated conscious is rediscovered. While nineteenth-century romantic poets sought refuge from the impersonal world of industrialisation

in the wilds of remote nature, the artists of the twenty-first century are likely to find sanctuary in spaces "off-line," such as the weaver's loom, that slip between the nodes of the information grid. The romantic legacy of the insect model is only beginning to emerge.

Thus, we can trace the entomorphic evolution of a new collective form of artistic creativity. First, the artist uses insects as tools of creative entropy. Second, the artist acts like an insect, using human substances. Third, the artist thinks like an insect, drawing on collective knowledges. Finally, the artist rediscovers his or her plight as a lone mortal subject. The insect paradigm provides a journey back to our human condition, rather than an escape from it.

"Art of the hive" offers an opportunity to rediscover a place for humans in the wider scheme of things. An essential part of this rediscovery is the momentary "letting go" of species chauvinism. Insect consciousness is not necessarily the antithesis of human spirit; instead, it offers a model for the evolution of artistic creativity. This retreat from anthropocentrism makes space for the understanding of processes beyond our individual control. But to be so uncreative requires a special kind of creativity. Though artistic genius may no longer be declared at customs as Oscar Wilde once did, it survives, nonetheless, smuggled inside the hive.

Contributors

Ingrid Bachmann is an interdisciplinary artist, writer, and curator, whose interests span obsolete technologies and new digital media. She is Associate Professor in the Department of Studio Arts at Concordia, Montreal, and a researcher in the Interactive Textiles and Wearable Computing Lab of Hexagram, Québec's media arts research lab. Currently, she is researching models of emergent behaviors in embodied systems and networks from the field of artificial life to create generative, interactive artworks. She is coeditor of *Material Matters* (YYZ Books, 1998), a critical anthology of essays that examines the relations of material to culture. www.ingridbachmann.com.

Carol Becker is a writer, critic, educator, and Dean of Faculty and Senior Executive Vice President for Academic Affairs at the School of the Art Institute of Chicago. She is editor of *The Subversive Imagination: Artists, Society, and Social Responsibility* (Routledge, 1994), and has authored numerous articles and several books including: *The Invisible Drama: Women and The Anxiety of Change* (Macmillan, 1987); *Zones of Contention: Essays on Art, Institutions, Gender, and Anxiety* (SUNY Press, 1996); and *Surpassing the Spectacle: Global Transformations and the Changing Politics of Art* (Rowman & Littlefield, 2002).

Andries Botha is a sculptor and cultural activist living in Durban, KwaZulu-Natal, South Africa. His work has been widely exhibited throughout South Africa and Europe. He conceived the *Amazwi Abesifazane (Voices of Women)* project in 2001, and is the founder of Create Africa South (www.cas.org.za), a nonprofit organization committed to promoting creativity in South Africa. www.andriesbotha.net.

Susie Brandt is an artist who has exhibited internationally including shows in New York, Brussels, and Helsinki. Articles about her work have appeared in *The Washington Post, Sculpture,* and *Fiberarts* magazines, and as part of the Telos Art Publishing "Portfolio Collection" series (vol. 32, 2004). Brandt has received grants from the Mid Atlantic Arts Foundation, the New York State Craft Alliance, and the New York Foundation for the Arts.

Lou Cabeen is an artist and Associate Professor in the Fibers Program of the School of Art at the University of Washington, Seattle. Her work is documented in numerous museum publications including *Subversive Craft* (MIT Press, 1993); *Subversive Domesticity* (Ulrich Museum of Art, 1996); *Conceptual Textiles: Material Meanings* (John Michael Kohler Art Center, 1996); *Painted with Thread: The Art of American Embroidery* (Peabody Essex Museum, 2001); and *Contemporary Art Quilts* (University of Kentucky Press, 2001).

Dorothy Caldwell is a textile artist, teacher, and curator, whose work incorporates North American stitching traditions with resist and discharged dyeing techniques. She has executed major architectural commissions, and her work is represented in numerous permanent collections in Canada, the United States, Europe, and Asia. She is also cofounder of the Canadian Surface Design Organization. Caldwell is a recipient of the Bronfman Award and has received grants from the Canada Council and the Ontario Arts Council.

Nick Cave is an artist and Chair of the Department of Fashion Design at the School of the Art Institute of Chicago. His *SOUNDSUITS* were recently on view at the Jacksonville Museum of Modern Art, North Carolina; the Chicago Cultural Center; and the Mattress Factory, Pittsburg. He has also participated in group shows at the Studio Museum in Harlem and The Armory Show, New York, and Art Basel, Miami. He is a recipient of a Joyce Award, a Creative Capital Grant, and the Richard H. Driehaus Foundation Individual Artist Award. He is represented by Jack Shainman Gallery, New York.

Park Chambers is an artist and Professor Emeritus of Fiber and Material Studies at the School of the Art Institute of Chicago. Working with appropriated, digitally manipulated, and collaged images, Chambers' work addresses such themes as freedom of speech, personal honesty, and AIDS. He has exhibited in the Metropolitan Museum, Manila, Philippines; the Asheville Art Museum, North Carolina; and the Museum of Contemporary Crafts, New York. He has received awards from the Illinois Arts Council and from the National Endowment for the Arts.

Helen Cho is a Los Angeles-based artist and filmmaker working as an information architect in the technology industry. Her artwork investigates the complicated intersections of immigration, cultural identity, and language, and seeks to address complexities of race and culture not always apparent. www.designings.net.

Lisa Clark is a multidisciplinary artist living in North Carolina. Her textile, video, sound, and movement pieces have appeared in both group and solo exhibitions across the United States. She is the recipient of many residencies and fellowships, including a Regional Media Artist Access Grant by the National Endowment for the Arts.

Lia Cook is an artist and Professor of Art at the California College of Arts, Oakland, California. Well known for her innovative work with computer-assisted weaving, she is represented in the collections of the Metropolitan Museum of Art and the Museum of Modern Art, New York. A monograph of her work is included in the Telos Art Publishing "Portfolio Collection" series (vol. 14, 2002). She has received numerous awards including fellowships from the National Endowment for the Arts and the California Arts Council. She is represented by Perimeter Gallery, Chicago, and Nancy Margolis Gallery, New York. www.liacook.com.

Alison Ferris has been Curator at the Bowdoin College Museum of Art, Brunswick, Maine, since 1996. She has organized over forty exhibitions including, most recently, *The Disembodied Spirit,* an exploration of art and culture in the late-nineteenth and late-twentieth centuries involving the depiction or suggestion of ghosts. Currently, she is organizing a traveling exhibition for 2009 featuring paintings by German artist Paula Modersohn-Becker.

Nancy Gildart is a Chicago-based artist whose studio practice spans textiles, installation, and gardening. Selected exhibitions and projects include *Dial(ed) 911, Three Acres on The Lake: DuSable Park Proposal Project,* and *Remembering the Unremembered, Part 1.*

Ann Hamilton is an internationally recognized artist and Professor in the Department of Art at Ohio State University. She has shown at: the 48th Venice Biennale; the Carnegie International, Pittsburgh; the Musée d'art Contemporain de Montreal, Canada; the Musée Art Contemporain Lyon, France; the Miami Art Museum; the Contemporary Arts Museum, Houston; the Akira Ikeda Gallery, Taura, Japan; the Irish Museum of Modern Art, Dublin; and the Wanås Foundation, Knislinge, Sweden. She is the recipient of a MacArthur Fellowship, a Larry Aldrich Foundation Award, an NEA Visual Arts Fellowship, and a Guggenheim Memorial Fellowship.

bell hooks is the author of numerous books of feminist theory and cultural criticism. Recent titles include *Homegrown: Engaged Cultural Criticism* (with Amalia Mesa-Bains, South End Press, 2006); *The Will to Change: Men, Masculinity, and Love* (Atria Books, 2004); *Teaching Community: A Pedagogy of Hope* (Routledge, 2003); *Where We Stand: Class Matters* (Routledge, 2000); *Feminist Theory: From Margin to Center* (South End Press, 2000); and *Teaching to Transgress: Education as the Practice of Freedom* (Routledge, 1994). hooks has taught at Yale University, Oberlin College, and City College of New York. She currently serves as Distinguished Professor in Residence at Berea College in Kentucky.

Alan Howard is a writer based in New York City. He was former assistant to the president of UNITE, the apparel and textile workers union. His work has appeared in *The New York Times Magazine, The Nation,* and on public television.

Mary Jane Jacob is an independent curator who advances the parameters of artists' public practices with programs such as *Culture in Action,* Chicago, and *Conversations at the Castle,* Atlanta. Her work in Charleston, South Carolina, began in 1991 with the site-specific exhibition *Places with a Past* and has evolved annually since 2001 with projects investigating the effects of regional redevelopment on the historic Lowcountry landscape. In 2004, she published *Buddha Mind in Contemporary Art* (University of California Press). Jacob is Professor and Chair of Sculpture at the School of the Art Institute of Chicago.

Janis Jefferies is an artist, writer, curator, and Professor of Visual Arts at Goldsmiths College, University of London. She is Director of the Constance Howard Resource and Research Centre in Textiles, London, and artistic director of Goldsmiths' digital studios. Over the last twenty-five years she has published widely and exhibited internationally, including *Selvedges,* a touring solo show with accompanying book.

Brian Jungen is a Canadian artist from British Columbia with Swiss and Dane-zaa First Nations heritage. Jungen's comprehensive solo exhibition opened at the New Museum, New York, before traveling to the Vancouver Art Gallery, and the Musée d'art contemporain de Montréal, among other sites. In addition to numerous group shows, he won the inaugural Sobey Art Award. He is represented by Catriona Jeffries, Vancouver, and Casey Kaplan Gallery, New York.

Iain Kerr is an itinerant worker in the arts, moving across the spaces of clothing design, architecture, biology, philosophy, geology, and urbanism. He has worked with the international research collective spurse and with J. Morgan Puett on *That Word Which Means Smuggling Across Borders, Incorporated.* Recent works include *Sub-Merging* (Indianapolis Museum of Art), *Sans Terre* (Mass MoCA), and *The Lost Meeting* (with J. Morgan Puett, the Abington Art Center, Jenkintown, Pennsylvania). He has also collaborated with a number of artists including William Pope.L, Mark Dion, Cesare Pietrosti, and Bartow+Metzgar. http://web.mac.com/iain6579/iWeb/iain6579/home.html.

Kimsooja is a multidisciplinary artist born in Taegu, Korea. Incorporating fabric, video, installation, and performance, her work has been exhibited internationally: *To Breathe: A Mirror Woman,* Crystal Palace, Reina Sophia, Madrid; *To Breathe/Respirare* at La Fenice and Fondazione Bevilacqua la Masa, Venice; *Conditions of Humanity,* Contemporary Art Museum of Lyon, France; Museum Kunst Palast, Dusseldorf; PAC Milan; and Rodin Gallery, Seoul. Group shows include the Whitney Biennial, *Cities on the Move, Traditions/Tensions,* and biennials in Kwangju, São Paolo, Syndey, Istanbul, Lyon, and Venice. www.kimsooja.com.

Barbara Layne is an artist and Professor at Concordia University in Montreal. As a member of the Interactive Textiles group at the Hexagram Institute, she works at the intersection of textiles and technology. Recent exhibitions include the *International Biennale of Design,* St. Etienne, France; *About Jacquard,* the Centre for Contemporary Textiles, Montreal; *Intersections,* the Art Gallery at SIGGRAPH, Boston; and *FUTURE TEXTILES: Fast Wear for Sport and Fashion,* the HUB National Centre, Lincolnshire, United Kingdom. Her work has been published in *Techno Textiles 2: Revolutionary Fabrics for Fashion and Design* (Thames & Hudson, 2006) and Telos Art Publishing "Portfolio Collection" series (vol. 19, 2003).

Judith Leemann, Assistant Editor, is an artist, writer, and educator living in Boston, Massachusetts. Recent exhibitions include shows at Lill Street Art Center, Chicago, and Macalester College, St. Paul, Minnesota. She currently teaches at Assumption College in Worcester, Massachusetts, and at the School of the Museum of Fine Arts, Boston. Her writing has recently been published in *LTTR, Textile,* and *Frakcija* performing art journal. She is also the recipient of an Illinois Arts Council Artists Fellowship award. www.judithleemann.com.

Lara Lepionka is an interdisciplinary, community-based artist. Her public projects explore issues of work and labor, and include *Hidden Value,* commissioned by the Northampton Arts Council, and the *Talking Towel Project,* a collaboration with the Cape Ann YMCA supported by a grant from seARTS in Gloucester, Massachusetts. She is a recipient of an Illinois Arts Council Artists Fellowship award, and was an artist-in-residence at the Skowhegan School of Painting and Sculpture, Maine.

Joan Livingstone is an artist and Professor in Fiber and Material Studies and the Undergraduate Division Chair at the School of the Art Institute of Chicago. Her studio practice includes sculpture, installations, curatorial projects, lecturing, and writing. She has had numerous national and international exhibitions including the Tokyo Gei Dai Museum, Japan, the Sonje Museum of Contemporary Art, Korea, and the Musée Cantonal des Beaux-Arts, Lausanne, Switzerland. Her work is in the collections of the Boise Museum of Art, Idaho; Detroit Institute of Arts, Michigan; Metropolitan Museum of Art, New York; and the Museum of Contemporary Art, Chicago. She is the recipient of grants from the Louis Comfort Tiffany Foundation and the National Endowment for the Arts. www.joanlivingstone.com.

Neil MacInnis is an artist and writer living in Toronto, Canada. His studio practice engages the theorization of textiles, technologies, and sexualities through installation works that incorporate selected textile objects and references to create tactile, electronic spaces. Recent exhibitions include *Boys With Needles,* shown at both the Textile Museum of Canada and Museum London. MacInnis has held teaching positions at Concordia University, Montreal, and the University of Toronto, Canada.

Merrill Mason is a multidisciplinary artist and a museum administrator at the Fabric Workshop and Museum, Philadelphia. She has taught at the Maryland Institute College of Art and the University of the Arts in Philadelphia. Upcoming books featuring her work include *Laced With History* (Kohler Arts Center, 2007) and *Reframing Representations of Women: Figuring, Fashioning, Portraiting and Telling in the 'Picturing Women' Project* (Ashgate, 2008). www.synaesthetica.blogspot.com and www.knittingwhilesleeping.blogspot.com.

Margo Mensing is an artist. She collaborated with Debra Fernandez on a 2004 performance of George Crumb's *Makrokosmos III,* initiating the exhibition *A Very Liquid Heaven,* curated by Ian Berry, Margo Mensing, and Mary Crone Odekon at Skidmore College's Tang Teaching Museum. She is currently working with John McQueen on *meta/Metasequoia* for the Morris Arboretum in Philadelphia. She is Associate Professor of Art at Skidmore College, Sarasota Springs, New York.

Darrel Morris is an artist and Adjunct Associate Professor in the Department of Fiber and Material Studies at the School of the Art Institute of Chicago. He has exhibited throughout the United States and Canada, including solo shows in Chicago and New York. His work is published as part of the Telos Art Publishing "Portfolio Collection" series (vol. 33, 2004). He has received the Louis Comfort Tiffany Foundation Fellowship, several Illinois Arts Council Artists Fellowship awards, and the Richard H. Driehaus Foundation Individual Artist Award.

Skye Morrison, Ph.D., is a Canadian folklorist, designer, educator, and curator with international experience in traditional crafts. She has celebrated a love of kites as host of the award winning TVOntario series *Kite Crazy* and upon having her kite stamp selected for Canada Post. After twenty-two years as a professor at Sheridan School of Crafts and Design, Ontario, she chose to pursue research projects, including forming artisan-run women's groups in India, writing a book and film script about traditional kite makers of Gujarat, India, and producing the exhibition and documentary film *Thread Has a Life of Its Own.*

Kevin Murray, Ph.D., is Director of Craft Victoria, Australia, and a curator and freelance writer. His curated exhibitions include *Symmetry: Crafts Meet Kindred Trades and Professions; Turn the Soil: What if Australia had been colonised by someone else?; Water Medicine, Guild Unlimited, Seven Sisters;* and *Common Goods: Cultures Meet Through Craft.* He is editor of *Judgment of Paris: Recent French Thought in a Local Context* (Allen & Unwin, 1991) and author of *Craft Unbound: Make the Common Precious* (Thames & Hudson, 2005). He is also director of the *South Project,* building a cultural highway across the south. Exhibitions and texts are kept online at www.kitezh.com.

Pepón Osorio is a Philadelphia-based artist whose large-scale installations and public works emerge from extensive community interactions and research. Recent exhibitions include *Trials and Turbulence* at Ronald Feldman Gallery, New York, and at the Institute of Contemporary Art, Philadelphia, and *Face to Face* at Bernice Steinbaum Gallery, Miami. His work has been shown at the Whitney Museum of American Art and El Museo del Barrio, New York; the Smithsonian Museum of American Art, Washington, DC; and El Museo de Arte Contemporáneo de Puerto Rico. Osorio has received numerous awards, among them a Skowhegan Medal for Sculpture and a MacArthur Foundation Fellowship.

Sadie Plant is a writer and philosopher living in Birmingham, United Kingdom, whose work investigates the intersection of technology and culture. She was a lecturer in Cultural Studies at the University of Birmingham and research fellow at the University of Warwick, where she established the Cybernetic Culture Research Unit in 1997. In addition to writing for publications as varied as *Financial Times, Adbusters,* and *Wired,* she has published several books including *The Most Radical Gesture: The Situationist International in a Postmodern Age* (Routledge, 1992); *Zeros and Ones: Digital Women and the New Technoculture* (Doubleday, 1997); and *Writing on Drugs* (Faber and Faber Ltd., 1999).

John Ploof is Associate Professor and Chair of the Department of Art Education at the School of the Art Institute of Chicago. An artist/educator/activist who works collectively with his neighbors, Ploof uses visual culture as a tactical means to galvanize group activity. He facilitates participatory design/build processes with urban youth, critically considering issues of social justice and the environment. In solidarity with artists with disabilities at Little City Foundation, Ploof cofounded Artistical Studios. He is a member of Haha, an artists' collective whose work explores and rearticulates social positions relative to particular places. Haha's exhibition venues include the Aperto/Venice Biennale; Grimaldi Forum, Monaco; New Museum of Contemporary Art, New York; Sculpture Chicago's *Culture in Action;* MASS MoCA, and everyday spaces. www.hahahaha.org.

J. Morgan Puett is a transdisciplinary project artist whose work negotiates intersections of history, sociology, economics, architectural practices, and the fashion system. She lectures and teaches, and has exhibited extensively including at the Serpentine Gallery and the Victoria and Albert Museum, London; the Fabric Workshop and Museum, Philadelphia; and Spoleto Festival USA, Charleston, South Carolina. She has also collaborated with Mark Dion, David Lang, Suzanne Bocanegra, and the collective spurse. Her current collaboration with Iain Kerr, *That Word Which Means Smuggling Across Borders, Incorporated* was exhibited at Mass MoCA and the Santa Barbara Contemporary Arts Forum, California. She was the recipient of a 2004 *Anonymous Was a Woman Award.* www.jmorganpuett.com.

Karen Reimer is an artist living in Chicago who has exhibited at the Museum of Contemporary Art, Chicago, and the Maryland Institute College of Art, Baltimore. Her work has appeared in *The New York Times, Art in America,* and *The Chicago Tribune.* Reimer has received both the Richard H. Driehaus Foundation Individual Artist Award and the ArtCouncil Chicago Grants to Individual Artists award. She is represented by moniquemeloche, Chicago.

Sue Rowley is Professor, Pro-Vice Chancellor, and Vice President of Research at the University of Technology, Sydney. She was President of the Australian Council of University Art and Design Schools, Chair of the Board of Object: Australian Centre for Craft and Design, and a member of the Australia Council's Visual Arts and Craft Board National Infrastructure Committee. Her research in contemporary art, craft, and design has resulted in several publications and international touring exhibitions of contemporary Australian art, craft, and design.

Maureen P. Sherlock is a retired philosophy professor, living in Chicago, who has published extensively on contemporary art and culture. She has done catalogues on Dennis Adams (Portikus, Frankfurt); Robert Gober (DIA, New York, and *Arts* and *Sculpture* magazines); Meret Oppenheim (Smithsonian Press); amongst many others. She is currently working on a book on Gober's art and another on the nature of war in the history of art and literature, as well as an extended essay on the graphic art of Chris Ware.

Yinka Shonibare, MBE, is a London-based artist of Nigerian descent. He has gained international attention by exploring issues of race and class through a range of media, including sculpture, painting, photography, and installation art. He was shortlisted for the 2004 Turner Prize for his *Double Dutch* exhibition at the Museum Boijmans Van Beuningen, Rotterdam, and for his solo show at the Stephen Friedman Gallery, London.

Susan Snodgrass, Managing Editor, is a critic, curator, and educator, and a Corresponding Editor to *Art in America*. She is also an editorial board member of *www.artmargins.com,* an on-line publication dedicated to contemporary Central and East European visual culture. She is co-curator of the exhibition *In Between: Art from Poland, 1945-2000,* the first major U.S. survey of postwar and contemporary Polish art. She has instituted courses on the history of women artists at DePaul University and Columbia College, Chicago, and taught seminars in art criticism at the School of the Art Institute of Chicago.

Viji Srinivasan (1938-2005) was the founder and managing director of ADITHI (Agriculture, Dairy, Industry, Tree plantation, Handicrafts, and the Integration of women), a nonprofit organization based in Bihar, India, dedicated to the empowerment of women through the revitalization of their existing skills. She worked for the Ford Foundation and held many important positions advising national and international organizations concerning women's rights. She was on the Board of Directors of Home Net, an international organization of home-based workers. She brought *sujuni* and *khatwa* textiles to international attention through exhibitions in New York, London, and Toronto.

subRosa is a cyberfeminist cell of cultural producers working in the public sphere to explore and critique the intersections of information and biotechnologies in women's bodies, lives, and work. Recent works include *Yes Species,* a performative tableau; *Love is Strong as Death: a Convivial Feast; Epidermic! DIY Cell Lab;* and *Cell Track: Mapping the Appropriation of Life Materials.* subRosa publications include *Domain Errors: Cyberfeminist Practices!* (Autonomedia, 2002). The collective is a recipient of two Pennsylvania Council on the Arts Fellowships and a Creative Capital Foundation Emerging Fields Grant. www.cyberfeminism.net.

Christine Tarkowski is an artist and Assistant Professor in the Department of Fiber and Material Studies at the School of the Art Institute of Chicago. Her architecturally based installations and public works have been exhibited widely, with recent solo exhibitions at the Museum of Contemporary Art, Chicago, and the UCLA Gallery of Architecture and Urban Planning, Los Angeles. She has created commissioned projects at Manilow Sculpture Park, Governors State University, Illinois; Franconia Sculpture Park, Shafer, Minnesota; and Mass MoCA. She has received an Individual Artist Award from the Richard H. Driehaus Foundation and a Creative Capital Foundation Grant.

Laila Tyabji is a freelance designer and writer. She is also a founder, member, and chairperson of DASTKAR, an Indian nongovernmental organization established in 1981 to help craftspeople, especially women, learn to use handwork skills as a means of employment, earning, and independence. She specializes in textile-based crafts, using traditional craft and design as a base for products with contemporary usage and appeal. She writes frequently on crafts, culture, and development, and is currently working on *Threads and Voices,* a book about Indian textile craftspeople. She has also received an Aid to Artisans Preservation of Craft award.

Ann Tyler, Designer, is an artist, artist bookmaker, designer, and writer. Her work is in numerous collections including the Tate Gallery Library, London; the Smithsonian Collection of Prints and Photographs, Washington, DC; and the Museum of Contemporary Art, Chicago. Her design work has received national and international awards and been published widely, appearing in *Communication Arts* and *Print* magazines. Her writing on design is included in *The Idea of Design* (MIT Press, 1995), the journal *Design Issues,* and is forthcoming in *Design Praxis* (Princeton Architectural Press). She is Professor in Visual Communication at the School of the Art Institute of Chicago.

Anne Wilson is an internationally acclaimed Chicago-based artist working primarily with textiles and animation. Her work is in the collections of the Metropolitan Museum of Art and the Art Institute of Chicago, and was included in the 2002 Whitney Biennial. Recent solo exhibitions include the Contemporary Arts Museum Houston and the Museum of Contemporary Art, Chicago. Wilson is the recipient of grants from Artadia and the Tiffany Foundation. She is Professor and Chair of Fiber and Material Studies at the School of the Art Institute of Chicago. www.annewilsonartist.com.

Acknowledgments

Originally conceived as a lecture series, this anthology emerged slowly and somewhat organically over the past ten years. It began in 1996 with an exhibition *The Presence of Touch* curated by Joan Livingstone and Anne Wilson, professors in the Department of Fiber and Material Studies at the School of the Art Institute of Chicago. This exhibition examined the relevance of material culture and the peculiar physicality of textiles and textile processes within the arena of new technologies through installations by nine international artists, a lecture series, and catalogue. The timely and generative character of these issues was extended through the teaching of John Ploof and Joyce Fernandes, who began to grapple alongside graduate students with social and political struggles in the cultural terrain brought on by shifts in the global economy. The confluence of these discussions became the impetus to explore the ways in which our lives and work are increasingly connected, socially, politically, economically, and technologically. They have emerged here in this anthology focused on critical perspectives on art, cloth, and cultural production, which serve as both the background for and an extension of an international symposium entitled *The Object of Labor* to be held in Fall 2007.

The labor of many people has influenced and guided the production of this anthology and accompanying lecture series. We acknowledge the extraordinary thinking, reasoning, and understanding of each contributor whose work has deeply influenced the direction of this volume. We are grateful for their enthusiasm and sustained interest in this venture over many years. Ann Tyler, Designer, has cultivated a comprehensive vision for the anthology while ensuring that each essay and artist project maintains its own visual voice. Susan Snodgrass, Managing Editor, has reviewed all copy insisting on exemplary scholarship, provocative content, consistency, and accuracy throughout the text. Judith Leemann, Assistant Editor, has managed research and innumerable details of correspondence and logistics. She has significantly contributed to several essays and to the Introduction. Kathi Beste, Director of Publications at the School of the Art Institute of Chicago, has expertly supervised all relationships with the printer.

We thank all the people who have assisted in design, editorial, and production: Nancy Bernardo, Marine Bouvier, Suzanne Flemens, Maria Flores, Manda Aufochs Gillespie, Amy Helfand, Amy Honchell, Erin Johnson, Lindsay Packer, Monica Ryan, Sandi Schroeder, Dave Snyder, and Shannon Stratton.

For various kinds of help and advice in developing this book, we thank Sally Alatalo, Paul Elitzik, Glenn Harper, Charles Kernaghan, Trevor Martin, Mary Minch, Sarah Quinton, Susan Rossen, Cynde Schauper, Karen Searle, Robert Sharpe, Kevin Tavin, Rae Ulrich, and Janine Zagel.

We are grateful for administrative support from the School of the Art Institute of Chicago and, in particular, from Tony Jones, President; Carol Becker, Dean of Faculty; Jana Wright, Vice President of Academic Administration; Brian Esker, Vice President of Administration and Finance; and Maria Simon, Associate General Counsel.

We are also grateful for the pivotal support and guidance of those at MIT Press, especially Roger Conover, Executive Editor of Art, Architecture, Visual & Cultural Studies; Susan Clark, Catalogue Manager; and Janet Rossi, Senior Production Coordinator.

Finally, we acknowledge the generous support of the William Bronson and Grayce Slovet Mitchell Lectureship in Fiber and Material Studies, which has made possible both the international symposium and this anthology. These and related programs are additionally supported by the School's Visiting Artist Program, the Department of Fiber and Material Studies, and the Department of Art Education.

We hope this volume is accessible to a broad spectrum of readers and that the diverse perspectives represented here will encourage productive discussion about our common future.

Joan Livingstone, John Ploof

Editorial Note: The editors have deliberately not attempted to obscure the diverse origins of the contributions by imposing a uniform spelling system; instead we have maintained the spelling system of each contributor's language of origin.

Credits

The editors and publisher gratefully acknowledge the following individuals and institutions for permission to reprint images and texts. All rights are reserved by the copyright holders listed below. Permission to reproduce any of these must be obtained directly from the copyright holder. Unless otherwise noted, all images courtesy the artist.

Maureen P. Sherlock, *Piecework: Home, Factory, Studio, Exhibit,* **1, 3, 6, 7, 9, 11, 15, 23–27, 30,** courtesy the author; **10,** reproduced with permission of *The Nation;* **12,** from a 1963 reprint of *Un Autre Monde* by J. J. Grandville; **14,** reprinted by permission of the Van Gogh Museum (Vincent van Gogh Foundation), Amsterdam; **18,** reproduced with permission of *Punch* Ltd; **28,** courtesy the author, photo: Brett Kallusky.

Alan Howard, *Labor, History, and Sweatshops in the New Global Economy,* revised and reprinted with permission from Andrew Ross ed., *No Sweat: Fashion, Free Trade, and the Rights of Garment Workers* (New York: Verso, 1997), pp. 151-72. **31(left), 32(left and right), 35(left and right), 37,** courtesy Brown Brothers; **31(right), 44(left and right),** courtesy the National Labor Committee, photos: Charles Kernaghan.

Karen Reimer, *Work Now,* excerpts reprinted from an interview by Julie Farstad, in *mouthtomouth* vol. 1, no. 2 (winter 2003), pp. 30-38. Images courtesy moniquemeloche, Chicago, photos: Tom Van Eynde.

Margo Mensing, *Lace Curtains for Troy,* **89, 98-102, 104,** photos: Arthur Evans; **91, 94, 95, 96, 103,** photos: Margo Mensing.

Carol Becker, *Amazwi Abesifazane: Voices of Women,* photos: Michael Tropea.

Andries Botha, *Amazwi Abesifazane: Reclaiming the Emotional and Public Self,* images courtesy Create Africa South.

Lara Lepionka, *Visible Links,* **143, 144, 147, 148, 149(bottom left),** photos: Lara Lepionka; **145, 146, 149,** courtesy of: Marcona Ocean Industries, International Longshoremen's Association Local #1804, Mobil Chemical Corporation, Samancor Mining Company, Mediterranean Shipping Company, Libbey Glass, Inc.

Viji Srinivasan, Dr. Skye Morrison, Laila Tyabji, and Dorothy Caldwell, *Stitching Women's Lives: Sujuni and Khatwa from Bihar, India,* reprinted from exhibition catalogue for *Stitching Women's Lives: Sujuni and Khatwa from Bihar, India,* by permission of the Textile Museum of Canada, Toronto, and individual authors. Photos: Eric Harris, Soft Science, Inc.

Lou Cabeen, *Home Work,* **198, 205, 217,** photos: Lynn Thompson; **202, 206, 209, 214,** courtesy Special Collections, University of Washington Libraries.

Brian Jungen, *from Prototypes for New Understanding,* excerpted from Trevor Smith, *Brian Jungen,* New Museum of Contemporary Art, New York, www.newmuseum.org/more_exh_jungen05.htm. Images courtesy Catriona Jeffries Gallery, Vancouver.

Susie Brandt, *Sew Your Own Stump Flag,* reprinted from exhibition brochure *Adirondackland* by permission of the Richard F. Brush Art Gallery, St. Lawrence University, Canton, New York.

Pepón Osorio, *from Trials and Turbulence,* adapted from Ingrid Schaffner, in exhibition catalogue for *Trials and Turbulence: Pepón Osorio, An Artist in Residence at DHS,* Institute of Contemporary Art, Pennsylvania. Images courtesy the Institute of Contemporary Art, University of Pennsylvania, and Ronald Feldman Fine Arts, New York, photos: Aaron Igler.

Nancy Gildart, *Torn and Mended: Textile Actions at Ground Zero and Beyond,* **239, 242, 246, 250, 253, 254,** photos: Paul Fetters; **241,** photo: Joan Livingstone; **243,** photo © Krystyna Sanderson, 2001; **251,** photo: Nancy Gildart.

Sadie Plant, *Ada Lovelace and the Loom of Life,* images reprinted by permission of the Science and Society Picture Library, London.

Lia Cook, *Hands on Spots,* **265-267,** courtesy John T. Hardaker Ltd., Bradford, UK; **268-270,** courtesy the artist; **271,** photo: Dana Davis.

Alison Ferris, *Biting and Chewing in Contemporary Art,* 273, 279, courtesy Matthew Marks Gallery, New York; **276,** courtesy Acconci Studio, photo: Bill Beckley; **277,** courtesy Luhring Augustine, New York, photo: Brian Forest.

Nick Cave, *from SOUNDSUITS,* photos: James Prinz.

Janis Jefferies, *Laboured Cloth: Translations of Hybridity in Contemporary Art,* **286, 287,** courtesy the author; **288,** courtesy Ikon Gallery; **291,** courtesy Whitechapel Art Gallery, London, photo: Janis Jefferies; **292,** courtesy Stephen Friedman Gallery, London, and James Cohan Gallery, New York, photo: Stephen White.

Yinka Shonibare, MBE, *from Big Boy, Leisure Lady, Gay Victorians,* excerpted from an interview with Janet Kaplan, "Give & Take Conversations," *Art Journal,* vol. 61, no. 2 (summer 2002), p. 82. **295, 296,** courtesy Stephen Friedman Gallery, London, and James Cohan Gallery; **296(top),** photo: Ahlburg Keate Photography.

Kimsooja, *from Cities on the Move,* excerpted from www.kimsooja.com/texts.html. Original text by Yilmaz Dziewior appeared in the exhibition catalogue *Art-Worlds in Dialogue: From Gauguin to the Global Present* (Museum Ludwig Cologne, 2000). **297,** courtesy the artist; **298(top),** photo: Lee Sang Gil; **298(bottom),** courtesy Samsung Museum, Seoul, photo: Kim Hyun Soo.

Mary Jane Jacob, *Material with a Memory,* **302, 303, 309, 312, 313,** photos: John McWilliams, McClellanville, SC; **306, 310,** photos: Simon Upton, London.

bell hooks, *An Aesthetic of Blackness: strange and oppositional* and *Aesthetic Inheritances: history worked by hand,* reprinted from bell hooks, *Yearning: Race, Gender and Cultural Politics* (Boston, MA: South End Press, 1990), pp. 103-22. Image Faith Ringgold © 1991.

Ann Hamilton, *from indigo blue,* photos: John McWilliams.

Neil MacInnis, in collaboration with Judith Leemann, *Deco-jamming is Eco-glam!* Every attempt has been made to contact the copyright holders for permission to use film stills.

Ingrid Bachmann, *Hand Labour and Digital Capitalism at the Chicago Board of Trade,* images courtesy the Chicago Board of Trade.

Merrill Mason, *Iron Into Lace,* **369, 370, 375,** photos: Aaron Igler; **371-374,** photos: Merrill Mason, in collaboration with Aaron Igler.

Kevin Murray, *Artist as Insect,* **337, 380, 382, 383, 385, 390, 391, 392,** reprinted by permission of the Science and Society Picture Library, London; **384, 389,** courtesy the author; **387(top and bottom),** courtesy the artist; **390, 391(top and bottom),** photo: Lynn Thompson.

Index

Abraham, Nabeel, 247
abstract aestheticism, 317
abstract appliqués, 160
abstract art, 21
abstract capital, 15, 16–17
abused children, 238
Acconci, Vito, xi, 275–276, 280
accountability, in underground economy, 77–78
Acts of Resistance: Against the Tyranny of the Market, 28–29
Adam and Eve, 273
Adirondack Park, tourism at, 234
ADITHI, 159, 163, 175, 176, 178; *khatwa* project of, 160; *sujuni* project of, 160
Adorno, Theodor, 18, 360
The Aeneid, 379
aesthetic inheritances, 326–332
aestheticism, abstract, 317
aesthetic reactionaries, 14
aesthetics, xii, 203, 205–206, 316–317; African-American, 317; Arts and Crafts, 203, 207–208; black, 319; *Craftsman,* 208; design, 207; intersection with race, xii; oppositional, 324–325; radical, xii–xiii
aesthetic value, 328
Afghans for Afghans, 251
Afghanistan, textile actions and, 250–251
Afghan war rug, 28
African-American aesthetics, 317
African-American art, 319
African-American folk culture, 318
"African" cloth, 293, 294, 296, 303, 305
African National Congress, 127; establishment of Truth and Reconciliation Commission, 114–115
After Stonewall (film), 340
Akbar, Shireen, 291
Albert, Prince, liberal internationalism of, 19–20
Alexander, Leigh, 307
alienated labour, 290
alienation, 290
Allen, Max, 250
Allowed to Open the Door, 156
Amalgamated Clothing and Textile Workers Union, 8, 34, 48
Ambition, 198
American flag, textile actions involving, 246–249
American Samplers (Bolton and Coe), 197
American Thread Company, 212
The American Woman's Home (Beecher and Stowe), 201
Analytical Engine, xi, 260, 262, 263–264
And Our Faces, My Heart, Brief as Photos, 289–290
Animal Architecture (Frisch), 378
Ansonborough, 309
Antoni, Janine, xi, 279–290, 280
appliqués, 208; abstract, 160
Archana, 172
Arrow collars, 97
art: abstract, 21; African-American, 319; body, 275; as a commodity, 7; conceptual, 275, 276; depicting and exploring food in, xi,

273–280; embroidery as form of, 201, 203; folk, 328; high, 318; hive, 387–389; insect, xiii, 377–392; intersection of commerce and, 1, 163–164; market-friendly, 18; neo-conceptual, 3; original work of, 171; philanthropy and, 203–204; political, 18, 317; pop, 3; in public sphere, 3; time-intensive works of, 217; worked, 197–218
Art and Revolution (Berger), 320–321
art bias of originality, 216
art criticism, 7; Western, 171
Art Deco, 357, 367
art economies, 6
art embroidery, 201, 203, 204, 208–209
Artforum, 278
art history, 2; Western, 302
artisans, fusing role of artists and, 198, 210
artist(s): autonomy of, 380; classes of, 6; fusing role of artisan and, 198, 210; as heroes, 381; isolation of, 6; origin of solitary, 380; subjectivity and creativity of, 17
artist-in-residence, experiences as, xiii, 370–376
Artists in Aprons: Folk Art by American Women, 328
arts, performance, 318
Arts and Crafts movement, 3, 203, 207–208, 215–216
Arts Center of the Capital Region, viii, 89–90, 101–104
art schools, 2–3
art training for women, 203
Asia Society of New York, 164
Astarte Syriaca, 274
"At Amaoti, Inanda, in October 1997," 121, 122
Atget, Eugene, 26
Auslander, Leora, 22
authenticity, 78, 172

Babbage, Charles, xi, 260–264, 383
Badla, 174
bandages, metaphor of, 252–253, 351
Bangladesh: factories in, 291–292; field work in, 290; garment industry in, 291
Bangladeshi Institute of Development Studies, 291
base, distinction between superstructure and, 360, 361–362
batik, xii, 293, 302–306; Victorian costumes made from, 295–296
Beecher, Catherine, 201
Belding Brothers and Company, 211
Bell, Daniel, 5
Bell, Rosa, 330
Ben, Ramba, 174
Berger, John, 289–290, 320–321
Berry, Ian, 103
Bhimji, Zarina, xii, 284, 288–289, 294
Bhusura cooperative, 167–168
Bhusura Mahila Vikas Samiti (Bhusura Women's Self-Help Group), 167
Bidgood, James, 344
Bihar, India, textile traditions in, ix–x, 159–180
Bing, Xu, 385
biting, 273–280

black aesthetics, 319, 321–322
Black Arts Movement, 319, 320
black cultural nationalism, 321; links between revolutionary politics and, 320
black cultural production, 323
Black Fire (Stewart), 319
black liberation, xii
black power movement, 319
Blair, David, 387
Bloomer, Amelia, 92
bloomers, 92, 95, 99
Body Art, 275
Bolton, Stanwood, 197
Bonney breeches, 307
Boris, Eileen, 202, 207
"The Borough Houses," 309, 312, 313
Bosch, Hieronymus, 274
bottari, xii, 298, 311
Bourdieu, Pierre, 5, 28–29
Boys Don't Cry (film), 337, 349–353
Brainerd and Armstrong Company, 205, 206–207, 210, 211, 212
Brandeis, Louis D., 34
Braudel, Fernand, 259
Braxton, Catherine, 309, 312
Breugal, Pieter, 273
bricolage, 240–241
Brinley, Katherine Sanger, 208–209
British Arts and Crafts Movement, 198
British High Commission, commission of sujunis, 167
Bronson, Po, 379
bubble economy, growth of, 18
Budd, Ann, 250
bulletproof vests, 100
burning, metaphor of, 289
Bush, George W., 20
Byron, Annabella, 261
Byron, Lord, 261

Caldwell, Dorothy, ix–x, 160, 164, 177–180
Campbell, Rebecca, 309, 311–312
Canetti, Elias, 382
Can I Help You?, 153
capital, 3; abstract, 15, 16–17; contradiction of utopia and, 14–15; cultural, 5, 6; industrial, 10, 11; late, 6, 11; predatory nature of, 26
Capital (Marx), 12
capitalism, 14, 284; cloth, 258–259; consumer, 317; defined, 135; digital, 357–368; examining, 9–10; global, vi–vii, x; industrial, 301, 359–360; late, 2; pace of, vii
Capitalism and Material Life, 259
Caribbean Basin Initiative, 47, 75
Celtic borders, 160
chain stitch, 160
chaos theory, 381
Chaplin, Charlie, 15
Charleston: Latina and African-American domestics in, 306; role of, in story of slavery, 305; Spoleto Festival in, 300–301, 336
Charleston project, 311
Charterist Movement, 19–20

Chatham, New York, PABKA factory in, 90–92
Chen, David W., 247
chewing, xi, 273–280
Chicago art world, vibrancy of, 6
Chicago Board of Trade, xiii, 357–358
China, People's Republic of: industrial capital in, 10; unions in, 73
Chin-tao, Wu, 22
A Chronicle of Days, viii–ix, 105–112, 386
Cibachromes, 3
circular warps, 257
Clark (thread company), 212
class distinction, 199
Clinton, Bill, labor relations and, 45
cloak makers, strike by, 34
cloth: archetypal power of, 309; cut, 310; dual nature of, 350–351; emergent meanings of, 301; ever-evolving meaning and value of, xii; found and made, xii, 197–218; as medium of cultural memory, 299–300; painted, 302; regenerative power of, 309–310; relationship of women to, 306; role of, in daily life, 299; social history of, 284; as source of wealth, 310; time and, 311; ubiquity of, in everyday life, vi; whole, 177. See also fabric(s)
cloth bundles, 298
cloth capitalism, 258–259
clothing: as metaphor, 288–289; as unpredictable commodity, 31
cloth trade, fluctuation of, 95
Cluett, George B., Brothers & Company, 97
Cluett, Peabody & Company, 97–98
Cluett, Sanford, 97
Cluett Brothers and Company, 89
Coca-Cola, 15–16
Coe, Eva Johnston, 197
Collar City, viii
collars: Arrow, 97; invention of detachable, 89, 96, 98, 100; lace, xiii; Sherwood, 98, 101; t-shirt, 98
Collingbourne's, 214
Coltrane, John, 324–325
commerce, intersection of art and, 1, 163–164
commodity chains, vii, 38
Commons, John R., 33
communication devices, 377
Company Picnic, 155
computing machines, influence of textile technologies on, xi
conceptual art, ix, 275, 276
consumer atomism, 19
consumer capitalism, 317
Corcoran Gallery of Art, 253
corporate cartels, 17
Cotán, Juan Sánchez, 273
Cottage Industry, xii, 306–310
cotton production, regional labor history of, xii–xiii
Coulome, Théodore, 103–104
Courage, 243, 244
Courbet, Gustave, 30
Cow Dung Sujuni, 168
crafts, textile as, 197
The Craftsman, 207, 208–209
Craftsman aesthetics, 208
Craftsman-style embroidery, 207–208

craft traditions, 174
Create Africa South, 116, 119, 139; *Amazwi Abesifazane* project of, ix–x, 113–130, 131–142; "Know Your Body" project, 119
Creative Time, 240
creativity, 377, 378, 381, 388–389, 392
cross-border links, in international trade and finance, vi
Crystal Palace, 2, 19
cultural capital, 5, 6
cultural decolonization, 322
cultural force, role of representation as a, 355–356
cultural hybridity, xii
cultural operations, privatizing of, 6–7
cultural profiteering, 22
Culture Jamming: Hacking, Slashing, and Sniping in the Empire of Signs (Dery), 338
cut cloth, 310

Daddy, 152
Damasio, Antonio, 365
Danto, Arthur, 299
darning stitch, 208, 210
DASTKAR, 173–176, 175, 176
da Vinci, Leonardo, 258, 273
"A Day I Will Never Forget," 116
day laborers, 1
de Certeau, Michel, 13
DeChamplain, Mitties, 245
Deco-jamming, 339, 340, 346, 347–348, 352, 354
decorative flags, do-it-yourself guide to sewing, x, 229–234
decorativist interventions, 339, 343
Le Déjeuner sur l'herbe, 273
De Klerk, 113
Deleuze, Gilles, 286
Dery, Mark, 338
Descartes' Error: Emotion, Reason, and the Human Brain (Damasio), 365
design, originality of, 205, 206, 213–214
design aesthetics, 207
detachable collar: history of, 90; invention of, 89, 96, 98, 100
The Development of Embroidery (Wheeler), 201
Devi, Ganga, 165
Devi, Geeta, 173
Devi, Nirmala, 177
dhotis, 177
Difference Engine, 260
digital capitalism, 357–368
digitized photography, 3
dishtowels, 197
Dislocutions: Interim Entries for a Dictionaries Elementaire on Cultural Translation, 290
dissociative fragmentation, 16
Dlamini, Thabisile, 120
dobby loom, 391
doilies, 197
Dolores, 274
domestic imaginary, 24
drawlooms, 258, 259
Drayton family history, 311–312
Drayton Hall, 311; memorial carpets for, xii, 312–314
Dressing Down, 292

dress shirt, evolution of men's, 98
Duma, Lindiwe, 126
dung, 170
dupatta, 171
Duprat, Hubert, 383–384
Durban Art Gallery, 118
Dürer, Albrecht, 273
Dutch wax-printed fabric, 303
dye-resist patterns, 303

Echaveste, Maria, 76
Eckes, Alfred E., 39
Eco-glam, 339, 340, 348, 354
economy: bubble, 18; capitalist, 284; global, viii, 31–50; underground, 77–78
Ehrenreich, Barbara, vi
electronic arts, 387
embroidered cotton, 204
embroidered dresser scarves, 198
embroidered pillowcases, 198
embroidered runners, 197, 198
embroidered tablecloths, 197
embroiders: elimination of self-expression, 197–198; secret remorse of, 206
embroidery, x; art, 201, 203, 208–209; *Craftsman*-style, 207–208; as female trade, 199; on found art, xii, 197–218; history of, 199; *khatwa* as, 160; medieval, 200; Mennonite view of, for women, 59; middle-class, 198, 201; stamped, x, 197; stereotype of, as female creative outlet, 199–200; *sujuni* as form of, 159–160
Embroidery Lessons with Color Studies, 205
embroidery stitches: chain, 160; circular blanket, 174; darning, 208, 210; outline, 210; running, 208; straight, 160
employer sanctions, 42
"end of art" rhetoric, 18
English Medieval Embroidery (Hartshorne), 199–200
Enlightenment, 13, 28–29
entomorphosis, artistic creativity in, xiii, 383
Etheridge, Melissa, 340
ethnic fabrics, 293
European Union, 47
Evans, Walker, 306
Exchange Movement, 213
exhibition/hotel promotions, growth of, 17
"Expositions of Economic Horrors," 27

fabric(s): batik, xi, 293, 295–296, 296, 302–306; Dutch wax-printed, 303; ethnic, 293; hybrid, 293; origins of, 296. See also cloth
Fabric Workshop and Museum in Philadelphia, 304
Face to Face, 235, 236, 237, 238
family wage, 73
fancy work, 202
Farstad, Julie, conversation with Reimer, Karen, 59–65
fashion, fates of, 2
Finley, John, 329–330
First Amendment Rights, 248
folk art, 328
food, depicting and exploring, in art, xi, 273–280

Ford Foundation, 164; commission of *sujunis*, 167
foreign zones, contracting out work to, 38–39
Foster, A. B., 386
Foster, Hal, 322
foster care system, xi, 238
found and made cloth, xii, 197–218
Frazier, Laura Margaret, 221
free trade, 20, 43
French Revolution, 21
Freud, Anna, 255
Freud, Sigmund, 255–256, 258, 264; biting, chewing and, 276–277;
 destruction of memory and, 285
Fridae, Rebecca, 247
Friedman, Thomas L., 20
Frisch, Karl von, 378
futures trading, 357, 363–364

Gallantry and Criminal Conversation, 293–294
Galliano, John, 290
Gambushe, Eunice, 134
Gandhi, 304
The Gap, 45, 46
Garçons, Comme des, 290
The Garden of Earthly Delights: Hell, 274
Gardner, Jefferson, 96–97
garment industry: decline of, in Hudson Valley region, viii; geographic distribution of production in, viii, 81–88; globalization of, 37–41, 71; immigrants in, viii, 36–37, 41–44; low-paid workers in, 39; organization of workers in, vii, 36–37; outsourcing of American jobs, 8; patterns in, 49; sweatshops in, 31–50; unions in, 48, 49–50
gay liberation movement, x
gay men, work clothes and, x
Gay Victorians, 296
Generalized System of Preferences (GSP), 47
geographic distribution of production, viii, 81–88
Georgian Palladian architecture, 311
Ghosh, Shirsendu, 178
Gibson, Charles Dana, 8
Gibson girl, 8
Gifford, Kathie Lee, 45, 46, 49
global capitalism, vi–vii, x
global economy: sweatshops in new, 31–50; systems of, viii
globalization: beneficiaries of, 40; of garment industry, 37–41, 71; as international phenomenon, vi; of labor, 78; visible links in, ix, 143–150
Gnaw, 279–290
Godey's Ladies Book, 202
goods, high-end, 13
Gordon, Jesse, 10
Great Exhibition of the Works of Industry of All Nations, 19
Greeley, Eva R., 209
Greeley, Horace, 97
Green, Nancy L., 11
Greenberg, Clement, 380
Ground Zero, textile actions at, xi, 239–254
Grundrisse, Marx Beyond Marx, 3
Guggenheim Museum, 22
gunboat diplomacy, 20

Haacke, Hans, 5
Hae-Nyos (sea girls), image of, in Korea, 67
Hair Inquiry, 386
Hall, Stuart, 284
hand labour, 357–368
Handsa, Nirmala, 170, 172
Hardaker Jacquard, 265–270
Harden, Blaine, 247
Harlem Renaissance, 318
Harris, Anne, 274
Harris, Lyndon, 243–244
Hart, Schaffner, and Marx firm, 34
Hartshorne, C. H., 199–200
Hawkers and Vendors Khatwa, 168, 170–171
Hayles, N. Katherine, 360
Hegel, 381
Hickey, Dave, 18
high art, 318
Hine, Lewis, 26, 306
Hinman, Tommy, 90–91
The History of Insects (Paley), 378
History Responds project, 243
hive art, 387–389
hive metaphor, 382
Holabird and Root (architectural firm), 367
Home Needlework Magazine, 212
homework, 34
Hooks, Bell Blair, 326–327
Hopper, Grace Murray, 264
Horn, Roni, 278, 280
How Societies Remember (Connerton), 129
The Humane Village, 170
human labour, 358
hybrid African fabrics, 296
hybridity, 283–294; cultural, xii; questions of, 284
Hyde, Lewis, 300, 314

I Fell Asleep, 286
Immediate Family, 278
immigrants: in apparel industry, viii, 36–37, 41–44; employment of, in sweatshops, 33, 34; illegal, 1
Immigration Reform and Control Act (1986), 42
indentured labor, 38
India, textile traditions in, ix–x, 159–180
indigenous women, undocumented lives of, in South Africa, 115–130
indigo production, regional labor history of, xii–xiii
industrial capital, in China, 10
industrial capitalism, 301, 359–360
industrial labour, 358, 359
industrial machines, time-saving devices on, 91–92
Industrial Revolution, 258–259
industry. See apparel industry
Inkatha Freedom Party (IFP), 127
In Praise of Shadows (Tanizaki), 325
insect art, xiii, 377–392
Institute of Contemporary Art: *Face to Face* at, 235, 236, 237, 238; *Trials and Turbulence* at, 235, 238

Intellectual and Manual Labour: a Critique of Epistemology, 16
International Labor Organization (ILO), 46
international labor standards, lack of, 43
International Ladies' Garment Workers' Union (ILGWU), 8, 29, 34, 48; membership of, 35
international trade and finance, cross-border links in, vi
"The Interventionists: Art in the Social Sphere," 88
Interview, 154
Interweave Knits, 250
Irigaray, Luce, 286
Item 807, 75
I WANT, 103–104
I Will Always Be There, 288

Jacquard, Joseph-Marie, xi, 260, 262, 263, 272
Jacquard loom, 256, 260, 272
Jacquard punch card system, 272
jacquard technology, in creating realistic images, xi, 265–272
James, Henry, 380
James, Wilmot, 113
Jameson, Fredric, 361–362
Jaures, Jean, 26
Jesse Bites, 278, 279
Jharkland, India, textile traditions in, ix–x, 159–180
jobbers, 11, 36, 38
Johnson, Richard, vi
joint liability, union's success in establishing, in women's clothing, 36
Jones, Lois Mailou, 318
J & P Coats (thread company), 212

Kaczynski, Theodore, 390–391
kantha, 159, 177; radiating motifs in, 160; stitching in, 180
Kantha wall hanging, 291
Karenga, Maulana, 319
Kawakubo, Rei, 290
Kelly, Kevin, 382
Kelly, Mary, 275
Kendall, Bobby, 345–348
Kentucky Quilts, 329
Kerr, Iain, vii–viii
khatwa: colours of, 175–176; commissioning of, 164; contemporary, 160; as form of cultural expression, 168; as income-generating project, 161–162, 165; investigation of stitch in, 180; material used in, 160, 171; revival of, 172; signing of, 171; subject of, 171; success of, in international markets, 171; techniques in, 175
khatwa project, introduction of, by ADITHI, 160
Khatwa self-help groups, development of, 167–168
Khumalo, Thobile, 124
Kimsooja, xii, 297–298, 300, 311–314
King, Martin Luther, 354
Kingsolver, Barbara, 248–249
Klein, Melanie, 277–278
Klein, Naomi, 338
Koenig, Susan, 250–251
Kohler, John Michael, Arts Center Arts/Industry Program, 370–376
Kohler Company, artist-in-residence at, xiii, 370–376
Komar, 388
Koons, Jeff, 2
Korea: mythology in, viii; unions in, 73

Korean-American women: labor of, 71; shifting identities of, 71
Korean refugees, cloth bundles used by, xii
Krathaus, Alan, 103–104
Kravis, Henry, 40
Krens, Thomas, 22
Krisniski, Claudia, 249–250
Kristeva, Julia, 290
Kumari, Archana, 162
kurtas, 288
Kuspit, Donald, 18
KwaZulu-Natal, 124

Labor, U.S. Department of: invoking of "hot goods" provision, 76; monitoring of industries by, 76
labor/labour: abstract, 16; alienated, 290; child, 1; globalization of, 78; hand, 357–368; human, 358; indentured, 38; industrial, 358, 359; manual, 360; mental, 360; organized, vii
Labor of Love, 217
labor segmentation, 16
labor unions: in apparel industry, 48, 49–50; in Asia, 73; collapse of, 8; need for, 8
lace collar, xiii
lace making, 342
lachrymatories, 386
Ladder of Life, 250, 251
Ladies Home Journal, 212
laissez-faire ideology, 37
laissez-faire market, 20, 21
Lajer-Burcharth, Ewa, 279
La Mode, 1–2, 11
Lange, Dorothea, 306
Langtry, Lily, 204
Language Lost, 385
Last Supper, 273
late capitalism, 2
Laundry Bundles II, 286, 287
Layne, Barbara, x, 181–188
Leebaert, Derek, 382
Leisure Lady, 296
Leitch, Christopher, 384
Lepionka, Lara, ix, 143–150
Lèvy, Pierre, 383
A Lighthouse Woman, 313, 314
Linda, Muriel, 121, 122, 123
Little Bathers, 274
Litvak, Joe, 277
Living in Afghanistan, 250–251
Look for the Union Label, 34
Lovelace, Ada, 261–264

macadamisation, 381
Machine Dreams (film), viii, 67–80; stills from, 67, 69, 70, 72, 76, 77
MacLaury, Kelly, 99
"Made in U.S.A." label, 95
Madhubani painting, 165
Maeterlinck, Maurice, 379
maquilas, 40
Maharaj, Sarat, xii, 289, 290, 300

Mahila Harit Kala (Eco-Friendly Store), 164, 167, 178
Main Boss, 156
Maines, Rachel, 211
malediction, 280
Maleuvre, Didier, 23
Manet, Édouard, 273
Mann, Sally, 278, 280
Manny, Raymond, 92
Manny & Rielly, 92
maquiladoras, 75, 82
market-friendly art, 18
Mark I, 264
Marling, Karal Ann, 252
Mars Attacks (film), 380
Marx, Karl, 3, 11, 12–13, 16, 19, 28, 290, 361
Massachusetts Museum of Contemporary Art, vii–viii; *Can You See Us Now? ¿Ya Nos Pueden Ver?* installation, viii, 81–88; *That Word Which Means Smuggling Across Borders, Incorporated: The Multipled Suit* installation at, vii–viii, 51–58
mastication, act of, xi
material arts, 387
material culture, investigation of, xi
Matrix (film), 380
Mazur, Jay, 48
McDaniel, George, 312
Mdlolo, Florence, 114, 127–130
Meckler, Nancy, 340, 342
medieval embroidery, 200
Melamid, 388
memorial carpets, xii, 312–314
memory cloths, ix–x, 113–130, 131–142; archival information in, 118–119; colored beads on, 116; colors of, 117–118; as cumulative archive, 119; designing and producing, 129–130; embroidery on, 116; images on, 117–118, 126–127; material of, 117; red thread weavings in, 125; stories represented on, 120–130; viewing, 118
Menebrea, Louis, 261–262
Mennonite view of work ethic, 59–65
Mensing, Margo, viii, 89–104
mental labour, 360
Mercer, Kobena, xii, 293
metaphors: of bandages, 252–253, 351; bottari as, 298; of burning, 289; of clothing, 288–289; hive, 382; insect, 387–388; textiles as, xii, 284; visual, 276; weaving, 299
Metropolitan Museum of Art, 2, 21
Mexico: Border Industrialization Program in; *maquiladoras* in, 75, 82
Mhlongo, Joyce, 139
middle-class women: embroidery of, 198, 201; productive role of, 23
Middle Passage, 313
Mid Management, 157
Miller, Mindy Yan, xii, 284, 286–288, 294
minimalism, 325
Mirandi, Salma, 174
mirror work, 174
Mithila painting, 165
Mize, Mahulda, 329–330
Mkhulise, Mildred, 123–124
The Modern Priscilla, 206, 209, 210–211, 212, 213, 214
Montague, Hannah Lord, invention of detachable collar, 96, 100

Montague, Orlando, 100
Morris, Darrell, ix, 151–158
Morris, William, 14, 172
Morrison, Skye, ix–x, 160, 163–172, 178
Moses, Tai, 247–248
The Most Wanted Paintings, 388
Mthiyane, Lillian, 136
multinational corporations, vi, xiv
multipled suit, 51–58; origins of, vii–viii
Mulvey, Laura, 319
Mumford, Lewis, 378
Munch, Edvard, 274
Museum for Textiles, *Stitching Women's Lives: Sujuni and Khatwa from Bihar, India* exhibit at, 160
museums: capital development at, 22; series of changes in, 20–21

NAMES Project AIDS Quilt, 240, 388–389
narratage, 172
narration, simple linear, 264
National Film Board of Canada, *Who's Counting? Marilyn Waring on Sex, Lies & Global Economics*, 169–170
National Labor Committee, 45
naturalism, 320
Ndebele, Njabulo, 116, 121, 123, 125
Neal, Larry, 319
Needlecraft, 212
Needle Woman, 311
needlework threads, 198
Negri, Antonio, 3
Nekrassova, Natalia, 250
neo-conceptual art, 3
Neo-Darwinism, 381
New Deal, 45, 50
New Museum of Contemporary Art, *Prototypes for New Understanding* at, x, 227–228
New World Order, 47
New York Exchange for Women's Work, 203–204
New York Historical Society, History Responds project at, 243
New York Society of Decorative Art, 203, 204
Next Generation series of *Star Trek*, 380
Nice Hat, 90, 91
Nicolosi, Josephine, 29
Nightingale, Florence, 354
Nike "mask" sculptures, x, 228
Nike plants, workers at, 45
Nissard, Charles, 3
Nixon, Mignon, 277–278
No Logo (Klein), 338
Nonotuck Silk Company, 211
North American Free Trade Agreement (NAFTA), 43, 47, 76
North American quilts, 171, 180
Nyembezi, Elsie, 124
Nzimonde, Thuleleni, 136

O'Dell, Kathy, 275
Of Weddings and Puppet Shows: Wall Hanging, 174
Oldham, Sarah Hooks, 326–327
O'Leary, Daniel, 5, 33, 48–49
Olsen, Tillie, 30

The Opening, 385
open outcry, 357, 364
open-source software, 382
oppositional aesthetics, 324–325
organized labor, intertwined coevolution of, with apparel industry, vii
originality: art bias of, 216; call for, in design, 205, 206, 213–214
Osborne, Peter, 24
outline stitch, 210
Out of Control: The New Biology of Machines (Kelly), 382
Out of the Sweatshop (Stein), 32–33

PABKA, Inc., 90–92, 95, 98–99, 101
painted cloth, 302
Paley, William, 378
Palmerston, Lord, 20
Papastergiadis, 283
PATCO strike (1981), 43
patriotism, new narrative of, 19–20
Paul-Majumder, Pratima, 291
Peirce, Kimberly, 349, 353–354
performance arts, 318
Perkins, Frances, 35
Persistent Data Confidante, 388
Pétroleuses, 30
philanthropy, art and, 203–204
photography, tenement, 26
piecework, vii, 1–30, 75; traditional, 7–8
Pinckney, Eliza Lucas, 307
Pink Narcissus (film), 337, 344–348, 352
Pirsig, Robert, 379–380
Planet IndigenUs, 164
Planted Names, xii, 311–314
Plato, 28, 299
poetic allusions, 379
political art, 18, 317
The Politics of Translation, 290
Pollock, Jackson, 385
Pondick, Rona, 274
pop art, 3
Portrait: Snake Eyes, 274
"Portraits of Grief" *(The New York Times)*, 240
Portrait with Pink Eyelids, 274
postcolonialism, xii
postmodernism, 300
poverty, 6
power looms, 259–260
Powers, Harriet, 328–329
pre-capitalist values, 14
price discovery, 363–364
Princess Feathers with Oak Leaves, 329
private galleries, 7
Progressive Era, 50
Prophet, Jane, 388
proprioception, 364
protectionism, evils of, 43
protective armor, 100
Protocol of Peace, 34, 45
Puett, J. Morgan, vii–viii, xii, 300, 306–310, 311–312, 314
Punch (periodical), 19–20

Purdah, 163

queer labour, 337, 338
quilts, 32; making, 326–332; NAMES Project AIDS, 240, 388–389; North American, 171, 180; patterns of, 332

racism, 323
radical aesthetic, xii–xiii
reading, play between subjective and objective modes of, viii, 65
Reagan, Nancy, 21
Reagan, Ronald: labor movement under, 8, 43; presidency of, 21, 39
realism, 320
Redick, Cynthia, 329
Reimer, Karen, viii; conversation with Farstad, Julie and, 59–65
Renaissance, 380
Rensselaer County Center for the Arts, 89, 90, 99; *Showroom* exhibition at, 90
Rensselaer County Historical Society, 90
representation, role of, as a cultural force, 355–356
revolutionary politics, links between black cultural nationalism and, 320
ribbons, wearing of, as textile action, 241–242
Richardson Silk Company, 211
Rielly, Chris, 90–92, 94, 95, 98–99
Rielly, Gerard, 93
Rielly, Joseph, 92–93
Rielly & Company, 90, 92–93; folding of, 94
Riis, Jacob, 26
Rilke, Rainer Maria, 380
Rimbaud, 3
Ringgold, Faith, 326, 330, 332
The River is Not Sacred for Her Purity, but for Her Acceptance of It All (Leitch and Sabato), 384–385
Robeson, Paul, 318
Rodin, 380
Romanticism, 14, 21
Rossetti, Dante Gabriel, 274
Rousseau, Jean-Jacques, 13
Royal School of Needlework, 203, 204, 210
Rubin, Ann, 251
Rugmark, 46
Run Mikey Run, 238
running stitch, 208
Rushdie, Salman, 283, 294

Sabato, Stephanie, 384
Sag, Dave, 385
St. Laurent, Yves, 21
St. Paul's Chapel, 240, 242–243, 254; *Unwavering Spirit: Hope and Healing at Ground Zero* exhibit, 245
Salazar, Kim Brody, 250, 251
Sam Overton, 151, 154
Sanctuary, 205, 217
sandbags, xiii–ix
Sanderson, Krystyna, 243, 244
Sankenshi, 383
Santos, Boaventura de Sousa, vi

sari, 171, 177
Saxon, Sue, 386–387
Scapegoat, 41–42
Schelling, Friedrich, 385–386
Schlossburg, Edwin, 245
Schnabel, Julian, 2
Schneider, Jane, vii
Sears, Roebuck and Company, 93
second-wave feminism, 24–25
Seneca Falls women's rights and temperance movement, 92
September 11, 2001: commemorative gestures following, xi, 239–254; concerns about illegal aliens following, 41–42
service flags, display of, 242
sewing contractors, 90
sexual identity, clothing as self-identified prop of, x
sexy-work, 337, 338, 345, 352; invention of term, xiii
Shandu, Nonkululeko, 126
Sherlock, Matthew J., Jr., 1
Sherwood collars, 98, 101
Shonibare, Yinka, xii, 284, 292–294, 295–296, 300, 302–305, 306, 314
Shozi, Thembisile, 117
Sierra, Jorge, 40
Silences (Olsen), 30
silk embroidery threads, 212
Sirali, 168
SiSSYFiGHT 2000, 388
Sister My Sister (film), 337, 340–344, 352
SkinTalks, 252–253, 254
Slabbert, Frederik Van Zyl, 113
Smith, Alfred E., 36
Smith, Patrick, 385
social space, textile actions in demarcating, 242–245
Socrates, 27–28
Sohn-Rethel, Alfred, 16, 17
solidarity, textile actions showing, 245–246
Song of Myself, 280
Soren, Subarsini, 174
S.O.S.–Starification Object Series, 275–276
South Africa: apartheid in, 114, 120, 121, 127, 141–142; HIV statistics in, 138; loss of history in, 114–115; Truth and Reconciliation Commission in, ix, 113, 114–115, 119, 120–130, 132; narratives told to, 115–130
Space Walk, xii, 302–305
speed of production, 16–17
spinning, 385
spinning wheel, 257
Spivak, Gayatri Chakravorty, xii, 289, 290
Spoleto Festival USA, xii, 300, 307, 309, 336
Srinivasan, Viji, ix–x, 159, 161–162, 170
Stallabrass, Julian, 7, 19
Stallybrass, Peter, 284–285
Stammen, Jessica, 244
The Star of David (quilt pattern), 332
Starship Troopers (film), 380
statesmanship, weaving as metaphor for, 299
Stein, Leon, 29, 32–33, 34
stereoscopic travel photography, 24
Stewart, James T., 319

Stewart, Martha, 24–25
Stickley, Gustav, 198, 207–208, 210, 213, 215–216
Still Life with Quince, Cabbage, Melon, and Cucumber, 273
Stitching Women's Lives workshop, 171
Stoddard, Seneca Ray, 234
Storr, John, 368
Stowe, Harriet Beecher, 201
straight stitch, 160
string, 256–257
stump flags, x, 229–234
subcontractors, 11
subcultural dress codes, x
subversive street literature, 3
sujuni: colours of, 175–176; commissioning of, 164, 167; creative process in, 165, 175–176; defined, 159; description of, as stitched drawings, 165; exhibition of, in New York City, 164; as income-generating project, 161–162, 165, 175; investigation of stitch in, 180; patterns of, 159; purpose of, 159–160; revival of, 159, 172; signing of, 171; success of, in international markets, 171; techniques in, 175; themes of, 159–160; unique qualities of, 175
Sujuni Mahila Jeevan (Stitching Women's Lives), 164, 168
superstructure, distinction between base and, 360, 361–362
Swarm, 388
"Sweated Industries Exposition" at Queen's Hall, 26–27
sweating, 5, 33
sweatshops, 1; efforts to end, vii; employment of immigrants in, 33, 34; in London, 290, 291, 292; in new global economy, 31–50
Swinburne, Algernon, 274

Tae Ja, 68, 73, 74; declaration of bankruptcy by, 76–77; move to U.S., 73; opening of garment factory in Los Angeles, 74–76
Tanizaki, Jun'ichiro, 325
Tannenbaum, Judith, 280
Tar Beach 2 from Women on a Bridge Series # 1, 330
tariffs, abandonment of protective, 20
Taylor, Frederick Winslow, 16–17
The Tears I Cried for You, 386, 389
Teena, Brandon, 349
Teeth, 158
textile actions: American flag in, 246–249; concept of, xi, 239; in demarcating social space, 242–245; at Ground Zero, xi, 239–254; history and function of, 241–242; participatory, 251–252
Textile Museum of Canada, 250
textiles: adaptability of, 337–338; historical relationship of, to labor history, vi–vii; metaphorical use of, xii, 284; ubiquity of, xi; view of, as craft, 197
textile technologies, influence on computing machines, xi
textile tools, x
textile traditions, in Bihar, India, ix–x, 159–180
Thailand, factory fire in, 8–9
Thatcher, Margaret, 20
Thesis on Black Cultural Nationalism (Karenga), 319
Third World, 139
"Third World Conference Against Racism, Racial Discrimination, Xenophobia, and Related Intolerance," 118
This is Me, This is You, 278, 279

Thompson, John, 26
Thompson, Nato, 88
Thread has a Life of its Own, 164, 168
time, cloth and, 311
time-intensive works of art, 217
time-saving devices on industrial machines, 91–92
Told and Retold: An Inquiry About Hair, 386, 387
trade cloth, evolution of, xii
Trademarks, 275, 276
transnational corporations, vii, 38, 43–44
traveling shows, 27
The Tree of Life (quilt pattern), 332
Trend, David, xiv
Triangle Shirtwaist Company, walkout of workers from, 34
Triangle Shirtwaist fire, 1, 8, 29–30, 34; hand-colored glass slides showing images from, 1, 3, 7, 9, 15, 23, 24, 30
Tribute in Light, 240
trickle-down theories, 20
Troy, New York: claims to history, 89; as collar city, 95–98; collar factories in, 89, 96–97; lace curtains for, 98–100; shirt factories in, 89; textile manufacturing in, 89
Trumpet Flower, 202
Trungpa, Chögyam, 316
Truth and Reconciliation Commission, ix, 113, 119, 120–130
t-shirt collars, 98
Tucker, Marcia, 217
Turbulence of Migration, 283
Tutu, Desmond, 114
Tyabji, Laila, ix, x, 173–176
Tyler, Gus, 34
Tylor, Clyde, 322

Ultracool Ventilating Undergarments, 93–95, 99, 100, 101
"Umlazi Graveyard 1996," 129
Unabomber Manifesto, 390–391
Uncle Sam, images of, 103–104
undercutters, 91–92
underground economy, accountability in, 77–78
union shops, 34
UNITE, 48
U.S. International Trade Commission, 39
U.S. tariff code, Item 807 in, 75
Unwavering Spirit: Hope and Healing at Ground Zero exhibit, 245
urban tourism, 17
utopia, contradiction of capital and, 14–15

value: aesthetic, 328; of cloth, xii; pre-capitalist, 14
Vampire, 274
Van Gogh, Vincent, 13–14
The Vice-Presidents, 153
Victorian costume made from batik, 295–296
Vietnam, unions in, 73
Vijver, Linda Van, 113
Violence in 1996–1997: Train Victims, 2001–2002, 114
Virgil, 379
visual metaphors, 276
Vreeland, Diana, 2, 21

Walkley, Mary Anne, 1, 12, 13
The Wall Brooded, 289
Wal-Mart, products available at, 37; control of working conditions and, 46; offshore manufacturing and, vii; price controls set by, 38; shopping at, 10
Waring, Marilyn, 170
Warm the City, 249–250
warp, 177
WaxWeb, 387–388
weaving, 385; association with women, 256–257; historical evidence of, 257–258; metaphor of, 299; as multimedia event, 258; Neolithic, 257
Wedding Feast, 273
Weiner, Annette B., vii
welt, 177
Welty, William, 382
Western art critics, 171
Western art history, 302
Wheeler, Candace, 198, 201, 202–207, 213, 215–216, 217
Whitman, Walt, 280
"The whole family died of AIDS," 117
Who's Counting? Marilyn Waring on Sex, Lies & Global Economics, 170
Wilde, Oscar, 349, 377, 392
Wilke, Hannah, xi, 275–276, 280
Wilson, Anne, viii–ix, 105–112, 386, 387
wiseNeedle, 250
Wollen, Peter, 4–5
Woman's Home Companion, 212
women: art training for, 203; association of weaving with, 256–257; indigenous; Korean-American, 71; middle-class, 23, 198, 201; relationship to cloth, 306; work of immigrant, in garment industry, viii
Women's Movement, demise of, 22
worked art, 197–218
workers, downward spiral of, 43
workers movement, decline of, 48
workers' rights, weakness of laws protecting, 43
Workers Rights Consortium, 46
work ethic, Mennonite view on, 59–65
work gloves, cuffed, 92
Working Group on Employment of Women, 163
World Bank, 15
World Concern, 251
World Trade Center attacks, commemorative gestures following, xi, 239–254
World Trade Organization (WTO), 43; rules of, 47
Worn Worlds: Clothes, Mourning and the Life of Things, 284–285

Zamukuziphilisa Community Project, 134, 135
Zeile, Todd, 245
Zemel, Carol, 13
Zen and the Art of Motorcycle Maintenance (Pirsig), 379–380
Zierdt, Gwendolyn, 390–391
Zimmerman, Eric, 388